PENGUIN MODERN CLASSICS

Why Are We 'Artists'?

Jessica Lack began her career at *Tate: The Art Magazine* before becoming preview arts writer at the *Guardian* and *i-D Magazine*. She scripted the short film season *Unlock Art* and has written for all the major art magazine publications. She co-authored the best-selling *Tate Guide to Modern Art Terms*.

Why Are We 'Artists'?

100 World Art Manifestos

Edited with an Introduction by JESSICA LACK

PENGUIN BOOKS

PENGUIN CLASSICS

UK | USA | Canada | Ireland | Australia
India | New Zealand | South Africa

Penguin Books is part of the Penguin Random House group of companies
whose addresses can be found at global.penguinrandomhouse.com.

Penguin
Random House
UK

First published in Penguin Classics 2017
003

Introduction and editorial matter copyright © Jessica Lack, 2017
The Sources and Further Reading section on pp. 478–99 constitutes
an extension of this copyright page

The moral right of the editor has been asserted

Set in 10.5/13 pt Dante MT Std
Typeset by Jouve (UK), Milton Keynes
Printed in Great Britain by Clays Ltd, St Ives plc

A CIP catalogue record for this book is available from the British Library

ISBN: 978–0–241–23631–4

Contents

Introduction xiii
A Note on the Texts xxi

THE MANIFESTOS

M1. Ananda K. Coomaraswamy,
Art and Swadeshi (1909) 1

M2. Ljubomir Micić,
Manifest Zenitizma (1921) 7

M3. The Art Movement Society,
Manifesto (1929) 16

M4. Légitime Défense,
Manifesto (1932) 20

M5. The Storm Society,
Manifesto (1932) 24

M6. Peyami Safa,
D Group Manifesto (1933) 27

M7. Aimé Césaire,
Négreries: Black Youth and Assimilation (1935) 29

M8. The European School,
Manifesto (1945) 33

M9. Georges Henein,
Manifesto (1945) 35

M10. Arte Madí,
Madí Manifesto (1947) 38

M11.Vladimír Boudník,
Explosionalism Manifesto No. 2 (1949) 42

Contents

M12. Shakir Hassan al-Said,
Manifesto of the Baghdad Modern Art Group (1951) 45

M13. The Fighting Cock Art Group,
The Nightingale's Butcher Manifesto (1951) 49

M14. Exat 51 Group,
Manifesto (1951) 52

M15. Grupo ruptura,
ruptura Manifesto (1952) 54

M16. The Calcutta Group,
Manifesto of the Calcutta Group (1953) 56

M17. Enrico Baj,
Interplanetary Art (1959) 58

M18. Uche Okeke,
Natural Synthesis (1960) 61

M19. El Techo de la Ballena,
For the Restitution of Magma (1961) 64

M20. Josip Vaništa,
Untitled (Gorgona Manifesto) (1961) 66

M21. Maya Deren,
A Statement of Principles (1961) 68

M22. Jikan-Ha,
Manifesto of the Jikan-Ha Group (1962) 71

M23. Group 1890,
Group 1890 Manifesto (1963) 75

M24. Alberto Greco,
Manifesto Vivo-Dito (1963) 78

M25. Tadeusz Kantor,
The Emballage Manifesto (1964) 81

M26. Aktual Art,
Manifesto of Aktual Art (1964) 87

M27. Otto Mühl,
Material Action Manifesto (1965) 89

M28. HAPPSOC,
HAPPSOC Manifesto (1965) 91

M29. David Medalla,
MMMMMMM . . . Manifesto (a fragment) (1965) 94

M30. Július Koller,
*Anti-Happening (Subjective Objectivity
System)* (1965) 97

M31. Arte de los Medios de Comunicación Masivos,
A Mass-Mediatic Art (1966) 99

M32. I. G. Plamen and Marko Pogačnik,
OHO (1966) 102

M33. Lev Nussberg,
A Kinetic Manifesto (1966) 107

M34. The Aouchem Group,
The Aouchem Manifesto (1967) 110

M35. The Vanguard Artists' Group,
Tucumán Arde Manifesto (1968) 113

M36. Eduardo Costa,
Useful Art Manifesto (1969) 119

M37. The Casablanca School,
Manifesto (1969) 121

M38. Hori Kōsai,
Why Are We 'Artists'? (1969) 126

M39. The Organization of African Unity,
Pan-African Cultural Manifesto (1969) 128

M40. Agnes Denes,
A Manifesto (1969) 141

M41. The New Vision Group,
Towards a New Vision (1969) 143

M42. Grupo Vértebra,
The Vértebra Manifesto (1970) 150

M43. Artur Barrio,
MUD/MEAT SEWER (1970) 154

M44. Gyula Pauer,
The First Pseudo Manifesto (1970) 156

M45. Rivolta Femminile,
*On Woman's Absence from Celebratory Manifestations of
Male Creativity* (1971) 159

M46. Ted Joans,
Proposition for a Black Power Manifesto (1971) 162

Contents

M47. Jarosław Kozłowski and Andrzej Kostołowski,
NET Manifesto (1972) 164

M48. VALIE EXPORT,
Women's Art: A Manifesto (1972) 166

M49. Mike Brown,
*I don't know what to think about anything (It don't matter,
nohow)* (1972) 169

M50. Vitaly Komar and Aleksandr Melamid,
Sots-Art Manifesto (1972–3) 177

M51. Anita Steckel,
Statement on Censorship (1973) 180

M52. Shakir Hassan al-Said,
One Dimension (1973) 183

M53. Barbara Jones-Hogu,
*The History, Philosophy and Aesthetics of
AFRI-COBRA* (1973) 188

M54. Generation Anak Alam,
Manifesto Generation Anak Alam (1974) 200

M55. Sulaiman Esa and Redza Piyadasa,
Towards a Mystical Reality (1974) 203

M56. Mikhail Chemiakin and Vladimir Ivanov,
*Metaphysical Synthetism Manifesto: Programme of
the St Petersburg Group* (1974) 233

M57. The Artists' Front of Thailand,
Manifesto of the Artists' Front of Thailand (1975) 239

M58. The Indonesian New Arts Movement,
Manifesto of the Indonesian New Arts Movement (1975) 242

M59. Rasheed Araeen,
Preliminary Notes for a BLACK MANIFESTO (1975–6) 245

M60. The Azad Group, *Manifesto* (1976) 286

M61. Kaisahan, *Kaisahan Manifesto* (1976) 289

M62. Maria Klonaris and Katerina Thomadaki,
*Manifesto for a Radical Femininity for
an Other Cinema* (1977) 292

M63. Valerie Jaudon and Joyce Kozloff,
Art Hysterical Notions of Progress and Culture (1978) 296

viii

M64. Melissa Meyer and Miriam Schapiro,
*Waste Not Want Not: An Inquiry into What Women Saved
and Assembled – Femmage* (1978) 313

M65. Grupo Antillano,
Manifesto (1978) 320

M66. The Crystalist Group,
The Crystalist Manifesto (1978) 324

M67. Mangelos,
manifesto of manifesto (1978) 327

M68. Huang Rui,
Preface to the First Stars Art Exhibition (1979) 329

M69. Andrzej Partum,
Animal Manifesto (1980) 331

M70. Reality and Utterance,
On Founding 'Reality and Utterance' (1980) 334

M71. Habib Tengour,
Maghrebian Surrealism (1981) 338

M72. Eddie Chambers,
Black Artists for Uhuru (1982) 340

M73. Colectivo de Acciones de Arte,
A Declaration by the CADA (1982) 343

M74. John Akomfrah,
*Black Independent Film-Making: A Statement by the Black
Audio Film Collective* (1983) 351

M75. Women Artists of Pakistan,
Women Artists of Pakistan Manifesto (1983) 356

M76. Bedri Baykam,
The San Francisco Manifesto (1984) 359

M77. Vladan Radovanović,
The Vocovisual (1984) 362

M78. Laboratoire AGIT'art,
Memory of the Future? (1984) 364

M79. Dumb Type,
Flyer for Plan for Sleep #1 (1984) 371

M80. Chinese United Overseas Artists,
Manifesto Chinese United Overseas Artists (1985) 373

Contents

M81. NSK,
Internal Book of Laws (1985) 376

M82. Vohou-Vohou,
The Vohou-Vohou Revolution (1985) 382

M83. The Pond Association,
Declaration of the Pond Association (1986) 385

M84. Wang Guangyi,
We – Participants of the "85 Art Movement' (1986) 387

M85. Chila Kumari Burman,
There Have Always Been Great Blackwomen
Artists (1986) 390

M86. The School of the One,
Founding Manifesto (1986) 398

M87. Ding Fang,
Red Brigade Precept (1987) 403

M88. Anita Dube,
Questions and Dialogue (1987) 407

M89. The Eye Society,
The Eye Manifesto (1989) 419

M90. Eda Čufer and IRWIN,
The Ear behind the Painting (1990) 421

M91. VNS Matrix,
Cyberfeminist Manifesto for the 21st Century (1991) 426

M92. Marko Peljhan,
Projekt Atol Manifesto: In Search for a
New Condition (1993) 428

M93. The Institute of People-Oriented Culture 'Taring Padi',
Manifesto (1998) 431

M94. Frente 3 de Fevereiro,
Manifesto of Frente 3 de Fevereiro (2004) 434

M95. Pélagie Gbaguidi,
Manifesto Against The 'Black Code' edict of
Louis XIV, 1685 (2008) 437

M96. Adam Pendleton,
Black Dada (2008) 440

M97. Allyson Mitchell,
Deep Lez (2009) 451
M98. Abounaddara,
What is to be done? (2011) 455
M99. Tania Bruguera and Immigrant Movement
International,
Migrant Manifesto (2011) 458
M100. Tania Bruguera,
Manifesto on Artists' Rights (2012) 461

List of Artist Groups 468
Sources and Further Reading 479
Acknowledgements 501

Introduction

It is easy to share the delusion in the West that the art manifesto has long outlived its finest hour. Those scabrous radicals the Futurists, with their ebullient and unreasonable demands, tattooed a template into our consciousness that no skin graft will repair: that the art manifesto is magical, verbose, provocative, absurd and untethered by the mania for creative destruction leading up to the First World War. So ingrained is this idea that it is characteristic to imagine that the art manifesto simultaneously began and ended – *tabula rasa* – in 1909, when F. T. Marinetti published his desire to abandon the past and embrace the future on the front page of *Le Figaro*.

Such a view of the art manifesto's history casts a certain melancholia which is hard to ignore. And it exists as much in the declamations of an online technofeminist art collective as it does in the onionskin pages of a long-forgotten document rapped out on a typewriter where the ribbon runs dry. But to read the manifestos in this book with one eye on the past would be wrong, because it presupposes the art manifesto to be a Western phenomenon rather than a global one, and an irrelevance in the contemporary era. These manifestos, written between 1909 and 2012, come from all over the world, and were created for a myriad reasons. Some are personal, some are political, and others are written with aspirations to high cultural ideals. What unites them, if anything, is a belief in art as a vital and empowering force.

Some of these manifestos have not been published in English before, others simply deserve to be better known, but it is hoped that together they will expand our knowledge of the history of art.

I have listed them chronologically, simply because to list them any other way felt curiously prescriptive. Certainly there are themes, ideologies and influences that bind and overlap; but the geographical expanses are too wide, the political circumstances too specific and the manifestos too idiosyncratic to be neatly categorized. And that is how it should be, for even the most directive art manifesto is a chimerical exercise.

The book begins with 'Art and Swadeshi', written by the Sri Lankan cultural theorist Ananda K. Coomaraswamy in 1909 (M1). At the very moment the Futurists were calling for cultural destruction, the Indian province of Bengal was in the grip of revolutionary nationalist fervour. For four years the region had adopted a policy of Swadeshi (self-sufficiency), refusing to buy British goods; as a result, local industries were beginning to thrive. It was amid this climate of revivalism that Coomaraswamy advanced his thesis that the possibilities of Swadeshi were not solely economic and political, but should be artistic, too.

Coomaraswamy's frustration was directed at the way indigenous culture had been subjugated to a colonial one. This was a critical subject for all artists living under the rule of imperial masters. In the 1930s and 40s it permeated the passionate tirades of the visionary Afro-Caribbean Surrealists belonging to the Légitime Défense group (M4) and to the influential Négritude movement (M7), which sought to reclaim the value of blackness and African culture. As the philosophy of Négritude stretched out to span the Atlantic and encompass both Africa and the Caribbean, its creative force profoundly reshaped the cultural landscape of the African diaspora. Perhaps most significantly it underpinned the ideology of Pan-Africanism – the idea that all peoples of African descent shared a common cultural heritage, and that a collective black consciousness should be fostered in order to forge the bonds of solidarity necessary to overcome the legacies of slavery and colonialism.

As the Caribbean philosopher and psychiatrist Frantz Fanon wrote in one of the essential texts for the black liberation movement, *The Wretched of the Earth* (1961): 'Colonialism is not satisfied

merely with holding a people in its grip and emptying the native's brain of all form and content. By a kind of perverted logic, it turns to the past of the oppressed people, and distorts, disfigures and destroys it.' The distinguished cultural theorist Stuart Hall quoted this passage in his landmark essay 'Cultural Identity and Cinematic Representation' (1989) when discussing the problems faced by post-colonial societies. As artists were given the unique opportunity to define their newly independent country's cultural identity, their manifestos each articulated the same fundamental paradox: a desire to resurrect traditional home-grown forms of artistic expression, while at the same time acknowledging the *Présence Européenne*. The Nigerian artist Uche Okeke summed up the dilemma in his 'Natural Synthesis' manifesto of 1960 (M18):

Our new society calls for a synthesis of old and new, of functional art and art for its own sake . . . It is equally futile copying our old art heritages, for they stand for our old order. Culture lives by change. Today's social problems are different from yesterday's, and we shall be doing grave disservice to Africa and mankind by living in our fathers' achievements. For this is like living in an entirely alien cultural background.

In the optimistic atmosphere of many countries immediately after they had won independence, a classical art education – and even conventional art materials – were replaced with new forms of modernism, built upon the foundations of traditional indigenous art forms, styles and motifs. In North Africa and the Middle East in the 1940s and 50s, artists such as those of the Khartoum School in Sudan (see M66) and the Syrian painter Madiha Omar in Iraq (see M52) pioneered a form of modern art based on Arabic calligraphy. The Aouchem Group in 1960s Algeria took their name from the ancient Berber body art whose designs inspired their abstract paintings (M34). In West Africa in the 1970s and 80s, the Vohou-Vohou artists of Côte d'Ivoire (Ivory Coast) used tapa cloth (made from beaten tree bark), soil and clay in their paintings (M82). Across entire regions, Pan-Africanism and the associated ideology of Pan-Arabism gained momentum as artists sought unifying

cultural identities that spanned the new national divisions. In Iraq in 1969, the New Vision Group championed the idea of an Arab modernism united on ideological and cultural grounds rather than stylistically (M41). In Senegal in 1966, President Léopold Sédar Senghor staged the first World Festival of Black Arts in order to promote unity throughout the continent and across the African diaspora. This was followed by other Pan-African festivals and a cultural manifesto written in 1969 (M39). And in Malaysia in 1974, the artists Sulaiman Esa and Redza Piyadasa advanced the notion of 'mystical reality' in order to try and establish a clear division between Asian art and that created by Western artists (M55).

Another of the most powerful influences on art manifestos, especially in the inter-war and immediate post-war years, was Marxist ideology. For artists whose countries were oppressed by authoritarian rulers – whether their own or those of a foreign power – Marxism's revolutionary idealism was often profoundly inspiring. In the manifesto he wrote for the Surrealist group Légitime Défense in 1932, the Martinican poet Étienne Léro proclaimed the group's desire to 'rise up here against all those who are not suffocated by this capitalist, Christian, bourgeois world to which, involuntarily, our protesting bodies belong' (M4). In Argentina in 1947, the Constructivist group Arte Madí (M10) strove to create an abstract art for the people as the aesthetic expression of their dream for a classless utopian society. In Iran, the short-lived era of optimism that accompanied the socialist reforms of the new government in 1951 seemed to offer artists unprecedented creative possibilities; opportunities that were explored in the revolutionary 'Nightingale's Butcher Manifesto' (M13). And, as late as 1987, the Indian artist and writer Anita Dube was arguing in her 'Questions and Dialogue' manifesto that art should be inspired by Marxism to challenge marginalization and oppression (M88).

For artists in communist Eastern Europe, however, the influence of Marxism was far more ambivalent. By the late 1950s, many found themselves facing an increasingly stark choice: to forgo creative experimentation and self-expression in order to extol the joys of communism in state-approved Socialist Realist art, or be driven

underground. The result, as many artists chose the latter course, was a prolific era of art ephemera, of performances and happenings, and of art manifestos, many of which took Dadaist forms or were metaphysical in theme. This was partly to circumvent the serious threat of state censorship, but partly also to ridicule aspects of life under an authoritarian, socialist regime and reflect a sense of alienation. The Czech artist Vladimír Boudník, for example, directed people in 1949 to tap into the explosive creativity contained within themselves (M11); the Serbian group Gorgona introduced the Yugoslavian public to their idea of 'anti-art', which embraced absurdity, nihilism and irony, in 1961 (M20); while the conceptual artist Július Koller defied socialist conformity in 1960s Czechoslovakia by presenting the cosmos as a place of creative possibility and playing ping-pong (M30). In 1970s Poland, Jarosław Kozłowski and Andrzej Kostołowski sent out the 'NET Manifesto' to recipients all over the world, its deliberately bureaucratic style designed to get its message – a request for art-related information not accessible in Eastern Europe at the time – safely past the post-office censors (M47).

Before the advent of communism in China, a short-lived moment of fragile liberalism in the late 1920s and early 1930s had seen the beginnings of modernism in Chinese art. The charismatic artist Lin Fengmian had attempted to reconcile traditional Chinese art and innovative art practices in Europe (M3), while the Storm Society had sought a complete break with the past in favour of a revolutionary avant-garde (M5) – but such tender shoots of artistic experimentation soon withered away beneath the storm blasts of Maoist ideology, and any last remnants of originality were obliterated by the onset of the Cultural Revolution in 1966. It was not until the late 1970s, following the death of Mao Zedong, that artists were able to exercise some creative freedom once again. The unofficial open-air exhibition staged by the Stars Group in Beijing in 1979 (M68) is often considered the forerunner of a nationwide cultural awakening in the 1980s. But this exhilarating era of artistic creativity and prolific manifesto writing (see M83, M84, M87) was abruptly ended by the reversal of liberalization following the

Tiananmen Square demonstrations in 1989, and the exodus abroad of many artists escaping the new oppression.

South America also has a fertile history of revolutionary art manifestos. The Brazilian poet Oswald de Andrade's provocative declaration in 1928 that Brazil's greatest strength was the cannibalizing of other cultures arguably set a precedent for extremist actions by South American artists. Many became activists, writing manifestos that sought to shock their societies out of complacency. As nascent democracies gave way to brutal military juntas and bloody guerrilla struggles, artists took to the streets, performing happenings and staging collective actions in order to drive forward their insurgent agendas. Their art was often as incendiary as the ideas they promoted in their manifestos. The Vanguard Artists' Group in Argentina used the cover of an arts festival to expose the appalling treatment of workers in the province of Tucumán in 1968 (M35). The collective El Techo de la Ballena (The Roof of the Whale) in 1960s Venezuela and the artist Artur Barrio in 1970s Brazil both used rotting matter as a metaphor for the corruption of society (M19, M43). The Colectivo de Acciones de Arte (Collective for Art Actions) in Chile sought to mobilize popular opposition against General Augusto Pinochet's dictatorship in the 1970s–80s through high-profile cultural interventions (M73).

Similar approaches were also taken by black activist artists fighting for recognition in the 1960s–1980s. The members of AFRI-COBRA (M53), who were involved in the Civil Rights movement in the USA, took their cue from the Harlem Renaissance and the philosopher Alain Locke's seminal study of the movement, *The New Negro* (1925), and articulated their aesthetic as 'expressive awe-someness' and 'shine'. Other artists were empowered by the force-ful rhetoric of works such as *The Wretched of the Earth* to begin challenging the white supremacy of the art establishment. Between 1975 and 1976 the British conceptual artist Rasheed Araeen wrote 'Preliminary Notes for a BLACK MANIFESTO' (M59), in which he castigated the endemic racism of the Western art world. His sentiments were echoed by the Turkish painter Bedri Baykam in 1984 in 'The San Francisco Manifesto' (M76) and by the British

artist Chila Kumari Burman's 'There Have Always Been Great Blackwomen Artists' in 1986 (M85). And, as cultural theorists called for the reconfiguration of the traditional centre–periphery relationship – in which Western cultural development is given primacy over the social and artistic developments of other regions – in favour of multiple centres of interconnectivity, art collectives like the Black Audio Film Collective (M74) were breaking cinematic convention by creating complex narratives that meditated on themes of migration and globalization.

These twin themes have continued to attract the energy of artists and find expression in myriad new ways – from the Slovenian conceptualist Marko Peljhan's pioneering 'Projekt Atol' (M92), which since the early 1990s has used information technology to navigate the post-modern world, map new cultural connections and create initiatives beyond the confines of traditional art institutions, to the Syrian collective Abounaddara (M98), who operate their 'emergency cinema' in the ever-evolving online territories of today.

This introduction does not do justice to the breadth and scope of the art manifestos in this book. There is the joyful irony of VNS Matrix's 'Cyberfeminist Manifesto for the 21st Century', which seeks to infiltrate and disrupt the sexist swamp of early web technology (M91). There is Anita Steckel's spirited defence of the penis in art (M51) and Carla Lonzi's brilliant rebuke to the male creative ego (M45). There are manifestos written for new visual utopias that still radiate like phosphorescence on the horizon, while toxic politicking and market forces make their spirited reality an impossibility. Others seek to remind us that there are many different ways of looking at the world.

The book concludes with the 'Manifesto of Artists' Rights' (M100), written in 2012 by the Cuban artist and activist Tania Bruguera: a universal plea for creative freedom for artists living and working in places of oppression. Its simple, direct message can stand for every manifesto in this selection.

'Art is not a luxury. Art is a basic social need to which everyone has a right.'

A Note on the Texts

The manifestos collected in this book originally took many forms: not only straightforward essays or conventional articles in periodicals, but also posters, flyers, pamphlets, personal manuscripts, samizdat typescripts, postcards, poems and performances. Others – for example Rasheed Araeen's 'Preliminary Notes for a BLACK MANIFESTO' (M59) or Adam Pendleton's 'Black Dada' (M96) – were conceived by their creators as artworks in their own right. Some of the manifestos appearing here have been translated into English for the first time; in other cases the authors opted not to use their first languages, but wrote in English themselves. With a couple of exceptions (duly noted at the appropriate point), all manifestos are reprinted in their entirety.

As mentioned in the Introduction, the manifestos are arranged chronologically. Because many were not formally published in print until long after the time of their composition (for example, those produced in places of totalitarian censorship), the manifestos are ordered as far as possible according to their time of composition or initial informal dissemination, rather than necessarily their first publication. Where manifestos cannot be dated any more specifically than to a particular year, they are placed after those where a more specific date within the same year has been established.

One of the pleasures of reading these manifestos is encountering the distinctive, often unique, forms of expression employed by their authors in order to give voice to their artistic ideas. Therefore, other than the silent correction of obvious typographical errors, and the occasional minor emendation arising from consultation with the respective authors, editorial interference within the texts

has been kept to an absolute minimum in order to preserve the individual style of each manifesto.

Because many of the individuals and groups responsible for the manifestos may not be familiar to every reader, each text is preceded by a short introduction which provides some information about the author(s), a brief outline of the context in which the manifesto was written and, where necessary, explanations of significant allusions or references within the texts. All footnotes, however, are original to the manifestos, rather than editorially supplied. In addition, further information about the manifestos and the artists associated with them can be obtained from the works cited in the section on Sources and Further Reading and from the List of Artist Groups towards the end of this book.

M1 Ananda K. Coomaraswamy

Art and Swadeshi (1909)

Swadeshi (Self-Sufficiency) was a grass-roots nationalist movement that began in the north-east Indian province of Bengal in the late 1800s. It became a decisive force in 1905 when Britain attempted to partition Bengal in order to weaken insurrection in the region against its imperial rule. The concept was very simple: by refusing to buy British-made goods, the region could become self-sufficient. As a result small Bengali industries, particularly the textile industry, began to thrive.

Into this revolutionary atmosphere came the Sri Lankan cultural theorist Ananda K. Coomaraswamy (1877–1947). Inspired by the artist Abanindranath Tagore's support of Swadeshi and his advocation of an all-Indian art, he urged Swadeshi to become a cultural movement that supported artisans in the creation of indigenous Indian art using traditional methods. Coomaraswamy's anti-colonial message was that India's culture had become enslaved to the imperial power: 'It is the weakness of our national movement that we do not love India; we love suburban England, we love the comfortable bourgeois prosperity that is to be some day established when we have learned enough science and forgotten enough art to successfully compete with Europe' . . . It was time to create an all-Indian art for, and supported by, the people.

'Art and Swadeshi' was first published in the *Central Hindu College Magazine* in 1909. The 'Mr. Havell' Coomaraswamy refers to in the manifesto is E. B. Havell, principal of the Calcutta School of Art, who, together with Tagore, sought to establish an Indian school of modernism.

* * *

I

If you go into one of those shops frequented by tourists in Indian towns, you will find amongst the flimsy wood carving and shallow brass work, the cheap enamels and the overloaded embroideries which are outward manifestations of the degradation of Indian craftsmanship, a few examples of real old Indian manufactures. These things, which used to be common in every market and were at once the wealth of the Indian people and the basis of their export trade for the last three thousand years, are now rare and difficult to obtain; they are called *purani chiz*, 'old things.' They are bought by American connoisseurs and German collectors for museums, for the education of Europe in design and for the benefit of the European manufacturer, for whom, too, they are reproduced in such papers as the *Journal of Indian Art*, and lectured on in Technical Schools and Schools of Art. For while the creative power of the craftsman has been long destroyed by commercialism in the West, it remained alive with us till yesterday, and even to-day some part of it survives.

Indian design is an inexhaustible treasure-house of fine invention. But have you ever reflected that all this invention belongs to the past – that modern India, Anglicised India, has produced no beauty and romance, but has gone far to destroy the beauty and romance which are our heritage from the past? Go into a Swadeshi shop – you will not find the evidences of Indian invention, the wealth of beauty which the Indian craftsman used to lavish on the simplest articles of daily use, the filmy muslins or the flower-woven silks with which we used to worship the beauty of Indian women, the brazen vessels from which we ate and drank, the carpets on which we trod with bare feet or the pictures that revealed to us the love of Radha, or the soul of the eternal snows. You will not find these things, but you will find every kind of imitation of the productions of European commerce, differing only from their unlovely prototypes in their slightly higher price and slightly inferior quality. You will find dingy grey 'shirtings'; other materials dyed with aniline dyes of the loudest and least permanent; travelling trunks that are painted every colour of the rainbow, and if carefully used may hold together for half a year; boot polish, marking ink, soaps

and fountain pens – anything and everything but beauty. It is the outward sign of the merely material ideal of prosperity which is too exclusively striven for by our economists and politicians. I shall show presently how even such an aim defeats itself, but in the meanwhile let us take another view.

You are familiar with the thought that the highest ideal of nationality is service. Have you ever thought that India, politically and economically free, but subdued by Europe in her inmost soul is scarcely an ideal to be dreamt of, or to live, or die, for? 'India, vulgarised by modern education, and by the ideals of modern commercialism, will never compensate humanity for India with its knowledge of beauty.' Have you ever realised that there are European artists who believe that when a new inspiration comes into European art it will come again from the East? Do you realise that when India was a great political power in Asia, when she colonised Java and inspired China, this also was the period of her greatest achievement in art? Has it never occurred to you that it is as much your duty to make your lives and your environment beautiful as to make them moral, in fact that without beauty there can be no true morality, without morality no true beauty? Look round about you at the vulgarisation of modern India – our prostitution of art to the tourist trade – our use of kerosine tins for water jars, and galvanised zinc for tiles – our caricature of European dress – our homes furnished and ornamented in the style proverbial of seaside lodging houses, with cut glass chandeliers and China dogs and artificial flowers – our devotion to the harmonium and the gramophone – these things are the outward and damning proof of 'some mighty evil in our souls.'

Try to believe that this callousness of ours, this loss of the fine taste that belonged to classic and mediæval culture is a sign of weakness, not of strength. Try to believe in the regeneration of India through art, and not by politics and economics alone. A purely material idea will never give to us the lacking strength to build up a great enduring nation. For that we need ideals and dreams, impossible and visionary, the food of martyrs and of artists.

You see, this loss of beauty in our lives is a proof that we do not

3

love India; for India, above all nations, was beautiful once, and that was not long ago. It is the weakness of our national movement that we do not love India; we love suburban England, we love the comfortable bourgeois prosperity that is to be some day established when we have learned enough science and forgotten enough art to successfully compete with Europe in a commercial war conducted on its present lines. It is not thus that nations are made. And so, like Mr. Havell, I would say to you, 'Leave off asking Government to revive your art and industries; all that is worth having you must and can do for yourselves; and when you have achieved all that you can do, no Government would refuse to grant you the political rights you desire, for the development of your artistic faculties will give back to India the creative force her people have lost. It will infuse into all your undertakings the practical sense and power of organisation which are now so often wanting.'

And now for the practical side of the question, to show, *i.e.*, that the ideal is (as always) the practical *par excellence*. The loss of artistic understanding more than anything else has ruined Indian industries and prevents the possibility of their revival. The neglect of Indian music has taken away the livelihood of the maker of musical instruments, with their hereditary and exquisite skill; has likewise destroyed the livelihood of Indian musicians; and fifteen lakhs worth of foreign instruments are annually imported from abroad! Observe that this is a double loss – material on the one hand, and spiritual on the other, for not only has the community lost wealth in the shape of things, but wealth in the shape of men, men who possessed the cunning and the skill to make them. Were India rich enough to spend a hundred lakhs per year on gramophones and harmoniums, this loss of men would still remain.

So too with the village weaver. Indian colouring and design have not been understood and loved: result, that the weaver's livelihood is gone, and he has to compete in agriculture, or in service in an already overcrowded field. Again, by concentration on the purely material side of the question, but not recognizing the superior workmanship of hand-made and individually designed materials, it has come about that instead of attempting to restore the

village weaver and the handloom, we are willing to waste the vital forces of the nation in child-labour and long hours of work under mechanical and unhealthy conditions, transferred from Manchester to India. Remember that it can be said of England that 'There is collected a population in our great towns which equals in amount the whole of those who lived in England and Wales six centuries ago; but whose condition is more destitute, whose homes are more squalid, whose means are more uncertain, whose prospects are more hopeless than those of the poorest serf of the middle ages and the meanest drudges of the mediæval cities.' Remember that one-tenth of the English people die in the workhouse, the gaol or the lunatic asylum. Therefore learn not to waste the vital forces of the nation in a temporary political conflict, but understand that art will enable you to re-establish all your arts and industries on a surer basis, a basis which will bring well-being to the people themselves; for no lovely thing can be produced in conditions that are themselves unlovely.

Take one concrete case. 'The Mirzapur carpets were at one time admired for their fast, bright colour, but are now identified with whatever is inferior in the name of dye or design. Aniline dyes and foreign models are responsible for the decline of a trade which gave fair promise of development not many years ago.' Now observe that mere bad taste alone, the lack of artistic understanding, in such a case has destroyed the livelihood of the maker of dyes and the maker of carpets, and ruined even the possibility of an export trade.

The truth is that without artistic understanding, Indian manufacture cannot be effectively restored. It is suicidal to compete with Europe on a basis of cheapness. Competition should be upon a basis of quality.

At the same time the competition in cheapness alone is destructive of the very fibre of the Indian people: for 'industry without art is brutality.'

Swadeshi must be something more than a political weapon. It must be a religious-artistic ideal. I have heard nationalists exhort each other to sacrifice, in using Swadeshi goods. To think that it should need to be called a sacrifice! At least it should not, as now, be

a sacrifice both in cost *and* quality. If we loved and understood Indian art we should know that even now the Indian craftsman could, if we would let him, build for us and clothe us in ways of beauty that could not be attained to in modern Europe for any expenditure of money at all. We would if we might, even to-day, live like the very gods but we lust after the fleshpots of Egypt, and deservedly our economy suffers.

Therefore I say to the well-to-do, that it is better to spend two hundred and fifty rupees on a Benares Sari, dyed with the country dyes, though two hundred would pay for it dyed in aniline, than to subscribe ten times that amount to some Swadeshi factory for making nibs or cloth and from which you expect a handsome dividend. And for the poor also in proportion to their ability remembering that 'a poor man, by building the smallest temple, is no less meritorious than a wealthy man who builds the largest.'*

Remember also that from the standpoint of national wealth, a few possessions that will endure, are better than many that will last only for a day. The builder whose work will last five centuries adds more to the national wealth than he whose work lasts only for fifty years. So, too, the weaver whose fair work is handed on from generation to generation does more for his country than a weaver whose work has soon to be cast aside. Civilisation consists not in multiplying the quantity of our desires, but in the refinement of their quality.

But let us not love art because it will bring to us prosperity; rather because it is a high function of our being, a door for thoughts to pass from the unseen to the seen, the source of those high dreams and the embodiment of that enduring vision that is to be the Indian nation; not less, but more strong and more beautiful than ever before, and the gracious giver of beauty to all the nations of the earth.

* *Agni Purana*, Ch. XXVIII.

M2 Ljubomir Micić

Manifest Zenitizma (1921)

In Zagreb in 1921 the Serbian artist and poet Ljubomir Micić (1895–1971) published the 'Manifest Zenitizma' in the first issue of *Zenit* (*Zenith*), his international art magazine. A fascinatingly paradoxical character, Micić was an anarchist nationalist who wanted to declare the Balkan Peninsula a separate continent and create a new Balkan art movement that embraced the contradictions of its history and geography, situated between the East and the West. At the same time, he argued that Zenitizma was a universal art, one rooted in Expressionism, Dadaism, Futurism and Constructivism, and that it transcended class and national boundaries.

The manifesto also promoted the artist's idea of a Balkan superman, a 'barbarogenius', who would revive Europe's ailing culture. In this respect Zenitizma can be seen to connect to Italian Futurism, which also promoted Nietzschean philosophy. Indeed, when Micić was threatened with imprisonment for communist sympathies, the leader of the Italian Futurists, F. T. Marinetti, helped him to escape, and Micić moved to Paris where he continued to promote his dream of a barbarian avant-garde.

An interesting side note is a protest by Micić and his brother, the poet Branko Ve Poljanski, in 1926 against the Nobel Prize winner Rabindranath Tagore (uncle of Swadeshi exponent Abanindranath Tagore: see M1). The Bengali poet was giving a lecture in Belgrade when the duo threw leaflets in the air and shouted, 'Down with Tagore, Long Live Gandhi!' They objected to Tagore's seemingly pro-Western, anti-Swadeshi stance in India's independence struggle, as opposed to Gandhi's grass-roots approach.

* * *

You cannot 'understand' z e n i t i s m
unless you feel it.
The e l e c t r i c i t y we do not 'understand'
but feel is perhaps the supreme
manifestation of the spirit –

Z e n i t i s m?

We are naked and pure.
Forget hatred – sink into the naked depths of **Yourself**!
Dive and fly to your own heights!

ZENITH

Fly above the criminal, fratricidal P r e s e n t!
Show your astral being to the visionary eyes of S u p e r l i f e!
Listen to the magic of our words, Listen to Y o u r s e l v e s!
There – on Šar mountain – on the Urals – stands

THE NAKED MAN BARBAROGENIUS

Fly above the Šar mountain, above the Urals and the Himalayas –
Mont Blanc – Popocatepetl – above Kilimanjaro!
We are now floating high, high above the bodily spheres of the Globe.

Break, binding chains! Fall, suburbs of large and plague-ridden
West European cities! Shatter, glass of gilded palaces
– tall towers – National Stock Markets and Banks!
Return to your fat bellies, fat war profiteers!
Hide your bought concubines deep in your dirty pockets!
Have you no shame!?
And you, blind mothers and you, stupid fathers, selling your innocent
daughters for money!
And you, you black underground spiders, spinning your webs
around pure souls

Freemasons!
Have you no shame, you drunken lodges!?

You – merchants of souls – art and culture – you lie the most!
Against you – *for Man!*
Bolt your doors West – North – Central Europe –
The Barbarians are coming!
Bolt them, bolt them, but

We shall still enter!

We are the children of arson and fire – we carry Man's soul.
And our soul is *combustion.*
Combustion of the soul in the creation of *sublimity.*

ZENITISM

We are the children of the Sun and the Mountains – we carry
Man's spirit.
And our spirit is the life of cosmic *unity* bound by Love.
We are the children of the *South East barbaro-genius.*

It is coming . . . It is coming . . .

THE RESCUE CAR

*Hot-blooded horses' hoofs hitting
the ground galloping to a savage rhythm.*

*Underground channels rumble
Crammed hospitals moan
City churches – streets and cathedrals
 celebrate Easter
 1921.*

*Moscow pours blood.
Far away bells of assumption thunder.*

Why Are We 'Artists'?

A closed yellow car hurtles
cutting through space of sinful and colorful streets
where war battalions of fratricides once passed.

--

Oh mortuary music of those gray battalions!
Oh bloody burials of attack trumpets!
Oh dull thuds of men's bodies
remember:
>!Man is your brother!
>!Man is your brother!

The sun spurts.
Astral bodies of the universe dance
Floating up there in the endless circular spheres
of the new planet
>>> ** Alpha and Pons **

And the red-colored crosses
on the milky panes of the yellow car
have hoisted high their visionary flag of R e d e m p t i o n
and sing the E a s t e r n S l a v i c song of Resurrection.

Countless crosses of our defeated land tremble.
The wooden gallows above our skulls are falling.
Bloody ropes snake above the fratricidal Black Peak.
And through big cities cars with red crosses rush
>EAST
>>SOUTH
>>>WEST

The yellow rescue car hurtles
carrying a hidden corpse – Man.

Man is dying everywhere.

The Sun has fallen into my soul
into the limitless space of All-love.

The red glass crosses shattered –
Man has died in the yellow car.

Letters are dancing, cast above the crosses

R S U C R
 E C E A

Black flags, brothers, flutter in our souls
because
Man is dying everywhere . . .
* * * * * * * * * * *

It is magic, the word: *Zenith*!

Man, a b r o t h e r a n d f a t h e r t o g o d s was born somewhere
in the jungle.
Man c r e a t e d God, for he saw terrible storms and arrows,
heard thunder and desired the *Sun*.
One magical and deep night he discovered H i m s e l f – Man
Man's first weakness created God – *the First Empire*.
The first Egyptian and Greek culture (G r e e c e a n d
M a c e d o n i a a r e b o t h i n t h e B a l k a n s!) – the *Second Empire*.

ZENITISM = THE THIRD UNIVERSE
A graphic picture of z e n i t i s m = an incarnation of the
metacosmic bipolarity:

```
                    ZENITH
                    Z
                    E
ETHER               N               ETHER
                    I
                    T
                    H
───────────────────────────────────────────
ASTRAL              I               ASTRAL
───────────────────────────────────────────
ASTRAL BODY         S               ASTRAL BODY
───────────────────────────────────────────
                    M
                  MAN
             EARTH ∩ EARTH
```

M a n is the center of the macrocosmos – the Earth's North Pole.
Z e n i t h is the center of the metacosmos – the Universe's North Pole.
Zenitism is a magical and electric interval between the macrocosmos and
the metacosmos – between M a n and Z e n i t h.
Man is thunder cast into space – on Earth.
We begin with Man.
Man is a victim. The victim is always central.
Man is tragedy. Tragedy is always sublime.

Man – Spirit – Metacosmos – Sun – Phenomenon – Zenith

ZENITISM = THE ORIENT OF AIRPLANE SPIRITS

Zenitism is the idea of all arts.
Zenitist art must be an art of ideas – a f f i n i t i v e.
A Zenitist must create new things.
A Zenitist must create the new.
Zenitism is an artistic affirmation of the **A l l s p i r i t**.

ZENITISM = ∞ = TOTALITY

Zenitism is the absolute supernatural individuation, the only creative one:

It must contain the a r t i s t + m a n.

Superman

It must incarnate the bipolar metacosmos

Phenomenon

Zenitism is more than spirit = the fourth dimension.

Zenitism is beyond dimensions = o. or the tenth

dimension = *Eternity.*

Magical Zenitist word = radio station A
Man's fluid feeling and jerk = radio station B

Manifestation = Radiogram.

A Zenitist word must be e l e c t r i f i c a t i o n
A Zenitist deed must be a r a d i o g r a m.

This is not a gospel. This is a M a n i f e s t o.
The people of the future, who come after us, they will write the Gospel.
And they will come . . . they will come . . .
The future Man!
He will be the son of the Sun and the Zenith.
He will speak the Zenitist language.
All . . . all . . . will understand.

This is not a philosophy.
The philosophy of zenitism is in the making.
It is emerging . . . happening . . .
Zenitism is mysticism and there is no philosophy of mysticism. There is
only the mysticism of philosophy – the mysticism of the *New Art*.
Zenitism is a revelation in the one hundred and twentieth century!!!

Expressionism, cubism, futurism – are dead.
We are an extension of their lineage – to higher ground!
We are their synthesis but as an arrow pointing upward, a reincarnation
– *the plusexistence of their philosophical ideas;*

> The soul of souls of the dead of those who died but lived one hundred and
> twenty centuries ago and yearned for the Zenith.
> The soul of the souls of the nameless ones whose proud children we are.
> Sons of creation – bonding – unification – travel
> through Chaos – the sons of **Original Sin**.
> Original Sin must have occurred, for that is how people came to know
> Themselves.
> There would be no Z e n i t i s m without O r i g i n a l S i n!

We who have discovered Ourselves – Man – we are Zenitists
You should be, too!
Our only *thought* is Z E N I T H – *the highest incarnation of Allexistence.*
Our path is only f o r w a r d – a b o v e – o v e r e v e r y t h i n g
t h a t h a s b e e n.
Down with pale traditions, systems, and borders! Borders are for the limited!
We keep going . . . going
Traveling from chaos to create a W o r k.

<div align="center">Led by the mystical demigod</div>

<div align="center">

ANARCH

</div>

You come too, though woe unto them who stumble and are left by the way-
side.
We w i l l n o t c o m e b a c k.
Poets! Brothers! Zenitists as yet unknown!
Cast off the cloak of lies!

14

Awaken Man and exalt him!
Sing of flames, fire, the burning and thirst for Zenith!
Put a stop to Man's fall. That will be our greatest work. That is
the vertical line that will pierce the heavens above. And *sunny
blood, sunny blood* shall flow.

Poets of Zenith! Sing of Man and not murderer!
Man is for Love and for Exaltation.

Above splintered human skulls, we extend our hands to all,
over all borders, to those who think like us: *to people!*

Even then, when the last N o n h u m a n dies,
then
in all the countries – in all the cities – on all the towers
ships – planes – palaces – court rooms – hospitals
– academies – insane asylums – seaports –
hang clean white flags and greet the *Future Zenitist Man*
then
in all the pavilions – churches – halls – theaters
– circuses – streets – roofs – railways – submarines
– army barracks –
in all the Z e n i t e u m s
sound your trumpets –
organs – tympani – drums – fanfares –
sing your hearts
sing . . . sing

THE ANTHEM OF ZENITISM

THE ANTHEM OF ZENITISM

Earth is for Man the Brother and not for Man the
Murderer!

Zagreb in the Balkans, June 12, 1921.

M3 The Art Movement Society

Manifesto (1929)

The Art Movement Society (*Guoli yishu yundong she*) was founded by the charismatic Chinese artist Lin Fengmian (1900–91) in 1928 in order to bring about a cultural renaissance in the arts in his homeland by seeking to reconcile Chinese traditional art with the innovative practices being championed in the West. Since the revolution of 1911, there had been attempts by the newly formed republic to industrialize and modernize China. This New Culture Movement hoped to revitalize what it saw as an ailing culture by promoting modern, Western ideas. In order to do this, artists and academics were sent abroad to study. Lin went first to Paris and then to Berlin; his paintings at this time have been likened to those of the German Expressionist movement. In 1928 Lin was made the director of the newly established National Academy of Art in Hangzhou, where he quickly instigated a radical programme of Western and Chinese art, introducing the paintings of Cézanne and van Gogh into the curriculum, as well as founding the Art Movement Society.

The society's manifesto was written by Lin and published in the eighth issue of the National Academy's magazine, *Yapole* (*Apollo*), in 1929. It draws a parallel with the war-torn era of the fourth and fifth centuries AD in China, when civil war between the North and South Dynasties ignited a flourishing radical arts scene. Arguing that in an unstable society there is a greater need for art as an emotional and spiritual refuge, he exhorts Chinese artists to collective action, stating that China's artistic future must be outward-looking and embrace an expansionist Pan-Asian culture.

* * *

Within the so-called New Culture Movement in the last decade or so, art has been ranked lowest of all. To date, the new term 'Art Movement' has not yet been accepted as a slogan, and has attracted little attention as compared with other surging political and social movements. This reality is not surprising to us, particularly during a transitional period of such dire poverty. Material existence has been extremely harsh. All emotional and ideological actions have been suppressed into apathy. Art, which has always been the ultimate expression of human emotional life, has to be consigned to oblivion for the time being. Speaking about Art Movements in this devastated China without addressing the needs of the time seems ridiculous. We should not forget, however, that the time of the South and North Dynasties was one of the most flourishing eras in the history of Chinese art, and the Renaissance of Europe took place during a period of religious wars. Evidently, whether today or yesterday, whether in China or elsewhere, the more unstable a society is for its inhabitants, the greater their need for art to serve as an emotional and spiritual refuge. Even at the individual level, we believe that a person's spiritual pulse will not stop as long as he holds a loaf of bread in his hands. Whether in peaceful or chaotic periods, Art Movements should not be interrupted any more than farming operations. Simply put, artists are farmers who work in the field of the spirit for all mankind.

Since we acknowledge the universal need of all civilised or barbaric nations for an engagement with the emotional during difficult or comfortable times, art movements then are at the centre of all cultural movements. After all, the purpose of cultural movements is nothing more than to bring people's lives to perfection. Having realised the truth of art, we firmly and determinedly uphold the banner of Art Movements, in such a period of ongoing wars and fleeing refugees, to promote the blessings of art amid the screaming and moaning. We regard this as our appointed mission!

Read, if you will, Article III of this Society's charter, which explicitly states that 'the purpose of this Society is to advance the emerging art of the Orient by uniting, through bonds of absolute

friendship, new forces committed to Art Movements within the art community.' Our attitude and goal may well be straightforward and clear, but nonetheless may elicit suspicion and misunderstanding from members of society. We therefore restate as follows: What artists value most, as we all know, is their emotional existence, as artistic creation totally relies on and arises from the arousal of emotion. Moreover, artists generally prefer to remain in solitude, as they desire to protect and preserve their individuality and introspection, without having their freedom tainted by accommodation to society at large. Since artists have these attributes, they are not steered by external interests. An organisation's structure must therefore rely on emotions to collectively pursue a common goal. Thus, members of this Society regard friendship, the purest and noblest of emotions, as the first essential. As attested to by countless examples in the world of poetry, artists have treasured friendship since ancient times.

Different schools have always existed among artists. From the perspective of artistic creation, this should be a very welcome phenomenon, as long as no battle for power ensues. No artist should denounce this inevitable element of artistic evolution. An organisation should neither focus on the relevance of interests, nor be restricted to similarity in style. Instead, its members should be led by a collective will. Then what is our collective goal? All sober-minded individuals know that art evolves with historical sensibilities. The art of the Song Dynasty could not resemble that of the Tang Dynasty, nor could the art of the Tang resemble its predecessor, the Han-Wei. The dispirited path trudged by artists in the Ming and Qing Dynasties, whose only skill was plagiarism, does not deserve mention. Today's advocates of traditional art are nothing more than destroyers of art. Why do we need Art Movements? We can just repeat the old saying: Be secluded in the mountains with long hair! As we thoroughly denounce the existence of the traditional school of art, any artist committed to creating a new age naturally shares our vision. These are our best friends, whether or not we know each other or belong to the same race. Herein lies the primary goal of this Society: to unite the new forces within the art community.

At their inception, Art Movements are visionary. How do we move them forward? We still need specific plans as guidelines for action. We are fully aware that the success of Art Movements, across the vast expanse of China, simply cannot be achieved by the power of a few people. The first purpose of this Society is to assemble and commit all the new forces in China's art community to Art Movements. Publishing art magazines to promote and enhance the level of public appreciation of art; organising more exhibitions to bring art closer to the public; devoting effort to art education in order to foster talented, emerging artists; founding art museums or sending out archaeological expeditions – these are our prospective tasks, prioritised according to programme and resources.

Finally, we should bear in mind that, on the one hand, modern artistic thinking cannot depart from so-called nationality and individuality. But on the other hand, the tendency towards universality is real in spirit. Eastern and Western art have a long history of influence upon one another, a topic upon which it is not necessary to expand here. The current relationship between Eastern and Western art communities is becoming increasingly interwoven. Artists should not confine their views within national boundaries, nor should different schools attempt to turn competition into a domestic conflict! It is our belief, therefore, that artists of this new era should study the art of all nations with a global perspective. Any art, not limited to the art of Europe, but extending to the art of the Philippines and Australia, deserves our attention as long as we can learn from it.

We all know that the highest mission bestowed upon the artist is to create. This should be the ultimate objective of the artist's life-long pursuit, and is the expectation society has of the artist. It is the ultimate vision of this Society to unite a majority of creative powers in the art community to expedite the realisation of a new artistic age, as a lasting spiritual contribution to society. Fellow artists, both at home and abroad, please show your understanding and sympathy for our vision by bestowing your advice.

M4 Légitime Défense

Manifesto (1932)

In June 1932 Étienne Léro (1910–39), a charismatic poet and theorist from the West Indian island of Martinique, founded a black Surrealist journal in Paris called *Légitime défense* (literally *Legitimate Defence*, or *Rightful Vindication*). Inspired by André Breton's 1926 pamphlet defending Surrealism's radical autonomy, from which it took its name, *Légitime défense* was used by Léro and his group of Caribbean intellectuals to promote a black West Indian artistic avant-garde that was both Surrealist and Marxist in tone. They sought to revolutionize the culture of the Caribbean: labelling themselves the 'intellectual spokespersons for the West Indian working classes', they called for artists of the Caribbean to rise up against the suffocating constraints of Western, Christian capitalism. They openly criticized Martinique's colonial culture, and described 'the French black bourgeoisie' as 'one of the saddest things on this earth'.

Only one issue of *Légitime défense* was ever published, due to insufficient funds, and to threats from the Martinique government who objected to its anti-imperialist, anti-colonial and dogmatically Marxist ethos. But its fiery rhetoric and uncompromising ideas awakened the conscience of many black artists, writers and intellectuals to write their own manifestos, including Aimé Césaire's 'Négreries: Black Youth and Assimilation' (M7) and Ted Joans's 'Proposition for a Black Power Manifesto' (M46). The revolutionary politics of Léro's group led them to garner support for the Scottsboro defendants in the US – nine young black men falsely accused of raping two white women in 1931 – as well as to confront the rise of fascism in Europe. Étienne Léro himself was killed

fighting for France during the Second World War; he was just twenty-nine.

* * *

This is only a preliminary warning. We consider ourselves totally committed. We are sure that there are other young people like us who could add their signatures to ours and who – to the extent that it is compatible with remaining alive – refuse to adjust to the surrounding dishonor. And we are against all those who attempt, consciously or not, by their smiles, work, exactitude, propriety, speech, writings, actions and their very persons, to pretend that everything can continue as it is. We rise up here against all those who are not suffocated by this capitalist, Christian, bourgeois world to which, involuntarily, our protesting bodies belong.

In every country the Communist Party (Third International) is in the process of playing the decisive card of the Spirit – in the Hegelian sense of the word. Its defeat, impossible as we think it to be, would be for us the definitive *Je ne peux plus*. We believe unreservedly in its triumph because we accept the dialectical materialism of Marx, freed of all misleading interpretation and victoriously put to the test of experience by Lenin. We are ready, on this plane, to submit to the discipline that such convictions demand.

On the concrete plane of modes of human expression, we equally and unreservedly accept surrealism to which, in 1932, we relate our becoming. We refer our readers to the two *Manifestoes* of André Breton, to the complete works of Aragon, André Breton, René Crevel, Salvador Dalí, Paul Éluard, Benjamin Péret and Tristan Tzara. It must be said that it is one of the disgraces of our time that these works are not better known everywhere that French is read. And in the works of Sade, Hegel, Lautréamont, Rimbaud – to mention only a few – we seek everything surrealism has taught us to find. As for Freud, we are ready to utilize the immense machine that he set in motion to dissolve the bourgeois family. We are moving with sincerity at a furious pace. We want to see clearly into our dreams and we listen to their voices. And our dreams permit us to see clearly into the life that has been imposed on us for so long.

Among the filthy bourgeois conventions, we despise above all the humanitarian hypocrisy, this stinking emanation of Christian decay. We loathe pity. We don't give a damn about sentiment. We intend to shed light on human psychic concretions – a light related to that which illuminates Salvador Dalí's splendid, convulsive, plastic works, where it seems sometimes, suddenly, that love-birds could be ink-bottles or shoes or little bits of bread, taking wing from assassinated conventions.

If this little journal, a temporary instrument, breaks down, we shall find other instruments. We accept with indifference the conditions of time and space which, by defining us in 1932 as people of the French West Indies, have thus settled our boundaries without at all limiting our field of action. This first collection of texts is particularly devoted to the West Indian question as it appears to us. (The following issues, without abandoning this matter, will take up many others.) And if, by its content, this collection is addressed primarily to *young* French West Indians, it is because we think it is a good idea that our first effort finds its way to people whose capacity for revolt we are far from underestimating. And if it is aimed especially at young *blacks*, this is because we believe that they especially have had to suffer from capitalism (outside Africa, witness Scottsboro) and that they seem to offer, in that they have a materially determined ethnic personality, a generally higher potential for revolt and for joy. For want of a black proletariat, to whom international capitalism has not given the means to understand us, we speak to the children of the black bourgeoisie; we speak to those who are not already killed established fucked-up academic successful decorated decayed endowed decorative prudish decided opportunist; we speak to those who can still accept life with some appearance of truthfulness.

Having decided to be as objective as possible, we know nothing of each other's personal lives. We want to go a long way, and if we expect much from psychoanalytic investigation, we do not underestimate (from those acquainted with psychoanalytic theory) pure and simple psychological confessions which, provided that the obstacles of social conventions are removed, can tell us a great deal.

We do not admit that one can be ashamed of what he suffers. The Useful – social convention – constitutes the backbone of the bourgeois 'reality' that we want to break. In the realm of intellectual investigation, we pit against this 'reality' the sincerity that allows man to disclose in his love, for example, the ambivalence which permits the elimination of the contradiction decreed by logic. According to logic, once an object with an affective value appears, we must respond to it either with the feeling called love or with the feeling called hate. Contradiction is a function of the Useful. It does not exist in love. It does not exist in the dream. And it is only by horribly gritting our teeth that we are able to endure the abominable system of constraints and restrictions, the extermination of love and the limitation of the dream, generally known by the name of western civilization.

Emerging from the French black bourgeoisie, which is one of the saddest things on this earth, we declare – and we shall not go back on this declaration – that we are opposed to all the corpses: administrative, governmental, parliamentary, industrial, commercial and all the others. We intend, as traitors to this class, to take the path of treason as far as it will go. We spit on everything that they love and venerate, especially those things that give them sustenance and joy.

And all those who adopt the same attitude as we, no matter where they come from, will be welcome among us.*

Étienne LÉRO, Thélus LÉRO, René MÉNIL, Jules-Marcel MONNEROT, Michel PILOTIN, Maurice-Sabas QUITMAN, Auguste THÉSÉE, Pierre YOYOTTE. 1932

* If our critique is purely negative here, if we do not propose any positive efforts in place of that which we mercilessly condemn, we excuse ourselves on the grounds that it was necessary to begin – a necessity which did not enable us to await the full development of our ideas. In our next issue, we hope to develop our ideology of revolt.

M5 The Storm Society

Manifesto (1932)

The Storm Society (*Juelanshe*) was a Chinese avant-garde art group founded in Shanghai in 1931 by the Europhile artist Pang Xunqin (1906–85) and the artist and writer Ni Yide (1901–70). Named to reflect their desire 'to hit the rotten art of contemporary China with a powerful wave', the group opposed traditionalists in both China and the West. Instead they supported a progressive art that embraced modernism as well as personal expression, sharing the revolutionary spirit of avant-garde European art and, in particular, the radical ideas promoted by Dadaism, Surrealism and the Fauves. The Storm Society's original plan was to promote their concept of a Chinese modern art in a self-published art magazine; however, this proved too expensive, and instead their manifesto was first published in the less radical *Art Journal* (*Yishu xunkan*) to coincide with their first exhibition in the reception hall of the Chinese Art Students Society (*Zhonghua xueyishe*) in October 1932.

The Storm Society emerged at a time of brief stability in China, during the rule of the conservative nationalist government; although the group had left-wing sympathies, they were relatively free to promote their avant-garde agenda. However, the country's political turmoil soon worsened, first with an attack on Shanghai by the Japanese in 1932 and then with the rise of the far left. By the time of the Storm Society's final exhibition in 1935, the artists were being called upon to be more nationalistic and socially relevant; and when war broke out with Japan in 1937, the Storm Society's individualistic avant-gardism could not be adapted for propaganda purposes and they came to be seen as unpatriotic. Although many

of the group's members continued to promote their radical modernist agenda, they could not survive the ascendance of communism in the 1940s.

<center>⋆ ⋆ ⋆</center>

The air that surrounds us is too still, as mediocrity and vulgarity continue to envelop us. Countless morons are writhing around and countless shallow minds are crying out.

Where are the creative talents of the past? Where are the glories of our history? Impotence and sickness are what prevail throughout the entire artistic community today.

No longer can we remain content in such a compromised environment.

No longer can we allow it to breathe feebly until it dies.

Let us rise up! With our raging passion and iron intellect, we will create a world interwoven with colour, line and form!

We acknowledge that painting is by no means an imitation of nature, nor a rigid replication of the human body. With our entire being, we will represent, unconcealed, our bold and daring spirit. We believe that painting is by no means the slave of religion, nor a mere illustration of literature. We will freely, and cohesively, construct a world of pure shapes.

We detest all the old forms and colours, as well as all mediocre and rudimentary techniques. We will represent the spirit of a new era with new techniques.

Since the beginning of the 20th century, a new atmosphere has emerged in the European artistic community, comprised of the outcries of the Fauvists, the twists of the Cubists, the vehemence of the Dadaists and the cravings of the Surrealists . . .

It is time for a new atmosphere to emerge throughout the 20th century artistic community of China.

Let us rise up! With our raging passion and iron intellect, we will create a world interwoven with colour, line and form!

M6 Peyami Safa

D Group Manifesto (1933)

D Group (*D Grubu*) was formed in Istanbul in 1933 by six radical art-ists who sought to create a form of Turkish modernism. They saw their art as comparable to the liberal reforms of the charismatic nationalist president Mustafa Kemal Atatürk, who had created the flourishing secular Turkish Republic out of the wreckage of the Ottoman Empire in the aftermath of the First World War. D Group's artists spoke of revolution and dynamism and they experi-mented with Western avant-garde styles, including Cubism and Constructivism, while refusing to embrace a single aesthetic approach. The novelist Peyami Safa (1899–1961), who had long been a critic of the old order, wrote D Group's manifesto, which was published in the brochure that accompanied the group's first exhib-ition, in Istanbul in 1933.

Subsequently, the artists of D Group regularly held further exhi-bitions and introduced avant-garde ideas into the curriculum of the Istanbul Academy of Fine Arts. By the time of their last exhibition, in 1960, the once-young rebels had become part of the establish-ment, running the Academy of Fine Arts and helping to define Turkey's cultural policy. As such, from the 1950s onwards, they faced mounting criticism from a generation of younger artists keen to assert their independence, particularly in the fields of non-figurative art.

*　*　*

The D Group is not a squad.
They turn neither to right nor left.
Nor a sergeant major,

Six heads turning on a single axis.

Six pairs of eyes look both at substance and within it; as if seeking the life which is concealed even in death. This is not new painting, neither European nor local, but just painting. Not Delacroix, nor Cézanne, nor Manet, nor Monet, nor Pissarro, nor Picasso.

> No, they are Abidin, Cemal, Nurullah, Naci, Zeki and Zühtü.
> Neither school, nor creed. Their rule is a single word: painting.
> Oxen and photographs see the same thing, but no person sees the same thing as another.

I am not expounding a theory. I wanted to reiterate what is already known; that the D Group is six separate points of view. Is there nothing which links these sides of a hexagon? There must be. Or you can deduce a formula of resemblance. Let us take the most natural: friendship. Then there is being contemporaries and being painters.

What is more some AESTHETIC links can be discerned.

But let us not be diverted into words and theories, but visit the exhibition.

It will be unfortunate if there is a painting there which exactly fits my views, because the trait of seeing the same thing is found in mirrors, photographs and oxen. My affectionate greetings to the D Group, who do not see as I do.

M7 Aimé Césaire

Négreries: Black Youth and Assimilation (1935)

Négritude was a cultural and political movement that emerged in Paris in the 1930s, led by three African and Caribbean students: Aimé Césaire (1913–2008), Léon Damas (1912–78) and Léopold Sédar Senghor (1906–2001). The concept was first alluded to by Césaire in a passionate tract against assimilation, published in the inaugural edition of the trio's magazine *L'Étudiant noir* (*The Black Student*) in Paris in March 1935.

Négritude sought to reclaim the value of blackness and African culture, taking its inspiration from the Surrealist group Légitime Défense and, later, the Harlem Renaissance. The group's members wrote of the wounds of physical and cultural displacement suffered by African diasporic people, and the need for a connection with their homelands in Africa. Their robust and eloquent criticism of colonialism was tempered by their appreciation of European culture – a paradox that would later be addressed by the social theorist Paul Gilroy in his influential book *The Black Atlantic: Modernity and Double Consciousness* (1993).

During the Second World War the movement gained momentum when its founders left Paris for the Caribbean and Africa, causing new forms of Négritude to arise in these locations. These included Creolization in the Caribbean, the École de Dakar in Senegal (M78) and the Natural Synthesis movement in Nigeria (M18). Négritude was also supportive of the Pan-African project (M39), although their philosophies differed. Césaire himself moved to the island of Martinique, where, together with his wife – the writer Suzanne Césaire – and

Légitime Défense poet René Ménil, he published the Surreal and anti-colonial literary review *Tropiques*, which promoted poetry, freedom and the marvellous. In later life he became a leading politician and president of the regional council of Martinique.

* * *

What is difficult is not to ascend, but in ascending to remain oneself.

– Michelet

One day, the Black seized hold of the White's neck-tie, grabbed a bowler hat, dressed up in them, and left laughing . . .

It was only a game, but the Black did not let himself take it as a game. He became so accustomed to the neck-tie and the bowler hat that he ended up believing he had always worn them. He made fun of those who didn't wear them at all and disowned his father whose name is Spirit of the Bush . . . This is a bit of the history of the pre-war Negro, who is only the Negro before reason. He sits down at the school of the Whites. He wants to be 'assimilated.'

I would gladly say that it is madness, if I didn't remember that, in a certain sense, the madman is always 'the man who has faith in himself,' and because of that saves himself from madness.

If assimilation is not madness, it is certainly foolishness. To want to be assimilated is to forget that nothing can change animal nature. It is to misunderstand 'otherness,' which is a law of Nature.

This is so true that the People, elder brothers of Nature, warn us of it every day: A decree says to the Blacks: 'You are similar to the Whites. You are assimilated.'

The People, wiser than the decree because they follow Nature, shout to us:

'Begone! You are different than us! You are only aliens and negroes.' They deride the 'Black man with a bowler,' bully the 'poorly whitened,' and bludgeon the 'negro.'

I confess that it is justice, though unfortunate for the one who needs to be convinced by means of a cudgel that he can only be himself.

Moreover, it is enough to reflect on the notion of assimilation to

see that it is a dangerous business for the colonizer as well as the colonized.

The colonizing nation that 'assimilates' another quickly becomes disgusted with its own work. Copies only being copies, the prototypes have the contempt for them that one has for apes and parrots. For if man is afraid of 'the other,' he also has an aversion for the similar. It is the same for the colonized. Once similar to the one who has molded him, he no longer understands the contempt of the latter, and he hates him. In a like manner, I have heard it said that some disciples hate the master because he still wants to remain the master when the disciple has ceased being a disciple.

Thus it is true that assimilation, born of fear and timidity, always ends in contempt and hatred. It carries within it the germs of struggle. The struggle of self against self, that is to say, the worst of struggles.

For this reason, Black youth turns its back on the tribe of the Old.

The tribe of the Old says, 'assimilation.' We respond, resurrection!

Black youth of today want neither enslavement nor assimilation. They want emancipation.

They will be called 'men,' because only man walks without a tutor on the great roads of thought. Enslavement and assimilation resemble one another. Both are forms of passivity.

During these first two periods, the Negro has been equally sterile.

Emancipation, on the other hand, is action and creation.

Black youth wants to act and create. It wants to have its poets and its novelists who will speak to it. It wants to have its misfortunes and its greatness. It wants to contribute to universal life, to the humanization of humanity. For that, it must preserve itself or find itself once again. It is the primacy of the self.

But to be oneself, it is necessary to struggle. First struggle against the misguided brothers who are afraid of being themselves, the senile mob of the assimilated.

Then struggle against those who want to inflate their egos, the legion of the assimilators.

Finally, to be oneself, it is necessary to struggle against oneself.

31

It is necessary to destroy indifference, extirpate obscurantism, strike sentimentalism at its root, and Meredith tells us what, above all, must be cut:

Black Youth, it is hair that keeps you from acting. It is the desire to conform, and it is you that carry it.

Crop your hair close so that this desire may escape.

Cut your hair.

It is the first condition of action and creation.

A long head of hair is an affliction.

M8 The European School

Manifesto (1945)

The European School (*Európai Iskola*) was one of the most utopian enterprises to emerge on the continent during the immediate post-war era. It was the brainchild of the Hungarian Dadaist brothers Árpád Mezei (1902–98) and Imre Pán (1904–72), who founded this movement of theorists, writers and artists in Budapest in 1945 as a response to growing concerns that Europe would remain permanently divided into West and East in the aftermath of the Second World War. For the next three years the European School organized exhibitions, published pamphlets and staged lectures that promoted its expansive vision of a continent united through a common art and culture.

Perhaps the idea's most urgent expression is the brief manifesto printed on the back of the books and pamphlets published by the Library of the European School. It is an optimistic and earnest call to 'create a vital European art'. Although the manifesto promoted no particular artistic style, the group's output came to be dominated by Surrealism and Abstraction – two styles that best encapsulated the contradictions of the post-war era.

After the communist takeover of Hungary in 1948, and the ensuing decree that henceforth Soviet-style Socialist Realism was the only valid form of art, the European School's activities went underground. Eventually, in 1957, Imre Pán left Hungary for Paris, where he established a lively artistic scene consisting of fellow Hungarian émigrés and members of the Parisian avant-garde. His brother Árpád Mezei moved to the United States in 1975 and wrote extensively about Surrealism.

* * *

Europe and the old European ideal have been destroyed.

The idea of Europe has, until now, entailed Western Europe. From now on we have to reckon with the concept of a Whole Europe. This new Europe can emerge only as the synthesis of East and West.

Everyone has to decide, in 1945 A.D. if s/he is entitled to be considered a European.

We have to create a living European school that will redefine the relations between life, the individual, and society.

This task delineates the activities of the first European School. Our talks, exhibitions and publications serve this goal.

We seek the philosopher's stone knowing that it is not a chemical substance but a living idea that comes to life only through the efforts of the individual and the society.

M9 Georges Henein

Manifesto (1945)

A born agitator with a ferocious mind, Georges Henein (1914–73) was a revolutionary Egyptian poet who established two Surrealist groups in Cairo. The first, which was founded in 1937 and came to be known as Art and Freedom (*Art et Liberté*), organized exhibitions and events, participated in workers' strikes and protests, and wrote polemics on the elitist, autocratic nature of Egypt's cultural institutions. They were provocative and embraced Surrealism's leftist, anti-imperialist, Marxist agenda. When the Futurist F. T. Marinetti delivered his lecture 'La Poésie motorisée' in March 1938 at the Club des Essayistes in Cairo, the Egyptian Surrealists volubly denounced its fascist ideology; and later that year they wrote the manifesto 'Long Live Degenerate Art' ('Vive l'art dégénéré'), in which they voiced solidarity with those avant-garde European artists who were being persecuted in Nazi Germany at the time.

Henein also established the Surrealist Group of Cairo, which took a stand against order, beauty, logic and traditional art, he also helped to publish three Surrealist journals in French and Arabic, which concentrated on political and cultural matters. Throughout the Second World War, both groups remained prolifically active, staging exhibitions and events which were notable for the number of women participants. However, they grew increasingly disillusioned with Surrealism's steadfast support of Marxism, with Henein sending a letter to the Fourth International (a multinational communist group opposed to Stalinism set up in France in 1938) stating their concerns. Their objections were clarified in the following manifesto, written by Henein in 1945 and, it is thought, first published in Cairo, in the pamphlet *L'Enfance de la chose* (*The Infancy of Things*) in 1945. It criticizes the

Surrealist leader André Breton's continuing support of Marxist ideology – particularly its censorship of freedom of speech – and calls for Surrealists to support the creative rights of the individual.

<p align="center">★ ★ ★</p>

I have sown dragons, I reap fleas.

<p align="right">– Karl Marx</p>

At the very time when events are sanctioning the partition of the globe into two unyielding fronts, what should our position be towards Marxist doctrine, which one of these two antagonistic blocks would aim to put into practice?

Our position regarding Marxism is the inverted reflection of that adopted by Marxist groups towards the individual, freedom and the activities arising from literary or artistic creation in general. At the stage that is historically considered as that of the struggle for power, Marxists always pursue a policy of systematic opportunism that consists of taking power soon followed by a change in both tone and purpose, that assumes a character of blatant terror. Indeed, it is of primary importance for the Marxist forces, during the difficult period of struggle for supremacy, to unite the most highly developed elements, the greatest minds, and the most representative intellectuals and writers under one flag. Insidious propaganda and outrageous underhandedness have been put into effect for the sake of this plan, and it has been displayed to all that the rights of the individual, respect for mankind, and cultural heritage could be in no safer hands than that of Marxism in practice.

In short, the new society to whose edification they mean to contribute will provide ample leeway for critical judgment as well as inventiveness. Sad to say, the real facts are far from confirming such claims; indeed, they are nowhere near. Let it suffice to mention that, one century after coming into being, Marxism is the sole economic doctrine which immediately considers blasphemous any critical views or any attempt to criticize it, despite the major upheavals that have affected the face and structure of the modern world, whose interpreter Marxism would be. We do not hesitate to

hold this type of 'taboo,' which has become the 'sign of the cross' of so many revolutionaries, as responsible for the foul smell of such wretched infallibility and 'infallibilism' pervading the laboratories of both the right and the left and that acts as a common denominator for both Marxist and Fascist parties. The faults of Marxism strike us as being due to a kind of mental rigidity that is unable to adjust to the shifting reality of the world in motion.

Our grievance against Marxism lies not in its leaning towards revolution, but on the contrary, to its taking a starchy, stagnant, reactionary stance towards the revolutionary growth of science and thought. Karl Marx's ideas may have enlightened the nineteenth century, but for us now, we must understand the crises of Western Civilization as a whole, and they are of no more help to us than the philosophies of Nietzsche or Spengler, to name but two of those necessary adventurers who have penetrated to the very depths of our age. And what can be said about the analysis and the forecasts that Marxists so generously conferred on us between 1920 and 1940? What can be said, indeed, other than that they are as far from our historical evolution as what Marxists in power have brought into being, a far cry from the original socialist ideal of the material and spiritual liberation of mankind.

Faced with such an aberrant state of affairs where, every day, we are mired more and more in the ways of lies and 'tactics,' and faced with such a huge detour from initial principles that we end up back at their beginning source and intention, we proclaim that we consider the individual as the only thing of worth, yet today, seemingly, it is under relentless fire from all sides. We declare that the individual is in possession of largely unexplored inner faculties, the most important of which is imagination armed with the most marvelous powers, an untapped force of vigor and spirit.

The individual against State-Tyranny.

Imagination against the routine of dialectical materialism.

Freedom against terror in all its forms.

Georges Henein, Hassan el Telmisany, Adel Amiu, Kamel Zehery, Fouad Kamel, Ramses Younane

M10 Arte Madí

Madí Manifesto (1947)

Arte Madí was an Argentinian group of Constructivist artists founded in Buenos Aires in 1944 by the charismatic sculptor and poet Gyula Košice (1924–2016), Rhod Rothfuss (1920–69) and Carmelo Arden Quin (1913–2010), who shortly after quit the group. The name is thought to be an acronym for *'Movimiento, Abstracción, Dimensión, Invención'* (Movement, Abstraction, Dimension, Invention). These young experimental artists promoted a playful art that embraced instability, innovation and exploration. They worked with water and light to make hydrokinetic sculptures, painted on irregular shaped canvases, using plexiglass and other industrial materials, and published the journal *Arte Madí Universal*, which promoted their energetic vision of an art that was not only classless but also boundless in time and space. 'MADÍ destroys the TABOO OF PAINTING by breaking with the traditional frame,' wrote Košice. They considered abstract art to be the art of the people – the aesthetic expression of a new utopian society along the lines of communism. They were anti-fascist and denounced the nationalist government of President Juan Domingo Perón.

It has been disputed as to who wrote Arte Madí's manifesto, although Košice seems to have drafted the most essential points. It was published in their journal in 1947 and called for an inventive, experimental art that blurred the boundaries between painting and sculpture.

* * *

Madí art can be identified by the organisation of elements peculiar to each art in its continuum. It contains presence, movable dynamic

arrangement, development of the theme itself, lucidity and plurality as absolute values, and is, therefore, free from interference by the phenomena of expression, representation and meaning.

Madí *drawing* is an arrangement of dots and lines on a surface.

Madí *painting*, colour and two-dimensionality. Uneven and irregular frame, flat surface, and curved or concave surface. Articulated surfaces with lineal, rotating and changing movement.

Madí *sculpture*, three-dimensional, no colour. Total form and solid shapes with contour, articulated, rotating, changing movement, etc.

Madí *architecture*, environment and mobile movable forms.

Madí *music*, recording of sounds in the golden section.

Madí *poetry*, invented proposition, concepts and images which are untranslatable by means other than language. Pure conceptual happening.

Madí *theatre*, movable scenery, invented dialogue.

Madí *novel and short story*, characters and events outside specific time and space, or in totally invented time and space.

Madí *dance*, body and movements circumscribed within a restricted space, without music.

In highly industrialised countries, the old bourgeois realism has almost completely disappeared, naturalism is being defended very half-heartedly and is beating a retreat.

It is at this point that abstraction, essentially expressive and romantic, takes its place. Figurative schools of art, from Cubism to Surrealism, are caught up in this order. Those schools responded to the ideological needs of the time and their achievements are invaluable contributions to the solution of problems of contemporary culture. Nevertheless, their historic moment is past. Their insistence on 'exterior' themes is a return to naturalism, rather than to the true constructivist spirit which has spread through all countries and cultures, and is seen for example in Expressionism, Surrealism, Constructivism, etc.

With Concrete Art – which in fact is a younger branch of that same abstract spirit – began the great period of non-figurative art,

in which the artist, using the element and its respective continuum, creates the work in all its purity, without hybridisation and objects without essence. But Concrete Art lacked universality and organisation. It developed deep irreconcilable contradictions. The great voids and taboos of 'old' art were preserved, in painting, sculpture, poetry respectively, superimposition, rectangular frame, lack of visual theme, the static interaction between volume and environment, nosological and graphically translatable propositions and images. The result was that, with an organic theory and disciplinarian practice, Concrete Art could not seriously combat the intuitive movements, like Surrealism, which have won over the universe. And so, despite adverse conditions, came the triumph of instinctive impulses over reflection, intuition over consciousness; the revelation of the unconscious over cold analysis, the artist's thorough and rigorous study *vis-à-vis* the laws of the object to be constructed; the symbolic, the hermetic, and the magic over reality; the metaphysical over experience.

Evident in the theory and knowledge of an art is subjective, idealist, and reactionary description.

To sum up, pre-Madí art:

A scholastic, idealist historicism
An irrational concept
An academic technique
A false, static and unilateral composition
A work lacking in essential utility
A consciousness paralysed by insoluble contradictions; impervious to the permanent renovation in technique and style

Madí stands against all this. It confirms man's constant all-absorbing desire to invent and construct objects within absolute eternal human values, in his struggle to construct a new classless society, which liberates energy, masters time and space in all senses, and dominates matter to the limit. Without basic descriptions of its total organisation, it is impossible to construct the object or bring it into the continuity of creation. So the concept of

invention is defined in the field of technique and the concept of creation as a totally defined essence.

For Madí-ism, invention is an internal, superable 'method', and creation is an unchangeable totality. Madí, therefore, INVENTS AND CREATES.

M11 Vladimír Boudník

Explosionalism Manifesto No. 2 (1949)

Explosionalism was a concept devised in the late 1940s by the pion-
eering Czech avant-garde artist Vladimír Boudník (1924–68) which
he promoted in a series of manifestos sent out to radio stations,
magazines and newspapers. The key notion at the heart of his the-
ory was that human imagination had the capacity to 'explode' so
that it was possible to find artistic forms in everyday life. To prove
this, Boudník would perform street actions, inviting passers-by to
mark out shapes on the bomb-damaged walls of post-war Prague,
encouraging them to see patterns in the scuff marks, dirt and
broken plaster. He carried out more than a hundred of these
actions, which anticipate later land artists of the 1960s and 1970s. By
the 1950s the communist authorities had declared Boudník's art to
be nonconformist, making it almost impossible for him to stage
public exhibitions or events. He committed suicide in 1968, aged
forty-four.

'Explosionalism Manifesto No. 2', dated 15 April 1949, was first
published in the Czech periodical *Tvář* (*Face*). In a fiery polemic,
Boudník castigates bourgeois artists for their lack of ambition and
inability to engage with the public. Explosionalism, in its cosmic
magnificence, meets the needs of the atomic age, as not just an art-
istic movement, but as a way of life.

* * *

People! We stand at the threshold of the atomic age. Tens of thou-
sands of factories, with an army of workers ten million strong,
are experimenting, building and striving to enrich our planet
with greater knowledge. The activities and contributions of past

centuries have all but come to an end, and information about them is stored in books available to the public at large. Therefore the labourer with a pickaxe is justified in feeling as important as the machine designer. Now every literate person, with a little concentration, can utilize the knowledge that, just a few decades ago, was the exclusive property of scientists. The whole world is energized by the attempt for a new creative movement! And how are artists responding to these changes? It seems as if their ranks are filled with impotent, degenerative conservative fanatics. The Surrealists tried to meet the needs of the contemporary age; if only their successors, yearning for a strange superiority, had not sabotaged the efforts and condemned the artistic movement to the role of drawing crossword puzzles in children's magazines. Only EXPLOSIONALISM is relevant to the present world order. It is a movement that elevates each member of the collective to the level of omnipotence, since his exploits are to the detriment of the universe and not the detriment of his fellow man. The Explosionalist's mind will find fulfilment in the trillions and trillions of cubic metres of cosmic space. Each of you will be an artist if you cast off your prejudices and indifference. ANALYSIS + SYNTHESIS: with the imagination's help most of you can make out various earthly forms in clouds, cliffs and molten lead. The same applies when you stare at a cracked wall or marble veins. You see faces, figures . . . Everything blends together and comes to life. These elements stir up old experiences stored in your mind in the form of memories. You see your own inner self transposed to two dimensions, to a surface. All you have to do is redraw or repaint the vision on paper. You seize hold of your inner world and thereby automatically render it comprehensible for the general public. One and the same cluster of spots will be able to remind people of a hundred different likenesses and combinations. Visions are governed by the intensity of mood and life experience of the observer. If a person has not seen some exotic flower or machine part, he will obviously not know how to draw either of them; and if he sees these things emerge from a cluster of spots, they will seem incomprehensible to him, while for another they will be clear. An inspired person can

approach the spots with a certain purpose. Many paintings that convince you of the brilliance of their creators were made on this basis. If your life is richer than that of an artist who used to depress you, your artistic expression will also be richer. If you are a manual labourer, don't use your feeble hand as an excuse. Today's art requires the truth of life and not the superficial, school-taught elegance of a juggler!

A painting is not supposed to be a snapshot. That's what photography is for. A painting must be a film strip of a myriad number of tensions and psychological explosions compressed into a static surface and presented in an infinitely short moment in conjunction with the viewer's kinetic imagination.

M12 Shakir Hassan al-Said

Manifesto of the Baghdad Modern Art Group (1951)

The Baghdad Modern Art Group (*Jama'et Baghdad lil Fann al-Hadith*) emerged at a time of revolutionary fervour in Iraq. Formed in 1951 by the artist Jewad Selim (1919–61) and the artist and writer Shakir Hassan al-Said (1925–2004), the group aimed to develop a contemporary national artistic style that incorporated concepts from Western modern art and traditional Arab cultural and intellectual influences. In April that year, their manifesto was read out by al-Said in the conference hall of the Museum of Ancient Costumes in Baghdad, at the opening of the group's inaugural exhibition of modern art. It argued for a distinctive Iraqi cultural identity, citing the achievements of the thirteenth-century miniature painter Yahya ibn Mahmud al-Wasiti, who had been active during the golden age of the Abbasid caliphate, when Iraq was the political and religious centre of the Islamic world. The manifesto proposed picking up the evolutionary thread of Iraqi art from where it had been cut short in 1258 by the Mongol invasion and the subsequent destruction of Baghdad.

After the July Revolution in 1958, in which the ruling Hashemite monarchy was deposed and a republic established, the Baghdad Modern Art Group became representative of a desire within Iraqi society to formulate a Pan-Arab identity based on the combination of the country's traditional heritage and modern progressive ideals. Yet the moment was short-lived: as infighting between tribal factions split the new republic, Selim was denounced as 'an enemy of the people' and died prematurely in 1961, while al-Said suffered a

near collapse of his mental health caused by the continuing turbulence of the political situation.

<p style="text-align:center">★ ★ ★</p>

At a time when Western civilization is expressing itself in the realm of art, an expression that marks the present age with a yearning to achieve freedom through modern trends, our audience remains oblivious to the importance of the art of painting as an indicator of the extent of the country's wakefulness and its tackling of the problem of genuine freedom.

However, a new direction in the art of painting will resolve this problem as a contemporary awakening that picks up a path begun long ago: the first steps along this path were taken by the artists of the thirteenth century AD, and the new generation will find that their ancestors' early efforts are still pointing a way forward, despite the darkness and the danger. The modern Iraqi artist is burdened with the weight of the culture of the age and the character of local civilization.

As a result of this, the following question will linger in the artist's mind: By what means will this new art be realized? Various answers will tempt his thought, and he will carry out all manner of experiments, as his head, eyes and hands dictate. As for the audience, who are shocked at first by the novelty of the effect, they would do better continuously to seek the key to the secrets behind the efforts that are exerted. And then the gulf that separates the audience from the artist will disappear.

Logic has been our guide since the beginning. There are two things: a means and a goal. In art, the goal becomes the means. On the one hand, the emergent modern art style becomes the crux of the concept that we will realize. As for the conventional view that constantly tears the concept from the style, it is a narrow view from the remnants of the romanticism of the beginning of the past century. There is no reason to keep clinging to that concept if it calls for a dismantling of the artwork. On the other hand, our efforts go to waste if they do not contain a spirit of renewal and innovation. This initiative, which appears today in the form of the

First Exhibition for Modern Art, and which brings together various modern studies such as Impressionism, Expressionism, Surrealism, Cubism and abstractionism, is the first following the Second World War, and it takes confident strides towards creating a unique personality for our civilization. If we do not realize ourselves through art, as well as in all other spheres of thought, we will be unable to take the feverish plunge into the fierceness of life. However, a work of only style alone does not solve the problem we seek to resolve, i.e., the necessity of creation that requires the introduction of new elements into our styles. Picasso, the artist of this age, who has today become one of the foundations of the most modern art, did not attain that status without passing through stages that showed him the validity of searching for new elements at their sources. It was not in vain that he was led to primitive Iberian art, then to black African art, then to the works of one of the authors of the post-Impressionist movement. These were first steps that would lead him to what is called Cubism. This shows us, from among the different paths diverging before our feet, a course we must explore. It requires on the one hand our awareness of the current styles, and on the other hand that we grasp the elements with which we will enrich our work. Here, the first presents the level of our understanding of those foreign styles; and the second our awareness of local character. This character – which most of us are ignorant of today – is what will allow us to compete with other styles in the universal field of thought.

We thus announce today the beginning of a new school of painting, which derives its sources from the civilization of the contemporary age, with all the styles and schools of plastic art that have emerged from it, and from the unique character of Eastern civilization. In this way, we will honour the stronghold of the Iraqi art of painting that collapsed after the school of Yahya al-Wasiti, the Mesopotamian School of the thirteenth century AD. And, in this way we will reconnect the continuity that has been broken since the fall of Baghdad at the hands of the Mongols. The rebirth of art in our countries depends on the efforts we make, and we call upon our painter brothers to undertake this task for the sake of our

civilization and for the sake of universal civilization, which is developed by the cooperation of different peoples. May the heritage of the present times and our awareness of the local character be our guides. May we receive support from the attention, good taste and encouragement that we anticipate from the public.

We, the Baghdad Modern Art Group, hereby declare the birth of a new school of art for the sake of our civilization, and for the sake of universal civilization.

M13 The Fighting Cock Art Group

The Nightingale's Butcher Manifesto
(1951)

In June 1951 a manifesto was printed on the back page of the Iranian radical modernist journal *Fighting Cock* (*Khorous-e jangi*), in which the authors presented a scathing attack on all major artistic trends in their country at the time. These included traditional Persian miniature painting and poetry, classical Western painting and Socialist Realism. The manifesto, which was signed by the anti-establishment poet and artist Hooshang Irani (1925–73), the musician and poet Gholam Hossein Gharib and the playwright and critic Hassan Shirvani, emerged at an optimistic time in Iranian politics. The prime minister, Mohammad Mosaddegh, leader of the Iranian National Front, had just nationalized the oil industry, and for the first time secular leftists, Islamists and nationalists were all working towards economic independence from the West. Seizing the moment, the group promoted an extreme artistic radicalism, that embraced absurdism and chance.

'The Nightingale's Butcher Manifesto' ('Sallakh-e Bolbol') was a forceful call to arms, which implored artists to rethink how art could be created in Iran. The word 'nightingale' in the manifesto's title has a double meaning in Farsi. It can refer both to a popular pattern of flowers and birds in traditional Persian decorative art and to a boy's genitals. The 'nightingale's butcher' therefore is an allusion to castration. Like the Dadaists and the Futurists before them, the manifesto's authors were violently rejecting tradition in favour of a new form of art.

<p style="text-align:center">* * *</p>

1. The art of *Fighting Cock* is the art of those still alive. This cry will silence all voices mourning at the tomb of the art of the past.

2. In the name of a new era in art, we wage our merciless attack on all art traditions and regulations of the past.

3. New artists are children of their time and the right to live is exclusive to the avant-gardes.

4. The first step in any new movement results in breaking old idols.

5. We condemn to annihilation all the admirers of the past with all its artistic manifestations such as theatre, painting, the novel, music, and sculpture, and break the ancient idols and their scavenger followers.

6. The new art considers sincerity to the inner self a gateway to artistic creation. It embodies all life forces and is inseparable from them.

7. New art walks on the graves of idols and of their sinister imitators, toward the annihilation of the chains of tradition and establishment of freedom of emotional expression.

8. New art cancels all conventions of the past and announces newness as the home for beauties.

9. Art's existence is in motion and progress. Only those artists are alive whose thought is based on new knowledge.

10. New art is in contrast with all the claims of the proponents of art for society's sake, art for art's sake, art for whatever's sake.

11. In order for new art to progress, all old art associations should be destroyed.

12. All creators of artworks! Be aware that the artists of the Fighting Cock group shall fight most strenuously with the distribution of old and vulgar artworks.

13. Down with imbeciles.

<div style="text-align: right;">

FIGHTING COCK ART GROUP
Gharib, Shirvani, Irani

</div>

M14 Exat 51 Group

Manifesto (1951)

Exat 51 – from *Eksperimentalni atelier* (Experimental Studio) *1951* – was founded in Zagreb in 1951 by nine Croatian neo-avant-garde architects and painters who were early advocates of geometric abstraction. They were also inspired by De Stijl, Bauhaus and the Russian Constructivists, who had striven to create a new, more scientific basis for culture in post-revolutionary Russia. In December 1951 the group self-published a short manifesto that set out their optimistic vision for a new form of art that would contribute to the reconstruction of post-war Yugoslavia. They championed experimentation, and sought to break down the barriers between fine and applied arts, while also trying to integrate modern art into everyday life. The group struggled to find official support for their utopian ideas; their abstract aesthetics were in defiance of the Socialist Realism and the moderate form of Modernism promoted in the country at the time. However, their non-representational art became a symbol of enlightenment in Yugoslavia. The artists Ivan Picelj (1924–2011), Vlado Kristl (1923–2004) and Aleksandar Srnec (1924–2010) and the architect Vjenceslav Richter (1917–2002) went on to join New Tendencies (*Nove Tendencije*) in the 1960s, a Neo-Concretist and Neo-Constructivist movement that pioneered new technologies in art.

* * *

— see no connection between the actual framework of our artistic commitment on the one hand, and the space arising from a coordinated relationship between the productive and the social standard on the other;

— see no difference between so-called pure and so-called applied art;

— consider that work methods and principles within the sphere of non-figural or so-called abstract art are not the expression of decadent aspirations, but, rather, believe that the study of these methods and principles could develop and enrich the sphere of visual communication in our country;

— the Group intended to operate in actual time and space, assuming plastic requirements and potentials as a tentative point of departure;

— by understanding our reality as an aspiration for progress in all forms of human activity, the Group believe in the need for struggle against outdated ideas and activities on the synthesis of all fine arts, and, secondly, emphasize the experimental character of artistic activity, because any progress in a creative approach to the fine arts will not work without experiment;

— consider the foundation and activity of the Group to be a positive outcome of the development of differences of opinion, a requisite for the promotion of artistic life in this country.

B. Bernardi, architect; Z. Bregovac, architect; I. Picelj, painter; Z. Radić, architect; B. Rašica, architect; V. Richter, architect; A. Srnec, painter; V. Zarahović, architect
Zagreb, 1951

M15 Grupo ruptura

ruptura Manifesto (1952)

In December 1952 members of the public attending the inaugural exhibition of Grupo ruptura at the Museu de Arte Moderne de São Paulo in Brazil received a controversial manifesto in the form of a flyer outlining the group's ideology. Written by the experimental artist and theorist Waldemar Cordeiro (1925–73), it promoted a form of pure abstraction, widely known as Concretism, which the group based on mathematical and rational principles. For Cordeiro, art was truth, 'in terms of lines and colours, that are nothing more than lines and colours, and have no desire to be pears or people'.

Cordeiro wanted to create a kind of Brazilian Bauhaus in São Paulo, where experimental art, technology, architecture and design could work together to support Brazil's rapid industrialization. Yet the group's dogmatic approach to abstraction, which rejected any notion of subjectivity, meant they alienated many Concrete artists in the country, in particular the Neo-Concretists, who sought a greater sensuality in abstract art. Even so, the radical vision of Grupo ruptura helped to shape the future of Latin American art.

* * *

old art was great when it was intelligent.
however, our intelligence cannot be the same as Leonardo's.
history has taken a qualitative leap:
> **continuity is no longer possible!**
> • those who create new forms out of old principles

now we can distinguish
> • those who create new forms out of new principles

why?

because the scientific naturalism of the Renaissance – the process of rendering the (three-dimensional) external world on a (two-dimensional) plane – has exhausted its historical task

it was crisis
 it was renovation

today the new can be accurately differentiated from the old, when parting with the old, and for this reason we can affirm:

the old is

- all varieties of hybrids of naturalism;
- the mere negation of naturalism, i.e., the 'wrong' naturalism of children, the insane, the 'primitive', the expressionists, the surrealists etc.;
- the hedonistic nonfigurative is spawned by gratuitous taste that seeks the mere excitement of pleasure or displeasure

the new is

- all expressions based on the new art principles;
- all experiences that tend to renewal of the fundamental values of visual art (space-time, movement, and matter);
- the artistic intuition endowed with clear and intelligent principles as well as great possibilities of practical development;
- to bestow on art a definite place within the scope of contemporary spiritual work, while considering art as a means of knowledge deducible from concepts, situating it above opinion and demanding, for its review, a previous knowledge.

modern art is not ignorance; we are against ignorance

M16 The Calcutta Group

Manifesto of the Calcutta Group (1953)

In 1943 an art group emerged in India that reflected the contradict-
ory realities of the country in the years immediately prior to in-
dependence. Known as the Calcutta Group, it consisted of eight
artists from Bengal who united in solidarity during one of the
worst famines in the province's history.

Up until this point, the modern aesthetic in India had been dom-
inated by the lyrical mysticism of the Bengal School, led by the
painter Abanindranath Tagore, which promoted a Pan-Indian art
inspired by ancient murals and medieval Indian miniatures. But, as
one of the Calcutta Group's founder members, the sculptor Prodosh
Dasgupta (1912–91), explained in his article 'The Calcutta Group –
Its Aims and Achievements' (1981): 'The time to preoccupy oneself
with Gods and Goddesses was over. The artist could no longer be
blind to his age and surroundings, his people and society.' Declaring
themselves to be artists of the world, the Calcutta Group sought an
aesthetic that was universal and not constrained by Indian culture
or nationalism. Dreamy depictions of the Ganges were replaced by
raw human suffering, perhaps best exemplified by the expressionist
ink sketches of emaciated Bengali peasants by Zainul Abedin.

In 1953 the Calcutta Group printed a handbook containing a mani-
festo, an extract from which is reproduced below. It is thought to be a
revision of a statement originally provided for an exhibition with the
Bombay Progressive Artists' Group in Calcutta (now Kolkata) in 1951.

* * *

[. . .] In the West, kings have long been dethroned and the reins of
the State have passed into the hands of the common man. Today

the artists no longer decorate the baroque palaces of kings or the interior of the chapels but work independently in their studios or decorate the communal buildings. The great French movements in art – Impressionism, Cubism, Surrealism, etc., all evolved through this changed ideal in art. Such a movement [is] underway in our country too [. . .]

[. . .] The guiding motto of our group is best expressed in the slogan: 'Art should aim to be international and interdependent'. In other words, our art cannot progress or develop if we always look back to our past glories and cling to our traditions at all costs. The vast new world of art, rich and infinitely varied, created by masters of the world over, beckons us . . . We have to study all of them deeply, develop our appreciation of them and take from them all that we could profitably synthesise with our own requirements and tradition. This is all the more necessary because our art has stood still since the eighteenth century. During the past two hundred years the world outside of India has made vast strides in art, has evolved epoch-making discoveries in forms and techniques. It is therefore absolutely necessary for us to close this hiatus by taking advantage of these developments in the Western world.

And this is inevitable, whether we like it not. In our world of super-sonic planes and televisions, it is not possible or desirable to preserve the lily-white purity of our tradition, because art, like science, is also becoming an international activity. It is better that we consciously, discriminatingly, choose and integrate foreign influences with our national style and tradition; for otherwise, influences unconsciously imbibed might distort rather than enrich our art. This is the ideal motivating the Calcutta Group, and we hope to succeed, because we try to understand the spirit of our times and acknowledge the dictates of necessity.

M17 Enrico Baj

Interplanetary Art (1959)

In September 1959 the avant-garde Italian artist Enrico Baj (1924–2003) published the 'Interplanetary Art' manifesto ('Arte interplanetaria') in the avant-garde journal *Il gesto* (*The Gesture*). The manifesto was announced on the cover in five languages: English, Italian, German, French and, finally, Russian – the last in recognition of the Soviet Union's visionary space programme, and also as a rebuke to Cold War ideology.

Baj had founded the Arte nucleare (Nuclear Art) movement some seven years earlier, which had sought to respond to the Cold War threat of nuclear annihilation through vividly gestural abstract works in oil and enamel. The Interplanetary movement was less apocalyptic and more open-minded and exploratory, embracing the unknown future in playful and ironic ways by incorporating references to popular science fiction. The fluid abstract paintings of the group's artists also suggested the possibilities of alien worlds and strange atmospheres out in the vast unknown.

At the heart of the movement's ideology was the optimistic belief that nuclear energy could be harnessed for interplanetary space flight. In this way, nuclear power could be transformed from a metaphor of total destruction into the essence of imaginative opportunity. Using the example of the Roman philosopher Lucretius, who had promoted the idea of atomism in his poetry, the manifesto argues that space flight and extraterrestrials should be just as important to art as they are to science.

* * *

It is time to make known that these days the force of gravity oppresses only fools, fat people, and abstract painters, or rather concrete painters, as many of them like to define themselves, concretely revealing their non-abstract ineptitude in art.

Our imagination roams to the ashen, volcanic regions before the arrival of the stinking, clattering metal carcasses full of horns and spheres, dreamed up by technicians and scientists. Ever greater is the creative need to celebrate the new interplanetary conquests, eternal myth kindred to the flight of Icarus, the Wright brothers' wings of tarred linen, and the mysterious confusion of cosmic radiation.

Nor does the force of gravity oppress our own minds any more with its petty earthly blackmail, for it has been overcome by *Nuclear Art*, atomic premium gasoline, intellectual leavening for our interplanetary travels.

. . .

Those who deny the possibility that artistic inducements might derive from nuclear intuitions and discoveries are those same intellectually and physically fat fools who want to limit their use to the catastrophic destruction of humanity.

. . .

When the world learned of the first space launches, we hoped, for a moment, with relief, that the attention of governments might shift from the study of even larger nuclear bombs to that of ever more potent rocket engines, and that the diabolical plans for earthly destruction might give way to plans for astral navigation and interplanetary conquest. Other disappointments have already followed since, and yet in spite of this, a new hope now guides our sensitivity toward the interplanetary aspect of artistic pursuits.

Space flight and extra-terrestrial bodies concern not only science, but above all culture, myth, art. Similarly, the myth, poetry and mystery of the atom, the investigation of the tiniest structure

of matter, were of greater interest to the poet Lucretius than to the fat, bearded sages of Alexandria. Do not ask too much of our works, but ask a lot: They contain our passionate and innovative desire, in the face of sterile, rotten abstractionism, to participate in the latest developments of human consciousness, to raise ourselves up from our tyrannical earth by overcoming the conventional and hence rescinded laws of gravity – even though our paintbrushes and colours might escape human control and our words and letters might float in mid-air, insubordinate to canvas and paper, like the sodium vapours and lithium crystals suspended in the dense atmosphere of Mars, the pink oceans of Venus, the sooty abysses of Neptune, the rainbow-like rings of Saturn.

From Planet Earth.

M18 Uche Okeke

Natural Synthesis (1960)

In 1958 a group of young artists at the Nigerian College of Arts, Science and Technology in Zaria founded the Zaria Art Society. They recognized that years of colonial rule had eroded the Nigerian people's faith in their own culture and values. For the country to become a truly independent nation with a strong identity, these cultural traditions needed to be restored; and they advanced the theory of 'natural synthesis', which called for a modern Nigerian art informed by indigenous artistic practices.

The Zaria artists rose to the challenge, studying the country's folklores, myths, philosophies and religions, experimenting with traditional art techniques and taking inspiration from Nigeria's natural environment. The society's president, Uche Okeke (1933–2016), produced drawings derived from *uli*, a style of body and wall decoration created by the Igbo people, while Bruce Onobrakpeya (b. 1932) pursued a mythical realism, depicting traditional folk tales and religious imagery in paintings, linocuts and, later, bronze sculptures.

After graduating in 1961, the artists of the Zaria Art Society dispersed across the country to gather support from other students who, in the spirit of independence, were also seeking alternatives to the Western art being taught in the academies, and to establish further artistic groups that embraced, rather than stigmatized, traditional art.

The 'Natural Synthesis' manifesto was written by Uche Okeke and printed in the Zaria Art Society's journal to coincide with Nigeria finally gaining its full independence from the British Empire in October 1960. Based on the principles of the Négritude

movement (M7), which was committed to reclaiming the value of blackness and African culture, it calls on Nigerian artists to embrace their new-found political freedom and develop their own unique artistic culture.

<p style="text-align:center">* * *</p>

Young artists in a new nation, that is what we are! We must grow with the new Nigeria and work to satisfy her traditional love for art or perish with our colonial past. Our new nation places huge responsibilities upon men and women in all walks of life and places, much heavier burden on the shoulders of contemporary artists. I have strong belief that with dedication of our very beings to the cause of art and with hard work, we shall finally triumph. But the time of triumph is not near, for it demands great change of mind and attitude toward cultural and social problems that beset our entire continent today. The very fabric of our social life is deeply affected by this inevitable change. Therefore the great work of building up new art culture for a new society in the second half of this century must be tackled by us in a very realistic manner.

This is our age of enquiries and reassessment of our cultural values. This is our renaissance era! In our quest for truth we must be firm, confident and joyful because of our newly won freedom. We must not allow others to think for us in our artistic life, because art is life itself and our physical and spiritual experiences of the world. It is our work as artists to select and render in pictorial or plastic media our reactions to objects and events. The art of creation is not merely physical, it is also a solemn act. In our old special order the artist had a very important function to perform. Religious and social problems were masterly resolved by him with equal religious ardour. The artist was a special member of his community and in places performed priestly functions because his noble act of creation was looked upon as inspired.

Nigeria needs a virile school of art with new philosophy of the new age – our renaissance period. Whether our African writers call the new realisation Negritude, or our politicians talk about the African Personality, they both stand for the awareness and

yearning for freedom of black people all over the world. Contemporary Nigerian artists could and should champion the cause of this movement. With great humility I beg to quote part of my verse, Okolobia, which essayed to resolve our present social and cultural chaos. The key word is synthesis, and I am often tempted to describe it as natural synthesis, for it should be unconscious not forced.

> Okolobia's sons shall learn to live
> from father's failing;
> blending diverse culture types,
> the cream of native kind
> adaptable alien type;
> the dawn of an age –
> the season of salvation.

The artist is essentially an individual working within a particular social background and guided by the philosophy of life of his society. I do not agree with those who advocate international art philosophy; I disagree with those who live in Africa and ape European artists. Future generations of Africans will scorn their efforts. Our new society calls for a synthesis of old and new, of functional art and art for its own sake. That the greatest works of art ever fashioned by men were for their religious beliefs go a long way to prove that functionality could constitute the base line of most rewarding creative experience.

Western art today is generally in confusion. Most of the artists have failed to realise the artists' mission to mankind. Their art has ceased to be human. The machine, symbol of science, material wealth and of the space age has since been enthroned. What form of feelings, human feelings, can void space inspire in a machine artist? It is equally futile copying our old art heritages, for they stand for our old order. Culture lives by change. Today's social problems are different from yesterday's, and we shall be doing grave disservice to Africa and mankind by living in our fathers' achievements. For this is like living in an entirely alien cultural background.

M19 El Techo de la Ballena

For the Restitution of Magma (1961)

The sixty-strong Venezuelan art collective El Techo de la Ballena (The Roof of the Whale) originated as a politico-tactical outburst in Caracas in 1961 in order to create an anarchic and violent alternative to the country's art establishment. Emerging at a time of nascent democracy under the newly elected Acción Democrática (Democratic Action) administration, this group of activist artists, poets and writers, set out to change lives and transform society. They opposed the government's centrist, moderately nationalist policies and participated in protests organized by the Venezuelan communist party.

The cultural guerrillas of El Techo de la Ballena, which included the poets Juan Calzadilla (b. 1931) and Francisco Pérez Perdomo (1930–2013), promoted in their work the visceral and unruly abstract aesthetic known as Art Informel, which had its roots in Surrealism and Art Brut. Their first exhibition was held in a garage in the Caracas neighbourhood of El Conde, and was marked on 25 March 1961 by the launch of their manifesto magazine, *Rayado sobre el Techo de la Ballena* (*Stripes on the Roof of the Whale*) which featured 'Para restituir el magma' ('For the Restitution of Magma'), along with other collective texts. The group's activities were extreme to say the least: their most controversial exhibition, *Homenaje a la necrofilia* (*Homage to Necrophilia*), consisted of rotting animal guts and detritus, but the intention was deeply serious – to shock society in order to bring about change.

* * *

It is necessary to restore magma
the boiling matter

the luxury of lava

to place a piece of fabric at the foot of a volcano

to restore the world

the luxury of lava

to show that matter is more lucid than colour

in this way the amorphous cuts away at the superfluous that prevents reality from transcending

it overcomes the immediacy of matter as a means of expression making it

not an instrument of implementation

but an active medium that explodes

impact

matter transcends itself

matter transcends itself

textures tremble

rhythms draw vertigo

violence presides over the act of creation

and leaves evidence of what is

magma must be restored in its decline . . .

informalism returns it to the essence of creative activity

reestablishes categories and relationships that science has already foreseen

informalism also has its own fungus

the beat of arbitrary matter that can be seen even by the most incredulous eyes

the possibility of creation is as evident and real as the earth and rock that shape mountains

because it is necessary to restore magma

the boiling matter

adam's prosthesis

M20 Josip Vaništa

Untitled (Gorgona Manifesto) (1961)

Gorgona was a Croatian anti-art movement founded in Zagreb in 1959 by a group of artists, architects and critics who aspired to art that embraced absurdity, nihilism, irony and black humour. The name 'Gorgona' was chosen randomly from a poem written by the artist, historian and critic Dimitrije Bašičević (1921–87), who operated under the pseudonym 'Mangelos' (M67).

The group's ideology was similar to that of Group Zero, and the Fluxus movement, with which they were in contact, in that it critiqued the alienation and dissatisfaction of everyday life. They rejected the conventional art practices promoted in Yugoslavia for more ephemeral actions and street happenings, as well as for pamphlets and handmade books. The movement emerged at an uncertain time in Yugoslavian politics. The liberalism which was supposed to have come from breaking with the Soviet Union in the late 1940s was less progressive than anticipated under Marshal Josip Tito. As a result, Gorgona events were discreet, word-of-mouth affairs that relied on photography for documentary evidence. However, their sense of radical modernism was to inspire later Yugoslavian conceptual artists, including members of the Slovenian OHO group (M32) and the Croatian Six Authors group.

Gorgona published an 'anti-magazine', also called *Gorgona*, which was a work of art in itself, and in which they promoted Gorgonesque ideology and Gorgonesque behaviour. Here, in the first number, issued in late March–early April 1961, Josip Vaništa (b. 1924) set out their manifesto.

* * *

Gorgona is serious and simple.

Gorgona stands for absolute transience in art.

Gorgona seeks neither product nor result in art.

It judges according to the situation.

Gorgona is contradictory.

It defines itself as the sum of all its possible definitions.

Gorgona is constantly in doubt . . .

Valuing most that which is dead.

Gorgona speaks of nothing.

Undefined and undetermined.

Zagreb 1961

M21 Maya Deren

A Statement of Principles (1961)

Maya Deren (1917–61) was a pioneering feminist Surrealist film-maker working in the United States in the 1940s and 50s. She collaborated with other artists associated with the Surrealist movement, including Marcel Duchamp and Robert Matta, and was interested in the Freudian concept of the unconscious. She experimented with naturalistic sound, montage structure and the camera's ability to capture reality. Her aesthetic was film as poetry, not prose, creating pictures with a language all of their own.

In 1943 Deren, together with her husband Alexander Hammid, made the psychodrama *Meshes of the Afternoon*, a revolutionary piece that endures as one of the most influential experimental films of all time. A non-narrative work, it is sometimes described as a 'trance' film, in which the protagonist's gaze is merged with that of the viewers, creating a dreamlike effect. Deren's work inspired many later avant-garde directors and artists, including Barbara Hammer, Carolee Schneemann and Su Friedrich.

Deren explained her visionary approach to filmmaking in 'A Statement of Principles', which she used to distribute privately at screenings of her work. It was published in the summer 1961 issue of the journal *Film Culture*, edited by Jonas Mekas, shortly before her death.

*　*　*

My films are for everyone.

I include myself, for I believe that I am a part of, not apart from humanity; that nothing I may feel, think, perceive, experience, despise, desire, or despair of is really unknowable to any other man.

I speak of man as a principle, not in the singular nor in the plural.

I reject the accountant mentality which could dismember such a complete miracle in order to apply to it the simple arithmetic of statistics – which would reduce this principle to parts, to power pluralities and status singularities, as if man were an animal or a machine whose meaning was either a function of his size and number – or as if he were a collector's item prized for its singular rarity.

I reject also that inversion of democracy which is detachment, that detachment which is expressed in the formula of equal but separate opinions – the vicious snobbery which tolerates and even welcomes the distinctions and divisions of differences, the superficial equality which stalemates and arrests the discovery and development of unity.

I believe that, in every man, there is an area which speaks and hears in the poetic idiom . . . something in him which can still sing in the desert when the throat is almost too dry for speaking.

To insist on this capacity in all men, to address my films to this – that, to me, is the true democracy . . .

I feel that no man has a right to deny this in himself; nor any other man to accept such self debasement in another, under the guise of democratic privilege.

My films might be called metaphysical, referring to their thematic content. It has required millenniums of torturous evolution for nature to produce the intricate miracle which is man's mind. It is this which distinguishes him from all other living creatures, for he not only reacts to matter but can meditate upon its meaning. This metaphysical action of the mind has as much reality and importance as the material and physical activities of his body. My films are concerned with meanings – ideas and concepts – not with matter.

My films might be called poetic, referring to the attitude towards these meanings. If philosophy is concerned with understanding the meaning of reality, then poetry – and art in general – is a celebration, a singing of values and meanings. I refer also to the structure of the films – a logic of ideas and qualities, rather than causes and events.

My films might be called choreographic, referring to the design

and stylization of movement which confers ritual dimension upon functional motion – just as simple speech is made into song when affirmation of intensification on a higher level is intended.

My films might be called experimental, referring to the use of the medium itself. In these films, the camera is not an observant, recording eye in the customary fashion. The full dynamics and expressive potentials of the total medium are ardently dedicated to creating the most accurate metaphor for the meaning.

In setting out to communicate principles, rather than to relay particulars, and in creating a metaphor which is true to the idea rather than the history of experience of any one of several individuals, I am addressing myself not to any particular group but to a special area and definite faculty in every or any man – to that part of him which creates myths, invents divinities, and ponders, for no practical purpose whatsoever, on the nature of things.

But man has many aspects – he is a many-faceted being – not a monotonous one-dimensional creature. He has many possibilities, many truths. The question is not, or should not be, whether he is tough or tender, and the question is only which truth is important at any given time.

This afternoon, in the supermarket, the important truth was the practical one; in the subway the important truth was, perhaps, toughness; while later, with the children, it was tenderness.

Tonight the important truth is the poetic one.

This is an area in which few men spend much time and in which no man can spend all his time. But it is this, which is the area of art, which makes us human and without which we are, at best, intelligent beasts.

I am not greedy. I do not seek to possess the major portion of your days.

I am content if, on those rare occasions whose truth can be stated only by poetry, you will, perhaps, recall an image, even only the aura of my films.

And what more could I possibly ask, as an artist, than that your most precious visions, however rare, assume, sometimes, the forms of my images.

M22 Jikan-Ha

Manifesto of the Jikan-Ha Group (1962)

The avant-garde art collective Jikan-Ha (School of Time) was formed in the early 1960s and was at the forefront of the development of anti-art in Japan. The four young provocateurs rejected traditional art, and the institutions that perpetuated it, in favour of imaginative experiments. They staged happenings and performances involving mass audience participation, invariably situating their work in the street rather than in the gallery. Sculptures were made of everyday detritus, causing considerable consternation from traditionalists.

In May 1962 the group staged an exhibition at the Satō Gallery in Tokyo, where they handed out their manifesto, 'Jikan-Ha sengen', written by the Jikan-Ha member Nakazawa Ushio (1932–2015). Referring to Isaac Newton's principles of mathematical philosophy, Gottfried Leibniz's laws of continuity and Leonardo da Vinci's belief that the eye is the universal judge, the document argues that mathematics, science and art have all failed to determine an eternal or absolute truth. Reality is only a construct – so, Nakazawa posits, the artist must be in a constant state of flux, adapting to the existing surroundings rather than following a rigid ideology.

* * *

This philosophical appeal is not the work of an individual; together with you, the artists will act, respond, and raise doubt.

Declaration: the whole of reality is a construct; all living things are created by a series of changes in geometric, astronomic, and temporal/spatial functions, and within these changing conditions

human beings perceive hues, shapes, colours, and aspects. The awareness of time is constructed in the gaps between physical changes or in the material, metabolic structure of life as it is generated and annihilated. In the same way, however, it is delimited by the rhythms of the earth and forced to conform to the framework of temporal pressures shaped by the rhythms of society.

Seeing the perceptual present as the simultaneity of individual people's activities, we represent and make visible the corresponding changes based on the premise that, in looking at them, we can see the distinct measuring function of each individual. Thus, experience and its evaluation are verified by each individual's responding to a variety of different processes, and the main factors in regulating this verification are diverse and varied. By locating these occurrences in the work in relation to each individual, we attempt to measure the sufficiency of perception. While negating a fixed, uniform total image – that is, a visual impression of an unchanging reality based in static spatial form – we aim to replace absolute time with particular time and, by bringing an unknown dimension to art, to identify another reality.

The point: a human being lives in a state of change. Before becoming aware of the changes within himself, he is a witness to the changing world. Night leads to day, good weather to bad, summer to winter, life to death, construction to destruction, and it is doubtless that every form of existence develops on the basis of a temporal operation.

When mathematics discovered negative and imaginary numbers along with zero, they expanded the scope of geometry and reason, and the examination of the maximum and minimum properties led in time to Newton's and Leibniz's superior means of differentiation. These methods of calculus led to the discovery of techniques with an unprecedented degree of acuity and power, and together with analytical geometry they completely killed the potential for an accumulation of the natural spirit. Astronomy and mechanics

explained that the very irregularity of appearances was proof of the complete validity of their laws. Along with the theory of relativity, quantum theory altered the course of this century by negating the absolute concept of time and space that had existed since Newton's mechanics and by doing away with the existence of ether. Likewise, by exploring the infinitesimal world through particle physics, we discovered the idea of a non-individuated body containing nuclear force that is generated only by the exchange of states. As metabolism itself is the essence of an organism, the metaphysical superiority of life can be completely rejected. If the conditions of our existence are constantly changing, then what remains consistent is the extent to which we are diversely formed. And Leonardo's view in which the eye is the universal judge of all things became, not long after the Industrial Revolution, entirely classical due to Cézanne's volumetric way of seeing nature and treating space in two dimensions, a development that led to Cubism and formed the theoretical basis for contemporary painting. By attaching importance to dynamism and functionality, the Constructivists called for works of art to have the expressive features of a high-performance machine, and according to Le Corbusier, for whom the house was a machine for living, Suprematist works could be considered machines to live with. Naum Gabo viewed reality as part of a physical transformation of time and space, and his aspiration not to recognise constant, absolute uniformity provides some insight into the era. Artists' methods of solving the riddles of nature intellectually altered the analysis of the internal labyrinth.

In this way, mathematics, science, and art have each attempted to establish a means of perceiving and reacting according to a unique method. None of them, however, has attained an eternal or absolute truth.

Today, no one believes that there is any certainty in the reality seen before us or in historical events. We can live only in the present; in other words, our actions are nothing more than a function of the whole that is prescribed in the here and now. But the present

constantly rejects us as something that no longer is or has yet to be. This instant of provocation and reaction itself constitutes our entire being, and to perceive time in change is the only way we can perceive our reality and affirm our existence. The continual, ceaseless generating of fragments of phenomena and modern conventions to be perceived in the realm of time will be annihilated. 'Time creates me, I create time' (Bonaparte).

M23 Group 1890

Group 1890 Manifesto (1963)

'Something precious is being born with these artists,' wrote the Mexican poet Octavio Paz in 1963. He was referring to the fledgling Indian art collective Group 1890, which had been founded a year earlier in Bhavnagar (in Gujarat). The twelve artists, led by the charismatic journalist, artist and communist sympathizer Jagdish Swaminathan (1928–94), had met in order to discuss the state of art in India, and the result was the formation of a group with a fervent desire to create an authentic modern Indian aesthetic independent of Western influences. Their name meant very little – 1890 was the number of the house where they met – yet for Paz the choice was significant. This was a movement affirming change, but at the same time refusing to be dogmatic about the direction of that change.

Group 1890's manifesto was written in English by Swaminathan and printed together with Paz's introduction in the catalogue for their inaugural exhibition in July 1963 at the prestigious Lalit Kala Akademi in New Delhi. It attacked 'the vulgar naturalism' of the celebrated nineteenth-century artist Raja Ravi Varma, who painted Indian subject matter in a classical European style, and 'the pastoral idealism' of the Bengal School, which had supported the Swadeshi movement in the early twentieth century (M1). Art, Swaminathan argued, was a state of freedom and should not prescribe any specific mode or manner. In this respect the manifesto reflected the spirit of independence that still enthused the nation a decade and a half after the end of its colonial era.

Sadly, despite Paz's optimism, the group was short-lived. Although there were plans for further exhibitions, none of them ever came to fruition. Perhaps the lack of a distinctive unifying

style in their work meant that their individual careers took precedence over the collective one.

* * *

from its early beginnings in the vulgar naturalism of raja ravi varma and the pastoral idealism of the bengal school, down through the hybrid mannerisms resulting from the imposition of concepts evolved by successive movements in modern european art on classical, miniature and folk styles to the flight into 'abstraction' in the name of cosmopolitanism, tortured alternately by memories of a glorious past born out of a sense of futility in the face of a dynamic present and the urge to catch up with the times so as to merit recognition, modern Indian art by and large has been inhibited by the self-defeating purposiveness of its attempts at establishing an identity.

the self-conscious search for significance between tradition and contemporaneity, between representation and abstraction, between communication and expression lies at the root of all eclecticism in art. to us creative expression is not the search for, but the unfolding of personality.

a work of art is neither representational nor abstract, figurative or non-figurative. it is unique and sufficient unto itself, palpable in its reality and generating its own life.

the image proper in art describes itself inevitably through the creative act. it is neither the translation of an experience, feeling, idea or act nor the objective organisation of form in space.

the image proper defines its own space, delineation, colour and composition. any objective criterion of perspective, of harmony and dimension is unreal to it.

to us, the creative act is an experience in itself, appropriated by us and therefore bearing no relation to the work of art, which creates

its own field of experience – as the experience of copulation is not the same as that of the offspring. a work of art has to be experienced, the experience not being subject to judgment or assessment.

the incapacity to see phenomena in their virginal state resulting from the conditioning of history creates the illusion that life can be ordained and made to flow from the image of one's own ego, whereas the creative process has its own volition and genesis, which does not conform to anticipation by man.

the genesis of the form proper is genetically anticipated and not conceptually determined. its significance therefore lies neither in its capacity to evoke memory responses nor its relevance to any objective criterion of perspective, of harmony. whatever be the history of its becoming, its being emanates its own connotation. the form proper is the free form; its freedom is neither the denial of its history nor its recapitulation.

for us, there is no anticipation of the creative act. it is an act through which the personality of the artist evolves itself in its incessant becoming, moving towards its own arrival.

art for us is not born out of a preoccupation with the human condition. we do not sing of man, nor are we his messiahs. the function of art is not to interpret and annotate, comprehend and guide. such attitudinising may seem heroic in an age where man, caught up in the mesh of his own civilisation, hungers for vindication. essentially, this self-glorification to us is but the perpetuation of the death wish, of the state of unfreedom of man.

art is neither conformity to reality nor a flight from it. it is reality itself, a whole new world of experience, the threshold for the passage into the state of freedom.

M24 Alberto Greco

Manifesto Vivo-Dito (1963)

'Manifesto Vivo-Dito' was written by the avant-garde Argentinian artist and poet Alberto Greco (1931–65) and broadcast on the streets of Genoa in June 1962, but it was never published. Greco revised the document at some point the following year, when he was living in Spain, and that is the version printed here.

A radical nonconformist, Greco was a member of the Art Informel movement in the 1950s, fly-papering Buenos Aires with farcical statements such as 'Greco, How Great You Are', and creating works such as Black Paintings (Pinturas Negras, 1960), before rejecting traditional media in favour of Vivo-Dito. The Italian words 'vivo dito' translate as 'living finger'. For Greco, this meant the act of showing or pointing as an art form: in other words, it was about appreciating the everyday as art, rather than viewing paintings in galleries. Greco would sign the stains on the walls of a public lavatory, or the severed heads of lambs in the local marketplace. Later he would autograph people – in 1965 he signed Jackie Kennedy as she walked past him on Fifth Avenue in New York – and draw chalk circles on the pavement around them. He attracted large crowds with his confrontational street performances and happenings; one theatre piece in Rome in 1963 was so scandalous he was forced to leave Italy. Greco died in the Spanish city of Barcelona on 14 October 1965, when, deeply depressed, he took an overdose, writing down his last feelings as he lay dying.

★ ★ ★

Vivo-Dito art is the adventure of the real, the urgent document, the direct and total contact with things, places, people, creating

situations, creating the unexpected. It means showing and encountering the object in its own place. Totally in accord with cinema, reportage, and literature as a living document. Reality without touch ups or artistic transformation. Today I am more interested in anyone at all recounting his life on the street or in a streetcar than in any polished, technical account by a writer. That is why I believe in painting without painters and in literature without writers. This explains why, in recent years, the visual arts have consciously found recourse in chance. It was a way of discovering the other side of reason. All our conscious thought, all our reason limits us, and we fall, very easily, into elementary and limited structures. 'Always go in the direction opposite to the one you should. It's the only way to get somewhere.' I find that stupendous.

I don't know if I said this before, but we must go out into the street and not see it as a means of transport, as though everything were a commercial object, or a streetcar that takes us from one place to another. Every death or, better said, every corpse – directly or indirectly, of course – has its assassin. Although this is not the time to cast blame on anyone as it would be too puerile, too simple, I believe dealers have greatly contributed to the demise of painting by turning it into a domestic and commercial object. The prints traced by my shoes on the way from my house to the gallery are more important than the canvases on view there. I don't know who said that, but I totally agree.

A work has meaning as long as it is made as a total adventure, without knowing what is going to happen. Once it's finished, it doesn't matter anymore, it has become a corpse. So let it rest in peace. The contemporary artist has lost his sense of eternity. The passivity of the public should also come to an end. The audience, as audience, should end. Everyone knows too much, or at least seems to, about his own life. And what more can we ask of a person if not to tell something to make his listener shudder? Let us hope that the activities of Vivo-Dito will turn things inside out so that the audience will do the talking. We must not forget that Vivo-Dito is above all the adventure of the real and of the direct contact with things. Art galleries are opaque whorehouses that have fallen into

decadence next to the butcher shops, bakeries, markets, tailor shops, theatres, subways, morgues, streets, and real whorehouses.

Conversation in an elevator, looking at the stains on the wood.

– Which is better? This, or doing this?

– This.

– Bring him to see or bring them to see?

– Bring them to see.

Manifesto Vivo-Dito, 1963

M25 Tadeusz Kantor

The Emballage Manifesto (1964)

The experimental artist and theatre director Tadeusz Kantor (1915–90) was a leading figure in the radical art world of mid-twentieth-century Poland. He had originally been an advocate of Art Informel – an umbrella term for European gestural abstraction – but after Socialist Realism became the official, state-sanctioned art of Poland in the late 1940s, he concentrated his energies on theatre and performance, helping to establish a thriving underground avant-garde art scene.

Emballage (French for 'the act of wrapping up') was a new artistic process invented by Kantor, in which objects, people and works of art were hidden and made inaccessible. Kantor believed this action to be significant, partly as a means of protection and concealment – important in a country with strict censorship rules – but also as a way of critiquing artifice in art: the act of unwrapping exposes, or unmasks, the truth.

Kantor wrote 'The Emballage Manifesto' in Switzerland in February 1964, while staying at the house of the art collector Theodor Ahrenberg; but it was not published until September 1968, when it appeared in the sixth issue of the French contemporary art journal *Opus*. It became the unofficial manifesto of the Polish 'happenings' culture of theatrical, improvisational events, and went on to inspire many other conceptual artists.

<p align="center">* * *</p>

Emballage –
one ought to

categorize first
some of the attributes
that define it.
It would not, however,
be wise to generalize
or to create ready-made formulas.
Anyway, it would be almost impossible to do so.
Emballage, Emballage.
Because a discussed phenomenon
has many meanings –
worse than that,
it is ambiguous –
I should state at the very beginning that
Emballage actually exists
beyond the boundaries of reality.
It could thus be discussed –
Emballage, Emballage, Emballage –
in terms of metaphysics.
On the other hand,
it performs a function that is
so prosaic,
so utilitarian,
and so basic;
it is enslaved to its
precious content
to such a degree that
when the content is removed,
it is functionless,
no longer needed,
a pitiful sign of
its past glory
and importance.
Emballage, Emballage.
Branded
and accused of
a lack of any content,

it is bereft of its
glamour and
expression.
Emballage, Emballage.
I must objectively note here
that it is a victim of
the fates' injustice.
First, an extremely high honour
is bestowed on it
because one's success depends on its
looks,
opacity,
ability to convey,
expressiveness,
precision.
Then
it is ruthlessly cast aside,
exposed to ridicule,
doomed to oblivion,
and banished.
Such an ambiguous behaviour towards it
leads to further
misunderstandings
and contradictions;
prevents any serious, legitimate
attempt to classify it.
Emballage.
As a described phenomenon, it
balances at the threshold –
Emballage, Emballage –
between eternity
and
garbage.
We are witnesses of
a clownlike tomfoolery
juggling

pathos and pitiful
destruction.
Emballage, Emballage, Emballage.
Its potential is limitless.
E m b a l l a g e .
Any extra activity connected with it
must be
a completely disinterested service
because one should remember
it is performed with a full awareness of
the fatal end.
Let us discuss some of
the stages of this ritual:
f o l d i n g ,
whose complicated strategies
requiring some mysterious initiation
and a surprising end effect
bring to mind magic
and a child's play;
t y i n g u p ,
the knowledge of various type of knots
touches almost on
a domain of sacred knowledge;
s e a l i n g , always full of dignity
and complete concentration;
this gradation of actions,
this adding of
surprising effects,
as well as human need
and desire to
store,
isolate,
hide,
transfer,
becomes an almost
autonomous process.

This is our chance.
We must not overlook
its emotional possibilities.
There are many such possibilities inside it:
promise,
hope,
premonition,
temptation,
desire for the unknown
and for the mystery.
Emballage –
marked
with the symbols of fragility,
of urgency,
of hierarchy,
of degrees of importance;
with the digits of its own time,
of its own language.
Emballage –
with the address of receiver,
with the symbols of power,
with promises of
effectiveness,
durability,
and perfection.
It shows up in
special,
mundane,
funny,
grand,
and final
circumstances of
our everyday life.
Emballage –
when we want to send
something important,

something significant,
and something private.
Emballage –
when we want to shelter
and protect,
to preserve,
to escape the passage of time.
Emballage –
when we want to
hide something
deeply.
EMBALLAGE –
must be isolated,
protected from trespassing,
ignorance,
and vulgarity.
Emballage.
Emballage.
Emballage.

(1964.)

M26 Aktual Art

Manifesto of Aktual Art (1964)

The Czech group Aktual Art published their manifesto in October 1964 in the first edition of their illegal underground art journal *Aktualní umêní* (*Contemporary Art*), each copy of which was hand typed and distributed privately to protagonists in the Prague avant-garde art scene. In it they declared their aim: 'TO SHOCK, FASCINATE, LAY BARE THE NERVES!'

The group rejected the official art of the state, Socialist Realism, and promoted an interventionist art that would rejuvenate the culture of Czechoslovakia and beyond. This took the form of street happenings: they would perform small, seemingly insignificant tasks that expressed their opposition to the idea of artworks as commodities. Art should inspire wonder, they argued, not artefacts. For nonconformists in Cold War Eastern Europe, the simple, spontaneous nature of happenings made it difficult for the authorities to police. Requiring few props, they could be performed anywhere, at any time, and could be witnessed by the ordinary public. Consequently, they were central to the artistic practice that informed many of the most significant East European art manifestos of the 1960s and 70s, including those of Gorgona (M20), Tadeusz Kantor (M25), HAPPSOC (M28), Július Koller (M30), the OHO group (M32) and Gyula Pauer (M44).

Aktual Art published a second manifesto two years later, 'AKTUAL: LIVE OTHERWISE' ('AKTUAL: ŽÍT JINAK'), which expanded on the same theme. It exhorted artists to create little acts of protest in order to rid society of 'all that is cramped and deformed'. To do this, the group suggested imposing 'small atonements' on

oneself, like wearing a coat on a hot summer's day or refusing to remove one's hand from a burning stove.

* * *

Our starting point is the basic feeling of an individual committed to everything that surrounds him. Our being and our end is commitment.

TOTAL COMMITMENT!

We are aware that man is drowning in the enormous abundance of products of the 20th century; we are concerned about him, maximally concerned, because he is us. US.

We have no utopian dreams of getting rid of the often monstrous advantages of the 20th century, but we want him (man) to be aware that they exist to serve him, and not he to serve them.

This is what we want!

Therefore we announce a program of

AKTUAL ART.

We are not interested in aesthetic norms that serve as a measure of perfection. We are interested in man. To overcome the indifference and emotional apathy so typical for modern man,

we will use,

WE MUST USE

forms that have the maximum effect.

Therefore

NATURALISM

BANALITY

MAXIMALISM

PROVOCATION

PERVERSION

ETC.

TO SHOCK, FASCINATE, LAY BARE THE NERVES!

Convince.

TO CONVINCE MAXIMALLY!

Milan Knížák, Jan Mach, Vit Mach,
Soňa Švecová, Jan Trtílek

M27 Otto Mühl

Material Action Manifesto (1965)

Viennese Actionism (Wiener Aktionismus) is an extreme version of performance art in which the body is used as the canvas. It emerged in Austria in the early 1960s, when the artists Otto Mühl (1925–2013), Rudolf Schwarzkogler (1940–69), Hermann Nitsch (b. 1938) and Günter Brus (b. 1938) were inspired by the psychological theories of Sigmund Freud and Wilhelm Reich to begin using their art as a form of therapy. Their transgressive actions featured elements of ritual, while often teetering on the edge of outright anarchy and violence. In these highly charged events, copious quantities of bodily fluids were used as a means to shock the audience out of its supposedly anaesthetized and alienated condition, as a kind of catharsis. Not all of these actions were executed in front of observers: Schwarzkogler created a series of actions privately in his apartment, the only evidence of their occurrence being a series of deeply unsettling black-and-white photographs.

Viennese Actionism's visceral ideology was propounded in a series of inflammatory manifestos written by Mühl, some of which he printed in his own journal, *Omo Super Material Action*. This particular manifesto appeared early in 1965 in the magazine *Le Marais*, which was edited by Brus and promoted the artist's work.

* * *

material action is portrayed painting, auto-therapy made visible with food stuffs. it seems like a psychosis, produced by the mingling of human bodies, objects and material. everything is planned. everything can be used and worked as material.

everything is employed as substance.

paint is not a means of colouring, but as goo, liquid, dust. an egg is not an egg but a slimy substance.

the associations of certain materials – whether on account of their form, their customary usage or their meaning – are utilised.

real occurrences are reproduced and mixed with materials. real occurrences can be mixed with other occurrences, as well as with every kind of material, just as the time and place of the occurrence can be interchanged:

a symphony orchestra plays naked in a swimming pool which slowly fills up with jam.

paint and foodstuffs are sprayed, tipped over and thrown at an opera performance. the singers are instructed to stick it out till the end. interminglings, interchanges, transformations can be employed for state receptions, the trooping of the colour, parades and other ceremonies in everyday life.

real occurrences are reproduced: car accidents, floods, conflagrations, mixed with material and other events. mingling and mixing are performed according to the logic of dreams.

events with deeper significance come into being.

jam, corpses, road construction machines.

occurrences are remoulded, material penetrates reality, loses its normal validity, butter becomes pus, jam blood, they become symbols of other occurrences.

the associative assumes a large place in the delineated possibilities.

if the audience joins in it becomes either material or accomplice. in order to avoid instincts breaking out, the action will resemble a gym lesson.

M28 HAPPSOC

HAPPSOC Manifesto (1965)

HAPPSOC was an alternative proposition to art conceived by the Slovak artists Stano Filko (1937–2015) and Alex Mlynárčik (b. 1934) and the art historian Zita Kostrová. They derived the name 'HAPPSOC' by combining the words 'happening', 'happy' and 'society', in a somewhat ironic reference to the propaganda promulgated in totalitarian Czechoslovakia.

HAPPSOC distributed their manifesto as a flyer on 1 May 1965 to accompany their first grand-scale public intervention. Believing that everyday reality needed to be perceived in more complex ways, the group announced that from now on life itself was a work of art. Choosing the nine days of socialist celebrations from Workers' Day on 1 May to Soviet Liberation Day on the 9th, the group claimed possession of the official parades and declared the entire city of Bratislava to be an artwork under the title *HAPPSOC 1*. Each day was called a 'reality'; they sent out invitations, and made an inventory of all 'objects' that would 'participate'. These included 137,936 women, 128,727 men and 48,991 dogs, as well as the city's apartments, balconies, water supplies and other infrastructure, and landmarks including the castle and the River Danube. Through this subtle subversion, HAPPSOC were able to circumvent state control and regain their creative freedom in a similar way to that also expressed by Július Koller in his 'Anti-Happening' manifesto (M30) in Bratislava that same year.

* * *

What is HAPPSOC?

It is an action stimulating the receptiveness and multifaceted enjoyment of reality, released from the stream of everyday existence.

Reality, thus encountered and limited in time and space, acts by means of the potency of its relations and tensions.

Bringing this reality into the open as a new concept ushers in the recognition of the immensity and breadth of mutually dependent relationships.

It stands for gentle and all-inclusive commitment.

It is a process that uses objectivity to stimulate a subjective way of looking at things and elevating their perception to a higher level.

It is, therefore, a generally valid way of dealing with life on the basis of an 'as found' reality, thus making it possible to bring into full play its scope in its entirety.

It allows for the possibility of investing a chosen reality with the superreal, that is, a new reality enriched by its own charge.

It is a synthetic manifestation of social existence as such and therefore, by necessity, a shared property of all.

It links up with a whole range of happenings and processes of change and shocks by its very existence.

In contrast to happenings, it manifests itself as a singular, unvarnished reality, which remains unaffected by any immediate encroachment upon its primordial form.

For those who share this concept [of reality], the immediate environment does not merely reveal itself as a thing, but, in addition,

includes as well all the relationships and chains of events that grow out of such cognition.

Its realization is not accidental, but intentional and stimulating.

It was realized for the first time between May 1 and 9, 1965 in Bratislava and thus became a manifesto of its own consummation.

M29 David Medalla

MMMMMMM . . . Manifesto
(a fragment) (1965)

In 1964 the Centre for Advanced Creative Study was founded in London by the avant-garde artists David Medalla (b. 1942), Gustav Metzger (1926–2017) and Marcello Salvadori (1928–2002), the art critics Christopher Walker and Guy Brett, and the curator Paul Keeler. Their interest lay in the crossovers between art and science, and they opened a space called Signals/London in which to showcase their experimental work, which had a special focus on kinetic art. They also produced the influential international journal *Signals Newsbulletin*, edited by Medalla, which featured critical essays, poetry, scientific studies and experimental art.

Medalla's manifesto was published in the eighth issue of *Signals*, in June 1965, its witty utopianism revealing that there was a place for the imagination in both art and science. The same issue also featured scathing damnations of the war in Vietnam by the leading American thinkers Lewis Mumford and Robert Lowell. The magazine closed down soon after, yet the prescient ideas the *Signals* artists promoted in art and science, including Metzger's auto-destructive art using corrosive and unstable materials, and Medalla's participatory experiments in which the audience became part of the creative process, have had a huge impact on the trajectory of contemporary art, with Metzger and Medalla considered to be cultural pioneers in the post-modern age.

* * *

MMMMMMM . . .
Manifesto
(a fragment)

•

Mmmmmmm . . . Mmmedalla! What do you dream of?

I dream of the day when I shall create sculptures that breathe, perspire, cough, laugh, yawn, smirk, wink, pant, dance, walk, crawl, . . . and move among people as shadows move among people . . . Sculptures that will retain a shadow's secret dimensions without a shadow's obsequious behaviour . . . Sculptures without hope, with waking and sleeping hours . . . Sculptures that, on certain seasons, will migrate *en masse* to the North Pole. Sculptures with a mirror's translucency minus the memory of a mirror!

•

Mmmmmmm . . . Mmmedalla! What do you dream of?

I dream of the day when I shall go to the centre of the earth and in the earth's core place a flower-sculpture . . . Not a lotus, nor a rose, nor a flower of metal, . . . nor yet a flower of ice and fire . . . But a *mohole*-flower, its petals curled like the crest of a tidal wave approaching the shore . . .

•

Mmmmmmm . . . Mmmedalla! What do you dream of?

I dream of a day when, from the capitals of the world, London Paris New York Madrid Rome, I shall release missile-sculptures . . . to fly – at nine times the speed of sound . . . to fall – slim as a stork on a square in Peking . . . bent, crushed – like a soldier's boot after

an explosion – on an airport in Ecuador . . . in splinters – on the fields of Omaha . . . A few – to cross inter-stellar space . . . accumulating, as they wing along, asteroids, meteorites, magnetic fields, interstellar germs . . . of a new life . . . on their way from our galaxy to the Spiral Nebula . . . *Mmmmmmmmmmmmmmmmmmmm*

•

David Medalla
London, 1965

M30 Július Koller

Anti-Happening (Subjective Objectivity System) (1965)

The conceptual artist Július Koller (1939–2007) created his first 'anti-happening' in the Czechoslovakian city of Bratislava in 1965. The work was a small card stamped with green text that said 'ANTIHAPPENING Systém Subjektivnej Objektivity Ceskoslovensko'. Later that year he produced a handwritten manifesto outlining his theory, which had its basis in the concept of the readymade. For Koller, anti-happenings were small, subtle actions that befell to the participant as part of the course of everyday life. They were not invasive or directive, they simply sought to expand the participant's experience of the world around him or her. Playing ping-pong could be anti-happening, the letter 'A' stamped on the back of a card could be anti-happening, a question mark could be anti-happening.

Indeed, the question mark became the defining element of Koller's work after the Soviet Union occupied Czechoslovakia in 1968 in order to bring an end to the liberal reforms of the Prague Spring. The symbol represented doubt and uncertainty and the need to ask questions and seek answers about social and collective relationships. As censorship in Czechoslovakia became tighter, and communication with the outside world harder, Koller critiqued this increasingly oppressive situation by looking to the cosmos and elaborating the concept of *U.F.O.* (the initials standing for different things at various times, including *Universal Fantastic Operations*), which became a metaphorical space for communication between

humans and extraterrestrials as a way of slipping the bonds of state control.

* * *

Subjective cultural activity creates a new cultural reality by a cultural demarcation in the entire spatio-temporal and psychophysical reality (the Duchampian principle of the 'readymade') and by a cultural anti-artistic treatment of objective reality. The programme of a cultural synthesis of art and life is a subjective-objective civilistic culture which moves from ways of implementing artistic actions (happening etc.) to a new cultural forming of subject, awareness, way of life, the natural environment, surrounding, and the real world. By means of text information (making known) the cultural demarcation becomes part of the cultural context.

M31 *Arte de los Medios de Comunicación Masivos*
A Mass-Mediatic Art (1966)

The group Arte de los Medios de Comunicación Masivos (Mass-Mediatic Art) was formed in Argentina in 1966 by the conceptual artists Eduardo Costa (b. 1940), Roberto Jacoby (b. 1944) and Raúl Escari (b. 1944). Their aim was to use the mass media as both the medium and the subject of an artwork, and they set out their plans to do so in their eponymous manifesto written in Buenos Aires in July 1966 and first published in *Happenings* (1967), a collection of writings on Argentinian conceptual and performance art compiled by the theorist Oscar Masotta.

As outlined in the manifesto, the group sent out a press release describing a collective happening in which a number of distinguished people participated. The event was duly recorded in the media, only for it to be revealed later that the happening had never taken place, giving rise to various discussions in the press as to whether it was intended as a sociological experiment, a conceptual artwork or a literary joke. The artists' position was based on the Canadian philosopher Marshall McLuhan's theory that 'the medium is the message' – in other words, that meaning varies depending on the characteristics and proclivities of the medium through which it is communicated. On those grounds, they argued, because their piece was entirely reliant on a mediator (in this case the press) for whatever existence it possessed, it was in fact an 'anti-happening'. As well as its debt to McLuhan, the manifesto also cites the American multimedia artist Nam June Paik, who was one of the pioneers of television as an artistic medium.

The group's tactics were used again in 1968, when Jacoby, as part of the Vanguard Artists' Group, helped hoodwink the

Argentinian media into exposing to the wider world the appalling living and working conditions of the inhabitants of Tucumán province (M35).

* * *

In a civilization dominated by the mass media, the public has no direct contact with cultural events, only with information about them in the media. The mass media's audiences do not view an art exhibition, nor do they witness a happening or attend a soccer game; instead, they receive reports of these spectacles in news broadcasts. Thus, real artistic events lose their importance because they reach only a very few people due to a lack of dissemination. 'To distribute two thousand copies of a work, in a big modern city, is the same as shooting into the air and waiting for the pigeons to fall from the sky,' Nam June Paik once said. The truth is that the consumers of information do not care if an exhibition is carried out or not; the only thing that matters is the image of the artistic event *rebuilt* by the mass media.

Today's art (especially Pop Art) occasionally brings into play elements and techniques taken from the media, isolating them from their natural context (Lichtenstein or D'Arcangelo's route charts, for instance). Unlike Pop Art, we intend to concoct a work 'inside' those media. We intend to give the press a written report, illustrated with photographs, about a happening that has never occurred. This false report will include the names of the participants and an indication of the time and place where the would-be happening was carried out, along with a description of the alleged spectacle and photographs of the alleged participants taken in different circumstances. Thus, from the mode of transmitting the information – from the mode of 'carrying out' the nonexistent event – and from the divergences between the different versions presented by the various broadcasters, the meaning of the work will emerge: it is a work whose existence begins the moment the viewer's conscience realizes that it has already ended.

Therefore, this is a threefold creation:

> – the writing of the false report;

> – the broadcasting of the report through the information channels;*

> – its reception by the viewer,

who – on the basis of the transmitted data and according to the meaning these acquire – bestows consistency on a nonexistent reality considered as factual.

We thus take a characteristic of the mass media to its ultimate consequences: divesting the object of reality. In this way, we privilege the moment of the work's transmission over that of its constitution. *Creation here consists in handing over the work's constitution to its transmission.*

Today the work of art is the product of a process that begins with the (traditional) making of the work and goes on until it becomes material transmitted by the mass media. Now we are proposing a 'work of art' in which the moment of the making disappears. Hence, the work becomes a commentary on the fact that it actually is a pretext to launch the process of information.

From the viewer's perspective, there are two possible readings for this kind of work. On the one hand, that of the viewer who trusts the media and believes what he sees; on the other, that of the viewer in the know, previously warned about the nonexistence of a work whose news is being broadcast.

In this way the possibility of a new genre emerges, a Mass-Mediatic art, in which what really matters is not 'what is said' but *the media itself as media,* as subject matter.

Furthermore, the report prepares the addressees for the second reading by warning some of them and thus creating the first step of the works we announced.

Buenos Aires, July 1966
Eduardo Costa, Raúl Escari, Roberto Jacoby

* The versions differ according to the channels that broadcast the news. 'The medium is the message' (Marshall McLuhan).

M32 I. G. Plamen and Marko Pogačnik

OHO (1966)

The OHO group was part of the wider OHO movement that emerged in Slovenia in the early 1960s. The name is a combination of the Slovenian words *oko* (eye) and *uho* (ear), as well as an expression of surprise. Founded in the tiny city of Kranj by the sculptor Marko Pogačnik (b. 1944) and the poet Iztok Geister (also known as I. G. Plamen; b. 1945), OHO promoted experimental art through visual poetry. Their interest in structuralism, and in the German philosopher Martin Heidegger's use of language as the vehicle through which being can be explored, attracted collaborations from numerous writers, sociologists and philosophers.

The OHO group explored the concept of reism, a theory promoted by the critic Taras Kermauner that reduces all categories to that of things. For OHO, these 'things' took the forms of books, games and happenings, anti-art that delineated everyday life. This led them to embrace Arte povera and land art until, in 1970, they conceived the idea of 'transcendental conceptualism' – art that exists beyond the boundaries of human experience. As a result of this theory, OHO stopped creating art altogether, opting instead for an aesthetics of silence. They formed a commune in the village of Šempas in which art became subsumed by the day-to-day realities of human existence.

Plamen and Pogačnik presented their idiosyncratic linguistic manifesto in the Slovenian student paper *Tribuna* in November 1966, on the occasion of the publication of their book *OHO*.

*　*　*

What is this on newspaper in printer's ink in a trace which falls and rises in a curve, then falls past three dots and runs part of the length

in a straight line and falls steeply and turns back sharply, curving, falls sharply and levels out lengthwise and curves up to the corner, whence it falls and rises in a curve, then falls past three dots?

This is not a body, rounded along the volume of a foot, with a hole in the form of a split mouth with three arches of thread punctured with three holes twice, which are encircled by six-sided, inwardly curved metal rings, while the tongue lolls out of the mouth, tipped with twelve little arches, opposite the belt which hugs the back, bordered by two columns of stitches, turning inward at the edge under the layer of leather which lines the interior, and is then sewn into the material which stretches to the end of the interior and touches the very bottom, etched on the sole with the golden letters E, X, P, O, R and T, and with rubber on the outer side with parallel ribs which line up from the rough plain on both sides of the centre, which is full of hooked teeth appearing from the right and disappearing to the right, emerges the inscription EURASIA, a sharp ridge rises to an arched wall which raises the heel with hooked teeth appearing from the left and disappearing to the right, with a row of parallel teeth on the sides between the threshold and the rough plain cut into the sole, which lies tightly against the thick leather line, which lies tightly hugging the body, rounded along the volume of a foot, with a hole in the form of a split mouth, with three arches of thread, punctured with three holes twice, which are encircled by six-sided inwardly curved metal rings.

OHO

When does prostor {space} break down into prosti zor {free vision}. When I write this, therefore immediately or simultaneously. When I sprostim {release, relax} prostor {space} into prosti zor {free vision}, therefore immediately or simultaneously. In the pred-stavi {representation, before-position} ob-staja {exists, near-position} prostor {space} which is empty, which is prost {free} in the sense that (n)aught is there. If it is true that (n)aught is there, then what is. Therefore the definition or claiming of space is not possible because

of the presence of nothing, which will be there (parts), if anything is already there at the time when (n)ought is.

And truly, prosti zor {free vision} is liberty-filled vision, such a vision is its own master. In the same way as a book is not thrown into (societal) space, as there is no space for the book there, rather the book itself is space, where again there is no space for anything else. Where there is space, there is no space.

Is any kind of engagement possible in space? It is not, as prostor {space} itself is engaged in its prostost {freeness}. And what is it doing in its prostost {freeness}? Looking. To look at oneself means being at liberty. To look elsewhere, away from oneself, means being in od-nosu {relationship, from-carry, from-nose} or in dichotomy. Absolutely and relatively these two have nothing in common. As they each preclude the other. Prosti zor {free vision} is absolute vision. The claimers of space are in odnosu {relationship} with space. Thus they are not in themselves and not in the claimed space.

OHO

What is this, the absurd. We cannot know how misel {thought} misli {thinks}. We can, however, misliti {think} brez misli {without thought} of it. To think means not to understand thought. (To understand thought means to know.) Misliti {to think} z misljio {with thought} of something, that is to be z misljio {with thought}, means to think smisleno {sensibly, wisely}. Misliti {to think} of something brez misli {without thought} of it, that is to be v mišljenju {in thought}, to think precisely, means to think nesmisleno {senselessly, unwisely}.

We can misliti {think} brez misli {without thought} of it because we cannot predstaviti (imagine) thought and because we cannot understand thought.

The criteria for whether something is predstavljivo {imaginable, before-position} or not predstavlja {is represented by, before-position} obstojnost {the quality of lasting, near-positionness}. For human thought, reality ob-staja {exists, near-position} in the

manner of predstave {representation}. Thought which is predstav-ljiva {imaginable} is obstojna {lasting, existent, near-position}. What is the nature of thought which is not predstavljiva {imagina-ble}. We shall say that such misel {thought} is miselna {of thought}. Is there anyone anywhere who thinks in the manner of misli {thoughts} and not in the manner of predstare {representations}. Children (infants) think in the manner of thought. A child's thought thinks in a fantastic manner. In its pure purpose, therefore, thought which is not predstavljiva {imaginable} is fantastic.

The criteria for whether something is understandable or not predstavlja {is represented} by the circumstances that the stvar {thing} (misli {thought}) which is zamišljena {in thought, thought up} has forced upon it the logos of razumen {reasonable, under-standing} viewing of the thing (thought), which is videnja {seeing} or vedenja {knowing, behaviour}. When the logos of the stvar {thing} (misli {thought}) is discovered in the stvar {thing} (misli {thought}), this stvar {thing} is found in its stvarnost {reality} (mentality). Reason is found only in vedenju {knowing, behav-iour}, which is the stvarnost {reality} of reason. We can, therefore, think (not understand) thought in a fantastic manner (this is not in the manner of representation). Misunderstood and unimagined thought which occupies its reality in a fantastic manner is absurd thought.

Now it is clear that thought should be (when it is the issue at hand) fantastic reality or real fantasy. Is not thus absurd thought the only thought?

OHO

A MAN A PLAN A CANAL PANAMA: se-stavljene {composed, self-position} words are in a sestav {composition} or a skupnost {cluster} of stavov {positions} (stališč {standpoints}). The stališča {standpoints} are the following: A, MAN, A, PLAN, A, CANAL, and PANAMA. But these stališča {standpoints} not only se-stavljajo {compose, self-position} the sestav {composition}, they also se rukajo {shove themselves}. The right roka {hand} ruka {shoves}

them, as this composition is left-handed. The standpoints of the right-handed composition are the following: ANAMAP, LANAC, A, NALP, A, NAM and A. A two-handed composition is also possible: AMANAPLANACANALPANAMA. But this kind of two-handedness is rare. However, the conceptual standpoint is occasionally more lax than that of words, as in the case of the two-handed composition, shut out by one eye and looked at by the other. LEWDDIDILIVEEVILIDIDDWEL. We obviously made up this word, but the concept has remained the same as if we had written dwell. The conceptual standpoint izhaja iz (za za) mišljenje besede {stems from (for for) the words thought, stems from behind the word thought-up}. Thus we extracted the word from the thought for this word. Or is it possible to think a word up at all?

Stvari {things} are stvarne {real}. We draw close to the stvar-nost stvari {reality of things} by accepting a thing as it is. And what is a thing as? A thing, we notice first, is silent. But the thing has something to offer!

With a word we entice the unheard voice from a thing. Only the word hears this voice. The word registers or mars the voice of the thing. This voice, marked with a word, speech utters. Here speech meets with music, which is the heard voice of a thing.

Now we would like to know whether we can entice with a word the unheard voice from thought. Is thought also ever silent, although it has something to offer? These are thoughts yet to be wakened, arising from the 'subconscious.' Words which these thoughts mark are not concepts as long as they are not thoughts. Only the thought-up word dewL is therefore a word which helps a thing do besede {to reach expression, to the word}.

OHO

A book has been published; its name is OHO. The bookstores are currently selling it.

M33 Lev Nussberg

A Kinetic Manifesto (1966)

Towards the end of the 1950s, the Soviet Union was struggling to compete globally in some areas of science and industrial design. The destructive political forces that had led to the condemning of intellectuals as bourgeois dilettantes in the 1920s had resulted in a lamentable lack of understanding of good design, leading to shoddy, poorly conceived products. The authorities agreed to the establishing of a series of technical research institutes, which began, tentatively, to re-evaluate the work of earlier designers, artists and scientists working in the hitherto unsupported fields of nuclear physics, cybernetics and industrial design. Nonconformist artists discovered they could work behind the cloak of these disciplines and their activities would be tolerated.

The Kineticist Group (*Dvizheniye*) was an association of just this type of artist. Led by the charismatic Lev Nussberg (b. 1937), they promoted their purely aesthetic experiments with light, colour, movement and rhythm as investigations into product and environmental design. Staging exhibitions in which their playful mobiles and kinetic constructions were presented as futuristic plans for products, towns and cities, they attempted to pick up the thread of the Russian Constructivists, whose work had been sabotaged by Stalin's ideological guardians in the 1920s. They later expanded the group's remit to include happenings, performances and improvisations.

Nussberg wrote the group's manifesto (originally titled 'Manifest russkikh kinetov') in 1966 and distributed it privately. In it he called on artists to embrace science and technology, for only through combining art and science could either practice truly flourish.

* * *

KINETICISTS OF THE PLANET EARTH!
TODAY'S WORLD: 'I demand my own forms and symbols!' in the
20th century TECHNOLOGY has united ART with SCIENCE.
Man TODAY: 'To everyone, absolute freedom of imagination!'
IMAGINATION says: 'Give me a new instrument – and I will
remake the world.' From the TREE OF SCIENCE springs many
new branches, from the TREE OF ART-FORM 20th-century man.
KINETICISM – FRUIT of many branches.
NOT TO BE GRASPED ALONE. Even the strong, if alone are
weak. PRIEST OF KINETICISM – THE KINETICIST. THE
KINETICIST – this is one and many. He is – both personal and
collective. THE WORLD SAYS: 'MANKIND, if you are not for
yourself then who is for you? But if you are only for yourself – what
are you worth?' TODAY'S WORLD: 'Why is it people are not yet
united? Surely you have ART . . .' TODAY – musicians, physicists,
actors . . . architects, psychologists, engineers, sociologists . . . and
poets – TOMORROW KINETICISTS. A new quality in art is
being born through the COLLECTIVE. Together we make this
art, which alone is impossible to do.

INTERACTION	⟵——⟶	INTERACTION
Artist		Scientist and
Artist		Technologist
	= KINETIC WORK	

'ENGINEER, what have you done for BEAUTY?' 'ARTIST, how
are you perfecting the INSTRUMENT of art?' 'WORLD, to you
we offer an art of SOUL, MIND and BODY.'

KINETICISM – art that reveals the secrets of life and transform-
ation. Nearer and nearer is the era of REAL ART, the time when all
mankind will understand through art. The era of KINETICISM is
coming. KINETICISTS of the planet EARTH, in our hands is the
greatest spiritual task. KINETICISM – not only is this a new form
of art, not only even a new aspect of art, but it is a new relation to the

world, to mankind, that has been evolving over thousands of years. Outside the man and without man there is no art. We – are pioneers. We unite the WORLD to KINETICISM! TODAY'S man is torn apart, sick. 'Man, are you not tired of destruction?' TODAY'S child – is already the cosmic generation. The stars have come nearer. Then let ART draw people together through the breath of the stars!
'PEOPLE, LET US CREATE A WORLD
INSTITUTE OF KINETICISM!'
Let kineticism bring life close to the world of dreams and imagination. We will push apart the horizons – let TOMORROW see it. We will master a new language of the soul.
TODAY WE HAVE THE SEED – TOMORROW WE WILL MAKE THE TREE BLOSSOM!! TODAY WE PROPOSE THE PROJECT: TO CREATE A WORLD INSTITUTE OF KINETICISM!

Moscow 1966. Lev Nussberg.
Members of Dvizheniye: Nussberg, Infante,
Kusnetsov, Buturlin, Koleichuk, Zanevskaya,
Glinchikov, Orlova, Muravieva, Bitt,
Dubovskaya, Stepanov.

M34 The Aouchem Group

The Aouchem Manifesto (1967)

The short-lived but influential Aouchem Group was founded in Algeria in 1967 by the Spanish-Algerian artist Denis Martinez (b. 1941) and the Algerian artist Choukri Mesli (b. 1931). Algeria had gained its independence from France in 1962 after eight years of bloodshed. In this post-independence era the Aouchem Group sought to challenge the cultural impositions of French colonialism while also searching for a new Algerian aesthetic. In order to do this, they adopted an expansive Pan-African ideology, collaborated with Algerian poets and looked towards traditional Algerian arts for inspiration.

The group chose the Arabic name *'Aouchem'* because it means 'tattoo'. Symbolic of something that could not easily be erased, the term was important not only in the context of cultural colonialism, but also because it refers to the body art of the indigenous Berber people (Imazighen) of North Africa, the motifs of which the Aouchem artists incorporated into their abstract canvases. Using typical materials of Berber art – such as feathers, copper and sand – the Aouchem artists created paintings that embraced ancient Berber traditions and sought to establish a connection with the prehistoric artists who had created the rock art of the central Sahara Desert.

The Aouchem Group produced a manifesto that was distributed after the opening of their first exhibition at Galerie UNAP (National Union of Plastic Arts) in Algiers in March 1967 was met with violent aggression from those opposed to their abstract aesthetic. Written in French, it rails against aesthetic mediocrity, and

encourages artists to continue the 'intellectual rigour characteristic' of their ancient indigenous society.

* * *

Aouchem was born thousands of years ago on the walls of a cave in the Tassili Mountains. Its existence continues into our own time, sometimes in secret, sometimes in the open, according to the fluctuations of history. It defended us and survived in many forms despite the many conquests that have taken place since the Roman period. The continued use of the magical sign reveals the retention of an [indigenous] popular culture, which has for a long time embodied the hope of a nation, even if, because of history, a certain decadence of its form was produced under foreign influence. Thus, for all time, across the works of the artists-artisans an intellectual rigour characteristic of our civilization, from north to south, has been maintained, and this has been expressed most notably in geometric compositions.

It is this authentic tradition that *Aouchem 1967* insists on rediscovering, not only in the forms of art works but also in the intensity of colour. Far from a certain gratuitous and even sometimes pointless freedom of contemporary Western abstraction, which forgot the Eastern and African lessons that had suffused Roman art, we want to define the true totems and the true arabesques capable of expressing the world where we live. That is to say, starting from the major solemn artistic themes inherited from Algerian history, [we must] reassemble all the plastic elements invented here or there, by the civilizations of the Third World that were crushed yesterday and that are coming back to life today. Our goal is that the new Algerian reality be situated within the growing universal humanism of the second half of the twentieth century.

That is why the '*Aouchem*' group is also engaged in reusing the major mythological themes – because they are still alive – in symbolizing the individual lyrical outburst, as well as in violently taking hold of the provocations that the current tragedies in Africa and Asia are throwing in the face of the artist.

We intend to show that, always magic, the sign is louder than the bomb. We believe that we have bluntly discerned similar preoccupations in the language of particular Algerian poets.

Realist visionaries, the *'Aouchem'* painters and poets declare to use effective creative forces against the rear guard of aesthetic mediocrity.

MESLI – ADANE – SAIDANI – MARTINEZ – BAYA – BEN BAGHDAD – ZERARTI – DAHMANI – ABOUN

Algiers, 1 April 1967

M35 The Vanguard Artists' Group

Tucumán Arde Manifesto (1968)

In 1968 a group of left-wing Argentinian artists and activists calling themselves the Vanguard Artists' Group (*Artistas de vanguardia*) decided to use their art and the mass media as tools in what they hoped would be a revolutionary struggle against the country's military dictatorship. Rejecting the dilettante avant-garde of the Di Tella Institute, which had been set up in 1958 to further Argentinian culture and science, the group's intention was to create art that was actively involved in society rather than simply a passive observer. One of the members, Roberto Jacoby (b. 1944), had been part of the provocative conceptual art group Arte de los Medios de Comunicación Masivos, which had duped the mass media into reporting a fictionalized happening two years before (M31).

The group began by launching a project to investigate and protest against appalling living and working conditions in the province of Tucumán in north-west Argentina, where the government's economic policy had recently led to the forced closure of the region's large state-owned sugar mills, leaving many inhabitants destitute and starving. They initiated their campaign by fly-posting the major cities of Rosario and Santa Fe with the mysterious words '*Tucumán arde*' (Tucumán is burning). They then announced to the press the staging of the First Avant-Garde Art Bienniale (*Primera Bienal de Arte de Vanguardia*) in Rosario, where they presented audio, photographic and documentary evidence of the plight of Tucumán's inhabitants. The group distributed its manifesto in and around the city during the exhibition, before it moved to Buenos Aires, where the government swiftly closed it down. Today, the 'Tucumán Arde' manifesto and exhibition are regarded as

pivotal to the emergence of a highly politicized artistic milieu in Argentina.

* * *

From 1968 on, the Argentinean visual arts scene was shaken by a series of aesthetic events whose expressed goal was to break with the supposedly avant-garde stance advocated by the artists of the Di Tella Institute. Up to that moment, the institute had assigned itself the right to legislate artistic activities and to propose new models for action, not only for its own artists, but also for all new aesthetic experiences in the country.

The exquisite and aestheticizing atmosphere of the false avant-garde experiences produced at the institutions of official culture provided the backdrop for these events, which gradually began to shape a new attitude that would postulate the artistic endeavor as a positive and real action whose aspiration should be to have a modifying effect on the milieu that engendered it.

Accordingly, the political content implicit in every work of art was to be made explicit as an active and violent charge. Only in this way might artists embrace reality with a truly avant-garde, and thus revolutionary, spirit. Aesthetic events that denounced the horror of the Vietnam War, as well as the cynical falseness of the United States policy, signaled the need to create effectively. The goal was not to produce a reaction to the milieu, but to transform it as efficiently as did political events.

The acknowledgment of this new understanding led a group of artists to formulate aesthetic creation as a *violent and collective action*, thus destroying the bourgeois myth of the artist's individuality as well as the presumably passive nature of the artwork. Hence, deliberate aggression became the form of the new art. To exert violence is to possess and destroy the old forms of an art built on the private ownership and personal enjoyment of the unique work of art. Violence then becomes an action that creates new contents; it destroys the official culture's subsystem, countering it with a subversive culture that launches the process of transformation by producing a truly revolutionary art.

Revolutionary art is born of a consciousness on the part of the artist of belonging to the political and social complex that encompasses him or her.

Revolutionary art considers the aesthetic act as the core where all the elements that constitute human reality: economic, social, and political, come together. It acts as an integrating factor of the contributions from the diverse fields of social endeavors, thus eliminating the separation of artists, intellectuals, and technicians. It is, therefore, a unifying action directed toward the transformation of the whole social structure – it is *total art*.

Armed with a lucid ideological conception based on the principles of materialist rationalism, revolutionary art operates in the social context through a process that grasps the fundamental elements that constitute reality.

In this way, revolutionary art presents itself as a partial form of reality integrated into the whole, thus nullifying the idealist separation between the world and the work of art. Insofar as it accomplishes a real transformation of the social structures, it is *transforming art*.

Joining with the revolutionary forces that fight against economic dependency and class oppression, revolutionary art is the disclosure of the political forces that struggle against the obsolete cultural and aesthetic schemes of bourgeois society. It is, therefore, *social art*.

The work carried out by the Artistas de vanguardia is the continuation of a series of acts of aggression against institutions and representatives of bourgeois culture. An example of this was the refusal to participate in and the boycott of the Braque Award organized by the Attaché Culturel of the French Embassy in Argentina; the action resulted in the imprisonment of some artists who tried to express their refusal violently.

The collective work executed by these artists is based on the current Argentinean political and social situation. In one of the country's poorest provinces, Tucumán, which has been subjected for a long time to economic oppression and underdevelopment, it grew significantly more radical. The Argentinean government,

which at the time had adopted a harmful colonizing policy, had closed down almost all sugar mills in Tucumán. As these were vital to the economy of the province, widespread unemployment and hunger ensued, along with other negative social consequences. A program called Operativo Tucumán, set up by government economists, tried to cover up this open aggression against the working class by announcing an alleged economic development in the region based on the creation of new but still-hypothetical industries financed with United States capital. The government's actual objective was the destruction of the genuine and explosive labor union that had spread in the northeast. As a result of this policy, unions were dissolved and workers re-grouped in small atomized industrial enterprises, or they were forced to emigrate to other regions to find temporary jobs that offered low pay and no stability. One of the most serious consequences of such a policy was the breakup of the working-class family, whose subsistence now depended solely on improvisation and chance. The economic policies carried out by the government in the province of Tucumán constitute a sort of test or pilot experiment that aims to measure the degree of worker resistance, to seek the subsequent neutralization of union opposition, and to control its spread to other provinces with similar social and economic characteristics.

Operativo Tucumán has been strengthened further by Operativo silencio, sponsored by governmental organizations in an attempt to conceal, distort, and suppress information on the serious economic situation in Tucumán. Motivated by shared class interests, the so-called free press has joined the fight on the side of the government.

In order to fulfil their responsibility as intellectuals engaged with their surrounding social reality, the avant-garde artists responded to this Operativo silencio by executing 'TUCUMÁN ARDE'.

The work consists of the creation of an *overinformational circuit* that aims at denouncing the deceitful distortion of the events in Tucumán by a media dominated by state officials and the bourgeoisie. The various mass media are a powerful force of

communication and mediation that lends itself to very diverse appreciations of the events: the positive influence they have on society depends on the veracity and truthfulness of this subject matter. Governmental information about the situation in Tucumán represents an attempt to deny the seriousness of the social problems caused by the closing down of the sugar mills. By evoking a false image of economic recovery in the region, this misinformation blatantly contradicts the real facts.

To gather these facts and denounce the mendacity of the government, as well as the bad faith of the class that supports it, the group of avant-garde artists, along with technicians and specialists, travelled to Tucumán to verify the real social situation in the province. Their effort culminated in a press conference in which they made public in a violent way their repudiation of the government's actions and denounced the complicity of media in the maintenance of the degrading and shameful social conditions under which the working class of Tucumán found itself. Groups of students and workers collaborated with the artists in the promotion of the work throughout unionist organizations.

The group of artists went to Tucumán armed with documents on the province's real social and economic situation, as well as with a detailed study of the media information on these topics that carefully analyzes its degree of distortion and falsification of data. The next step consisted of organizing the information gathered by the artists and technicians to be presented at the Confederación General del Trabajo de los Argentinos [General Confederation of Labour of the Argentines]. Subsequently, the information prepared by the media on the artists' actions in Tucumán was added to the informational circuit in its first phase.

The second part of the work comprises the presentation of all the information on the situation and the artists in Tucumán to be aired in union assembly rooms, student centers, and cultural organizations, including the audio-visual performance at the CGT de los Argentinos in both its Buenos Aires and Rosario chapters.

The main objectives of the overinformational circuit is to carry out a process against reification that redresses the image of

Tucumán's reality produced by the media. This process will culminate in a third and final phase as it creates a third degree of information. All information will be gathered and formalized in a publication that will also offer a report on the work's conception and creation processes, along with the corresponding documentation and a final assessment.

The position adopted by the avant-garde artists prevented them from showing their work in the cultural institutions of the bourgeoisie. Thus, this show was presented at the CGT de los Argentinos, the organization that represents the class situated at the avant-garde of a struggle whose objectives are shared by the authors of this work.

<div align="right">

María Teresa Gramuglio

Nicolás Rosa

</div>

Participants in this work:

Ma. Elvira de Arechavala, Beatríz Balbé, Graciela Borthwick, Aldo Bortolotti, Graciela Carnevale, Jorge Cohen, Rodolfo Elizalde, Noemí Escandell, Eduardo Favario, León Ferrari, Emilio Ghilioni, Edmundo Giura, Ma. Teresa Gramuglio, Martha Greiner, Roberto Jacoby, José Ma. Lavarello, Sara López Dupuy, Rubén Naranjo, David de Nully Braun, Raúl Perez Cantón, Oscar Pidustwa, Estella Pomerantz, Norberto Púzzolo, Juan Pablo Renzi, Jaime Rippa, Nicolás Rosa, Carlos Schork, Nora de Schork, Domingo J. A. Sapia, Roberto Zara.

<div align="right">

Córdoba 2061 – 3–9 Nov. 1968

</div>

M36 Eduardo Costa

Useful Art Manifesto (1969)

After the Argentine revolution of 1966, artists began to explore how they could use their art to combat the repression and censorship of the new military dictatorship. The Argentinian artist Eduardo Costa (b. 1940), who was one of the founding members of the conceptual art group Arte de los Medios de Comunicación Masivos (M31), believed that art should not be elitist, but should serve society in some practical way. Between 1966 and 1971, Costa visited New York, where he belonged to the thriving 'happening' avantgarde art scene. As part of *Street Works*, an event organized by a group of poets and artists, he devised and performed a series of small acts of public usefulness together with the American artist Scott Burton on 15 March 1969. He recorded these performances in the 'Useful Art Manifesto', which he wrote in English. Costa's manifesto directly inspired the Cuban artist Tania Bruguera's Immigrant Movement International (M99), an activist art organization which agitates for the rights of migrants across the world.

* * *

On March 15, 1969, Eduardo Costa introduced the initial two works in his series *Useful Art Works*, as part of *Street Works* performed in N.Y.C. by a group of artists and poets.

The first of these works consisted of buying at his own expense and placing in the right place the missing metal street signs at the North East corners of 42nd St. and Madison Ave., 51st St. and Fifth Ave., 49th St. and Fifth Ave., 45th St. and Fifth Ave., 44th St. and Fifth Ave., and 51st St. and Sixth Ave. These new ones replaced only some

of the street signs missing in the area of midtown New York designated for the performance of *Street Works*. The signs read E 42 St, E 51 St, E 49 St, E 45 St, E 44 St, and W 51 St, and might be considered as a discontinuous literary work with six lines.

The second *Useful Art Work* consisted of painting the subway station at 42nd St. and Fifth Ave. on the Flushing line.

These art works were intended to attack the myth of the lack of utility of the arts, while being in themselves a modest contribution to the improvement of city living conditions.

Both *Works* were performed – with the help of Scott Burton – between 2:30 and 7:00 a.m., to avoid any problems involving the municipal laws. The second *Work* could not be finished.

E. C.

M37 The Casablanca School

Manifesto (1969)

In the early 1960s a group of artists in Morocco set about reforming the École des Beaux-Arts in Casablanca. Led by the college's director, the painter Farid Belkahia (1934–2014), and inspired in part by the Pan-Arabist movement – a generally secularist ideology devoted to the modernization and unification of the Arab-speaking world (see M41) – they became known as the Casablanca School. They opposed the Western art curriculum in schools, and sought to replace it with a new style that incorporated time-honoured elements from North African art, such as bold colour and Arabic and Berber calligraphy, and experimented with traditional natural materials like henna and leather.

Since Morocco gained its independence in 1956, the country had suffered political repression, human rights abuses and economic hardship. There had been little state support for the arts, either economically or politically. As a result, there were few exhibition venues available to artists in the country, other than the lobbies of predominantly Western-owned banks and hotels, or, as the manifesto below argues, spaces run by foreign embassies to further their own post-colonial agendas. None of them were easily accessible by the general public. In protest, the Casablanca School began, in 1966, to boycott the country's exhibition venues and display their artworks in local high schools and public squares.

In 1969, the group published a manifesto in the May–June issue of the radical leftist French-Moroccan journal *Lamalif*, in which they criticized the Moroccan government for the lack of public galleries and demanded better support for the arts. The 'organizers' the artists refer to in the first line of the manifesto are the Ministry

of Culture in Morocco, with whom the artists met to articulate their case for better investment after the success of their outdoor exhibition in Marrakech's Djemaa el-Fna square. The group's ideological commitment to public engagement, which also saw the introduction of an annual arts festival in Asilah, continues to influence artists, like Yto Barrada, who are working in Morocco today.

* * *

The fact that the organizers deem it necessary to unite artists around a body of work mirroring the current state of the arts in Morocco is an initiative which deserves our consideration. Beyond mere mundane dealings with the administration, never in the past have artists as a whole been recognized as a credible partner when reviewing the difficulties encountered by art in Morocco. In the aftermath of independence, a few painters sought to make contact with officials responsible for the fine arts, armed with proposals, but their ideas never took hold with the administration. Equally, the creation of the Society for Fine Arts could have brought to life an influential connection between artists and official policy makers within the fine arts administration, but this was in vain. We regret that the creation of the society came too late. That the fate of Moroccan art should continue to be in the hands of individuals who were incompetent, and that not a single panel including the artists most concerned should be involved, was aberrant enough. Throughout the existence of the fine arts administration, management errors and anomalies could also be observed – such as the annual exhibition of Moroccan painters, short-lived due to its poor management, which suffered from an absence of the sort of advertising campaign that typically goes hand in hand with such events, from a lack of the public relations that would have provided a rationale for its existence, and finally from the poor quality of the works exhibited.

Besides, a good number of artists chose not to take part in national and international exhibitions after their works were lost or simply disappeared. Officials never deigned to respond to complaints or compensate artists whose work ought to have been

insured as is common practice. For a lack of galleries and exhibition halls, artists were forced to exhibit in the buildings of foreign cultural missions, where the paternalistic approach to art that had defined the protectorate era was only reinforced. Worse still, in order to reach their audience at home as well as abroad, artists often had to accept the patronage of cultural missions.

Those cultural missions mostly favoured naive painting, which held sway in the aftermath of independence. This was essentially an extension of previous colonial policies which intended to impose on Morocco this form of painting as the sole artistic expression fit enough to represent local mentalities and sensitivities, thereby asserting/reinforcing that an underdeveloped country could only produce underdeveloped art. The fine arts administration followed suit, almost fostering this art form by providing a wide range of facilities to painters of naive art.

It should be noted here that the organization of exhibitions destined for abroad was deeply flawed: there was no proper panel to select the work – hence the poor representation of Moroccan art; hastily improvised preparations took no account of the actual location of those exhibitions; and, furthermore, no real contact was made with prominent international artistic bodies (such as biennales).

Whereas the above relates to the relationship between organizers and painters at the time, in terms of educating the youth and the masses at large through the medium of art, the management of the fine arts administration did not, in our opinion, assume all of its responsibilities.

Undeniably, education underpins any development of the arts and the achievements of pupils who have had no exposure to art are very low. Art and painting in schools must hold their own place alongside the teaching of history, and not be a recreational activity on the margins of the curriculum. Education in Morocco is patchy. Nothing prepares the Moroccan people to grasp the country's artistic creations or appreciate our artistic heritage. Young people's visual perception is not developed. The schools of applied art and academies of fine art were inherited from the colonial education

system and no review of the curriculum has ever taken place, resulting in a syllabus that is alien to the culture of our country. Unfortunately, the only state academy dedicated to art education (the École des Beaux-Arts in Tétouan) has been following the very same curriculum since the days of the protectorate, and is biased against our needs. The École des Arts Nationaux (Tétouan), which ought to play a crucial role in safeguarding traditional arts, suffers from being poorly managed.

The administrative departments regulating the fine arts have yet to provide those educational institutions with a curriculum that mirrors our current circumstances, our traditions and the need to decolonize our teaching. Nor have they tackled the issue of the training needed in order to improve the teaching. Indeed, several students who needed to complete their art-training course in schools abroad have been denied grants, which in turn has resulted in a tangible gap in competent leadership.

Since the protectorate, the establishments we call 'museums' have been turned into storage depots. No attempts have been made to grant them their true function: to inform and educate. We feel that museums should be places where vibrant programmes allow for a better diffusion of the arts. The popular arts are currently depreciated, misunderstood, known only superficially and often confused with poor quality handicrafts. Museums could play a part in raising the profile of popular art, and the presence of artists would facilitate this.

A great proportion of historical monuments in our national heritage need protection and maintenance. Making an inventory and saving our patrimony (both monuments and exhibits) has now become an urgent need. The fine arts administration will have to take effective steps to regulate the export of works of art – such laws are commonly enforced in most countries.

These national issues demand the creation of a dedicated council for the arts. This council would comprise experts, historians and critics, painters, sculptors, architects and town planners, sociologists and writers. The council's mission would be to:

- devise and ensure the application of a policy of the arts
- write up an inventory and ensure the protection of our national heritage, past and future, and its preservation
- monitor the quality of art
- create new policy for art galleries and national museums
- consider creating a museum of modern art in the future
- organize and deliver all national and international artistic events
- devise and monitor a policy on the teaching of art in high schools and art colleges
- ensure the application of a policy aiming to give Moroccan artists a stronger voice in both public and private sectors (in architecture, graphic design and advertising).

In organizing an annual national exhibition, we should not discard the criticisms and considerations entertained above.

With regards to the creation of a new institute of modern art, we propose that a commission be authorized to carry out the project, following consultation.

M38 Hori Kōsai

Why Are We 'Artists'? (1969)

By the late 1960s, artists in Japan had shifted away from the material-based 'anti-art' (*Han-geijutsu*) and had begun to embrace the conceptual 'non-art' (*Hi-geijutsu*). Based on the theory of 'institutional critique', it questioned the relationship in art between the subject, the object and the place where it was exhibited. Among those most strongly influenced by these ideas were a cluster of radical art and political groups known as Bikyōtō, from the Japanese phrase *Bijutsuka Kyōtō Kaigi* (literally, 'Artists' Joint-Struggle Council').

Founded in 1969, by students staging a ten-month-long occupation of Tama Art University in Tokyo during a period of profound social activism in Japan against undemocratic policies, Bikyōtō argued that art needed to get out of the museum and become part of everyday life. Their leader, Hori Kōsai (b. 1947), wrote 'Why Are We "Artists"?' during the occupation, and distributed it as a flyer on 20 July 1969. An excerpt is printed below.

* * *

Conceptually, the most problematic part [about our name] was the word 'artist'. To Bikyōtō, this, of course, is not just a matter of a name but involved the most basic theoretical problem. If we understand ourselves through the normative label of 'artist', which is a product of the establishment, then we will not be able to initiate any sort of fundamental interrogation. So long as we confine ourselves to the position referred to as 'artist', our critique will never go beyond the technical aspect of the 'how' or beyond simply reforming individual things around us. This must be our point of departure.

This expression of the 'how' threatens to alienate our creative activity. We seem to be living in an age in which we are confined to different individuated places and separate genres, and our inquiries will lead nowhere. Only by pointing toward a change in kind will we achieve liberation of the individual and our own creative expression. Then why are we 'artists'? For us, this is a question of our battleground. There is no reason for us to remain as artists, since we could put ourselves in any place. And the interrogation has to come from us – that is, before the naming. But can we escape the 'name'? Living in this world as we do, the only way for us to wage a concrete battle is to use this given name to our advantage. Today, if we are called artists, then that is our battleground. Other basic conditions have been confirmed, including that our battle is staked on this place of ours, which encompasses everything – meaning that this is a battle that cannot be compartmentalized. It is not an art movement or a movement relying on political shock tactics and abstract ideas. Furthermore, this is not a battle where current values are confronted by opposition, but a fight that brings forth something in the abolishing of the present condition and gives rise to our own creative expression.

M39 The Organization of African Unity

Pan-African Cultural Manifesto (1969)

The essence of the ideology of Pan-Africanism, which had its origins in the mid-nineteenth century, was a belief in the racial solidarity of Africa and its diaspora: all African peoples needed to unify under the banner of race in order to achieve their potential. The hope was that this would foster a sense of racial pride and identity that would overcome the legacies of slavery and colonialism and help solve the continuing problems associated with racial discrimination against those of African race and heritage.

Between 21 July and 1 August 1969, the first Pan-African Cultural Festival was held in Algiers. Four thousand artists from all over Africa and its diaspora came together to promote the idea of a single African cultural consciousness, denounce colonialism and continue the fight for freedom from external oppression. For the next ten days, artists, poets, writers, musicians and intellectuals performed, debated, exhibited art and collaborated in a highly creative atmosphere. The choice to stage the festival in Algeria was significant; its eight-year struggle for independence had been brutal, with countless atrocities. It had also been the adopted home of anti-colonialism's most articulate voice, the Caribbean philosopher and psychiatrist Frantz Fanon. His revolutionary analysis of the Algerian War of Independence in *The Wretched of the Earth* (*Les Damnés de la terre*, 1961) became an essential text of the black liberation movement and inspired many later manifestos, including that of the Senegalese group Laboratoire AGIT'art (M78) and the British artist Rasheed Araeen's 'Preliminary Notes for a BLACK MANIFESTO' (M59).

The festival's participants, who included members of the Organization of African Unity (OAU), used Fanon's writings to

challenge the prevailing Négritude philosophy (M7), which they believed to have a Western bias. Their manifesto, a substantial extract from which is featured here, was published as part of the festival. Among other things, it called for a black culture that would support the development of a brave, new, modern Africa, and hasten the achievement of continental unity.

<p style="text-align:center">* * *</p>

Introduction

Taking as a basis for study, reflexion and discussion the inaugural address by His Excellency, Houari Boumediene, President of the Revolutionary Council, President of the Council of Ministers of the Algerian People's Democratic Republic and Acting Chairman of the Conference of Heads of State and Government of the O.A.U., the Symposium of the First Pan-African Cultural Festival held in Algiers from 21 July to 1 August 1969 fully discussed the theme of the Symposium, i.e.:

the realities of African culture;

the role of African culture in national liberation struggles and in the consolidation of African unity;

the role of African culture in the economic and social development of Africa.

I. Realities of African Culture

Culture starts with the people as creators of themselves and transformers of their environment. Culture, in its widest and most complete sense, enables men to give shape to their lives.

It is not freely received but is built up by the people. It is the vision of man and of the world and is thus systems of thought, philosophies, sciences, beliefs, arts and languages.

It is likewise the action of man on himself and on the world to transform it, and thus covers the social, political, economic and technical fields.

Culture is essentially dynamic: in other words it is both rooted in the people and orientated towards the future.

We must go back to the sources of our values, not to confine ourselves to them, but rather to draw up a critical inventory in order to get rid of archaic and stultifying elements, the fallacious and alienating foreign elements brought in by colonialism, and to retain only those elements which are still valid, bringing them up to date and enriching them with the benefits of the scientific, technical and social revolutions so as to bring them into line with what is modern and universal.

Colonialism is an evil that has been experienced and endured by all our people, first in its most distinctive form, the slave trade, which devastated almost all the African continent, and in its most tangible and insolent form, political domination, over which we must strive to triumph.

But its machinery is complex and cannot be simplified into a single operation. It is a well-known economic, social and political fact that colonialism is a total action, both in its essence and its spirit.

In order to survive it has to justify itself morally and intellectually by force and coercion to extend its hold over all fields of human activity.

In order to exist as such, it must exercise a social and intellectual hold in addition to its concrete and material hegemony.

Thus it manages to achieve what it believes to be the perfect synthesis and, consequently, thinks that it can challenge men with impunity and destroy their very essence.

We believe, we spontaneously feel, that liberty is one and the same as nationhood, and that the welfare and progress of our peoples have to be achieved around our specific personality. We naturally accept that liberty, nation, personality and, eventually, universality are but the product and origin of culture.

Culture is the essential cement of every social group, its primary means of intercommunication and of coming to grips with the outside world; it is its soul, its materialization and its capacity for change.

Thus culture is the totality of tangible and intangible tools,

works of art and science, knowledge and know-how, languages, modes of thought, patterns of behaviour and experience acquired by the people in its liberating effort to dominate nature and to build up an ever improving society.

An imposed culture generally bred a type of African intellectual not at home in his national realities because of his depersonalization and alienation.

The African man of culture, the artist, the intellectual in general, must integrate himself into his people and shoulder the particularly decisive responsibilities incumbent upon him. His action must inspire that revolution of the mind without which it is impossible for a people to overcome its economic and social underdevelopment. The people must be the first to benefit from their economic and cultural riches.

Culture is experienced by the people through concrete experiences and expressions tied to history. Consequently, corresponding to this culture as far as we are concerned, there is an Africanity of specific expressions. Africanity obeys the law of a dialectic of the particular, the general and the future, of specificity and universality: in other words, of variety at the origin and starting-point and unity at the destination.

African culture, art and science, whatever the diversity of their expression, are in no way essentially different from each other. They are but the specific expressions of a single universality.

Beyond similarities and convergent forms of thought, beyond the common heritage, Africanity is also a shared destiny, the fraternity of the liberating struggle and a common future which should be assumed by all in order to master it. Africanity springs from the double source of our common heritage and our common destiny and that is why it is worthwhile, at the present stage of our historical development, to examine a number of problems linked with the origin, the existence and the development of our culture.

Culture is a dynamic means of edifying the nation over and above tribal or ethnic divisions and African unity above all forms of chauvinism. Culture, which is created by the people, may be confiscated by a dominating class. Now culture should be a

constant search for the people's creative consciousness. Any African cultural policy should therefore be based on the necessity of enabling the people to become informed, educated, mobilized and organized so as to make them responsible for their cultural heritage and its development. The preservation of culture has saved Africans from the attempts made to turn them into peoples with no soul or history.

Culture protected them. It is quite obvious that they would henceforth wish to use it to forward their progress and development, for if culture – a permanent and continuous creation – is a definition of personalities and a link between men, it also gives an impetus to progress. This is the reason why Africa devotes such care and accords such value to the recovery of its cultural heritage, to the defence of its personality and the creation of new branches of its culture.

It would have been easy for certain people and convenient for others if we had not set out conditions for our political independence – we could have been satisfied with merely that and have borrowed thought, language and art from those who had the good fortune to enjoy a harmonious internal development. We might have also been satisfied with a folkloric cultural past, a poor man's culture, and have given up all thought of true freedom and real independence. But the colonized peoples have never given up their inner identity.

In this, the national language plays an irreplaceable role, it is the mainstay and the medium of culture, the guarantee of popular support both in its creation and its consumption.

Once we had recovered our sovereignty, it was a first essential duty for us to revive the national languages inherited from our forefathers, without in any way calling to question the profound unity of our nations.

Language is one of these features in the life of peoples which embody their genius. It develops with them, and they cannot be deprived of it without being cut off, wounded and handicapped.

Nevertheless, and in order to survive and fight, some of our peoples had to learn the language of our colonizers.

There is no one language which is basically more suited than another to be a mainstay of science and knowledge. A language translates and expresses the lives and thoughts of men. From the time when our development was suspended, our cultures trampled underfoot and the teaching of our languages often forbidden, it has been obvious that we must double our efforts to make African languages efficient instruments for our development.

The analysis of our cultural realities reveals to us the dynamic elements in the life of peoples, in both their spiritual and material aspects. Among these elements which make up our indomitable African personality, we should emphasize these values which have come down to us in spite of the vagaries of our history and the colonialist attempts at depersonalization. From them can be abstracted a sense of ethics revealing a profound inborn sense of solidarity, hospitality, mutual aid, brotherhood and the feeling of belonging to the same humanity.

These values and this sense of ethics are to be found expressed in our African languages, in our oral and written literatures, in our tales, legends, sayings and proverbs, transmitting the wisdom and experiences evolved by our peoples. Our African cultures, media of knowledge and spirituality, are an eternal source of inspiration for our arts and letters. Our artists can draw from them dynamic themes in which our peoples will recognize themselves.

The knowledge of our history will scientifically establish the bases of our personality and will thus be a factor for progress, enabling us to measure our limitations and to assess our possibilities.

The modes of organization of African society can teach us lessons which will enable us to be ourselves whilst at the same time taking our place in the modern world.

The inventiveness of our techniques would suffice to show our creative potentialities.

Our cultural existence and presence are proven by our arts, paintings, sculptures, architectural styles, music, songs, dances and drama.

This culture, for a long time condemned by colonialism to exoticism or confined to the solitude of museums, asserts itself today as

a living expression of the modern world. This world in which we seek to have a place, this future which it is our duty to construct, are dominated by problems of development and progress.

We must re-emphasize that our culture would be ineffective if it took no account of contemporary science and technology. It therefore sees itself as a personal and original contribution within a single, constant and dynamic movement towards progress and social revolution.

II. The Role of African Culture in the Liberation Struggle and African Unity

It is the duty of African States to respond to total colonization by a total struggle for liberation.

The unity of Africa is based first and foremost on history. Under colonial domination the African countries were in the same political, economic and social and cultural situation. Cultural domination led to the depersonalization of a part of the African people, falsified their history, systematically denigrated and opposed their religious and moral values and made a progressive and officially sanctioned attempt to replace their language by that of the colonizer in order to devitalize them and to deprive them of their raison d'être.

Consequently, at the level of the masses, African culture, impeded in its development, found a refuge in its language, in its customs, songs, dances, beliefs and so on . . . And in spite of its diminution, it proved to be an essential bulwark of resistance to colonial intrusion and thus illustrated the perenniality of the African soul.

Colonization favoured the creation of a cultural elite won over by assimilation, which had had access to the colonial culture, and both supported it and often stood guaranty for it. Thus a serious and profound rupture came about between the African elite and the African masses.

Only through adhesion to the concepts of freedom, independence and the nation could the conflict be placed in its proper

context. The transcendence of cultural duality was made possible by the liberation movements, the wars of independence and the firm and unshakeable opposition to colonial subjection. Africa's combat provided the material and spiritual framework allowing the further development of African culture, thus attesting the natural dialectical interaction between the national liberation struggles and culture.

For the African countries which won their freedom and for those that are in armed conflict with the colonial powers, culture has been, and will remain, a weapon. In all cases, armed struggle for liberation was, and is, a pre-eminently cultural act.

The experience of liberation movements shows that the integration of the intellectuals into the masses gives a great authenticity to their work and vitalizes African culture.

Both the winning of true independence and the armed struggles still in progress have permitted a cultural renaissance. The fight for freedom, in all its forms, has logically become the constant factor of cultural Africanity. Thus Africanity is a reality deriving essentially from men born of the same land and living in the same continent, bound to share the same destiny by the inevitable process of decolonization at all levels and complete liberation, notwithstanding regional or national specificities.

Because it is involved in the same struggle, because it is a prerequisite of national and continental liberation – in a word, because it is the primary and final motive of man and because it alone is likely to constitute the first basis of resistance to threats hanging over Africa – Africanity goes beyond national and regional concerns.

Africa's present necessities require from artists and intellectuals a firm commitment to Africa's basic principles and its desire for freedom. Today's cultural act should be at the centre of today's strivings for authenticity and for the development of African values.

The cultural policy of neo-colonialism calls for an objective and concrete critical analysis of our present cultural situation. Neo-colonialism, aware of the still negative aspects of this situation, has

conceived a new, well-concerted form of action which, although no longer violent, is no less ominous, dangerous, subtle and insidious as it is for the development and future culture of Africa.

Real dangers are menacing our culture as regards both the perpetration of alien norms, and that of mental prototypes of institutions and political life.

A cultural front should therefore take the place of the front of resistance, for culture remains the vital and essential force of the nation, the safeguard of our existence and the ultimate resource of our combat. Therefore only Africanity can bring about a resurrection and a rebirth of an avant-garde African humanism, confronted by other cultures; it will take its place as part of universal humanism and continue from there. Our artists, authors and intellectuals must, if they are to be of service to Africa, find their inspiration in Africa.

Complete independence is thus the basic condition for the development of culture in the service of the masses.

III. The Role of Culture in the Economic and Social Development of Africa

Heirs to a civilization that is thousands of years old and rich in untold economic possibilities, we stand ready today to continue in the total recovery of our personalities, the struggle that won us our independence.

The assertion of our profound identity and the utilization of our material riches for the good of the people will enable us to participate actively in the building of a universal civilization as freed and free partners.

Culture, simultaneously representing a style of life, an economy and social relationships determined at a particular moment in human evolution, forms a totality with political life. As a permanent and continuous creation and the expression of the perenniality of a people, African culture definitely intends to put itself to the service of the liberation of Africa from colonialism in all its forms and from all forms of alienation, and to serve the economic and

social betterment of the people. Safeguarded and experienced by the people, it becomes a motivating element in social and economic development and a factor in the transformation of the environment.

A society or a culture can stay itself while undergoing economic development, providing it takes the necessary steps.

A place must necessarily be made for science and technology as it must for economic rationality, the need to look ahead and other prerequisites of our age. This is because no culture is passively operative. In order to give its resources to aid development, it must be revived and brought up to date by contact with technology which tends to create a universal civilization. A society should both retain its essential being or else crumble away, and its usefulness, or lose its existence and autonomy. It perseveres and adapts itself by a continuous dialectic effort of giving and contributing between national culture and universal values.

Moreover, it is absolutely necessary to watch over the defence and preservation of African dignity and personality. But this looking back or constant reference to the living sources of Africanity must avoid a complacent and unfruitful evocation of the past, but must, on the contrary, imply an innovating effort and an adaptation of African culture to the modern requirements of well-balanced social and economic development.

The following objectives must be adopted: free African society from the socio-cultural conditions hindering its development; rid African culture of alienating factors by integrating it, in particular, with popular action.

African culture, faithful to its origins, must be revived and brought into the modern world by contact with science and technology in order to develop its operative capacities for, while technology progresses by accumulation, culture progresses by creation and fidelity. All means of doing this should be set in motion.

Africa must recover from a delay which is primarily cultural. This entails:

a) a change in attitude towards the material world, towards quantification and scientific rationalism. The role of education may

have a determinant, beneficial or baneful influence according to the importance one attaches to technical instruction;

b) the movement of political power towards a genuine revolution in the climate of opinion;

c) the combined effort of members of the community which will only be possible if the citizens really take their future into their own hands in an atmosphere of freedom and happiness.

In addition to Arabic, which has been for some years an official language of the O.A.U., it is recommended that studies be undertaken to promote the use of other widely-spoken languages.

The immediate tasks impingent upon all of us are to turn African languages into written languages and the medium of scientific thought, and to bring about education, adult literacy and the emancipation of women.

Any delay in the reorganization of the present educational system will result in a delay in the training of responsible cadres and this justifies the continuation of foreign technical and cultural aid. We must get out of this vicious circle as quickly as possible as this aid, if prolonged, could turn into a scarcely disguised form of domination.

The principal aim of higher education is to form the trained personnel needed for both economic and cultural production, and these people need to make themselves understood by both the workers and the masses. This higher education should, then, wherever possible, be given in the national language. These tasks will be all the better carried out by being supported by mass information media belonging to Africa (radio stations, T.V., cinemas, theatres and cultural centres in factories, offices, etc.) and by an increase in the number of cultural events and exchanges.

These values will enable us to face, without frustration or alienation, the inevitable social transformations entailed by the process of development. We must use those that can contribute to economic progress and the mobilization of the masses, so as to arouse the enthusiasm needed for major collective effort.

In this gigantic effort to recover Africa's cultural heritage and adapt it to the needs of technological civilization, the artist, the

thinker, the scientist and the intellectual have all their part to play, i.e. to contribute, within the framework of popular action, to revealing and making known the common inspiration and common heritage which go to make up Africanity. Generally speaking, Africa must return to its original modes of perception, its techniques, its communication media and bring them up to date so as to turn them into powerful means of dominating Nature and of harmonizing the development of African society.

Likewise, we must avoid the obstacle of the academic and futile search for a dilettante culture leading to unproductive and decadent aestheticisms.

We should therefore take systematic and appropriate measures to imbue our youth with African culture so that the young people of our continent may understand its profound values and be better armed to resist certain demoralizing cultural manifestations, and be better prepared to become integrated into the masses.

In this way, African culture, true to itself and drawing strength from the deep sources of its wealth and of its creative genius, not only intends to defend its personality and its authenticity but also to become an instrument in the service of the people in the liberation of Africa from all forms of alienation, an instrument of a synchronized economic and social development. It will thus bring about the technico-industrial promotion of the African, and also a living and fraternal humanism far removed from racialism and exploitation.

Culture, as a decisive force in economic and social development, constitutes the surest means for our peoples to overcome their technological (i.e. economic) handicap and the most effective force in our victorious resistance against imperialist blackmail.

It has become now both urgent and necessary to free Africa from illiteracy, to promote the permanent education of the masses in every field, to develop in them a scientific, technological and critical spirit and attitude, and to render popular culture fully effective.

All our efforts should be directed towards a true revolution in Africa's cultural activity.

The popular character of our culture should promote a specific conception of scientific organization and the rationalization of our productive activities, as well as the methods of appropriating the means of production (land, natural resources, industry, etc.) and the distribution of the goods produced.

Africanity should be apparent in a concrete and tangible manner in the joint use of our national forces and natural resources to promote a harmonious and accelerated economic, social and cultural development throughout the continent.

M40 Agnes Denes

A Manifesto (1969)

The American conceptual artist Agnes Denes (b. 1931) is one of the pioneers of the ecological and environmental art movement. Having worked in poetry and fine art, she proceeded to abandon painting for an ecologically conscious form of art in the late 1960s, having realized that humanity was in trouble. 'I left the ivory tower of my studio and entered the world of global concerns,' as she succinctly put it. While the practice of the land art movement became increasingly invasive, bulldozing estuaries and digging up parking lots, Denes forged a solitary path, working with scientists and creating art that confronted the coming reality of global warming; as a result, her work can be seen as a forerunner to the current research-based investigations of Marko Peljhan (M92). Denes came to worldwide prominence in 1982 when she planted a wheatfield in a four-acre wasteland near Wall Street, in New York. The photograph of Denes, holding a staff, surrounded by waving golden wheat, in an invaluable patch of real-estate overlooked by the Manhattan skyline, has become a defining image of environmental art. Other works have included the planting of 6,000 trees of an endangered species in Melbourne, Australia to alleviate erosion.

In 1969, Denes wrote herself a philosophical manifesto which she intends to live by.

<p style="text-align:center">*　*　*</p>

Working with a paradox
defining the elusive
visualizing the invisible

communicating the incommunicable
not accepting the limitations society has accepted
seeing in new ways
living for a fraction of a second and penetrating light years
measuring time in the extreme distances –
long before and beyond living existence
using intellect and instinct to achieve intuition
striving to surpass human limitations by searching the mysteries
and probing the silent universe, alive with hidden creativity
achieving total self-consciousness and self-awareness
probing to locate the center of things –
the true inner core of inherent but not yet understood meaning –
and expose it to be analyzed
being creatively obsessive
questioning, reasoning, analyzing, dissecting and re-examining
understanding that everything has further meaning,
that order has been created out of chaos.
but order, when it reaches a certain totality must be shattered by
new disorder
and by new inquiries and developments
finding new concepts, recognizing new patterns
understanding the finitude of human existence and still striving to
create beauty
and provocative reasoning
recognizing and interpreting the relationship of creative elements
to each other:
people to people,
people to god,
people to nature,
nature to nature,
thought to thought,
art to art
seeing reality and still being able to dream
desiring to know the importance or insignificance of existence
persisting in the eternal search

M41 The New Vision Group

Towards a New Vision (1969)

In the late 1960s a vibrant art scene emerged in Iraq. The socialist Ba'ath party, which had assumed power after a revolution in 1968, soon established a lively, well-supported cultural system, creating museums, art festivals and touring exhibitions in order to promote the ideology of Pan-Arabism – a predominantly secular, transnational, political and cultural movement devoted to the unification and modernization of the Arabic-speaking world.

This flourishing gave rise to several artist associations, one of the most influential being the New Vision Group (*Al-Ru'yya al-Jadidah*). Founded in 1969 by the artist Dia al-Azzawi (b. 1939), who co-wrote the manifesto with Rafa al-Nasiri, Muhammad Mahr al-Din, Ismail Fattah, Hashem Samarji and Saleh al-Jumaie. The group espoused ideas of Pan-Arab unity and called for a new Arabic modernism, one that connected artists ideologically and culturally rather than stylistically. As the second generation of pioneer modern artists – the first being those associated with the Baghdad Modern Art Group (M12) – they recognized the importance of taking an active role in building a new society; yet, having lived through a period of extreme political turmoil, they were cautious of the new regime, advocating an artistic vision that served humane ends. Their apprehensions turned out to be well founded. The brief blossoming of the arts in Iraq soon wilted as the Ba'athist regime evolved into a dictatorship. The group disbanded after their last exhibition, in Beirut, Lebanon, in 1972, and Dia al-Azzawi moved to London in 1976.

The New Vision Group's Arabic manifesto argues that the artist must live in a state of constant sacrifice and they refer to the

seventh-century Sufi mystic Mansur al-Hallaj, who most famously said 'I am the truth', and exhorted his followers to find God within their souls. The manifesto was first published in a Baghdad newspaper at some point in 1969, and then collected in *Al-Bayanat al-Fanniyya fi al-Iraq* (*Art Manifestos in Iraq*) by the artist and writer Shakir Hassan al-Said (M12, M52) in 1973.

<p style="text-align:center">★ ★ ★</p>

There is an internal unity to the world that places the human within a non-visible position towards it. There is no doubt that contemporary consciousness is nothing other than a process of discovering the essential identity of the human on the one hand, and of civilization on the other.

If our current stage of civilization is the inevitable outcome of humankind's previous discoveries and surpassing of his external world, then actual existence will only be realized through a living movement that rejects any ultimate purpose for existence. The presence of an object lies in its continuing evolution and constant change. Since the continuity of exploration has become an intrinsic characteristic of the conscious man, the contemporary artist has refrained from presenting the world as something stagnant and incapable of change. As such, its mystery drove him to take interest in discovering the true essence of things, and he has placed himself in confrontation with the great challenges of the external world, demonstrating his capacity to transgress the limits of appearances that nature and social relations force upon him in the domain of experience.

If the primitive peoples endowed art with magic, and the Greeks ascribed to it the study of beauty, and the medieval era expected art to reinforce the realm of faith, our civilization makes of it a human practice undertaken by one who lives in constant contact with the world, using it to present a human existence laid bare before the truth, and thus bringing about a different form of relationship between the contemporary human and the world.

Art is the practice of taking a position towards the world, a continual practice of transgressing and discovering human interiority

from within change. It is a mental rejection of all that is wrong in the structure of society, and thus becomes a practice of constant creation, by which it offers to human existence its own independent world, composed of line, colour and mass. In this way, rejection and resistance – not in their absolute form – become two indispensable presences for the continuous practice of innovation.

The artist is a fighter who refuses to put his weapon down as he speaks in the name of the world, and in the name of the human. He lives in a state of constant sacrifice towards his world, expressing a burning desire to denounce the masks of falsity, and so he always owns what he wishes to say. The unity of artistic production throughout history places the artist at the centre of the world and at the focal point of the revolution. Change and transgression are two faces of a conscious challenge to all the regressive social and intellectual values that surround his world. A true artist is one who affirms his refusal to fall captive to a mummified body of worn-out social values. Instead, he must rise against the world so that he finds himself on the opposite side, from where he is able to judge it. At the centre of the revolution, he rises above any ready-made givens, transforming himself into another Hallaj, standing against injustice and intellectual servitude. The artist is a critic and revolutionary, negating the world around him.

The presence of the revolution confronts him with the spirituality of self-annihilation and sacrifice as he explodes the fallacies of the past and present, and seeks to restructure the world within a new artistic vision. The closure of the self, and the commodification of art, is the result of a superficial view of the world. The rejection thereof will not be realized except by continuous change so that man is rescued from the crushing effect to which his material and social relations subject him. As such the artist's task is to place these relations in human terms, so that they develop and grow with new discoveries and successive modulation; his task is to bring a lasting end to previous forms of thought and relation, so he may grow anew. For the new always has its own vision, and its own voice. Unity with the new will not be achieved except by engaging it in terms of that vision and voice.

An artist grounds his justifications for human existence in nature. Alongside the historical dimension of existence, he grants it a human one, such that, by the legitimacy of his existence, he acquires the possibility of creating history or inventing it once again. For when he brings, on a one-dimensional surface, his own unique world into existence, he is presenting to the world a truth which, at first, appears not to exist. Through his creative capabilities he gives that truth a presence in the world of light so that it may help us uncover some of the hidden aspects of our lived experience – those that cannot otherwise be revealed in mental perceptions.

Artistic vision is only one of the images we use for our internal and external world, but an artist draws on that vision in order to secure the foundation of that world, which he wishes to build anew. Thus, the artwork is a manifestation of the emergence of the artist's world into public existence. A good artist is one who realizes the greatness of uniting with others through his artistic production. For an artist who relates to art as production only, and who produces work as a commodity, cannot be a historical witness to the human capacity to create. He cannot become an authentic artist so long as he is a Trojan horse carrying inside him the body of a dead society.

The artist lives the unity of all periods of history, even while he lives in his time, and as a part of his own society. As much as he feels that he must change the past through contemporary vision, he also feels that the past orientates the present, that between the past and the present there is unity and coexistence. For if artistic vision is presence realized in the painting, and this presence is a self that is anxious to search for a civilizational identity, then legend and historical sensibility are the means by which the artist will arrive at his new world. It is a return to the singular self, in which he may either live or die. For we die in the unity of our human and civilizational selves, and it is through the unity of that self that we begin the journey of change and creation. We find no artistic generation among the generations of our nation that lived its whole life demanding this, as we now do. No generation was as immersed in the spirit of homeland and humanity, with such urgency, as ours is. We are

continually called to challenge and confront all the threats to the homeland. We live in the midst of a vortex of the military advances of a new Nazism. Our existence is always under threat. We work for the sake of clarity and the call for an avant-garde art that integrates its humanist goals with a new artistic vision. And we shall continue to be a generation which brings its spirit to these challenges with urgency, making art not a means of seclusion in individual existence or immersion in one's private world, but rather a vision directed to the world by a tacit language articulated by the artist in his own way. This rejects any mechanical understanding of art and its role in society that limits the artist to what is readily available within the restrictions of existing relations. The processes of obliteration that social relations have enacted upon the artist, and which at times made him a bearer of masks of fakeness and subservience, and at other times a victim, cannot retain their legitimacy, nor prevent us from extending our perceptions beyond things.

Let us be the vanguard of the challenge. We want to be nothing but the artists who carry the spirit of homeland and humanity. Be with us so that we unite the new vision of the world. Grant it the aggressiveness and rebellion of youth, transforming academic halls into strongholds of change, so that we may have an independent painting of transgression – the painting which shakes our depths, tears through falseness, opens the river of life in our society.

There shall be no presence of such painting nor building of a new vision, except by a plunge, by a work of creation, by a civilizational, humanist, creative self – the repository of human creation.

Let us remember our art in the lands of Mesopotamia, Syria and the Nile, and let us reject the world of rigidity and imitation. Let us construct a permanent and honest relationship with our generation.

We must tear apart heritage so that we recreate it.

We must challenge it in order to surpass it.

We must recognize it, within the confines of its museum existence, and recognize the aggressiveness and fierceness of the encounter. Let us unite in our souls a desire to surpass. We will not be ripped from our roots, but rather extend them deep into the land – a

depth of reach, of honesty, filled with vivid life. So long as we hold a free stance towards it, heritage is not dictatorial art that drags us in and locks us inside of itself. It is that malleable dough worked by the hands of the creating artist. We will not traverse our heritage with fear of slavery; rather we shall place it on our foreheads so that we may wade through the world, speaking in the new language of life, using its symbols, its new humanity. We carry the spirit of incursion, a spirit of rebellion that tears all ossified things apart, so that we may return from our journey bearing a new vision.

We are the generation that demands change, transgression and innovation. We reject the embalmed past.

We reject the artist of divisions and boundaries. We advance. We fall. But we will not retreat. We present to the world our new vision:

- Modern art is the language of contemporary society. The artist is the human being in this society who is capable of transgressing the boundaries of the contemporary self, to adhere to a purity that is free of all the prejudices of modern civilization, in an effort to affirm the innovative existence of this national community through art. Those who reject this language are the living dead.
- Freedom of expression is the freedom of the revolutionary against everything that turns thinking into a muddy quagmire. It is freedom of vision, of rebellion against all of society's false constructions.
- Art is every novel innovation. It is incompatible with stagnation; is continuous creation. As such it is not merely a mirror of the artist's lived reality, but also the spirit of the future.
- Good art criticism is that which delivers the artistic endeavour to the public and strengthens the features of the actual art movement, moving away from a spirit of appeasement and adulation. Between criticism and art there is a process of correlation and complementarity. As such, criticism's failure to keep pace with developments is a severe blow to the evaluation of the plastic art movement and its growth.

- The past is not a dead object that we study, rather it is a stance that goes beyond time to produce comprehensive human evidence of both plastic and psychological aspects together. Thus, the significance of the past is seen and renewed in light of the present. To consider the past as a fixed vision is but a ruse aimed at freezing contemporary experience in moulds that history has already worn out. As such, the whole of national and human heritage becomes a tributary throughout our journey of change and innovation.

- The issue of the relationship with the public is a social one. Our artistic production is what interacts with the public, not us. As such, the street, and not the museum and galleries, is the true site of adhesion.

- We reject social relationships that lead to deceitful masquerades, and we reject things that are given to us as charity. We justify our existence through our journey of change.

- We laud the generation of pioneers for their historic role in our artistic renaissance, and we reject academic guardianship and instructional thinking.

- We defy the world. And we reject the military and intellectual defeat of our nation. We glorify the popular war of liberation in the chests of the martyrs, the glory of our nation.

- Revolution is the transgression of negative values and the crystallization of the spirit of the future. As such, it is the maker of the new human – the liberated human who surpasses his own existence in the path of realizing his individual human essence. Art is the bright face of that human, for revolution and art are two inseparable features of humanity's development.

- The practice of art is contingent upon man's practice of his human essence, and the best thing the revolution can do for the human artist is to provide him with the means to implement this essence, rejecting a lagging existence and dead relationships. For, the revolution that transgresses and makes the revolutionary paradigm is also an astounding future-oriented art, through which the new vision is realized.

M42 Grupo Vértebra

The Vértebra Manifesto (1970)

Between 1960 and 1996, the Central American nation of Guatemala was nominally a democracy – people had the right to organize, speak and protest – yet in reality it was in a state of civil war, ruled by a series of brutal military governments, who used death squads and torture to maintain order. Revolutionary (and counter-revolutionary) fervour pervaded every aspect of life, together with a deep desire to find a solution to the bloodshed.

In March 1970 the literary monthly magazine *Alero*, published by the Universidad de San Carlos de Guatemala, printed a manifesto written by the semi-figurative artists and teachers Marco Augusto Quiroa (1937–2004) and Elmar René Rojas (b. 1942) and the artist and social historian Roberto Cabrera (1939–2014) under the collective name Grupo Vértebra. The group's title alluded to their desire to create an aesthetic spine running through the countries of Central America, culturally uniting the artists of Guatemala, El Salvador, Nicaragua, Honduras and Costa Rica. They promoted collage and a technique called 'matter painting', in which paint was mixed with sand, shells and mud to create texture. Additionally, they believed that it was not enough to embrace the region's indigenous Maya heritage in the wake of post-colonialism; they also had to draw attention to the contradictory realities of everyday life in contemporary Guatemala.

As the civil war in Guatemala worsened, the group disbanded when Cabrera left the country for Costa Rica. Yet their aesthetic and social radicalism, which sought to challenge the political situation in Guatemala, continues to influence artists in the country today.

* * *

Straddling myth and legend, uncertainty and fear, science and fiction, technique and progress, reason and barbarism, abstraction and nature. Aware of our own truths, and of everyone else's. Deeply embedded in the century of military hells and of the atomic pandemic. Haunted permanently by others that have yet to come. Stirred by futures that herald themselves. And in the certainty that the art and the language we create will stand the test of time.

Of all the expressive possibilities in contemporary visual arts, we are most interested in the one rooted in a new humanism. The one that has found its way back on to the lost path and submerged itself in the communion and vitality of man, as the measure, the impulse and the fire of creation. Amid the century's anxiety and existential tentativeness, we are interested in the environment that moves us, stirs us and leaves in our hands the salt of our final tear and the ember of our first cry. Alongside the agitated and terrible transcendentalism of the gothic world we seek ourselves in the labyrinth of contemporary torment. Our own, and that of others. The one where we hung up our inheritance, which we now unhang and integrate into our latent circumstance. The one just beyond our reach, the one that can only influence us when we reveal our certainties. Because we stand by a body's external forms in opposition to a computer's mechanical, cold and impermanent design. Instead of the scientific functionality that envelops us, we extol the constancy and the expansion of our essence.

Our language seeks to be twinned with the universe of cells and the matter that gives us meaning. Not as an efflorescence of scientific analysis, but rather as an alchemy of cathartic evolution. A mystical evocation of our own inner lives, unveiling the intensity of an age and an environment. What we are, where we are, we go. Because we live in a time that belongs to us, and where the one-eyed man is no longer king among the blind. A moment of defining tension and redemptive prophecy. Of existential balance at the furthest reach of the quest.

The hair shirt of progress oppresses us: visions and temptations

in the anxiety of a multiform teratology. From our vantage point, we wish to emphasize what lies beneath the mask. In the expression or the grimace concealed by the mask of expansive physics. The mask of technical development for the few, where everything is synthesized into plastics. Beyond the place where hearts are transplanted and corpses are refrigerated only to be resuscitated later. The place of flying machines and lunatic wanderings. Of devices transformed by space technology and merged with the infernal powers of war. Of disasters and veiled information reaching us through the unilateral medium of the teletype.

Here, in our flowing, evolving, primeval milieu, we want to give form to a conscience. Our art aspires to rise above all the conformist game-playing and the siren calls of global artistic purism. Above the falsified abstracting expansion as much as it is above crass traditionalism. We place ourselves on the path of our genetic make-up, faithful to an expression that connects it to the setting. Our humanly rooted language springs from the reality that surrounds us. We are unconcerned – with good reason – by the death rattle of the mechanical and egotistical art repeated in New York or London. We acknowledge and value the intrinsic quality of its roots, but we are interested in the flipside: the face that reveals the integrity of man. Of man, his problems, his temporary smallness and his eternal greatness. Not the geometric decoration – the product of a classic scientific nostalgia – that followed the first authentically liberated art at the beginning of the century, and that today has led to the commercial design of fashion and mass-produced objects.

Where once we followed in others' footsteps, down foreign and well-trodden paths, we now discover the dominion of our unique geographical position and anthropological qualities. We are immersed in, and saturated with, the natural experiences of the clay we tread on, imbued with its very own past and present. What we are, and where we are, matters more than the stylistic novelty of what we do. We feel certain of our destiny, and are at constant boiling point, in the fullness of a reconquered truth. We are not guests in our world, or reporters watching the battle from the rearguard, but fighters with historical initiative and genuine responsibility.

We are committed to the expression of our own visual art. Though things charm us we are not blind to their vulnerabilities. We are on the road to encountering an authenticity that we consider valuable. The newly figurative expression we practice – by which we mean that it is human and realist because it aims to show man bare – has to be outspoken and brutal. It protests with caustic, cutting and critical judgement. It has to be passionate, cathartic, direct.

We take from art of the past and the present the necessary parallels for a more integrated communication. We acknowledge our debt to all those visionaries who left in their paintings the traces of a latent humanity. The old and the new, the completely unknown, the anonymous and the ignored. But above all we are mindful of the beings and the things in the environment that surrounds us. We live here, and here are the roots that bind us.

We join our previous and present experiences to imbue our actions with a more radical and violent intent. We share a common experience and a visual concept rooted in a present moment that is ours and is very near, by our side. We disregard the mystification or the supposed naturalism of advertising or demagogic posters. What interests us is the visionary, prophetic and accusatory integration. Finding artistic values with popular content, the embodiments of daily life, of the time that passes and ties us to novelty, to unsuspected circumstances. We forged the power and the efficacy of this realism in the restlessness of contemporary man and the conscience of his times, torn and aspiring for communion and unity. And beyond ourselves, the human expression of a future art and a future coexistence.

<div align="right">

Grupo Vértebra
Guatemala, March 1970

</div>

M43 Artur Barrio

MUD/MEAT SEWER (1970)

The Portuguese artist Artur Barrio (b. 1945) came to prominence in
Brazil in the late 1960s as a member of a revolutionary art move-
ment in Rio de Janeiro that created works in response to the cen-
sorship and the violence of the country's brutal military regime.
Barrio advocated anti-art as a survival strategy, performing actions
and situations in the street, rather than exhibiting in a gallery, in
order to circumvent strict governmental controls.

In 1970 Barrio began to promote a new aesthetic created out of
decaying and degradable materials. Traditional media were elitist,
he argued, and constrained the artist. It was time to embrace the
abject and find meaning in junk, raw meat, saliva and urine –
substances chosen for their perishable and provocative qualities. In
accordance with his manifesto, written and distributed in April
1970, Barrio left hundreds of bags filled with rotten meat, bones and
excrement on the streets of Rio and photographed the reactions of
passers-by. These bloody bundles memorialized the dead bodies
found in the streets during the worst years of repression. He then
proceeded to perform the same action in the city of Belo Horizonte.
Like the earlier Argentinian activist group El Techo de la Ballena
(M19), Barrio believed in shocking society out of its complacency in
order to confront the realities of authoritarianism.

* * *

What I look for is contact with reality in its totality, everything that
is rejected, everything that is set aside because of its contentious
character. A contesting which encloses a radical reality, because
this reality exists, despite being dissimulated through symbols.

In my work, things are not indicated (represented), but rather lived, and it is necessary to dive into one, to dive into/manipulate it. And that is diving into yourself. The work has its own life because it belongs to all of us, because it is our everyday reality, and it is at this point that I give up my categorisation as 'artist', because I no longer am. Nor do I need any other label and that, obviously, extends to the work. It cannot be labelled because it does not need to be, nor are there any other words that can categorise it, because it happens that everything and nothing have lost their sense of being.

Therefore, these works, at the moment in which they are placed in squares, streets, etc., automatically become independent, with their initial author (me) having nothing more to do with the matter, handing that compromise onto the future manipulators/ authors of the work; in other words . . . passers-by, etc. The work is not recovered as it was created to be left and follow its own trajectory of psychological involvement.

I have already realised works throughout Rio de Janeiro, getting the city involved, as in some of these works I have used more than 500 bags (pieces), spreading them over different points. In that dispersion of deflagrating elements the important thing is that the involvement is total, at all points, at the same time, there being no defined single point, creating poles of energy between the bags.

Belo Horizonte 20/4/70

M44 Gyula Pauer

The First Pseudo Manifesto (1970)

The Hungarian conceptual artist Gyula Pauer (1941–2012) distributed the 'First Pseudo Manifesto' ('Elsö Pszeudo Manifesztum') as a flyer in October 1970 at the opening of his exhibition at the József Attila Culture Centre in Budapest. At the time, Hungary's communist regime still operated a repressive cultural policy. Pauer's manifesto proposed a form of art that expressed and interrogated the tensions, contradictions and duplicities of living in a socialist society by drawing attention to the differences between that which is seen and that which really exists. He created 'pseudo' artworks that were false or deceptive: for example, 'pseudo-cubes' that appeared to be three-dimensional objects, but were in fact two-dimensional images; or a painting of a pregnant woman that gave the impression she was not expectant.

In April 1972 Pauer tried to stage an avant-garde festival in Budapest, but the event was banned by the authorities. It went ahead later under the suitably innocuous title *Direct Week*, and during it Pauer circulated a 'Second Pseudo Manifesto' ('Második Pszeudo Manifesztum') which began with the rousing declarations:

PSEUDO: FALSE! DECEPTIVE! UNREAL!
 PSEUDO: SEEMINGLY REAL!
 DOWN WITH UNCERTAINTY!
 FAMILIARIZE YOURSELF WITH PSEUDO and you will never be embarrassed in the company of erudite people again, because PSEUDO is the mode of existence of modern man, the secret to self-assurance!
 YOU ARE UNIMAGINABLE WITHOUT PSEUDO!

<p style="text-align:center">*　*　*</p>

The English equivalents for the expression PSEUDO are: false, deceptive, unreal, and seemingly real. In the field of sculpture, the term has been used in connection with the works made by Gyula Pauer in 1970. It refers to one of the striking features of sculpture, and therefore one of the new aspects of sculpting. The PSEUDO sculpture does not seem to be what its genuine form actually is. The PSEUDO sculpture is not about the medium of sculpture itself, but rather the circumstances of the medium of sculpture.

One of the historical antecedents of PSEUDO sculpture is MINIMAL ART. MINIMAL sculpture is a kind of plastic art that has been reduced to a few simple geometric forms, the shocking effect of which lies in their pure, almost puritanical appearance and their deliberate avoidance of ornament and sentimentality. Its other antecedent was the illusionist technique of OP ART. The pure form in OP ART is dissolved in the endless possibilities of motion. However, OP ART has remained a two-dimensional art of decorative illusionism.

PSEUDO misleadingly creates the impression of the surface of another sculpture over the puritan forms of MINIMAL sculpture, giving the image of two sculptures simultaneously. This effect is achieved by projecting the picture of a more complex object onto the surface of simple geometrical forms. This is done by means of a photographic process. On the surface of the sculpture there appears the surface of another sculpture. The PSEUDO sculpture thus portrays reality and illusion, the material and the immaterial, on the same object at the same time. The exact forms are discernible, but perception is always hampered by the illusionist image. Essentially, PSEUDO includes the following questions:

1. The existence of sculpture.
2. The absence of sculpture.
3. The PSEUDO-like attitude, the manipulated nature of the object.

These themes move beyond the material space of sculpture and demand functional interpretation. We consider the following interpretation correct:

The PSEUDO quality depicts the manipulated nature of the sculpture as a work of plastic art. This manipulated nature may characterize the existence of art in general. The manipulated nature of the PSEUDO sculpture, both in its form and in its technique, is only a symbol of the existential manipulated nature of plastic art (and the arts in general).

In the last third of the twentieth century, modern art entered into the maelstrom of social manipulation by following the path of consumer goods. Of course, PSEUDO cannot tell us about the manipulated nature of the price, commerce, advertising strategies, and functions of art objects, because PSEUDO sculpture is not a historical treatise or sociological essay, nor is it an illustrated popular lecture. The PSEUDO sculpture is a sculpture representing itself as a manipulated sculpture, thus proving the existence of the state of manipulation. PSEUDO reveals itself as a false image, or at least as a complex object that also gives a false image.

But PSEUDO does not commit itself merely to the act of exposure. PSEUDO sculpture carefully sets new surfaces on the surfaces of simple and concrete objects, and these visual elements, settling gently on the surface of the object, present the forms from a new perspective. Consequently PSEUDO not only negates manipulated existence, but affirms it as well, exposing its complexity and structural richness. Finally, PSEUDO cannot be interpreted as an unambiguous stance. With the dialectical unity of affirmation and negation it gestures towards the world beyond it, but it also reverts into itself.

PSEUDO remains neither philosophy nor history, but what it was at the very moment of its birth – sculpture. PSEUDO will exist as long as appearance is a real factor, and vice versa.

M45 Rivolta Femminile

On Woman's Absence from Celebratory Manifestations of Male Creativity (1971)

The Italian feminist separatist group and publishing house Rivolta Femminile (Feminine Revolt) was founded in Milan in 1970 by the writers Carla Lonzi (1931–82) and Elvira Banotti (1933–2014) and the artist Carla Accardi (1924–2014). The group's most articulate voice was the brilliant Lonzi, who had been a prominent art critic in Italy until she came to realize that creativity, like society, was not without its compromises and mythologies. Having lost her illusions about the freedom of artists, she abandoned her profession, and began to promote a highly politicized and radical alternative to society and the arts through her writings for Rivolta Femminile. Lonzi believed that art, as it stood, needed to be eroded away, and that those artistic roles, identities and definitions that had been created by a paternalistic society had to be rejected.

In Milan in March 1971, Lonzi wrote a short manifesto called 'On Woman's Absence from Celebratory Manifestations of Male Creativity' ('Assenza della donna dai momenti celebrativi della manifestazione creativa maschile'), later published for the first time in her book of essays *Let's Spit on Hegel* (*Sputiamo su Hegel*) in 1974. The manifesto, which was signed by Rivolta Femminile, confronts the traditional structures ascribed to art – that man is the creator and woman is the passive observer. Lonzi turns this on its head, arguing that being an observer has power, so therefore the role assigned to women can also have the power to legitimize male creativity.

* * *

We at Rivolta Femminile refuse to take part in the celebratory manifestations of male creativity, having become aware that in a patriarchal world – a world made by men and for men – even creativity, which is a liberating experience, is actuated by men and for men. A woman, as a subsidiary human being, is denied all interventions that might imply being acknowledged as a subject: there is no provision for her liberation.

Man's creativity has, as a counterpoint, another man's creativity; it is a woman, however, who is kept as client and spectator of this activity, as her status excludes competition. The woman is confined to a category that guarantees *a priori* the appreciation of the values embodied in the creativity of the male protagonist. While creativity is acknowledged as having a liberating function, Art is institutionalized, as is woman (the neutral counterpart), who merely witnesses the gesturing of others. In Art, like in all activities, man is divided between competition with a partner, also a man, and the veneration he demands from a woman.

This is the nature of patriarchal creativity, stimulated by the aggressiveness with a rival and the helpless acquiescence of woman. Man, and therefore the artist, feels abandoned by woman the moment she relinquishes her archetypal spectatorial role: their solidarity was built on the belief that woman had arrived at the reincarnational apex granted to her species when she became a spectator gratified by creativity.

Woman discovers, however, that the patriarchal world has an absolute need for her: she is the element which allows the man's efforts at liberation to be reached. Women's liberation can only take place independently from patriarchal expectations and the dynamics of male liberation. The male artist expects the woman to mythicize his stance, and woman, until she begins her own process of liberation, fulfils precisely this need. Artistic creation does not want to lose the security of a myth that is supported by our exclusively receptive role.

By becoming aware of her condition in relation to male creativity, woman discovers that she has two possibilities. One, used until now, consists of reaching parity in the creative field historically

defined by the male. This is alienating, and granted indulgently to her by the male. The other, which has been sought by the Feminist Movement, is the autonomous liberation of the woman, who then recuperates her own creativity, fed on the repressive examples imposed by the dominant sex.

To participate in the celebration of man's creativity means to give in to the historical allure of our own colonization at this climactic point of patriarchal world strategy. Without woman the cult of male supremacy becomes a personality clash between men.

By being absent from the celebratory manifestations of male creativity, we do not pass an ideological judgement on it, nor do we contest it; but by refusing to accept it, we put a strain on the male concept of Art as a beneficial and administrable grace. By ceasing to believe in this reflexive liberation, creativity is free to escape patriarchal relationships. By her absence, woman shows her new consciousness, liberation and creativity.

Milan, March 1971
Rivolta Femminile

M46 Ted Joans

Proposition for a Black Power Manifesto (1971)

Ted Joans (1928–2003) was a prolific underground artist and Beat poet who popularized Surrealism in the United States – 'Jazz is my religion and Surrealism is my point of view,' he once said. He collaborated with the Chicago Surrealist Group, contributing to their ad hoc periodical *Arsenal*, and he was a friend of André Breton, who championed Joans's poetry and 'jazzaction' paintings. Joans embraced Surrealism's international character, living between North America, Europe and Africa, and calling himself 'a tricontinental poet'; he also loved Surrealism's ribald ability to antagonize bourgeois pretentiousness. Yet, ultimately, it was the movement's belief in the freedom of the imagination, and how this could bring about radical social change – as championed by earlier Surrealists such as Étienne Léro (M4) and the founder of Négritude, Aimé Césaire (M7) – that Joans subscribed to. Convinced that Surrealism had its roots in Africa rather than Europe, he used it to promote the black struggle for civil rights in the US as well as to support the wider goals of Pan-Africanism (M39).

In 1969, at a time of rising activism in the US, with the Black Panthers and the development of the black consciousness movement, Joans wrote his powerful longform poem 'Black Power Manifesto' (first published, in French, as 'Proposition pour un Manifeste BLACK POWER pouvoir noir') in order to agitate for a self-assertive black art that celebrated its African ancestry. The much shorter version reproduced here, which was written at some point in 1971, first appeared in *Arsenal: Surrealist Subversion, No. 2* in

the summer of 1973. It nevertheless still powerfully evokes the spirit of the era.

* * *

Black Power is the vanguard of the insurrection inside America today.

Black Power is that marvelous explosive mixture which has accumulated since the first Black slave uprising – Always the same motive: FREEDOM!

Black Power is dreams that are carried out into reality. Black Power has the real and beyond the real in which to move. Our African ancestry has enriched us with this marvelous surreality.

Black Power is not out to win the Civil Rights struggle, but to win the Human Rights struggle. Black Power is like jazz, it is based upon the freedom of the spirit.

That spirit is black. Black people must never lose their freedom of spirit.

Black Power is fanatical for freedom.

Black Power is Black people charting their own destiny.

Black Power is marvelous and beautiful.

Black Power is a fierce black hope. Black Power is determined to surmount all obstacles.

Black Power is black truth.

Black Power! Black Power!

M47 Jarosław Kozłowski and Andrzej Kostołowski

NET Manifesto (1972)

Devised by the Polish artist Jarosław Kozłowski (b. 1945) and the art historian Andrzej Kostołowski (b. 1940) in 1971 and created in January the following year, the 'NET Manifesto' ('Manifest SIEĆ') was an ingenious work of conceptual art, which took the form of an autonomous, self-proliferating network for the open exchange of information across international borders. At the time, strict censorship rules and travel limitations in Poland made it difficult to access art and ideas from outside the Eastern Bloc. So Kozłowski typed 350 manifestos and sent them to international artists and critics, proposing a dialogue. In order for the manifesto to get past the post-office censors, the artist wrote the document in a deliberately bureaucratic way, even stamping it with the word 'NET'. While this enabled it to pass through the postal exchange uncensored, it was also a way of ridiculing the socialist government's obsession with red tape.

The response to the manifesto was overwhelming, with Kozłowski receiving books, journals and art ephemera from all over the world. In late 1972 the artist decided to present the responses in a private exhibition, but he was denounced to the authorities, the security services invaded his apartment and everything was seized. Both Kozłowski and Kostołowski were interrogated, in the belief that they were members of a fledgling anarchist organization intent on overthrowing the state. Over the next year they were questioned several more times before the material was returned to them, after which Kozłowski exhibited the documents in an official venue to avoid suspicion. Some of the artists who had responded

to the manifesto were later invited to Poland to exhibit in Kozłowski's space, Akumulatory 2, in Poznań, keeping alive the original purpose of the manifesto.

<p style="text-align:center">★ ★ ★</p>

NET

— a NET is open and uncommercial

— points of the NET are: private homes, studios and any other places where art propositions are articulated

— these propositions are presented to persons interested in them

— propositions may be accompanied by editions in the form of prints, tapes, slides, photographs, catalogues, books, films, handbills, letters, manuscripts etc.

— NET has no central point nor any coordination

— points of the NET can be anywhere

— all points of the NET are in contact among themselves and exchange concepts, propositions, projects and other forms of articulation

— the idea of NET is not new and in this moment it stops being an authorized idea

— NET can be arbitrarily developed and copied

<div style="text-align:right">

Jarosław Kozłowski
Andrzej Kostołowski

</div>

M48 VALIE EXPORT

Women's Art: A Manifesto (1972)

VALIE EXPORT (b. 1940) is a feminist artist who uses photography, film and video to raise questions about female objectification. Born in Austria, she shed her father's and her husband's names in 1967 for the alias VALIE EXPORT, which she emblazoned on a packet of cigarettes now held at the Museum of Modern Art, New York. Early in her career, she chose direct engagement with the general public over exhibiting in art institutions, her performances often featuring her own body in deliberately provocative ways in order to raise questions about society's perception of women. Perhaps the most famous photograph of EXPORT is *Action Pants: Genital Panic* (*Aktionshose: Genitalpanik*, 1969): the artist, dressed in crotchless trousers, holds a machine gun that she looks set to turn on the viewer.

'Women's Art: A Manifesto' was written by EXPORT in March 1972. Like Rivolta Femminile's manifesto (M45), it originated at a time when the women's movement was confronting the fetishization of women's bodies in both art and the sex industry. It was first published in the Austrian left-wing magazine *Neues Forum* in January 1973, and later distributed at an exhibition EXPORT curated in Vienna in 1976 called *MAGNA Feminismus: Kunst und Kreativität* (*MAGNA Feminism: Art and Creativity*). In this forceful statement, EXPORT urges women to take control of their own image and use art as a creative means of expression to develop a new female consciousness.

<p style="text-align:center">* * *</p>

THE POSITION OF ART IN THE WOMEN'S LIBERATION MOVEMENT IS THE POSITION OF WOMAN IN THE

ARTS MOVEMENT. THE HISTORY OF WOMAN IS THE HISTORY OF MAN because man has defined the image of woman for both man and woman, men create and control the social and communication media such as science and art, word and image, fashion and architecture, social transportation and division of new media, and in accordance with these medial patterns they gave shape to woman. if reality is a social construction and men its engineers, we are dealing with a male reality. women have not yet come to themselves, because they have not had a chance to speak insofar as they had no access to the media. let women speak so that they can find themselves, this is what I ask for in order to achieve a self-defined image of ourselves and thus a different view of the social function of women. we women must participate in the construction of reality via the building stones of media-communication. this will not happen spontaneously or without resistance, therefore we must fight! if we shall carry through our goals such as social equal rights, self-determination, a new female consciousness, we must try to express them within the whole realm of life. this fight will bring about far reaching consequences and changes in the whole range of life not only for ourselves but for men, children, family, church . . . in short for the state. women must make use of all media as a means of social struggle and social progress in order to free culture of male values, in the same fashion she will do this in the arts knowing that men for thousands of years were able to express herein their ideas of eroticism, sex, beauty including their mythology of vigour, energy and austerity in sculpture, paintings, novels, films, drama, drawings etc., and thereby influencing our consciousness. it will be time. AND IT IS THE RIGHT TIME the consciousness of all of us, let our ideas flow into the social construction of reality to create a human reality. so far the arts have been created to a large extent solely by men. they dealt with the subjects of life, with the problems of emotional life adding only their own accounts, answers and solutions. now we must make our own assertions. we must destroy all these notions of love, faith, family, motherhood, companionship, which were not created by us and thus replace them with new ones in accordance

with our sensibility, with our wishes. to change the arts that man forced upon us means to destroy the features of woman created by man, the new values that we add to the arts will bring about new values for women in the course of the civilizing process. the arts can be of importance to the women's liberation insofar as we derive significance – our significance – from it: this spark can ignite the process of our self-determination, the question, what women can give to the arts and what the arts can give to the women, can be answered as follows: the transference of the specific situation of woman to the artistic context sets up signs and signals which provide new artistic expressions and messages on one hand, and change retrospectively the situation of women on the other. the arts can be understood as a medium for our self-definition adding new values to the arts. these values, transmitted via the cultural sign-process, will alter reality towards an accommodation of female needs.

THE FUTURE OF WOMEN WILL BE THE HISTORY OF WOMAN.

M49 Mike Brown

I don't know what to think about anything (It don't matter, nohow) (1972)

In July 1972 the Australian radical nonconformist artist Mike Brown (1938–97) distributed his punk manifesto 'I don't know what to think [. . .]' at the opening of his solo exhibition of paintings, text works and collages at the Watters Gallery in Sydney. Inspired by the American novelist Kurt Vonnegut, the manifesto is a rolling polemic against consumerism, mass culture, and the grasping realities of the art market and the advertising industry.

Together with Ross Crothall (b. 1934) and Colin Lanceley (1938–2015), Brown had been a member of a revolutionary art collective designed to shake the foundations of modernism in Australia. They were known initially as the Annandale Imitation Realists (after the location of their shared studio in Sydney). The word 'imitation' was ironic, reflecting the artists' need to borrow or parody other cultures due to the paucity of innovation in Australia's modern art scene. The trio had first met at the East Sydney Technical College in the late 1950s, where they had become interested in Aboriginal art. They also embraced Dadaism and humour, and paid little attention to conventional art practices. Their exuberant assemblages combined designs and symbols from Aboriginal and Oceanic art with pornography, pop lyrics and everyday trash, resulting in works which they believed reflected the chaos of modern life. Although the group disbanded in 1964, Brown continued to make art in the spirit of Imitation Realism, ironically appropriating pop culture and taking scabious delight in attacking the commercial art

world. In this respect, he can be regarded as one of the pioneers of post-modern art.

<p style="text-align:center">* * *</p>

This is an exhibition somewhat in the telegraphic schizophrenic manner of the arts of the planet Tralfamadore, where the flying saucers come from.

If you've read any of the novels of Kurt Vonnegut Jr. you'll know what I'm talking about. If you haven't read any Vonnegut you're an ignoramus ill-equipped to survive the 20th century. Peace anyhow.

Here we all are, huddled together for failing comfort, in the near-ruins of a civilization marked for early destruction by a wide array of gruesome means: – 'art' has meant a lot of different things at different times, what can it possibly mean in 1972?

You tell me, I'll tell you, and then we'll both know. Here's a bagful of muddled thoughts I guarantee you'll find most unhelpful . . .

Recently I moved from the city which was driving me nuts to a farmhouse 100 miles out in the country. From that vantage-point the machinations of the art-world seem more weird, remote and incomprehensible than they ever did.

Why do I bother to scribble and paint pictures and do all that sort of stuff?

For me, the answer comes back clear and strong – NOTHING BETTER TO DO.

That is to say, out of all the woeful array of non-activities that this society makes possible and permissible, art has for me the look of something at least marginally worth doing. Yet I am constantly reminded that even that narrow margin of 'worthwhileness' is probably a mirage: by the time an exhibition of any kind has been mounted in the hallowed, stilted, exclusive air of an art-gallery, it has been turned into something that one's healthiest reaction would be to throw mud-pies at.

What started out as a metaphysical inquiry has been turned into a sale of high-class chattels, and a public examination and judgement of something that was never meant to be either bought-and-sold, examined or judged, but lived.

... But so what? Is this then a complaint, or proclamation that something ought to be done? That we need different, better types of art-gallery, or that they should be done away with? That artists should change to nonmarketable artforms, or simply be 'better' artists than they in fact are?

We could make any or all these changes and still find ourselves just where we were.

The truth is that art considered as a separate subject from anything else has quite abruptly run out of validity; it can derive no more vitality from within itself until it is well into a process of becoming indistinguishable from science, politics, sociology, religion – & – philosophy, etc., etc., etc., until the 'artist' has been recognized for what he is, a sort of dinosaur doomed by fantastic over-specialization to extinction.

Alienation from people and their 'ordinary' doings has resulted in Art becoming an unforgivably dull subject. Visual art especially has alienated itself from fruitful social context and exists in an eerie limbo peopled by everyone-you-wouldn't-want-to-know-about about: socialites and hip bank-clerks, businessmen and art-scholars, professors and 'instant' newspaper critics, art-teachers, government officials and horse traders.

(Hold it there: – I'm not trying to start class-war fare, but hell, what a heavy mix artworld people are!!)

Since art can never really be distinct from, and certainly not superior to, its social context, it follows that this exhibition, and this screed as well, is the uttermost bullshit. It's the best I could manage, yet bullshit it remains.

I should die of shame to exhibit it, especially when not far away, at La Perouse and Redfern there live the embattled remnants of a race that was massacred by mine, whose art-and-culture and way-of-life, superior to that of my own race in every important sense, was ferociously, contemptuously, deliberately suppressed and destroyed. I refer, of course, to the Australian Aborigines.

I sense an immense self-satisfaction in Western art still, that is quite void of justification: we think we're really somewhere, when in fact we're truly nowhere; lost a million miles from home: the

most blazing heights of modern visual art are a tiny spark, albeit a healthy one, in an eternity of screeching blackness. We don't know what we're doing: we don't know what-the-fuck we're talking about. We grope, we dither, we idly fool about with concepts and notions that are as thin and tasteless as thin-air; the moment a feeble ray of light chances the way of one of us, we go into orgasms of adulation and crown him a genius.

The arts-&-culture of the Aborigines, the Africans, New Guineans, South Americans, Indians and Chinese, Red Indians and Polynesians, in fact of almost every-one but us except perhaps in our far-distant past, were no mere sparks of confused talent; they were, at best, lights that lighted up the universe. In their light men became scarcely distinguishable from gods.

We are sick, sick, sick, and in self-disgust we're doing our best to destroy ourselves: the Bomb, poisoning-and-asphyxiation, social-collapse and starvation, what'll it be?

And then again, so what? It don't matter nohow . . . In fact, the collapse of Western civilization will be a blessing to the earth vastly greater even than the collapse of Rome, and that in its day was a blessing beyond compare.

The point I want to come back to is, what in the name-of-all-that's-merciful do I hope to achieve, what do I imagine I'm doing, hanging a row of daubed sheets of canvas on the walls of an elegant salon in this doomed putrescent shitheap of a city, then sending invitations out to those scum-of-the-earth, the art-intelligentsia, to come and gawk at the mess I've made?

Precious-fucking-little. I am utterly pessimistic about the prospect of any event within the teacup-whirlpool that is the Australian artworld having any effect, good or ill, on anything whatsoever. However deftly one might deploy one's alleged aesthetic sensibilities, the fact remains that in utilising the existent art-vending machinery one is barking up the wrong tree entirely. Nor does any 'right tree' exist, at least as yet. The only earthly present use for the artist's imagination is in devising social circumstances, and means and methods of communication that will combine to create a 'meaningful' human situation. What 'meaningful' means, don't

ask me – but we have all experienced isolated, usually happen-chance events where some normally-moribund artform has sprung into sizzling life: a song sung at a fireside by an amateur guitarist, which combined with the flickering shadows and awesome background silence to strike joy or holy terror deep into one's heart; a street-poster pasted-up at clandestine mid-night which by morning light is a flash of brilliance against the peeling paint of a factory wall . . . a poem or speech at an impromptu meeting which fills one with indignation and lust-for-action against some injustice . . . a Bob Dylan verse heard above the din of a riotous party . . . a room that has been made into such a warmly human environment that artefacts such as pottery, furniture, even paintings can 'live' there without appearing to be mere status-symbols, and are freed to deliver up their messages of utility or philosophy as they were meant to.

If an art-form doesn't 'live' in this human-environmental sense, then it is meaningless, and dead, and the best thing to do is to bury it. We have a lot of burying to do: 99% or more of our culture is stillborn, never having even been intended by its makers to have life-abundance but merely to serve as a distraction from, a decoration to, a justification for, a way-of-life that is leading us nowhere, or to hell.

The first step for artists should be to despecialise themselves, so that they are no longer dependent on any one type of communication machinery (art-gallery, publishing-house, cinema, etc.) nor moulded by its inherent limitations or corruptions into a crippled stance.

The notion that one was 'meant to be' a painter rather than a writer, musician, philosopher, scientist or politician is a self-perpetuating cultural hypnosis. The only valuable quality any of these types of people have, is not their special skills, but their acute awareness of the world and what it's about: if this awareness is genuinely present it only takes time and work to develop the skill needed to translate it into any medium or activity.

Anyone with a brain in his head can write; anyone with soul can play music if he tries; and everyone should develop

political-philosophic-scientific understanding and integrate it with his activities.

So: this precious exhibition of mine, what does it represent?

An exercise, in de-specialisation, yes: but still so coloured by its art-worldliness as to make it nearly worthless as a human experience, except perhaps in a very negative sense.

Implicit in the act of painting is the expectation that it will be exhibited once or twice, and there-after either put in a cupboard to rot, or displayed in someone's lounge-room, or in a public collection if it's incredibly lucky. This is what actually happens: so it goes.

What have I to say to anyone within such an environmental context?

Certainly nothing to the cupboard, nothing to most people's lounge-rooms, and nothing to the gallery-going jet-set. Nothing, that is, except DOODLY-DAH, and YAM, and HOO-HAA, and GRUNK ... and fiddle-twiddle with the brush, and scribble-scribble, and humm, that looks quite nice there, and I'll just slosh a little bit of red stuff on there, and any colour will do for there, it's all the goddam same ... within the context of the art-world, I don't know what to think, I don't know what to do or say, except: WHAT-THE-HELL ARE YOU PEOPLE DOING IN AN ART-GALLERY ANYWAY?? IF YOU'RE LOOKING FOR ART YOU WON'T FIND IT HERE. You might as well hope to find religion in a church, health in a pill-bottle, youth in a jar of cosmetics, or true-love in a brothel.

A few of the paintings have ended up despite themselves looking as though they mean something or other, or are trying to. Well fancy _that_. And so what. And big-deal. Forget it. It wasn't what I meant to say, anyhow.

You and I, we're a row of dummies in strait-jackets in a dungeon. And what have dummies in strait-jackets to say to each other? Nothing much except, let's get the hell outa here. And _that's_ what I'm saying to you now.

We have grown so used to constraint that we have forgotten that it's possible to be free, that there's a whole world outside our dungeon-cell, and outside that again a whole universe, and outside

that who knows what? We have forgotten that art isn't some special condiment you splash on life to make it taste a little better: – if it's anything at all, its everything there is, or was or will be, everything that a person can do, think or say to another. It's a way of living and thinking, a way for me to transmit to you the totality of my being and for you to transmit your totality to me.

But that's not the way we use it.

I see modern art generally as the first strivings of a healthy consciousness; but hundred of years will probably have to pass before it has evolved into any-thing worth pissing on.

It won't evolve by the efforts of artists slugging away manfully at artistic problems, because artistic problems don't exist as such: they are merely mental blocks created by absurdities of our social condition. Artists should forget about art a little and start wondering about what they were born onto the earth for, where they stand in relation to everything that's happening in this world, whether what they are doing is as meaningful in a total sense as, say, planting a row of beans or cabbages, building a chicken-coop, or going for a walk in the bush.

Does one really enjoy art, or is it just another rat-race? A truthful answer to this question should in the end produce some positive results, but it's unlikely that they'll take the form of anything we now recognise as art – except sometimes.

Painting pictures is O.K., people were painting pictures before the Flood, and probably they'll still be doing it when the moon falls to earth. But painting pictures isn't the problem: first we have to revolutionize the world, and that's a tall-order, a long nearly-hopeless task.

SMASH U.S. IMPERIALISM

DOWN WITH EVERYTHING

CAPITALISM IS A FAT MAN EATING A THIN ONE

ORDER = CHAOS

EVERYTHING = NOTHING

WE ARE NONEXISTENT VIBRATIONS IN A FORMLESS
SEA OF NAMELESS GUNK

EVERYTHING'S ALL RIGHT JUST AS IT IS

IT DON'T MATTER, NOHOW; and/or SO IT GOES.

M50 Vitaly Komar and Aleksandr Melamid

Sots-Art Manifesto (1972–3)

The Russian artists Vitaly Komar (b. 1943) and Aleksandr Melamid (b. 1945) founded Sots-Art in the early 1970s. Their aim was to create a new style that bridged the gap between the official, state-sanctioned Soviet Realist art of the USSR and the 'unofficial' art deemed anti-Soviet by the authorities – in other words, anything that was influenced by the Western avant-garde or considered subversive by the regime. The duo exploited totalitarian symbols in their paintings in the same way that Western Pop artists exploited symbols of mass consumerism. They produced paintings, posters and banners that parodied Socialist Realism, used advertising clichés to provoke a debate about propaganda and identity, and critiqued the peculiarly Russian cultural norm of 'double thinking' – that is, of saying one thing in public and thinking another in private.

In 1974 Komar and Melamid took part in a small open-air exhibition of 'unofficial' art staged in a field on the outskirts of Moscow. Organized by the Neo-Expressionist painter Oscar Rabin, it was an attempt to evade the Soviet authorities' increasingly strict control of the dissemination of unofficial art. Artists deemed nonconformists were often subject to random, humiliating interrogations and denied permission to exhibit their work in galleries; but this only intensified their desire to present their work to the ordinary public. Rabin's show became notorious when the authorities wrecked it with bulldozers, prompting international outrage. Some of the artists who participated in it were later forcibly conscripted into the

army or incarcerated in insane asylums. Many were exiled or left the Soviet Union of their own volition. Komar and Melamid themselves emigrated in 1977 and settled in New York. However, the spirit of Sots-Art found a new home in the work of the Slovenian art collective NSK in the 1980s, which similarly appropriated authoritarian iconography in order to try and subvert the communist Yugoslav state (M81).

Komar and Melamid first set out their vision for Sots-Art in a manifesto written at some point in 1972–3. Although it could not be published under the totalitarian censorship laws of the Soviet Union, versions of the text were read out to kindred artistic spirits at private meetings. The following variant, translated here into English, comes from Vitaly Komar's own archives.

* * *

We live in the USSR – the country where consciousness is defined by being.

We are the artists of Sots-Art – the artists of conceptual eclecticism – a new movement which connects official and unofficial art.

'Sots' is the first part of the term 'Socialist Realism' [*Sotsialisticheskiy realizm*], and 'Art' the last part of the term 'Pop Art'.

We are grandchildren of the Avant-Garde and children of Socialist Realism.

If Western Pop Art reflects the excess of advertisements for consumer goods, then our Sots-Art reflects the excess of Soviet ideology – its visual propaganda.

Official state Socialist Realism has entered our unconscious, at the same time as the unconscious has become a topic of discussion in society.

Sots-Art is the admission that a Soviet person's spiritual life has become state and societal property.

Sots-Art is conceptual eclecticism – it is a realistic reflection of the ambivalence within the collective consciousness of our peers.

Sots-Art's eclecticism loves the Avant-Garde's anti-aesthetic nihilism as well as the traditional aesthetics of kitsch.

Sots-Art is visualisation of the provocative, unarticulated part of our consciousness, where there is a border between the societal and the personal.

This is the twilight zone of unarticulated images in our consciousness.

This zone needs to give birth to a new word.

Art is less important than a conversation about it.

The creators of Sots-Art are the midwives of this new word.

Sots-Art is a word which appeared at the beginning of the end, and will be there at the end of the beginning.

M51 Anita Steckel

Statement on Censorship (1973)

The early 1970s saw a number of feminist artists in America begin to represent sex from a female perspective in their work. One such was Anita Steckel (1930–2012), who founded the Fight Censorship Group in 1973, after attempts were made to close down her solo show at Rockland Community College in Suffern, New York State. The exhibition, entitled *The Sexual Politics of Feminist Art*, featured erotic imagery – including, most controversially of all, erect penises. Refusing to allow the authorities to censor her artworks, Steckel sent a letter to a number of newspapers and local media outlets announcing the formation of a group that would fight discrimination against sexual art made by women artists. The *New York Post* and the *Daily News* covered the growing controversy, as did public television and radio. In her letter, Steckel included extracts from the following manifesto, which she had originally issued to fellow artists early in March. As well as an incisive understanding of the social and institutional frameworks that inhibit women from becoming artists, it contains a spirited defence of the penis as a fit subject for art.

The Fight Censorship Group, which also included the feminist artists Joan Semmel, Hannah Wilke, Martha Edelheit, Judith Bernstein and Juanita McNeely, emerged at a critical time, when historians, curators and art critics were re-examining the history of Western art and raising questions about female autonomy. Like Rivolta Femminile in Italy (M45) and VALIE EXPORT in Austria (M48), the group and their actions contributed forcefully to this

wider debate surrounding the way women were objectified and represented in art and Western society.

* * *

Statement on Censorship by Anita Steckel (Woman Artist)

We women artists

We believe sexual subject matter should be removed from the 'closet' of the fine arts where it resides in small portfolios, small works, off the walls, in private collections, etc. We believe sexual subject matter includes many things: political statements, humor, erotica, sociological and psychological statements – as well as purely sensuous aesthetic 'art' concerns – and of course – the primitive, mysterious reasons [that] none of us know.

Sexual subject matter is kept out of museums and in 'smut' magazines, films etc. – by men still in power – because it is considered too unwholesome for such 'high places.'

Nude and sexually portrayed women however, are *not* kept out of museums. It is always the men who cover their sex – who hide what they consider 'their shame,' who think of this sexuality as unwholesome – the 'fig leaf' tradition.

We women artists object to this unhealthy and sexist discrimination & we demand an end to past sexist puritanism in the museum. We assert that sexual as well as any other subject matter is entirely the artists' concern and the museums have no right to impose their puritanical and sexist – unbalanced – therefore unhealthy – timidity and coyness upon us all and upon future generations – and we demand that sexual subject matter – as it is part of life – no longer be prevented from being part of art. And since the woman has traditionally been exposed in her full nakedness and sexuality in all the great museums in the world so should the male be uncovered – as sexually on display as the woman – and the erect penis, therefore, as it is part of life, no longer be

prevented from being part of art. If the erect penis is not whole-some enough to go into a museum, it should not be considered wholesome enough to go into women.

And if the erect penis is wholesome enough to go into women – then it is more than wholesome enough to go into the greatest art museums.

Distributed to other women artists
on March 8, 1973 in NYC.

M52 Shakir Hassan al-Said

One Dimension (1973)

The One Dimension Group (*Al-Bu'd al-Wahad*) was founded by the Iraqi artist and writer Shakir Hassan al-Said (1925–2004) in 1971, after he had suffered an acute spiritual and mental crisis and left the Baghdad Modern Art Group (M12). The new group's ideology was complex. Essentially it rejected conventional three- and two-dimensional art in favour of an illusory 'one' – or inner – dimension, similar to the concept of existential temporality promoted by the German philosopher Martin Heidegger. In practice this 'One Dimension' was difficult to manifest artistically, as drawing or painting on a surface is two-dimensional; instead, al-Said's paintings did not convey conventional forms or shapes, but the trace of something, like a crack in a wall.

At the same time, inspired both by Heideggerian ontology and by the mystical form of Islam known as Sufism, al-Said began to employ the Arabic language, in its written form, in his work as the means to reveal the hidden essence of being. Joining forces with the abstract painter Madiha Omar (1908–2005) and the Cubist-inspired Jamil Hamoudi (1924–2003) – both of whom had been pioneers of the Arabic letter in modern art in the 1940s – al-Said sought to create a unifying Arab modern art through the expressive use of calligraphy and other forms of script.

Al-Said's elucidation of the concept of 'One Dimension' was first published in the catalogue for the opening of the group's second exhibition, in Baghdad in March 1973, along with essays by the other artists. It encapsulates his desire to create a spiritual form of art that explored the meaning of existence and expressed profound universal truths.

* * *

The principle of adopting the letter in art, then developing it in order to express its meaning, makes it necessary to study One Dimension from several perspectives.

1

From the philosophical perspective, we can consider the thinking of the enthusiast for adopting the letter in art as transcendent thinking. He does not attempt to delve deeply into research with an experimental scientific approach, but rather attempts to branch off into the experiment of comparison between two worlds: the linguistic one (the world of the letter) and the representational one (the world of two dimensions). So, from this perspective, One Dimension is a human/non-human vision because it goes beyond its own world towards its universal horizon. The artist who is an enthusiast of adopting the letter will not be satisfied with representational art of itself because he will add letter signs to it. This means that the painting will become more than an attempt at representation because, if artistic representation is essentially one of form (spatial), then the interjection of a linguistic element goes beyond the heart of this act to its horizon (in time). And this means that what the artist wants to debate at that time is not human or spatial existence but the problem of the existence of space-time. Thus, the fundamental subject of One Dimension is the existence of the universe itself.

In this sense, the theory of One Dimension presumes that the true meaning of the universe is realized by reverting from form to its linear eternity, and from size to its morphological eternity. It is a practice of transcendence (and by implication absence) through the relationship entered into between the self and the external world, in such a way that this relationship does not become a restriction within which subjective human existence is confined, but rather a developed relationship in which the self senses its own being within the universal presence.

We can observe the human/non-human features of One Dimension when we compare the Surrealist vision with the

Contemplative vision. The Surrealist vision is at its core a human vision because it holds that the authentic form of human existence is not consciousness, but rather the combination of emotional expression with subsurface layers of awareness or the subconscious. Hence Surrealist alienation is an alienation that does not transcend its human setting. The Surrealist is a human being who believes in his complete positive humanity, but feels that Western traditional art is impeding his human reality as it continually hides its bright and authentic side. And this aspect is what calls him to the subconscious or the world of dreams and hallucinations. From here he returns with his new vision of true human existence. However, the Contemplative vision holds that human feeling, insofar as it is positive towards the universe, constantly criticizes its true existence because it is not enough to express the truth of existence in space-time. However, it can be a productive feeling if it does not become devoted to the universe merely because a negative existence is inconceivable. For if 'amazed' is the paradigm of the Surrealist man, then 'contemplator' is the paradigm of the Contemplative man . . . or the One Dimension man.

This Contemplator is a man who feels his universal existence through his humanity when he makes his negativity into a new element to unify with the creation as a whole, for he does not live (himself) as positivity facing the negativity of the external world but rather lives (himself) as negativity facing the positivity of the same world.

Thus the ability of the graphical surface to express the self as soon as he accepts the positivity of the linguistic letter to interject his world into the world of the painting. The adoption of the letter in art, then, is no longer anything other than the universal position of the Contemplator, because this adoption strives to reveal the unity of the two worlds that he lives in simultaneously – the world of thought (the linguistic one) and the world of vision (the representational one).

2

As for the technical aspect, One Dimension is concerned with transforming linguistic symbols into a representational dimension. Because if, in the olden days, the 'vitality' of outward appearances was the philosophical basis of a whole theory of worshipping the various deities through metaphysical thought – and, in another sense, of choosing 'allegorical models' to express knowledge, and not perceptible vision to express the visual senses – then the 'principle of imitating nature' became, in the modernist era, the philosophical basis of human and scientific predilection; whereas, in the current era, the 'conciliatory technique' – i.e., a form that expresses the unity of universal existence – is the new framework for expressing comparative vision. Therefore the discovery of collage merely broadened such a vision.

In One Dimension, artistic technique becomes an attempt at collage when it unites in a painting the letter signs on one hand with their representational environment. Hence, in the technique, the letter also plays the role of a witness from the world of language when it is present at the heart of the pictorial surface. In reality, it remains surrounded by an aura from the world of the linguistic concept, in addition to its features connected with the adopted Arabic calligraphy. For the adopted letter, and the distance mapped out by it, is the rhetorical witness: it is, indeed, all the oral and symbolic heritage of the world of thought that can be read. It is true that the technique of modification will transform the letter in its turn into a representational sign, either by changing it into a non-linguistic form or by breaking it up, but it will remain an expression of the concept of the spectator in the world of language. In summary, although the conciliatory technique of One Dimension art seems to be an attempt to bring together various materials, but at its core it combines two worlds . . . Thus it is a clear ideological collage.

3

As for the expressive aspect of One Dimension, the script environment is a rich one, which brings together the internal and external

dimensions of the creative possibilities in art. Arabic script has varied methods of expression. There is the concentrated Kufic style, and there are other forms which have curved momentum, such as the Naskh script, the Thuluth script, the Persian script, etc. . . . But whether it is all those richly figurative and expressive forms of script which are adopted, or more everyday forms, such as ordinary handwriting, children's writing and graffiti – they all remain an expression of the innermost human soul, which presents itself in a spontaneous manner, loaded with conscious and subconscious expression at the same time. Or, in another sense, when a painting is charged with the letter in this way, the expression in it almost represents what a seismograph communicates through its signs . . . For there is a form of writing used by schoolchildren, especially those at elementary school, and there is a form of writing used on city walls that is filled with alarm and fear and spontaneity, and also teems with signs of ambiguity and repression and deception.

One Dimension, then, aspires to express the human soul by combining these forms of writing whenever they encounter walls or earth. Hence writing's expressive role in art.

Shakir Hassan al-Said

M53 Barbara Jones-Hogu

The History, Philosophy and Aesthetics of AFRI-COBRA (1973)

The influential African Commune of Bad Relevant Artists (AFRI-COBRA) was founded in Chicago in 1968 by Jeff Donaldson (1932–2004), Wadsworth Jarrell (b. 1929), Jae Jarrell (b. 1935), Barbara Jones-Hogu (b. 1938) and Gerald Williams (b. 1941), with other artists joining later. The group sought to develop their own aesthetic philosophy of the visual arts in order to empower black communities, first in the United States, and later – looking to the burgeoning Pan-African movement (M39) – across the globe. Many of the artists associated with AFRI-COBRA were involved in the civil rights movement, were in contact with artists and poets of the Chicago Surrealist Group (M46), and had worked previously on the community mural *Wall of Respect* (1967) in Bronzeville, Chicago, which depicted black heroes. It was through projects like the Bronzeville mural (which was razed in 1971) that these artists had hoped to unite the disparate African-American communities, yet they came to realize that conventional heroic representations were not enough: their art needed to promote the 'expressive awesomeness of African art and life in the United States', as Donaldson had written so elegiacally in his essay 'Ten in Search of a Nation' in 1969. To that end, AFRI-COBRA used the term 'super-real' to describe their heightened form of Surrealism.

Barbara Jones-Hogu expanded on Donaldson's essay with this manifesto, first published in the catalogue for the exhibition *AFRI-COBRA III* held at the University of Massachusetts at Amherst in September 1973. It sets out the principles of AFRI-COBRA style:

based on the sensibilities of African-Americans – their music, fashion and world view – but also looking directly to Africa (and especially African music) for artistic influences, such as 'super-real' colours, unstructured symmetry and repetition with change. The result is an ideology that seeks to define a common, radical black culture across the African diaspora.

* * *

In 1968, a group of artists came together at the request of Jeff Donaldson in the studio of Wadsworth Jarrell to discuss the premise that Black visual art has innate and intrinsic creative components which are characteristic of our ethnic group. The artists who were present at the meeting consisted of painters, printmakers, textile designers, dress designers, photographers and sculptors who felt that their visual expression was definitely affected by the fact that they were Black and that their Blackness contributed a specific quality to their visual expression. Many of the artists at the first meeting were members of a visual art group which was then defunct, the Visual Workshop of OBAC (Organization of Black American Culture) – who created the 'Wall of Respect' in Chicago in 1967. This mural became a visual symbol to the struggle of Black nationalism and liberation.

Once the artists concluded that we had specific visual qualities intrinsic to our ethnic group, a future meeting was set for each person to bring in their work for analysis by the group. At that meeting the following visual elements were selected: bright colors, the human figure, lost and found line, lettering, and images which identified the social, economical and political conditions of our ethnic group. When we had found our common denominator our next step was to ponder whether a group of Black artists could transcend the 'I' or 'me' for the 'us' and 'we' in order to create a basic philosophy which would be the foundation of a visual Black art movement. We wanted to create a greater role as Black Artists who were not for self but for our kind. Could we sacrifice the wants for self and ego in order to create the visual needs of our kind? Yes, we can!

A nucleus of artists felt that a collective effort was possible under a common philosophy and a common system of aesthetic principles.

The basic nucleus was composed of Jeff Donaldson, painter-teacher; Wadsworth Jarrell, painter-photographer, Jae Jarrell, clothing designer, Barbara J. Jones (Hogu) painter-printmaker-teacher, and Gerald Williams, painter-student. We had all noted that our work had a message: it was not fantasy or art for art's sake, it was specific and functional by expressing statements about our existence as Black People. Therefore, we began our philosophy with functionalism. Functional from the standpoint that it must communicate to its viewer a statement of truth, of action, of education, of conditions and a state of being to our people. We wanted to speak to them and for them, by having our common thoughts, feelings, trials and tribulations express our total existence as a people. We were aware of the negative experiences in our present and past but we wanted to accentuate the positive mode of thought and action. Therefore our visual statements were to be Black, positive, and direct with identification, purpose and direction. The directness of our statement was to be conveyed in several ways:

A. The visual statement must be humanistic with the figure frontal and direct to stress strength, straight forwardness, profoundness, and proudness.

B. The subject matter must be completely understood by the viewer, therefore lettering would be used to extend and clarify the visual statement. The lettering was to be incorporated into the composition as part of the visual statement and not as a headline.

C. The visual statement must identify our problems and offer a solution, a pattern of behavior or attitude.

D. The visual statement must educate, it must speak of our past, present, or future.

Black, positive, direct statements created in bright, vivid, singing cool-ade colors of orange, strawberry, cherry, lemon, lime and grape. Pure vivid colors of the sun and nature. Colors that shine on Black people, colors which stand out against the greenery of rural areas. Cool-ade colors, Black positive statements stressing a direction in the image with lettering, lost and found line and shape were

the beginning elements which created COBRA, the Coalition of Black Revolutionary Artists.

As COBRA began activating their philosophy we felt that everyone should work on a particular theme, the Black Family. The group met every two weeks to analyze and criticize the progress of each member as they completed their composition. These critiques became extremely important since it gave the artist a chance to work independently and jointly while having a group of his peers point out his strengths and weaknesses. As each artist developed his expression in a COBRA philosophy and aesthetics we moved on to the second theme, 'I am Better Than Those Mother Fuckers,' and we are. When the second theme was finished we dropped the idea of a definite theme and decided to start identifying problems, and solutions to problems, which we as Black people experience. Therefore in the third work and thereafter each artist worked on a theme which he felt was pertinent to our existence as a people.

At this point Napoleon Henderson, the weaver, joined the group and we moved from five to six which later changed to seven as Nelson Stevens, painter-printmaker came into the group. Yet we continued to grow with Carolyn Lawrence, painter; Omar Lama, a draftsman in pen and ink; and Sherman Beck, a painter and illustrator. During the same period of time we moved from COBRA to African COBRA to AFRI-COBRA, an African Commune of Bad Relevant Artists. We moved from a national perspective to an international perspective. All Black people regardless of their land base have the same problems, the control of land and economics by Europeans or Euro-Americans.

The change from COBRA to AFRI-COBRA also crystalized our philosophy and aesthetics, such as:

The Philosophical Concepts

A. IMAGES, a commitment to humanism, inspired by African people and their experience, IMAGES which perform some function which African people can relate to directly and experience. Art for the people, the people reflect the art, and the art is the people, not for the critics.

B. IDENTIFICATION, to define and clarify our commitment as a people to the struggles of African peoples who are waging war for survival and liberation.

C. PROGRAMMATIC, art which deals with concepts that offer positive and feasible solutions to our individual, local, national, and international problems.

D. MODES OF EXPRESSION, that lend themselves to economical mass production techniques such as 'Poster Art' so that everyone that wants one can have one.

E. EXPRESSIVE AWESOMENESS, that which does not appeal to serenity but is concerned with the eternally sublime, rather than ephemeral beauty. Art which moves the emotions and appeals to the senses.

The Aesthetic Principles

(These principles were not only drawn from the work of the artists in the group but were also drawn from our inheritable art forms as an African people.)

A. FREE SYMMETRY, the use of syncopated rhythmic repetition which constantly changes color, texture, shapes, form, pattern, movement, feature, etc.

B. MIMESIS AT MID-POINT, design which marks the spot where the real and the unreal, the objective and the non-objective, the plus and the minus meet. A point exactly between absolute abstractions and absolute naturalism.

C. VISIBILITY, clarity of form and line based on the interesting irregularity one senses in a freely drawn circle or organic object, the feeling for movement, growth, changes and human touch.

D. LUMINOSITY, 'Shine,' literal and figurative, as seen in the dress and personal grooming of shoes, hair (process or Afro), laminated furniture, face, knees or skin.

E. COLOR, Cool-ade color, bright colors with sensibility and harmony.

As we expanded our philosophy we developed as a group who created messages that dealt with the past, to give definition to our existence, in the present, to identify the images and activities of our present situation, and the future which would show a direction toward purpose and solution. Our endeavors and thoughts culminated in 1970 in 'TEN IN SEARCH OF A NATION,' an exhibit which was held at the Studio Museum in Harlem. The work we exhibited was on view to educate and was not for sale. We did not want to promote individual gain of the images but we did want to stress a unified effort of giving our messages to the people. We had plans to create poster prints of the work, so that everyone could have some AFRI-COBRA messages. Our endeavor was well received. It was the first time that most of the viewers had seen a group of artists jointly working together toward a concerted philosophy with images which stated to Black people 'Unite,' 'Unite or Perish,' 'We Will Build Here or Nobody Will,' because 'I Am Somebody,' 'I Am Better.'

Each artist dealt with their images in different perspectives. Nelson Stevens dealt with the spiritual aspect of nation building in 'Jihad,' 'Uhuru,' and 'Ujamma;' he wants 'to get as close as possible to the jihad . . . to images of those brothers and sisters who have never existed before,' while Jeff Donaldson dealt with the modern 'Amos and Andy' who are not for 'Toming' but are seriously dealing with an advanced weapon. His Oshun, Oba, and Yansan, the 'Wives of Shango' (God of thunder and lightning who balances all debts), are three sisters who are ready for combat with bullet, belts and guns; while the 'Shango Shortys' are dealing with their past in the tensions of today in a high-strung society of crystal clear glass.

Carolyn Lawrence wants to 'Take the past and the present and make the new image.' She records her concepts in 'Pops,' a tribute to an old man, while in 'Manhood' she pointed a direction of responsibility for all men. Jae Jarrell, the dress designer, laid out strong messages on her garments with strong patterns, textures and colors of 'Black Family,' 'Unity,' and 'Manhood.'

Wadsworth Jarrell stated, 'If you can get to Be-Bop, you can get to me. That is where the truth is.' The rhythms of his Be-Bop can be seen in the repetitive letters and colors òf 'Cool-ade Lester.' Jarrell's 'Homage to a Giant' pays tribute to many pertinent leaders, such as Malcolm X, Martin Luther King, Jesse Jackson, Fred Hampton, Huey P. Newton. His images (visual) state that we must be about 'Tightening Up the Game,' and 'This Time Baby' we are not going to be turned around from our objective of total liberation.

Each artist brought his peculiar talent to the commune and exhibit. Sherman Beck, a magic maker, extended himself through the magic of his medium. Although he had no titles on his work he dealt with another realm of the spiritual essence of man which could be seen and felt in his paintings. Napoleon Henderson, the weaver, looks toward himself and Africa as his future. The title of his work does not speak of the significant symbolism, bright harmonizing colors and textiles in his words 'Doodles' 'Cool-ade Icicles' and 'Bakota.'

Yesterday, today and possibly tomorrow Gerald Williams will respond to the potential for Black Nationhood and the need to develop that potential when he created 'I Am Somebody,' 'Nationhood,' and 'Wake Up' to the King Alfred plan of concentration camps; while Omar Lama works toward positive images – images that will inspire Black people to a higher level of consciousness in 'Black Jesus' and 'United or Perish.'

Last but not least is Barbara J. Jones, who states 'Black People' a total people, a total force, Unite, Unite, as we learn of our 'Heritage' as an African in a racist country in the 'Land Where My Father Died' which need to 'Stop Genocide' while Black men must 'Rise and Take Control.'

We moved from 'Ten in Search of a Nation' homeward with important feedback from our viewers which gave encouragement, inspiration and direction for the future . . . The future works of AFRI-COBRA became stronger, more powerful and more accessible as we started creating silk screen poster prints which was another phase of our basic philosophy. The poster prints made our

images available to a larger audience at a reasonable price. For the prints, which were a total group effort, we selected one work from each artist, especially those that had been exhibited in the 'Ten in Search Of A Nation' exhibit. Carolyn Lawrence's 'Manhood,' the first print, enthralled everyone in the group as we finished the last color and saw the crystalization of many trials, errors, and color separations. The completion of the first print produced a quick production of the next three which were 'Unite,' 'Wake Up,' and 'Uhuru.' The prints which followed were 'African Solar,' and 'Victory in the Valley of Esu.' In the process of working on the prints we lost Sherman Beck and Omar Lama but we gained Howard Mallory, ceramicist-jeweler-textile designer, who did a great deal of work on producing all the prints.

In between the production of the prints we did find time to create broader visual statements about the changing conditions of our time and our people. Our new statements related the strength and determination of Angela Davis and Martin Luther King, the truth and wisdom of Malcolm X, the continual fall of Black education and the need of education to be based on the history and accomplishments of Black People. Our children have to put up a tough struggle to 'Keep Their Spirits Free.' Our images still stressed 'Nation Time,' but emphasized: 'Don't Forget the Struggle,' we all need spiritual unity as featured in 'Spirit Sister,' 'Wholy People,' and 'From These Roots' we gain strength. If we 'Get Some Land Black People,' we need land to survive for land provides the essentials which cultivate and nourish life, and 'We Must Go Home with Something.' These images were the foundation for our AFRI-COBRA II show at the Studio Museum in Harlem in the fall of 1971.

Nothing is continuously stable, and things must change, perhaps from young to old, east to west or vice versa or marching seconds of infinite time never to return. In our development we began to change; we first changed in position, time and space. The first to extend our commune was Jeff Donaldson who moved to Washington, D.C. to become the head of the Howard University Art Department early in the spring semester of 1971. Next to leave,

the Wadsworth Jarrells with one child at hand and one on the way moved eastward to Connecticut, Massachusetts, and later to Washington, D.C. The extension of our space relationship broke down our immediate communications and communal development, but it also built personal progress without the intervention of momentary feedback of criticism in our trials and tribulations which created a more responsive or irresponsive action. As we attempted communications across the country we continued to work and develop but at a slower pace. Before long another AFRI-COBRA member, Nelson Stevens, had made his way eastward to Amherst, Massachusetts, and what was six became five again. We began with five members in Chicago. The work of AFRI-COBRA will continue to grow because we have a foundation by which we have built a value system of our work and a philosophy which guides us toward a common aim of artistic endeavor. The works which are exhibited in AFRI-COBRA expressed the expansion of our creative effort in new media, new techniques, new styles and a new member, Frank Smith, painter.

Where will we go from here? As time moves so shall we, to a broader and more expanded commitment to our people visually, mentally and physically. Our new visual statement shall explore the total gamut of our existence:

The Individual and the Family

A. The growth of the individual from the cradle to the grave. We will express the physical, mental and emotional changes of the male and/or female as they develop from a baby to a child to a teenager – adult and old age; and in so doing, we can state their trials, their errors, accomplishments and success, their character, wisdom, foolishness, etc.

B. We will make visual statements of how we see the positive or negative relationship between husband and wife, mother and child, and father and children. What type of roles are we playing and are our roles relevant to our whole existence as a people. We will extend our visual imagery to speak of our relationship

and activities of our extended family – the cousins, uncles, aunts, grandparents, godparents. How they created strong influences on our life, past and present? The family relations with other families or other groups of the same or different ethnic groups. We will identify ourselves visually at this time-space and record our daily activities, our values and the styles of our day. We will record our dances, our athletics, our hobbies, our night life, our parties, our meetings, our leaders, our labors, our children and their education.

Our Visual Image Will Be Greatly Concerned with Education

A. There are different contents of education, including the spiritual education of the family. This is not to place spiritual education in the Christian church, but to state a need for a spiritual religion based on the needs of our people and a supreme being which reflects ourselves and our needs.

B. The humanizing aspects of education are respect, truth, and brotherhood: The role of man: the role of woman: the role of child and family to the total group. We must be concerned about establishing positive values and relationships in these aspects of education.

C. Our visual image will express the academic education of learning one's history, circumstances and accomplishments.

D. The industrial education of producing and being productive for self and kind in the building of every component needed to run a nation.

Our Visual Image Can State Our Social Needs and Social Services

A. Health facilities and services. Visually, what is the state of health facilities and services. We will express the need to develop our own health facilities in order to safeguard the health of our people.

B. We will express the protection of safeguarding the welfare of our old, young and those in need. We must be responsible for their welfare.

C. We will visually analyze our protective forces in the police or the use of security guards. Do they actually protect and serve our communities? If not, how can this be altered? The protection of the community and all of its components should be our responsibility and should not be allocated to an opposing group.

D. We will visually express a need to establish and develop our community institutions such as cultural, social, educational and religious or spiritual centers and provoke positive actions by visually stating how these organizations should develop the philosophy and ideology of blackness and its welfare and continuous existence.

The Economic Needs

A. We will visually state types of jobs available to our people and the types of skills and professions needed to run a nation are not just those that are teachers, lawyers, and doctors; but those who are also needed are people skilled in the technology of food, clothing and housing industries. Those who make operations run such as janitors, secretaries, programmers, repairmen, etc.

B. We will be concerned about the types of businesses and industries which must be created to be self-sufficient people.

C. We will develop new solutions to different types of needs and services which employ community personnel, yet develop and perpetuate our people as a cohesive community.

Visual Statements Concerning the Present, Past and Future Political Needs and Developments

A. What type of governmental or guidance unit should be developed and put into practice and the types of rules and regulations which should govern us as a group, which would

provoke the need for government and self-governmental plans over not today but the next twenty or thirty or one hundred years. We are kept from developing future programs because we are kept in an unbalanced state of either acting or reacting to our present circumstances. These methods and solutions to constant flux can be visually stated.

B. Political and group cohesiveness is needed to build a strong Black nation and to develop our total culture. Visually we can state the need for group action toward the positive needs in a cooperative direction.

Religious Needs

A. We will develop an image which stresses a strong religion which has us as the base of its origin with the Supreme Being and the mediator reflecting our physical being. We must illustrate stronger ties between our people and for our people. We must develop a more concrete moral code.

In fact, AFRI-COBRA can move toward stating and restating repeatedly the needs for organization, purpose, and goals of our people for a stronger cohesive body and the need for racial nationalism. AFRI-COBRA will not only state our problems and solutions but also state our emotions, our joys, our love, our attitude, our character, our total emotional and intellectual responses and feelings. Art can be a liberating force – a positive approach concerning the plight and the direction of our people. Visual imagery should bring us together and uplift us as a people into a common – a common unit, moving toward a common destination and a common destiny. WE IN AFRI-COBRA SHALL HELP BRING THIS ABOUT.

Barbara Jones-Hogu
Chicago

M54 Generation Anak Alam

Manifesto Generation Anak Alam (1974)

Generation (or *Jenerasi*) Anak Alam were a group of young, socially engaged, often self-taught Malaysian artists, who were keen to promote a Surrealist form of art inspired by the natural world (*anak alam* means 'children of nature') and free from the constraints of traditional academic teaching. Founded in 1974, during a period of emergency rule in the country originally enforced after violent race riots five years earlier, they hoped their romantic vision of collective creativity could help transcend racial and religious differences. They were multidisciplinary, embracing painting, sculpture, street performance, Concrete poetry, happenings and improvisation, and staging informal exhibitions in an old bungalow in Kuala Lumpur known as Anak Alam House, which became a meeting place for young activist writers, actors and other artists.

Although the group received some support from the Malaysian Ministry of Culture, on the whole they were considered anti-establishment by the state, and suffered continual harassment and threats of eviction from Anak Alam House. According to the founding member Ali Mabuha Rahamad (b. 1952), the authorities eventually succeeded in confiscating the house in November 1988, and later demolished it.

Generation Anak Alam's manifesto was first published in June 1974 in *Dewan Sastra* (*Arts Council*), a literary journal produced by the Malay Institute of Language and Literature.

* * *

all around us are machines assuming control,

humans making judgments
purely
in blacks and whites,
and truth is but
assigned to accepted beliefs
from times before,
and art a hobby
attached to status.
all around us are miscarriages of words about 'art'
and
speeches on art from people who know not
let alone appreciate art.
and all around us
the greens
are transforming
to bricks and glass
with dust
that compels
us to gasp for each moment of time.
and all around us
the ropes and nets of bureaucracy
are restraining
our walk
and speech
until we lose ourselves
and the reality.
we are the children of nature.
with a consciousness and a love which warms to a thousand colours
and which believes in the freedom of humanity
to announce its presence
in
a single force
of artists communicating
with
the environment
with tonalities of language

and design as our expression
that is known by all humanity.
our generation is a vessel
of enthusiasm and readiness
where the ideas
and imagination of artists
are embedded with honesty and
qualities of truth.
all art practitioners from all branches of arts
who feel this tremor
and turmoil and are with us
in this manifesto are our comrades
in the same vessel.
with no divisions of ancestry,
of skin colour,
of beliefs,
of age,
of gender and length of hair
in this generation of nature's children.

M55 Sulaiman Esa and Redza Piyadasa

Towards a Mystical Reality (1974)

In June–July 1974 the Malaysian artists Sulaiman Esa (b. 1941) and Redza Piyadasa (1939–2007) staged a controversial exhibition entitled *Towards a Mystical Reality* at the Writer's Corner, Dewan Bahasa dan Pustaka, a government publishing agency in Kuala Lumpur. The art consisted of remnants from everyday life, including a coat found in a rubbish tip, an empty bird-cage after the occupant had been released, a pot plant cared for by the artists over several months and a discarded silkscreen that had been used to make beautiful prints. Through these mundane objects they illustrated their belief that the artist was both a maker of art and the maker of ideas. Responses to the exhibition were both celebratory and visceral, with the writer Salleh Ben Joned urinating on a copy of the manifesto that Esa and Piyadasa had written in English for their catalogue.

Like the artists of Generation Anak Alam (M54), Esa and Piyadasa had been profoundly affected by the racial violence in Kuala Lumpur in 1969 that had led to an extended period of emergency rule, and they believed art had a role to play in forging a unified national identity out of Malaysia's fractured post-colonial society. The duo also declared that an entirely new, more intellectually rigorous, visual reality needed to be created in Asia in order to counteract prevailing Western artistic thought. As they strove to define the precise nature of their alternative vision, the two artists wrote about the metaphysical essence possessed by every artwork, arguing that while Western art was focused on outward form, Asian artists have always endeavoured to emphasize the innate spirit within their work.

* * *

One: The Dilemma of Modern Malaysian Art

The present exhibition has been motivated by the two participating artists' desire to raise some questions regarding the direction of Malaysian art in the 1970s. In attempting to do this, we are, however, not limiting ourselves to a wholly provincial outlook. It is our belief that the questions we are raising relate directly to a greater Asian situation and as such, we are not functioning within 'nationalistic' considerations. This is especially so because the kinds of problems faced by Malaysian modernists today are also being faced by Asian modernists elsewhere who are beset with the dilemma of having to employ idioms and styles which are not altogether indigenous to their own cultural traditions. The flirtation with modern art influences which seems to have manifested itself over the last fifty years at least certainly reflects a cultural dilemma of sorts. Several factors may be attributed to it and perhaps, the most important is the general displacement faced by the Asian artists who have found themselves uprooted from their own cultural influences. The very long period of exposure to colonial domination has certainly contributed to the general disruption. Clearly, the link with a traditional culture is all but severed today as far as the plastic arts are concerned. What with 20th century scientific and psychological advancements, the serious Asian modernists have been left with little choice but to lean heavily on a modern art tradition that has its origins in the western scientific and intellectual climate.

That vague generalisations still persist today regarding the notion of a 'western-centric' and 'eastern-centric' approach to art only reflects the complexity of a situation that is as yet not fully understood by most Asian artists themselves. The general tendency amongst Asian artists to become involved with picture-making pursuits which still persists today does not seem to have made it easier to understand the problem for what it is. No real attempts have been made to requestion the underlying considerations which have given rise to this artistic dilemma which is peculiarly Asian.

That so much modern art produced in Asia these last few decades has tended to be trivial underlies the seriousness of the situation. THE PRESENT EXHIBITION THEREFORE ATTEMPTS TO RAISE SOME PERTINENT QUESTIONS ABOUT THE SITUATION AND OFFER SOME ALTERNATIVES. WHILST DEALING WITH SPECIFICALLY 'MALAYSIAN' REFERENCES, THE QUESTIONS RAISED HOWEVER APPLY DIRECTLY TO THE MODERN ART SCENE IN ASIA. ANY ATTEMPT TO VIEW OUR CONTRIBUTIONS WITHIN A PURELY 'MALAYSIAN' CONTEXT CAN ONLY RESULT IN A FAILURE TO REALISE THE IMPLICATIONS OF THE QUESTIONS WE ARE ATTEMPTING TO RAISE. THE PRESENT EXHIBITION DEALS WITH A KIND OF SITUATION WHICH PREVAILS IN MANY PARTS OF ASIA WHERE SOME KIND OF MODERN ART INVOLVEMENT EXISTS.

It seems necessary from the outset to state that we are MODERN artists and as such, we are not involved with traditional Asian art forms. We are however borrowing from Asian philosophies in order to come up with an attitude which we hope will help enrich the international modern art movement which needs to be considered in global terms these days. It is therefore not our intention to condemn or criticise all the major developments that have taken place in the west after the advent of the School of Paris. WE ARE HOWEVER ATTEMPTING TO WORK OUTSIDE THE WESTERN-CENTRIC ATTITUDE TOWARDS FORM. WHAT WE ARE TRYING TO DO IS TO SOW THE SEEDS FOR A THINKING PROCESS WHICH MIGHT SOMEDAY LIBERATE MALAYSIAN ARTISTS FROM THEIR DEPENDENCE ON WESTERN INFLUENCES. It is our belief that all modern art produced in Malaysia up to the present time has not been altogether free of some kind of eclectic influences derived from the various '-isms' of the west. Clearly, there has as yet been no real attempt to re-question this underlying eclecticism behind our flirtation with idioms and styles derived from the major art

movements of the west. Ours has been a total dependence on a system of aesthetics that derives its impetus from western philosophical considerations. Malaysian artists have, as a result, not been able to come up with a viewpoint of reality that differs from that being adopted by western artists. So long as we do not attempt to requestion the philosophical basis upon which we are functioning, we will go on producing works which for all their technical brilliance can only remain derivative and at worst, imitative!

IT IS OUR BELIEF THEREFORE THAT MALAYSIAN ART CAN ONLY BECOME PRODUCTIVE AND CREATIVE WHEN OUR ARTISTS BEGIN TO FUNCTION ON A VERY MUCH MORE DEEPER LEVEL THAN THAT WHICH HAS EXISTED TO DATE. To do this our artists will first of all have to requestion the kind of developments that have taken place so far. That the artistic activity has by and large been influenced by a 'picture-making' rather than a 'problem-solving' approach to art certainly accounts for the absence of any polemical or dialectical tradition within the local art scene. Too many artists, for instance, remain incapable of discussing their works formalistically and too many remain oblivious of the implications of those modernist idioms that they are manipulating. Nor is there any serious attempt made to view their contributions within the context of time. The notion which still persists that artists do not have to verbalise on or justify their work certainly underlies a kind of thinking which accepts the artist as essentially a maker of artefacts and not as a thinker or theoretician. Perhaps such an attitude might have been excusable 20 years ago but certainly it is out of joint with the times in the 70s. That Malaysian art in the 70s has still to surmount these considerations certainly reflects the seriousness of the situation.

THE GENERAL ABSENCE OF A SERIOUS INTELLECTUAL AND POLEMICAL ATMOSPHERE WITHIN THE MALAYSIAN ART SCENE THEN BECOMES A CRUCIAL PROBLEM THAT NEEDS TO BE SURMOUNTED IN THE 70s. IT MUST BE OVERCOME. The absence of an intellectual

tradition for the most part despite the fact that we have so many trained artists today may be attributed to several factors. A superficial involvement with stylistic and technical considerations alone certainly seems to have limited the involvement to a 'picture-making' one in most cases. Very little attempt has been made to consider the aesthetic and philosophical aspects of the artistic commitment. Where there has been some kind of attempt made to consider aesthetics there has unfortunately been not enough understanding of the particular issues being dealt with. Again the general tendency amongst local artists to have ignored the relevance of Art History and the history of ideas must surely account for the weakness of so many artists when it comes to a reconsideration of the rationale behind their work. Too many of our best artists have become exhausted of ideas within a few years and ceased to become committed to Art because of this. That so many of our best artists of the last ten years have become bogged down by stylistic idiosyncrasies and artistic whimsicalities certainly necessitates a very serious requestioning of our involvement with modern art under the circumstances. How valid is such a superficial commitment to the language of modernism? It is our belief that if Malaysian artists are going to become involved with modernism they should at least know their area of involvement thoroughly and meaningfully! Until this is done, our modern artists for all their technical brilliance will never succeed in arriving anywhere. It will remain very much a closed circuit activity that cannot possibly become productive and innovative!

There are many other important reasons for the inability of local artists to function on a much deeper level than that which has manifested itself so far. Perhaps the most serious has been the tendency by so many of our artists to become involved with modernistic idioms and yet go on functioning on the basis of essentially 19th century attitudes toward creativity. The idea of the 'uniqueness' of the artist and his work has, for instance, certainly been dictated by a 19th century Romanticism and by the notion that art is essentially for the museums and the art gallery. ONE RESULT OF THIS

KIND OF REVERENCE FOR THE SACREDNESS OF ART AND FOR THE SALEABILITY OF ONE'S WORK HAS CERTAINLY BEEN A REFUSAL TO CONSIDER OTHER POSSIBLE FORMS OF EXPRESSION. THE OBSESSION WITH TRADITIONAL ARTEFACTS CONTINUES THERE-FORE EVEN IN THE 70s AND WITH IT A SLAVISH DEPENDENCE ON TECHNIQUES WHICH REFLECT MANUAL DEXTERITY RATHER THAN MENTAL DIS-CIPLINE. It is still very much an 'artefact-oriented' attitude which prevails even today and it is no wonder then that so many of our supposedly 'modern' artists still persist in carefully stretching their canvases and laboriously preparing their etching-plates! The general absence of a sculptural involvement so far amongst our artists certainly points to the fact that our artists have so far been not so much interested in the many dimensions of reality as with the making of pretty 'pictures' that will hang on a wall! In retrospect, the works produced so far have constituted little more than exercises in good taste. Modern Malaysian art proper has hardly begun.

The local artists under the circumstances have never come face to face with the analytical and requestioning nature of modern art. The search for a new viewpoint of reality or a new means of reflecting reality has certainly witnessed no real incentives so far. The kind of academicism that passes off for modernism in Malaysia then needs to be very seriously requestioned. What is the function of the Malaysian artist within the Malaysian context and what is the lesson to be learnt from the modern art developments which have manifested themselves in the west so far? THE ANSWER CERTAINLY DOES NOT LIE IN THE EMULATING OF EXPRESSIONIST INFLUENCES OR EVEN CONSTRUC-TIVISM. THE ARTISTS IN THIS EXHIBITION ARE THEREFORE REJECTING ALL THE DEVELOPMENTS WHICH HAVE TAKEN PLACE IN MALAYSIAN ART SO FAR, ESPECIALLY THE ABSTRACT EXPRESSIONIST INVOLVEMENT OF THE 60s AND THE CONSTRUCTIVIST 'NEW SCENE' INVOLVEMENT OF THE LATE 60s AND

EARLY 70s. WE BELIEVE THAT THESE TWO GROUPS OF MALAYSIAN ARTISTS WHO CONSTITUTE THE TWO MOST SERIOUS GROUPS OF ARTISTS TO HAVE EMERGED SO FAR HAVE FAILED TO COME UP WITH ANY REAL SOLUTION TO THE DILEMMA OF MODERN MALAYSIAN ART. THE FACT THAT ALMOST ALL THE ARTISTS WHO FUNCTIONED WITHIN THESE TWO 'MOVEMENTS' HAVE BEEN UNABLE TO CONTINUE DEVELOPING MEANINGFULLY FOR ANY ACTUAL LENGTH OF TIME CERTAINLY UNDERLIES AN INABILITY TO CONTINUE MANIPULATING THOSE INFLUENCES WHICH THEY HAD ATTEMPTED TO INTRODUCE. IT IS OUR BELIEF THAT THERE WAS, IN THE FINAL COUNT, NO REAL INTELLECTUAL CON-VICTION BEHIND THEIR INVOLVEMENTS! THE COMMITMENT, IN RETROSPECT, HAD TENDED TO BE MOTIVATED BY STYLISTIC RATHER THAN INTEL-LECTUAL CONSIDERATIONS AND NO WONDER THEN THAT THE ARTISTS OF THESE TWO MOVEMENTS HAVE SO EASILY CEASED TO PRODUCE WORKS. THE MOST MOTIVATING INFLUENCE ON ANY WORTH-WHILE ARTIST HAS, IN THE FINAL COUNT, BEEN HIS ARTISTIC CONVICTION. THIS FACTOR IS, SADLY, MISSING IN MALAYSIAN ART!

It is our belief therefore that some honest reconsiderations be made at this juncture in the 70s. Perhaps, the most important will have to do with the nature and function of art within the Asian context. Some interesting observations may be made when we begin to look at the art forms which appeared in the Asian past. If in the past, Asian artists had produced works which reflected the under-lying philosophical and religious attitudes within which they lived and functioned there is today an almost total absence of such com-mitment. If in the past, Asian art had reflected particular cultural considerations there is today a very serious absence of such influ-ences. The modern Asian artists have by and large opted for a

scientific and rationalistic attitude and ignored the mystical and religious considerations which helped produce the great artistic traditions of Asia in the past. Clearly, the dilemma of modern Asian art to a very large extent has been the inability of Asian artists to identify themselves with their own cultural and philosophical traditions and values. The long periods of colonial domination plus the advent of a 20th century scientific materialism seems to have overwhelmed the Asian artist and left him dependent on a wholly rationalistic outlook. His art forms have changed in the process and he today mirrors an almost total dependence on artistic influences which are the outcome of a tradition which found its impetus in the west. The story of modern Asian art, ironically, has really been the story of an almost self-conscious attempt to escape this tradition! Very few Asian artists up to the present time have attempted to study the problem at its roots. THIS EXHIBITION IS AN ATTEMPT.

The argument that a scientific and rationalistic attitude toward artistic creativity is very inevitable in the light of a 20th century materialism seems somehow to ignore the very essence and purpose of art which is the heightening of the spectator's perception and experience of reality. The artist HAS a choice and he CAN dictate the process of perception. IT IS OUR CONTENTION THAT THERE ARE ALTERNATE WAYS OF APPROACHING REALITY AND THE WESTERN EMPIRICAL AND HUMANISTIC VIEWPOINTS ARE NOT THE ONLY VALID ONES THERE ARE. AS SUCH, THE TENDENCY AMONGST MODERN MALAYSIAN ARTISTS TO HAVE SUCCUMBED TO A WESTERN-ORIENTED VIEWPOINT OF REALITY WHICH BEGAN IN THE EUROPEAN RENAISSANCE (REALLY, GREECE!) SEEMS INDICATIVE OF AN EASY CAPITULATION TO A SCIENTIFIC VIEWPOINT OF REALITY. THERE HAVE, IN FACT, BEEN VERY FEW ATTEMPTS MADE BY ASIANS (EXCEPTING PERHAPS FOR SOME JAPANESE ARTISTS) TO SUBSTITUTE AN ALTERNATIVE APPROACH IN THE APPRECIATION OF

REALITY. ONE RESULT OF THIS READY ACCEPTANCE OF THE WESTERN VIEWPOINT HAS CERTAINLY BEEN THE INEVITABLE DEPENDENCE AND EMULATION OF FORMS AND IDIOMS THAT HAVE THEIR ORIGINS IN THE WEST. AS SUCH MOST MODERN ASIAN ARTISTS WILL NEVER BE ABLE TO COME UP WITH CONTRI-BUTIONS THAT ARE TOTALLY OUTSIDE THE WESTERN EXPERIENCE. AS SUCH, THEY CANNOT POSSIBLY MAKE ANY SIGNIFICANT CONTRIBUTIONS TO THE INTERNATIONAL MODERN ART SCENE. THEY WILL GO ON PRODUCING WORKS, WHICH NO MATTER HOW EFFICIENT THEIR HANDLING OF WESTERN-ORIENTED IDIOMS, WILL ALWAYS REMAIN DERIVATIVE AND SECOND-RATE!

Two: 'Anti-Formalist and Anti-Aesthetic'

The present exhibition needs to be viewed as an extension of the 'Dokumentasi 72' show which was held at the Dewan Bahasa Dan Pustaka in May 1972. The exhibition featured the results of our individual experiments carried out between December 1970 and May 1972. We were then very much influenced by Post-War devel-opments in Constructive Art. In accepting the actual physicality of things, we had reached a point where our works drew attention to the 'realness' of the elements that we were employing. We had abandoned illusionistic devices altogether by 1971 and had become involved with actual space, actual time and actual light. Problems pertaining to actual gravity and movement were also manifesting themselves in our scheme of things then. Our approach at that time was however still dictated by 'formal-aesthetic' considera-tions. THE DIRECT CONFRONTATION WITH A REALITY THAT WAS NO LONGER DEPENDENT ON ILLUSION-ISTIC DEVICES HOWEVER FORCED UPON US A RE-CONSIDERATION THAT HAD TO BE MADE IF WE WERE TO CONTINUE WITH THE MANIPULATION OF ACTUAL PHYSICAL SITUATIONS. HOW, FOR INSTANCE,

WERE WE GOING TO CONFRONT PHYSICAL REALITY? AS CONSTRUCTIVE ARTISTS, WE HAD UNTIL THEN TENDED TO VIEW REALITY SCIENTIFICALLY AND OBJECTIVELY BUT AFTER THAT SHOW, WE BEGAN TO CONSIDER THE POSSIBILITY OF APPROACHING REALITY FROM AN ALTOGETHER DIFFERENT PREMISE. The examples of certain modern Japanese artists who had attempted to view reality from an essentially oriental standpoint tempted us to requestion the validity of a scientific and materialistic viewpoint of reality that is essentially western in origin. This exhibition is the outcome of several developments which took place following that decision nearly two years ago.

There were two fundamental issues that occupied our attention after the 'Dokumentasi 72' show. We requestioned two essential considerations behind the traditional work of art, namely, (i) THE RELEVANCE OF 'FORMAL-AESTHETIC' INFLUENCES IN THE WORK AND (ii) THE HUMANISTIC NOTION OF THE ARTIST AS A 'UNIQUE' INDIVIDUAL AND HIS EGOCENTRIC INVOLVEMENT IN THE ACTUAL CREATION OF A WORK.

We were at that time fully aware of the 'anti-formalist' developments which had taken place in the west during the 1960s. Having arrived at a point where we were faced with the prospects of having to deal with the actual physicality of things, it seemed natural that we should requestion the validity and effectiveness of 'traditional' art-forms (i.e. painting, sculpture, relief, print, etc.). Our attention was inevitably drawn to such 'anti-art' artists as the Dadaists, Marcel Duchamp, Yves Klein, Piero Manzoni, Tinguely and John Cage (the composer of 'silent music'). The conceptual work of the Japanese Conceptualist Yoko Ono also interested us at this point. The realisation that it WAS POSSIBLE to jettison all formalistic and aesthetic considerations from the work of art drew us quite inevitably to the notion of art as Conceptual experience. We became determined to work outside 'formal-aesthetic' considerations. Again, the realisation

that so many of the 'anti-art' pioneers of the west had in fact been inspired by essentially oriental philosophical considerations certainly bolstered our determination to function outside 'western-centric' considerations.

There were some implications about the move toward a Conceptual involvement, however. For one thing, we realised that our art-college backgrounds had left us with very little to go on with. The many skills that we had acquired suddenly seemed irrelevant and with it, the many aesthetic theories that we had been exposed to in Art History. The crucial issue now seemed to point to a philosophical involvement! It was here that we found ourselves very inadequate. One outcome of this realisation has been a voracious reading programme that has lasted nearly two years. We read eastern as well as western philosophy. The realisation that the task at hand was a complex one resulted in our deciding to enter upon an intellectual collaboration that was to finally lead to our deciding to produce works together. This was not to be achieved until very much later but it seemed inevitable even then in 1972.

The voracious reading programme then constituted the most important aspect of the search. Besides reading philosophy, we also read books on the art of the east and west in the hope of discovering essential differences which exist between the artistic traditions of the east and the artistic traditions of the west. We began to find even at this stage that local artists were unable to help us very much as their interests lay in 'picture-making' pursuits that were still dependent on stylistic and technical considerations that are linked to a 'formal-aesthetic' approach. One outcome of this fact has been a dependence on persons outside the Malaysian artistic community. We consulted at various stages people outside the art scene who were very well-versed in the history of ideas and with the evolution of historical events. We consulted university lecturers, historians, sociologists, religious experts, writers and dramatists. The search for a philosophical rationale that would allow us to function outside

a 'western-centric' viewpoint of reality demanded that we think and function beyond the confines of art itself.

The desire on our part to reject 'formal-aesthetic' considerations in our scheme of things must also be attributed to our belief that what is needed in modern art in the 70s is not so much an involvement with techniques and styles but rather a new way of confronting reality that is not hampered by purely 'artistic' considerations dependent on formalistic and aesthetic criteria. Very simply, the crucial issue in modern art today is not so much the problem of how we 'see' things (visual/retinal) but how we 'conceive' reality (conceptual). This new attitude in art today demands that we requestion the very validity of a codified Art Criticism which has so far been founded upon aesthetic and formalistic criteria. That the validity of a schematised art criticism founded on an objective methodology is today being attacked by younger artists points to a deliberate desire on the part of the serious artist of the 70s to view aspects of reality without the limitations of certain 'relationships' of codified data which are based upon the art historian's form-inspired view of art. There is today a deliberate desire on the part of the most serious artists to understand 'phenomenal' processes via dialectics and this seems to have brought the artist to a position that is akin to that of the philosopher's! The deliberate attempt to reject the myth of the 'unique artistic soul' and with it, the notion of the artistic experience as being an interplay of esoteric circumstances between the 'artist/creator' and his 'stimuli' has in fact been motivated by a new respect for the spectator's ability to confront reality directly. This new reconsideration of the spectator's relevance in the whole scheme of things has in fact resulted in a reconsideration of the very purpose of art itself.

THAT ART IS BECOMING A VERY DIALECTICAL AND CONCEPTUAL ACTIVITY TODAY IS INDICATIVE OF A NEW STATE OF AFFAIRS WHICH SUPPOSEDLY 'MODERN' ASIAN ARTISTS ARE YET TO BECOME AWARE OF! Aesthetic and formalistic influences then become

quite irrelevant and obsolete in the new scheme of things for they are essentially founded on the notion of art as something that is 'created' out of the manipulation and organising of the various elements of design (i.e. line, shape, colour, texture, form, surface, design, etc.). Very clearly, the modern art commitment today is pointing to an involvement that transcends preoccupation with the manipulation of materials and styles and finding its raison d'être in a dialectical reconsideration of phenomenal processes that exist outside a 'form-oriented' notion of art. The artist has, as a result, been forced to requestion the nature of his idioms.

The notion of art as a conceptual and dialectical activity then demands that the artist equip himself with the means to undertake such a complex activity dealing with the world of pure ideas! He has, as a result, been forced to look beyond technical skills and equip himself with some semblance of awareness of such diverse areas of knowledge as philosophy, linguistics, psychology, sociology, physics, mass-communication and even mathematics! The effectiveness of any serious artist of the future therefore will depend on his ability to think and function beyond the confines of 'traditional' notions of art itself. The best modern artists of the 70s are very clearly no longer makers of artefacts but rather thinkers and theoreticians and this fact must surely place their contributions on the same level as those of the most creative and influential minds of our epoch. Art is finally shedding its somewhat traditional function and acquiring a new significance that places upon the serious artist of the 70s a whole new challenge.

Three: 'No Humanistic or Subjective Intent'

We discussed the possibility of jointly-producing works even as early as 1972. The idea of producing works jointly brought with it some reconsiderations that had to be made about the artist's ego in our scheme of things. The question of the artist's ego in fact drew our attention to some fundamental differences which exist between the 'western-centric' and 'eastern-centric' modes of artistic expression.

The Humanist viewpoint with its emphasis on the artist as an individual and its scientific and objective view of reality, we found, contrasted with the traditional Asian view of things as it had once existed. The attitude toward Nature, for instance, was not so much 'felt' as in the case of the Chinese artist but observed and analysed on the basis of its outward appearances by western artists from the Renaissance onwards. The essential difference then was not so much one of viewpoint as that of attitude, we found. WHEREAS ONE WAS MOTIVATED BY MYSTICAL CONSIDERATIONS, THE OTHER WAS ESSENTIALLY SCIENTIFIC! Again, the realisation that all our important Malaysian artists have in fact functioned within a Humanistic and rationalistic attitude which stems from the European Renaissance of the 15th century seemed quite absurd to us. No one had bothered to requestion this tendency!

The essential difference between the individualistic approach of the western artist with his egoistic preoccupations and that of the oriental artist who remains a nonentity in his confrontation with Nature is also worth considering. Benjamin Rowland in his 'Art in East and West' sums up the situation by discussing the work of Michelangelo and the eighth-century Chinese painter, Wu Tao-tzu:

'Michelangelo's violence and dynamic contortion appear as the outward manifestation of an internal conflict of forces mutually stimulating and paralysing each other. These titan forms are typical of the West, in that they are called from the vasty deep of the soul of an individual genius and are the expressions of his unique reaction to the world. Wu Tao-tzu's forms are not so much expressions of an individual's own state of emotion, but universal graphic portrayals of the flux of the world movement in action, the force that sucks up the tide and breathes whirlwinds. Wu Tao-tzu's design has no humanistic or subjective intent!'

IT WAS THE SELF-EFFACING ASPECTS OF ORIENTAL ART THEN THAT BEGAN TO ATTRACT OUR

ATTENTION. That so many modern Asian artists involved with modern art have so readily accepted the scientific and humanistic view of things without having bothered to reconsider any other possibilities seems to us quite sad today. That they have up till the present time never bothered to requestion their acceptance and manipulation of art-forms derived from the west must certainly account for the fact that up till now all the art-forms produced have tended to remain little more than echoes of their western originals. CLEARLY, WE FOUND OURSELVES REQUESTIONING THE TYPES OF FORMS THAT WE COULD POSSIBLY MANIPULATE AND THE PURPOSE OF THESE FORMS. WE NOW HAD TO PURGE OURSELVES OF ALL WESTERN-CENTRIC INFLUENCES IN ORDER TO PRO-CEED FURTHER. THE DECISION TO THROW OVER-BOARD EVERYTHING THAT WE HAD LEARNT IN A WESTERN ART COLLEGE BECAME A NECESSARY PRE-REQUISITE. THERE WAS NOW A SERIOUS NEED TO RECONSIDER THE 'ROLE' OF THE ARTIST IN OUR NEW SCHEME OF THINGS.

Our interest in the self-effacing role of the artist must certainly explain our decision to start looking at the traditional artistic forms existing within the indigenous cultural traditions of Malaysia. Our special interest in the 'Wayang Kulit' [shadow puppetry] repertoire and especially, the role of the 'Dalang' or the manipulator of this indigenous form of shadow-puppetry was to result in our discovering a new 'role' for ourselves in our new scheme of things. The 'Dalang' suggested to us the possibilities of functioning within a 'mediumistic' capacity. What seemed especially interesting about the 'Dalang' was that whilst he had to mouth all dialogue in the plot and play out the parts of all his puppets, the audience never saw him or learnt anything about him! His self-effacement, we discovered, was almost complete even if he constituted the real force in the whole performance! He was quite simply the 'medium' and the 'initiator' between the audience and his puppets. Here was very clearly an 'oriental' artist who functioned with no humanistic or

subjective influences! Our idea of the artist as functioning within a 'mediumistic' capacity then must be attributed to the 'Dalang'.

It was at this point that we decided to produce works jointly. THE DECISION TO PRODUCE WORKS JOINTLY WAS MOTIVATED BY OUR DESIRE TO PLAY DOWN INDI-VIDUALISTIC CONSIDERATIONS AS FAR AS THAT WAS POSSIBLE. ALL DECISIONS WE DECIDED WOULD BE MADE JOINTLY AND NO EMOTIONAL CONSIDER-ATIONS WOULD BE ALLOWED TO DICTATE THE MANIPULATING OF THE FORMS THAT WE WOULD USE. THE OBJECTS WE WOULD USE, AS FAR AS IS POSSIBLE, WOULD NOT BE CONSTRUCTED BY US. IN A SENSE, WE WERE AIMING AT A CONSCIOUS DETACH-MENT FROM THE WORK OF ART. THERE WOULD BE NO HUMANISTIC OR SUBJECTIVE INTENT! OUR WORK, WE ALSO DECIDED, WOULD BE MYSTICAL IN NATURE.

Four: The Relevance of a Mystical Viewpoint

The decision on our part to approach the artistic involvement from a mystical rather than scientific standpoint must inevitably raise certain questions about the relevance and validity of such an under-taking in the light of 20th century conditions. There are those who will no doubt question the relevance of a mystical approach and dismiss it as a somewhat 'unrealistic' involvement in the context of our scientific and technological times. Are we not guilty of func-tioning on the basis of something that is vague and difficult to account for? Our answer to such a question would be that a mys-tical approach is as valid today as it was before simply because the very basic questions about life and death still remain with us and with it, the desire to attach some kind of meaning to our very exist-ence! The overbearing materialism of the west seems somehow to have forced our attention to a consideration of tangible rather than intangible forces and no less an artist than John Cage, the composer of 'silent music', has drawn attention to the dilemma of modern

man. Calvin Tomkins in his book, 'Ahead of the Game' describes Cage's attitude toward the situation:

'Cage believes that the world is changing more rapidly and more drastically than most people realise. A great many of the traditional attitudes of western thought will soon be obsolete, he feels, and a great many of the older traditions of oriental thought are becoming increasingly relevant to life in the west. Cage insists that the true function of art in our time is to open up the minds and hearts of contemporary men and women to the immensity of these changes in order that they may be able "to wake up to the very life" they are living. Art and life, for Cage, are no longer separate entities as they have been in the western past, but very nearly identical; and Cage's whole career can in fact be seen as a long campaign to break down the demarcations between the two.'

It is perhaps interesting to note that (i) John Cage was very much inspired by Zen Buddhist influences and (ii) that art and life have never been divorced in the East! Professor Daisetsu Suzuki, the great Zen scholar, has in fact alluded to this fact in his book, 'Mysticism: Christian and Buddhist':

'In the same way, every minute of human life as long as it is an expression of its inner self is original, divine, creative and cannot be retrieved. Every individual life is thus a work of art. Whether or not one makes it a fine inimitable work of art depends upon one's consciousness of the working of "sunyata" [emptiness] within oneself.'

We wish to quote the opinion of yet another western art-critic in our efforts to prove the relevance of a mystical approach in art today. Kenneth Coutts-Smith in his article 'Violence in Art' which appeared in 'ART AND ARTISTS' (Aug. 1966) states:

'Art is not an isolated phenomenon, or a matter of simple aesthetics, but is on the one hand part of our total experience, both psychologically and socially, and on the other an objectification of our "inner" experience. But we have, as Ronald Laing has pointed out, "largely lost touch with our

inner world in gaining control of our external world. We have become strangers to our own experience, we have become alienated from ourselves".'

The relevance of a mystical approach then should seem meaningful enough. In the deliberate attempt to reject a materialistic viewpoint of reality we are simply returning to an artistic attitude that is essentially oriental. The desire to search for an approach that will induce a direct 'spiritual' rather than 'intellectual' involvement on the part of the spectator underlies the adoption of an alternate approach from that employed by the western artist. It is as such not a nihilistic involvement nor is it destructive in outlook. IT CONSTITUTES A VERY POSITIVE AFFIRMATION THAT ART, AT ITS MOST PROFOUND, AFFORDS THE VIEWER A MYSTICAL PSYCHIC EXPERIENCE THAT LEADS HIM DIRECTLY TO LIFE ITSELF.

That there is today in the west a serious need for mystical and spiritual commitments is certainly indicative of a somewhat unusual situation which has arisen out of the western society's overemphasis of materialistic values. One needs only to be reminded of the many pseudo-religious cults that have manifested themselves in the U.S. lately to become aware of the general absence of 'inner' peace in the west. Again, the tendency amongst the younger generation in the west to seek a 'higher reality' via the taking of hallucinogenic drugs certainly underlies a crying need for the balming and soothing influences that mysticism can provide. In the face of a technologically-inspired alienation from life itself, the search for 'inner' peace becomes one of the crucial problems of our time. There are certainly many lessons that the Asian artist can learn from the developments taking place in the west and one of these is the very relevance of his oriental view of life and the world around him. It is perhaps symptomatic of our times that a mystical and spiritual viewpoint is so often ridiculed and dismissed as 'old-fashioned' by Asians themselves in the face of a growing materialism!

It is our belief that the strength of the Asian artist of the past (especially the Far Eastern artist) lay in his ability to view life and reality in terms of the meditative and the spiritual. The mystical attitude of the eastern artists with its 'spiritual' rather than 'intellectual' outlook certainly contrasts with the notion of 'art for art's sake' that seems to be the fashion these days. Art in the Asian past was never meant to provide 'intellectual entertainment' but rather it aimed at a heightening of one's awareness of reality and helped bring about a spiritual and mystical communion with nature and the Universe itself. As such, there was no dichotomy between art and life. Again, that so many major western artists of the 20th century have in fact drawn their inspiration from the mystical philosophies of the east (e.g. John Cage, Yves Klein, Ad Reinhardt, [Mark] Tobey, [George] Brecht) certainly indicates how necessary it is for Asian artists to reconsider their Asian heritage. The tendency amongst so many creative Asian artistes (be they artists, writers, poets, dramatists, or musicians) to go on functioning on the basis of a 'western-centric' aesthetics and formalism whilst remaining oblivious of their own artistic and philosophical traditions is certainly indicative of a very sad state of affairs which prevails all over Asia today!

It seems necessary here to discuss some fundamental differences which exist between the mystical and materialistic philosophical viewpoints for an understanding of their essential differences might allow for a better appreciation of reality itself. If the scientific viewpoint draws its impetus from an empirical approach founded on 'logical' demonstration, the mystical viewpoint functions on the basis of 'feeling' and 'intuition'. What seems especially interesting is that whereas the scientist aspires toward an 'intellectual' understanding of the tangible forces of nature via 'objective' research and analysis the mystic strives toward a 'spiritual communion' with the unknowable forces of the Universe via 'mental' contemplation and meditation. As a rule, the scientist has tended to dismiss mystical considerations in his adherence to a 'no nonsense'

approach to things whilst the unperturbed mystic on his part has tended to smile tolerantly at the scientist's objectivity. It used to be a truism that positivist science would not admit anything that could not be explained 'objectively' but things seem to have changed. If in the past 'intuition' had seemed a suspicious word to the scientist, it is today becoming a necessary key to new discoveries. After all, how many significant scientific 'breakthroughs' have been made on the basis of notions that first manifested themselves as 'intuitive' deductions! Similarly, if previously science had refused to function on the basis of uncertainties, there is today a greater willingness to entertain factors which cannot be explained logically. A classic example in 20th century physics is Heisenberg's 'uncertainty principle' which marks the limit of the scientist's interest in the electron's exact nature and location in space. There have been profound changes in western thinking in the last ten years as regards the nature of the physical world, most clearly expressed in the physical sciences. No longer do scientists believe in a finite world or in the permanence of matter. The physicist may describe it in terms of waves, particles, or energy, according to the aspect of nature which he is investigating and he no longer speaks of objects but of events. It is interesting to note that oriental mystics have in fact been advocating the notion that reality and our world is a collection of processes rather than entities nearly 2,000 years ago!

The last ten years have witnessed many new discoveries which have upset the scientist's traditional insistence upon 'objective' scrutiny. One result has certainly been a new willingness to have second thoughts about the mystic. No wonder then that an eminent American scientist, Dr. Elmer Green of the Menninger Foundation chose to spend months in India sticking all kinds of wires on the body of a meditating Indian Yogi who remained quite oblivious of the happenings going on around him. The naked Hindu fakir resting on his bed of nails has evidently begun to interest the scientist! Again, the realisation that only one-tenth of the workings of the human brain is known to science has certainly brought with it a new reconsideration of such things as ESP and EEG which were at

one time dismissed as mystical nonsense. In the field of cosmology, some of the most remarkable discoveries have been made that have upset traditional notions about the Universe. It is coming from all sides now – the inexplicable and the extraordinary. Matter over anti-matter, time flowing backwards, black holes in space, particles flying faster than the speed of light and passing through Earth without bumping! WHAT WE ARE TRYING TO SUGGEST QUITE SIMPLY IS THAT THE SCIENTIFIC AND EMPIRICAL VIEWPOINT OF REALITY IS NOT THE ONLY VALID ONE THERE IS. THE MYSTIC'S VIEW OF THE UNIVERSE IS ALSO VALID FOR THE MANY PARALLELISMS THAT ARE BECOMING APPARENT TODAY. In so many cases, the differences are no more than linguistic differences. What the Taoist mystic referred to as the 'Chi' or Hindu yogi refers to as the 'samsara' may be described scientifically as that 'energy' which can neither be created nor destroyed but which may be transformed! WHAT WE ARE INSISTING IS THAT THERE ARE MANY LEVELS OF REALITY AND THE SCIENTIFIC AND EMPIRICAL VIEWPOINT ONLY LEADS TO AN UNDERSTANDING OF ONE FACET OF THAT REALITY. No less a thinker than Arthur Koestler, a scientifically-trained western writer, has openly admitted to this fact. In his book, 'The Roots of Coincidence' Koestler admits:

'I have no patience with religious dogma. As for mysticism, it's an undefined term. I just say there are other levels of reality than those we see with the eyes of the common man, of the scientist.'

Five: A Mystical Concept of Time and Event

The search for a philosophical rationale within which we could function constituted our most serious problem. It must be stated at this juncture that we were not interested in any specifically 'Asian' forms or imagery but rather in a viewpoint that would allow us to work outside the western-centric attitude toward form. We had chosen to work outside the 'western-centric' approach (with its

Humanistic, materialistic and empirical connotations) and were now interested in approaching art from a mystical standpoint. In our search for a suitable Asian philosophical tradition, we were careful however to avoid those traditions which had their origins in the notion of an absolute and moralistic God. We did not want to become encumbered by moralistic and religious issues! A close scrutiny of the various Asian philosophical traditions then drew us to Taoist/Zen influences. The Taoist view of things with its emphasis on the spontaneity of 'feeling' and its 'peripheral' viewpoint of reality seemed to us a direct contrast to the scientific objectivity of the west. Again, it was very free of dogma. The fact that Taoist/Zen attitudes emphasised a 'mental' (i.e. mind) rather than 'retinal' (i.e. eye) view of the world convinced us that our answer might lie in this direction. It seems necessary to state at this point that Taoism (and Zen, which springs from it) is essentially a philosophy rather than a religion. Taoist thinking concerns itself with the understanding of life and reality directly instead of in the abstract, linear terms of representational thinking.

Our interest at this stage was with the perception of reality itself. We were now faced with two particular ways of perceiving reality. There was firstly a conscious one-thing-at-a-time 'central' vision that went back to the European Renaissance and there was the 'peripheral' vision of the Taoists which envisaged reality as a never-ending continuum of 'events'. If in the west, the tendency had been to isolate aspects of reality and study them consciously, in the Far East the tendency had been to observe reality in its entirety. The 'peripheral' vision of the Taoist mystic thus allowed for the noticing of objects and movements not in the line of a 'central' vision! It is perhaps interesting to note that the Taoist mystic had utilised this manner of looking at things nearly 2,000 years ago and that the west was not to accept this viewpoint until Einstein published his theories on matter, time and space. Picasso's much celebrated Cubism was, in retrospect, a very belated attempt to correct the limitations of the Renaissance artist's Euclidian view of reality!

On the face of it, the kind of 'peripheral' viewpoint we have borrowed from the Taoist/Zen mystics might appear similar to the viewpoint accepted by the western artist after the advent of Cubism and Constructivism. It is our belief that there are certain parallelisms but whereas the western artist still persists in viewing the physical state of the world, we are essentially approaching reality from a purely 'mental' and 'metaphysical' standpoint. The essential differences between the Taoist point of view and that of the western artist still remain today and it is in the final count one of attitude. The western artist's interest in the 'physicality' of things must surely account for his interest in a 'form-oriented' approach that generally persists. The following quotation from Neville Weston's 'Kaleidoscope of Modern Art' on Cézanne might be interesting to consider:

'Cézanne wanted to see nature with the uninhibited eyes of the newly-born, and to deal with this idea, he evolved a method which was almost wholly concerned with planar abstractions. Looking for and emphasising planes parallel to the picture-plane, he involved himself and the spectator in the very PHYSICAL ACT OF LOOKING AND SEEING. Cézanne's method relied on an acceptance of the hemispheric quality of personal vision, which is contrary to the Renaissance Albertian perspective with its central vanishing-point. Cézanne allowed his eyes – both of them – to wander over the scene in front of him, whether it was portrait, still-life or landscape, and select different vanishing-points. In a letter to Émile Bernard, he recommended the study of geometric objects such as the cone, cube, cylinder and the sphere, later adding that Nature could be treated in terms of these shapes. CÉZANNE WAS SUGGESTING A WAY OF SEEING NATURE'S COMPLEX FORMS.' (The capitals are ours.)

The essential difference between the Taoist/Zen 'ontological view' of reality and that of Cézanne's 'retinal' approach is summed up by Alan Watts in his book, 'The Way of Zen':

'Thus scientific convention decides whether the eel should be a fish or a snake, and grammatical convention determines what experiences should

be called objects and what shall be called actions. How arbitrary such conventions may be can be seen from the question, "What happens to your fist (noun-object) when you open your hand?" The object miraculously vanishes because an action was disguised by a part of speech usually assigned to a thing! In English, the differences between things and actions are clearly, if not logically, distinguished, but a great number of Chinese words do the duty of both nouns and verbs – so that one who thinks in Chinese has little difficulty in seeing that objects are also events, that our world is a collection of processes rather than entities.'

Again, the mystical viewpoint of the Taoist artist is very aptly stated by Mario Bussagli in his book 'Chinese Art':

'For the Chinese artist, plants and animals are not just physical presences, nor are landscapes just representations of places. All have a direct connection with something infinite and indefinable, as the very life of nature itself, for which the Chinese artist feels an almost mystical propensity.'

Mario Bussagli goes on elsewhere in his book:

'Being convinced of the unity of the Universe, the Chinese artist (and the Far East) refuses to halt reality in a single instance in time or localise it in a definite point in space.'

It will be gathered from all this that the Taoist view of reality is one that has already considered the question of time. The Taoist/Zen tendency to view the object as an 'event' rather than as 'form' presupposes that object's existence within an interrelated field or continuum. Time in this case is a 'mental' time that cannot be measured for all measurements can only remain relative! Let us on the other hand consider the western artist's treatment of the time-element in art. Working within a temporal TIME/SPACE concept the western artist has tended to go on dealing with the time-element in 'physical' terms. He has emphasised time by the deliberate activating of spaces either by actual 'Kinetic' movement ([Naum] Gabo, [László] Moholy-Nagy, [Alexander] Calder, [Jean] Tinguely, [Julio]

Le Parc, [Nicolas] Schöffer, Takis etc.) or by forcing a physical inter-action between the viewer and the work by means of 'environ-mental' considerations ([Alberto] Giacometti, [Anthony] Caro, Carl Andre, [Richard] Serra, [Dan] Flavin, [Walter] De Maria, [Yaacov] Agam etc.). The western artist's attempt to create works which exist 'within the viewer's own space' then must seem quite redundant to the oriental artist. Similarly, the commonly held notion amongst so many 'Kinetic' artists that their works are only 'active' when 'switched on' would seem very naive to the Taoist. Whereas the western artist has tended to envisage time through 'physical' action, the oriental artist 'feels' it mentally. It is essentially a very meta-physical concept of time that the oriental artist deals with!

IT SEEMS NECESSARY AT THIS POINT TO STATE THAT ALL OUR WORKS, WHILST REMAINING STATIC ARE NEVERTHELESS 'KINETIC' FOR THEY ENCOMPASS TIME/SPACE CONSIDERATIONS. THE TIME FACTOR IN OUR WORKS IS VERY MUCH A 'MENTAL' TIME. THE EXPERIENCE OF THE FOURTH DIMENSION EXISTS IN THE MIND OF THE SPECTATOR. THE FORMS TRANSCEND THEIR 'OBJECT-NESS' AND EXIST PRI-MARILY AS DOCUMENTATIONS OF 'EVENTS'. WE ARE AS SUCH NOT INTERESTED IN THE FORMAL AND AESTHETIC CONSIDERATIONS. WE ARE INTERESTED IN THE PROCESSES THAT THEY ARE. WHEREAS THE WESTERN ARTIST APPROACHES ART IN TERMS OF 'SPATIO/TEMPORAL/SENSORIAL' CONSIDERATIONS, WE ARE APPROACHING ART FROM A 'MENTAL/MEDI-TATIVE/MYSTICAL' STANDPOINT.

Six: A 'Mental/Meditative/Mystical' Viewpoint of Reality as Opposed to a 'Spatio/Temporal/Sensorial' Viewpoint of the Western Artist

There are some fundamental pre-requisites that seem necessary for anyone wanting to understand and appreciate our work. For one

thing, it seems necessary for the spectator to rid himself of any pre-conceived notions about what 'Art' is and ought to be. Anyone coming to this exhibition with the expectation of being exposed to traditional artefacts (painting, sculpture, print etc.) will certainly be disappointed. We are not involved with artefacts but rather with a series of 'mental' experiences which we have jointly-initiated. Our work very clearly is of a conceptual nature. It is our hope that these 'experiences' which we are initiating will result in a new awareness of the multi-dimensional nature of reality on the part of the spectator. As we have already mentioned, we are not interested in formalistic and aesthetic considerations. By rejecting all aesthetic and formalistic considerations we are attempting a deliberate liberation from 'form-oriented' considerations. As such, concepts governing 'beauty', 'harmony', 'structure', 'style', 'symbolism' and 'technique' are non-existent in our scheme of things. Any attempt to read 'aesthetic' considerations into the pieces that we have randomly selected can only result in a failure to understand our objective which is an involvement with the 'mental' awareness of time rather than of form. What are we aiming at is not the spectator's aesthetic appreciation of forms but rather his spiritual realisation that all forms are in essence events as real as his own existence in time and space. We are trying to force upon the viewer a consciousness that he is himself the result of a series of processes. The 'objects' that we have chosen to display therefore encompass fragments of actual events. Any attempt to view them as essentially 'physical' forms can only result in limiting oneself to an essentially 'western-centric' view of reality that is founded on 'Spatio/Temporal/Sensorial' considerations. Ours is essentially an ontological view of reality that is not based on 'physical' but rather 'mental' and mystical considerations. It is as such a viewpoint that transcends the senses and finds its impetus in the workings of the mind.

It might also seem necessary to remind our audience once again that there are no humanistic and subjective influences in our work. The artists' egoistic preoccupations are non-existent in our scheme of things even if we are initiating the process of mental perception.

We are quite simply the 'initiators' of a mental process that begins initially with the confrontation which takes place between the spectator and the situation we have placed him in. What we are aiming at is a 'meditative empathy' on the part of the spectator. It is an empathy that is the outcome of meditative and contemplative action. Our work is therefore founded upon a deliberate attempt to force contemplation and meditation on the part of the spectator. It is however a contemplation of a special kind that we are aiming at. It is a contemplation that does not seek 'beauty' or 'harmony' but aims at an awareness of the forces, the energies and the ungraspable laws of reality within which the spectator himself exists and functions!

We have placed the spectator in a situation in which he is forced to requestion his own reality. By supplying the spectator with the barest 'hints' in each situation we are forcing upon the spectator an experience of 'mental' time which interferes with his own consciousness of physical time. A series of time shifts manifest themselves in the spectator's mind and the spectator is transported 'mentally' into a time-dimension that is essentially fluid and not hampered by physical limitations. The final result should be a multiplicity of 'time-experiences' which exist beyond the work and the spectator himself. An ontological experience of reality that is not hampered by 'spatio/temporal/sensorial' considerations results. The final outcome of these thought-processes functioning within 'mental' time is dependent on the workings of the spectator's mind and his own imagination. At this point, we, as the 'initiators', have no more control over the situation! The spectator is free to move backwards and forwards in time as his mind takes over in contemplation and meditation.

It seems necessary to break down the process of stimulation that exists within our scheme. There are three basic requirements in the process: (i) the 'object/event' (ii) the data we have supplied which helps to qualify the event and (iii) the spectator's ability to interpret and decipher the situation we have presented (both

'object/event' and the data). The realisation that the 'object' is really an event draws the spectator's attention to the fact that it exists within a continuum just as he does. The realisation that he and the 'object' are both processes existing in time results in a breaking down of the essential differences between the 'thing' and the 'person'. In a sense, both are essentially energies in an infinite situation. As such, no hierarchy can exist between the animate and the inanimate! The spectator's realisation of this fact should result in a gradual liberation from humanistic considerations. This does not result in 'dehumanisation' (a western phobia!) but rather in a new spontaneity which brings him closer to 'sunyata' (nothingness). This first pre-requisite of meditation and contemplation constitutes a significant objective in our work. Alan Watts in his book, 'The Way of Zen' sums it up:

'The idea is not to reduce the human mind to a moronic vacuity, but to bring into play its innate and spontaneous intelligence by using it without forcing it. A philosophy restricted to the alternatives of conventional language has no way of conceiving an intelligence which does not work according to an (one-at-a-time) order of thought. Yet the concrete evidence of such an intelligence is right at hand in our thoughtlessly organised bodies. This unconsciousness is not coma but what the exponents of Zen later signified as "wu-shin" – literally "no-mind" which is to say unself-consciousness. It is a state of wholeness in which the mind functions freely and easily, without the sensation of a second mind or ego standing in the way.'

It should become clear that our whole effort is geared towards the initiating of 'state of mind' via meditation. We are attempting to bring about a situation whereby the spectator will be able to grasp the 'essence' of the work itself which is the event that it is. The relevance of the data that we are supplying the spectator then seems necessary in order to draw the spectator's attention to the fact that what he is seeing in the first instance is an event not a form. It seems almost necessary at this stage to remind people used to thinking in terms of 'entities' that an empty chair is really 'a chair on which

many spectators have sat on'. Similarly, by providing necessary data we are reminding the spectator that an empty bird-cage is not so much a 'thing' as an event because of the fact that it is 'an empty bird-cage with the bird flown away'. It will be noticed that all our titles allude to the event. As such, it will be quite difficult to read the objects in this exhibition as forms, which would be the case, otherwise.

BY DRAWING ATTENTION TO THE EVENT WE ARE INDIRECTLY ALLUDING TO THE 'ESSENCE' OR 'SPIRIT' OF THE WORK WHICH EXISTS BY VIRTUE OF THE EVENT. ONE IS AS A RESULT CONSCIOUS THAT THE MOST MUNDANE OBJECTS IN OUR EVERYDAY SITUATIONS ARE CHARGED WITH THE 'ESSENCE' OF EVENTS. THIS NOTION OF OBJECTS POSSESSING 'SPIRIT' (OR 'SEMANGAT') IS NOT DIFFICULT TO GRASP IF ONE IS AN ORIENTAL. THE ORIENTAL ARTIST HAS ALWAYS STRIVEN TO EMPHASISE THE 'SPIRITUAL ESSENCE' RATHER THAN THE OUTWARD FORM! Professor Daisetsu Suzuki has in fact summed up this 'eastern-centric' approach in art:

'Oriental art consists in depicting spirit and not form. For they say that when the spirit is understood the form creates itself; the main thing is to get into the spirit of the object which the artist chooses for his subject. The West on the other hand emphasises form, endeavours to reach the spirit by means of form. The East is just the opposite: the spirit is the all in all.'

It will become obvious that what seems so essential to our scheme of things is the willingness of the spectator to accept an altogether new way of perceiving forms that transcends the purely sensorial. Whilst the forms we have chosen to exhibit in this show may appear banal and mundane, they are nevertheless charged with the essence of phenomenal processes. As such, what we are drawing attention to is something that cannot be experienced by sensorial

means but can be very easily grasped by the mind. In effect, we are advocating an alternate manner of viewing the most mundane things around us in our everyday situations. The works in the show, as such, are not 'works of art' but the most randomly-chosen fragments of reality itself! To offer these randomly-chosen examples of reality for sale would therefore be most absurd. Indeed how does one go about pricing the most banal aspects of reality in dollars and cents? This fact should explain why all our works in this show are 'unsaleable'.

It seems necessary to state finally that the view of reality that we advocate whilst dealing with phenomena is not so much phenomenological as mystical and spiritual. The experiences that we are forcing upon the spectator as such should not stop with this exhibition, but rather it should begin from this exhibition and continue with the spectator's realisation that he constitutes yet another link in the whole chain of 'processes' that is the mystery of life itself. By choosing to contemplate on the most mundane of events, the spectator, we hope, will come face to face with the mystery of his own existence within an infinite and ever-evolving Universe!

M56 Mikhail Chemiakin and Vladimir Ivanov

Metaphysical Synthetism Manifesto: Programme of the St Petersburg Group (1974)

Metaphysical synthetism was a philosophy conceived by the Soviet émigré artist Mikhail Chemiakin (b. 1943) and the professor of Russian symbolism Vladimir Ivanov (b. 1943). Chemiakin was regarded by the Soviet authorities as a nonconformist. He had been expelled from the prestigious Ilya Repin Institute of Arts in Leningrad for 'aesthetically corrupting' his fellow students with his enduring interest in formalism; and, following a period of forced psychiatric treatment, he founded the St Petersburg Group of artists in 1967.

The group believed that for art to flourish it must have a spiritual dimension, rather than just serving society. This concept was deeply rooted in the history of Russian religious art, right back to its Byzantine origins; but the use of Christian symbols in the group's paintings – there to mark their rejection of materialism for a more transcendent reality – was at odds with the state-sanctioned style of Socialist Realism. As a result, they had their exhibitions closed down by the authorities and they struggled for recognition.

After a failed attempt to escape from Russia, Chemiakin finally obtained permission to emigrate to Paris in 1971. It was here, in 1974, that he and Ivanov issued the 'Metaphysical Synthetism Manifesto' (an extract from which is printed below), which expanded on the ideology of the St Petersburg Group. Yet their

beliefs were as much at odds in a Western capitalist society, where few artists invoked religious themes, as they were in the USSR.

The Filonov mentioned in paragraph 15 of the manifesto is the early twentieth-century Russian avant-garde painter and theorist Pavel Filonov, who promoted the idea of analytical realism in art.

<p style="text-align:center">★ ★ ★</p>

1. God is the basis of Beauty. A drawing close to God means the highest tension in the existence of Beauty. A moving away from and forgetting of God means a weakening of the existence of Beauty.

2. Art means the paths of Beauty leading to God. The artist must always aspire to God. The power and viability of his style is determined by the extent of his faith. 'As the branch cannot bear fruit of itself, except it abides in the vine; no more can ye, except ye abide in me.' (St John, 15, 4)

3. Before the coming of Christ the canon was the most perfect embodiment of Beauty. After the coming of Christ, it was the icon; as leaves are transformed into the calyx of a flower, so was the canon transformed into the icon.

4. When a flower fades, the seeds ripen and are scattered by the wind. So also in art, after conjunctive (synthetic) periods, there follow analytical periods, periods of the greatest possible deviation from the tension of the phenomena of Beauty, which lead to decomposition and the separation of form and colour.

5. The laws of art are the laws of Pythagorean numbers. These laws are in no way an abstraction, but the essences of life, recognised through intellectual contemplation. At the basis of the development of every style lie two triangles: (i) The triangle is the triangle of form: the cone, the sphere, the cylinder; their complementary forms: the circle, the triangle, the square. (ii) The triangle is the triangle of colour: blue, red, yellow; their complementary colours: green, orange, violet. The hexagon is the symbol of the interpenetration and the unity of form and colour.

6. Seven basic concepts, like the seven spirits, govern the laws of form and colour, defining the fate of every style, the length

of its life; they also determine its legacy. These seven basic concepts make up the triangle and the square. The square: Spontaneity. The demonic. Deformation. The absurd. The triangle: The canon. The icon. The principle of unification.

7. Analytical periods dissipate that energy of form and colour which synthetic periods accumulate. Ultimately, a complete enfeeblement and decadence of the feeling of form and colour takes place. The hexagon disintegrates. The square triumphs. Art returns to darkness, chaos. Freedom is lost. Tyranny reigns. Art is no longer an embodiment, but a mask.

8. The Renaissance only possessed the power it did thanks to the extravagant and ungrateful dissipation of the treasures of the Middle Ages. The energy gathered in the Russian icon has remained undissipated until now. Using the analytical approach, that is, one which separates out the elements, it remains a tormenting enigma and an attempt to use it leads only to dead stylisation. The only way lies not in dissipating but in increasing the accumulated energy – in creating a new icon-painting.

9. The contemporary artist who examines the monuments of ancient cultures falls into a tormenting contradiction capable of damning him to total sterility: on the one hand he sees in the past an unusual intimacy with his own quest, with his feeling of form, on the other, he is struck by the incredible gap between them and him, by their inner reserve and remoteness which stands in the way of any attempt at intimacy. This contradiction is determined by three causes: (i) Forgetting the religious sources of style. Refusal to penetrate the pretersensual world of ideas. (ii) Increased consciousness of the historical-chronological viewpoint – an arrangement which does not give a concrete scale for the measurement of the time distances between styles. (iii) The resulting examination of style not as a form-producing force, but only as its ultimate and limited consolidation in the material. The contradiction can only be removed in the following way: (i) Through contemplation of styles as living organisms – in the unity of idea and material.

(ii) Through recognition of the basic law of the development of style as the law of metamorphoses. (iii) Through the differentiation of styles according to religious principles: (a) Before the coming of Christ. (b) After the Mysteries of the Crucifixion.

10. Two kinds of contemplation of the metamorphoses of style are possible: (i) Mythological (style as myth). (ii) Morphological. Morphological contemplation is in the spirit of the further development of Goethe's views on natural science. 'The leaves of the calyx are the same organs as were hitherto visible in the form of stem leaves, but then, often in a much changed form, they turn up and gather around one common centre.'

11. From the first method of presentation it follows that the origin of style is cosmogonical. The styles themselves are deities, 'souls'. The basic thing is the contemplation of the transformation of chaos into harmony, and then the inevitable disintegration of harmony into chaos. Form-producing forces collide with each other like gods and Titans. As the Titans were plunged into Tartary, so Greek antiquity conquered Eastern irrationalism, demonism and spontaneity. Orpheus.

12. From the second method it follows that styles are the pure, self-propelled movements of form and colour. Here it is not deities which are contemplated but pre-phenomena, ideas. The very styles form of themselves something whole – an absolute world. Each style presupposes the existence of another. Everything is organically interdefined and conditioned.

13. Form and colour for the second method are the same, whether as the object of study or the means of symbolising knowledge.

14. In its understanding of the number, metaphysical synthetism follows Pythagorean occult mathematics. If for the contemporary mathematician the number 3 is expressed by a segment of straight line with three equal divisions, then for Pythagorean mathematics the number 3 is a triangle, the symbol of the divine and perfect unity. All the numbers quoted in this book should be understood from this point of view.

15. The tension of Being in this world cannot be conveyed by simple mirror-like reflection. In reflection there is no tension. The

job of the artist is to lift form and colour to the highest degree of tension. In analytical art this is called the principle of wholeness (Filonov).

16. The highest tension of form and colour is attained by styles originating in the principle of symbolisation. They achieve the maximum accumulation of energy. The model for this is ancient Egyptian art. A second kind of style is inspired by the naturalistic principle. In the first case God is felt in oneself, in the second, God is found in the world. The basis of the naturalistic principle is perception. It is possible to reproduce naturalistically a vision of the pretersensual world. Only when the pretersensual world is embodied as a symbol is the icon born.

17. The symbol is a combination of the uncombinable. The following types of symbolisation exist: (i) Astral-occult. Each combination of the uncombinable is conditioned by the constellations contemplated in revelation. Fantasy as such plays no part here. All the means of symbolism are beyond arbitrary rule, they are canonical, holy. The Sphinx. (ii) Rosicrucian Esoteric Christian symbols as the basis for the combination of the uncombinable forms of the external world. At this stage a considerable degree of freedom is achieved. The artist relies more on his inner experience, using occult knowledge for the expression of his own pretersensual experiences. At the same time, for the depiction of the realms of the other world into which he cannot yet climb, he uses the description of the experiences of the Great Initiates. Such works no longer appear to be the objects of a cult. Bosch. An example of symbolisation is the panels of the triptych, *The Garden of Heavenly Joys*: the realm of the pretersensual world is depicted, through which pass the souls of the dead on their way from death to birth; in the centre of the panel is the 'man-tree'; its extremities – shrivelled branches – signify the loss of ethereal powers, its steps are two boats 'without rudder and without sails' which wander over the waters of the nether regions of the other world. On the head of the man is a millstone; on it march demons which have taken possession of the soul of the dead man in the course of

his life on earth: the Bear is the symbol of anger, the woman of voluptuousness, the purse of miserliness. In the middle of the millstone are huge bagpipes, the symbol of the tongue of this man which has fallen victim to Ahrimanic numbness. (iii) Surrealist Freedom of the imagination turns into demonic tyranny. Idolisation of the subconscious. Automatism of creation. The artist avoids trying to provide a basis for the combination of the uncombinable: the arbitrary symbolisation of tyranny. The incestuous introduction of the naturalistic principle into imagination. Salvador Dali: 'The difference between me and a madman is that I am not mad.' (iv) Nihilistic-absurd. The principle of the simple anecdote. The symbol is no longer the voice of the subconscious but the voice of Nothing: speaking from the foundations of the world and speaking as a foundation of the world. The interpretation of the symbol, unlike surrealism, is not impossible, but it is not necessary, for everything leads to Nothing. Being thrown into Nothing. Kabakov. Black comedy. (v) Metaphysical synthetism.

18. Form is one, but the creative processes of its embodiment are not one. In the twentieth century the birth of a new type of creative consciousness is taking place: those processes which earlier played in the subconscious and superconscious regions of the soul are now – thanks to the power of the 'I' – boldly introduced into the realm of the conscious. The artist is no longer holy fool. He is a creator, a friend of God. The degree to which he is permeated by Christ's impulse determines the degree of consciousness in his work.

19. The icon is the most complete and perfect form of the revelation of Beauty in the world. ALL THE EFFORTS OF THE METAPHYSICAL SYNTHETISTS ARE DIRECTED TOWARDS THE CREATION OF A NEW ICON-PAINTING. FROM PICTURES TO THE ICON.

20. Art renouncing Beauty is Eros. The artist creates harmony only through his love of Beauty.

M57 The Artists' Front of Thailand

Manifesto of the Artists' Front of Thailand (1975)

The student uprising in October 1973 which led to the overthrow of the military government in Thailand, and the political upheavals that dominated the subsequent few years of unstable democracy, had an immense impact on the country's cultural landscape. For artists, much of the political activity centred around the Department of Thai Art at Silpakorn University in Bangkok, where a Marxist agenda that opposed Western-centric teaching was championed. The artists rejected abstraction, which they considered apolitical, and embraced representational art in order to document the reality of life in a country riven with hostilities.

The Artists' Front of Thailand (*Naewruam Silapin haeng prathet Thai*) was a large association of artists formed in 1974 with the twin aims of opposing capitalist and imperialist artistic ideologies and of promoting the Thai Marxist theorist Chit Phumisak's call for an 'art for life'. In 1975 the movement, chaired by the figurative painter Kamchorn Soonpongsri (b. 1937), responded to Phumisak's appeal by staging a vast public exhibition of posters along the Rajdamnern Avenue in Bangkok. The choice of venue was significant: traditionally the monarchy had used the road to stage royal parades, and it had been the centre of the 1973 uprising.

Yet the optimism of the students – and of the Artists' Front – was short-lived. Soon after the exhibition, the monarchy rejected the left-wing student movement in favour of a military regime, which violently repressed the opposition, leading to a student massacre in October 1976. Many of those associated with the Artists' Front

went underground or were killed. Although their manifesto was originally written at some point in 1975, it was not published until much later.

* * *

For thousands of years, 'small groups of big people' have taken power over politics and economics of a country or an area, have used their 'power' to frighten or hurt and take advantage of 'big groups of little people'. The 'small groups of big people' waged wars against each other, but have deceived the 'big groups of little people' into fighting to the death for their parties. The 'small groups of big people' have formed constitutions without an agreement of the 'big groups of little people'. Under these Constitutions, the 'big groups of little people' have been placed under the control of the 'small groups of big people'. The 'small groups of big people' have used religion and culture art in dishonest ways, as a tool to prop up social face and name; they have promoted or invented misleading beliefs and ways of thoughts to the 'big groups of little people'. The above mentioned were acts of the 'small groups of ruling people', which were seen as an insult to the dignity and intelligence of the 'big groups of poor people'.

Thailand encounters all these kinds of situations, especially in politics, economics, education, and culture art. That is to say, the economic arena, which takes great part in society, is firmly under the control of the 'small groups of elite people' who are Thai and foreign nationals. They agreed to cooperate with each other in extorting the 'big groups of poor people's' living. Similarly, in the political affairs, the 'small groups of big people' and their foreign partners, who share the excessive profits, have been the ones who make all national decisions for the 'big groups of little people'. Most of the political acts have not served the 'big groups of little people' in Thailand, but the 'rich' people. The majority of the Thai people have not been living in a democracy. The foreign parties have exerted their influence in the Thai government and have promoted western imperialism to the Nation.

At the same time, policies of education and culture art given by

the government, have failed in developing 'little people's' ethnicity (value of living including social, intellectual, and moral thoughts) as they should primarily do. In fact, the policies were promoted for the 'rich' individuals' sake, not for the priceless value of education and culture arts for the public. These kinds of empowering policies have been used as a tool to mislead the 'big groups of little people', to give up on their own beliefs and stop developing/fighting for their own right and society. The misleading policies have led the 'little people' to believe and follow the western imperialism as the 'big people' do.

As long as all the misleading structures of the government in politics, economics, education, and culture art continue taking great part in Thailand and/or Thai society, the real democracy of the Nation and its assets, i.e., independence, freedom, equality, and justice in society would be impossible to establish. The so-called democracy used in the country these days is what we may call 'a democracy of the 'big people'.

We, who are not satisfied with what the 'big people' have done and we, who are conscious of the priceless Thai culture art's conservation, innovation, and development for the 'little people', then organize ourselves into **The Artists' Front of Thailand**. Our mission is to conserve, innovate, and develop Thai culture art and make it serve all Thai people in the correct ways it should. **The Artists' Front of Thailand**'s promotion on the valuable culture art could help the 'little people' develop their ethnicity (value of living and social, intellectual, and moral thoughts) to fight the injustice in society. All in all, to develop the whole Nation and society, the living basics, i.e., politics, economics, education, and culture art must be correctly and relatively promoted.

M58 The Indonesian New Arts Movement

Manifesto of the Indonesian New Arts Movement (1975)

The avant-garde Indonesian New Arts Movement (*Gerakan Seni Rupa Baru Indonesia*) began as a protest collective in 1974, when a group of students from the ASRI Arts Academy in Yogyakarta rallied together to object to the jury's selection of paintings at the *Pameran Besar Seni Lukis yang Pertama Indonesia* (*The First Great Exhibition of Indonesian Painting*) – the first staging of what is now the Jakarta Biennale. The judging panel had dismissed the students' vibrant attempts at radical experimentation, and instead chosen five traditional paintings in the decorative Indonesian style as the best artworks. The New Arts Movement railed against the awards, and wrote the 'Pernyataan Desember Hitam' ('Black December Statement') in protest. As a result, five of the student artists – B. Munni Ardhi, Ris Purwono, F. X. Harsono, Siti Adiyati and Hardi – were immediately suspended from the academy.

In 1975 the 'Black December Statement' became the basis of the group's first manifesto, which is reproduced below. Its rhetoric can be seen as mimicking the declamatory statements issued by President Suharto's authoritarian regime. Art was too elitist, they argued. Modern Indonesia needed a popular new art: one that traced its aesthetic history back to the nineteenth-century Indonesian modernist Raden Saleh, but which was not inward looking – it should embrace innovation and radical new ideas, not just technical skill.

The New Arts Movement proceeded to promote their spirited vision through a series of exhibitions between 1975 and 1979, when

their manifesto was finally published in the *Gerakan Seni Rupa Baru* book compiled by the group member Jim Supangkat. The movement disbanded soon after, due to internal disagreements; but they reunited eight years later in Jakarta for the exhibition *Proyek 1: Pasaraya Dunia Fantasi* (*Project 1: Department Store Fantasy World*), which they marked by issuing a new manifesto that reconfirmed their core beliefs.

* * *

The Five Methods of Indonesia's New Arts Movement

1. In carrying out our creative work, we discard as far away as possible the vision of 'art' that has thus far been recognized (we consider it as 'old art'), i.e. art that is limited to only painting, sculpture, and drawing (prints).

 In the Indonesian New Arts Movement, crossing-over between the above-mentioned forms of art, which can give rise to works of art unable to be boxed into one of those recognized forms of art, is considered 'legitimate' (New Arts).

 As we embark on our creative travails, we reject the vision about the existence of discrete elements in art such as elements of painting, drawing, or prints. All exists as a whole within one category, a unity consisting of visual elements that might be related to elements of space, movements, time, etc.

 Therefore, all activities that can be categorized as art in Indonesia – albeit based on different 'aesthetics', for example the activities that have their basis in traditional art – are logically considered as legitimate and living art forms.

2. In carrying out our creative work, we discard as far away as possible the 'specialist' stance in art that tends to create an 'elitist language' based on the attitude of 'avant-gardism', which was

constructed on the vision that artists should go deep within themselves and seek subtle issues (so that the public does not understand them, because artistry is a part of the mystery of life).

We instead believe in the aspect of 'similarities' that we share as human beings due to the similar living environments. We believe that actual social problems are more important than private sentiments. In this case, we give greater emphasis on the richness of the ideas or concepts rather than on masterly skills in creating visual elements.

3. We long for 'creative possibilities' in the sense that we desire a rich variety of styles in art in Indonesia. We inundate Indonesian art with new possibilities, recognizing all possibilities *sans* restrictions, reflective of our searching gestures. We henceforth reject all reductions of possibilities, including the patronizing teaching stance in which a master's style is followed by his disciples, who are actually able to do differently and enrich the possibilities of style in Indonesian art.

4. We aim for the development of art that is 'Indonesian' in nature, by laying the emphasis on the knowledge about the history of new Indonesian art, which began from Raden Saleh. We learn about the different periods and shrewdly observe how this new Indonesian art has developed, then consider and perceive subsequent developments in that context. We believe that the history of new Indonesian art contains issues that are on a par with those found in imported books on art; issues that are able to augment the art in Indonesia, whether for the critics, historians, or philosophers. We firmly reject the opinions saying that the development of art in Indonesia is a part of the history of world art, that art is universal, and that the issues of Indonesian art are dependent on the issues of international art.

5. We aim for art that is more alive, in the sense that its existence is readily accepted and that it exists naturally, usefully, and widely among the people.

M59 Rasheed Araeen

Preliminary Notes for a BLACK MANIFESTO (1975–6)

The Pakistani-born, London-based conceptual artist and author Rasheed Araeen (b. 1935) wrote his ground-breaking essay 'Preliminary Notes for a BLACK MANIFESTO' between 1975 and 1976. The roots of the manifesto lie in a profound identity crisis the artist underwent in 1971, when, having read the Caribbean philosopher and psychiatrist Frantz Fanon's essential text of the black liberation movement, *The Wretched of the Earth* (*Les Damnés de la terre*, 1961), and become affected by the killing of a young Nigerian man in Leeds by the police, Araeen began to make art that confronted the socio-political realities he was witnessing in Britain. Employing performance and multimedia, he created artworks like *Playing Anguish* (1974–7) – an eighteen-minute tape/slide sequence – and the performance *Paki-Bastard (Portrait of the Artist as a Black Person)* (1977), which tackled the lived experience of racism in the UK. He became an active member of the Black Workers Movement and joined David Medalla's (M29) Artists for Democracy, which encouraged artists to support liberation movements throughout the world.

Araeen's manifesto drew attention to the white supremacy endemic in the international art world. Calling for a radical 'Third World' art that confronted neo-colonialism and sought to change old power relations by rejecting reactionary ideas such as the concept of the individual artistic genius, he argued that black artists should seek to serve the interests of ordinary people, avoid

isolation and separatism, and challenge the presiding Western version of the history of art.

Araeen conceived his manifesto as an artwork in its own right. It was originally published in the first issue of the cultural journal *Black Phoenix*, which was launched by Araeen and the poet Mahmoud Jamal in January 1978 as a much-needed platform for artists from a non-Western background, and it has been reprinted on numerous occasions since.

* * *

Introduction

The problems of contemporary art in the Third World today are part of its socio-economic and political predicaments, resulting from colonialism and its present relationship with the West. We must therefore go beyond formal and aesthetic considerations and look into the historical factors which influenced or suppressed artistic developments in the last few centuries, as well as those forces which are today predominant, in the Third World.

By Third World, we mean Asia, Africa, Latin America, and the Caribbean. But we *must* also include in it all those non-European peoples (whom we shall collectively call 'blacks' or 'black people') who now live in various Western countries and find themselves in a similar predicament to that of the actual Third World.

What concerns us here specifically is the situation of contemporary visual art in the Third World. But we cannot meaningfully deal with the problems of visual art alone isolated from the cultural context. What affects culture as a whole is also reflected in art activity.

A cursory glance at the Third World today shows that, even after years of 'independence', its contemporary cultures in general and the visual arts in particular remain what could be described as the stagnant backwaters of western developments or what Paulo Freire* calls the 'culture of silence' of the masses.

* For Paulo Freire's works see *Pedagogy of the Oppressed* and *Cultural Action for Freedom*, both published by Penguin, London.

There does exist, however, an increasing awareness of the situation and efforts are being made to confront the problem. We must therefore look into how this problematic situation is actually being dealt with. **How are Third World people trying to enter the modern era or/and create their own contemporary history? If their voice is muted or not heard at all, what are the underlying causes? And what are the actual alternatives open to them?**

The awareness that the Third World must now find a direction which is different from that imposed on it by the West has been growing; and, in fact, organized attempts pointing towards this goal have recently been made. But these efforts* have either remained confined within different regions or lacked a clear (ideological) perspective. They have not therefore made any impact on the overall situation or offered a real challenge to those forces which have been responsible for the present predicament of art and culture in the Third World. This is partly due to the lack of *direct* communication of ideas within the Third World. And the problem has been further compounded by the extremely oppressive political situation in many Third World countries; which is, in most cases, the legacy of past colonialism or/and the result of continuing Western imperialist domination.

Although there does exist an opposition to imperialism and questions are being asked about the growing dominance of Western culture, the general situation *in practice* remains West-oriented. That is, even when there is a strong tendency among many Afro/Asian countries to maintain the continuity of their own traditions, resulting in the preservation and revival of old forms – particularly their reintroduction in contemporary works, the actual result or its underlying criterion often tends to conform to the standards created in the West. This could be explained by the fact that it is not

* Although the activities of CAYC, Buenos Aires, Argentina, have been confined to Latin American situation and those of *Artists for Democracy, London*, tend to centre around particular political issues, they both are worth mentioning here. FESTAC '77 was in fact the most important and spectacular event of 'Black Arts' which took place in Lagos, Nigeria, in January/February 1977.

unusual today for many Afro/Asian countries to seek advice from the so-called Western experts of Oriental/African Art in understanding their own traditional past and to depend on guidance from the West for contemporary developments.

And therefore Third World artists today are *in general* accepting the 'supremacy' of Western developments in the contemporary field by following whatever styles are developed or produced in the major art centres of the West. This not only uproots them from the reality of their own culture and history, but leads them into an alienated situation which cannot question the domination of foreign values, thereby also denying them any opportunity to develop their art indigenously.

This is not, of course, due to what many Western critics would have us believe. As Edward Lucie-Smith has put it: 'In places such as India and Japan, traditional culture between the wars was already in a state of decay; it was natural therefore that artists in those countries should try and rebuild upon the European and American model.'*

It is typical of many (if not most) Western critics not to see things in the correct historical perspective. Mr Lucie-Smith has very cleverly tried to conceal the actual truth. He might have impressed his own lot, but he cannot fool us. Who does not know that Western colonialism in India – and for that matter in the whole Third World – was responsible for what he himself calls a 'state of decay' of traditional culture? And then he has the arrogance to suggest that it should be *natural* for the people, who have been subjected to the traumatic experience of colonialism, to rebuild their future on the model created by those who once were, and still are, their oppressors. This is no more than an attempt to keep the Third World people perpetually under Western domination so that the apologists like Lucie-Smith may continue enjoying their international privileges granted by the system they unashamedly serve.

It is essential not to fall into the pitfalls of the Western attitude

* Edward Lucie-Smith, *Movements in Art Since 1945*, Thames & Hudson, London; paperback p. 17.

that tends to disguise the truth. On the one hand, Western interpretation of human history is often extremely biased against non-European peoples and their achievements; and on the other, while ignoring the real dynamics of historical developments, it lays a great emphasis on the *individual* achievements of Western men supposedly struggling against all odds. The fact is that socio-economic and political forces play a fundamental role in moulding, nourishing, supporting, and sustaining all human productive and creative activities, both physically and psychologically.

This brings us face to face with the question of the developments of our own socio-economic and political institutions. The question here really is: what actually happened to these institutions, and why did they fail to play an historical role in providing support to the indigenous developments of arts in the Third World in the colonial period of the last few centuries? The answer to this is, of course, well-known but not widely and fully acknowledged, particularly in the West, for reasons which we hope will become more clear by the end of this manifesto.

Contrary to what we are often told by the West, the colonial era was one of the most exploitative and oppressive periods in human history; and its legacies are still with us today as part of neo-colonialism. This was the period when the West preached **human liberty, equality and fraternity.** But at the same time, it was the very same West which, in brutal and blatant violation of basic human dignity and in contradiction to its own presumed human values, actually enslaved and subjugated the majority of the world's population and plundered its resources for the West's interests alone. The wealth it thus acquired helped the West develop its various institutions. This development was in fact achieved at the expense of ignoring, if not actually suppressing, the historical developments of indigenous institutions. And on top of this, it had the audacity to perpetrate lies about the 'primitiveness' of indigenous Third World peoples whom, as most Western people still believe, the West *only* wanted to 'civilize'.

The truth of the matter is, whether one likes it or not, that the actual aim of colonialism was to merely appropriate other peoples'

wealth and resources, by hook or by crook, as a result of which the West was able to become what it is today. As Frantz Fanon has rightly said: **'This European opulence is literally scandalous, for it has been founded on slavery, it has been nourished with the blood of slaves and it comes directly from the soil and from the subsoil of that under-developed world. The well-being and the progress of Europe has been built up with the sweat and the dead bodies of Negroes, Arabs, Indians, and the yellow races.** *We have decided not to overlook this any longer.'** (italics added).

While the West flourished during colonialism, Western art also flourished along with the emergence of its various institutions. The historical developments of Western art of the modern era took place not because of the 'mental superiority' of Western artists (as is commonly believed in the West), but due to the advantage they had by being placed within the complex totality of developing forces of an historical process. And this was made possible to a large extent with the material resources from the Third World. While the historical process in the West provided Western artists with necessary incentives or driving force for their creativity, colonialism suppressed the developments of indigenous art and culture in the Third World by preventing the historical development of the productive forces of its peoples.

For this reason the history of Western art over the last few centuries also becomes an issue here; not only for the fact that its developments took place at the cost of Third World people, but more essentially because of the West's assertion today that its history must be accepted as the mainstream of human development, and that in the light of this all human achievements must be seen. THE ESTABLISHMENT OF EUROPEAN CIVILIZATION AS THE MAINSTREAM IS ONE OF THE MOST CATASTROPHIC DEVELOPMENTS THAT HAVE TAKEN PLACE IN HUMAN HISTORY, DESTROYING OR SUPPRESSING OTHER CULTURES AND CIVILIZATIONS. And today this European MAINSTREAM is used to measure the

* Frantz Fanon, *The Wretched of the Earth*, Penguin, London; p. 76.

achievements of the peoples whose very historical developments were suppressed by it. It is therefore not a surprise that the West either ignores other peoples' contributions to human knowledge or history, or it allocates them an inferior status determined by an attitude that sees all non-European phenomena as ahistorical.

This is, of course, a fundamental feature of the dominant ideology that perceives the world in terms of its different parts arranged in a hierarchical order, so that this system serves the interests of those who control it from the top. As such, the West sees the rest of the world as its own appendage and expects all the world resources, natural as well as human, to serve the interests of Western civilization alone. THIS WESTERN PERCEPTION OF THE WORLD HAS REDUCED TODAY THE WHOLE WORLD INTO A 'GLOBAL VILLAGE' WITH A VULGARLY AFFLUENT WEST AT ITS CENTRE SURROUNDED BY STARVING PEOPLE WITH BEGGING BOWLS IN THEIR HANDS.

Moral double standards, arrogance, hypocrisy, and racism are some of the manifestations of the ideology which maintains that Western people alone have a civilized existence and that they should constantly maintain and protect this even at the expense of other peoples' humanity. WHILE EUROPEANS ARE HAILED AS PATRIOTS, FREEDOM FIGHTERS AND HEROES, OTHERS ARE DENOUNCED AS BLOODTHIRSTY TERRORISTS. The various attempts of some pseudo-scientists to prove the 'superiority' of the white race, is also part of the same apparatus which deliberately perpetuates lies about non-European peoples. And these attempts to give scientific respectability to racism only reveals the hideous designs of those who are an integral part of the Western imperialist domination of the world today.

The present state of affairs in the Third World is not the result of the 'natural laziness' or 'a lack of imagination' of its peoples, as we are often told by the West, neither is it the legacy of the devastation of some oriental 'barbarian'. It is in fact the direct consequence of the colonial pillage by the 'civilized' West whose pretentious claims to all humanity have now turned out to be no more than a mask to hide its pathologically excessive greed and which has today

reached dangerous proportions. The Western obsession for more and more material wealth (mostly in the form of consumer goods), which in the West is euphemistically called 'a higher standard of living', cannot be perpetually fulfilled without further exploitation and appropriation by the West of resources *which are not its own resources*. These resources actually belong to Third World peoples who themselves should now utilize them to fulfil their own needs, by developing their own productive forces and rebuilding their own socio-economic, political, educational, cultural and artistic institutions *which must be free from foreign domination*.

Against this historical background, therefore, we must place the present predicaments of our art and culture. We must recognize that as long as we allow the West (and for that matter, anybody else), willingly or unwillingly, to dominate our lives, we will only be exploited. As long as our physical and mental resources are under its direct or indirect control, our development will either be suppressed or used for the benefit of the West alone, its art and culture, and its civilization. In other words, **we must free ourselves from foreign domination before we can create our own contemporary art and culture**.

But this does not mean that we have no option open to us at present or that we cannot carry on an art activity. Of course, if we continue accepting the general situation today which demands our subservience to the West we are doomed as a people. On the other hand, we can and must stand on our feet and oppose those alien values, as well as our own, which obstruct radical change by preventing the development of internal dynamism of our people; and in the process of confronting these values we can and shall discover new art forms that will authentically reflect our own reality today. However, before we proceed further to look into possible alternatives, we must examine here the various aspects of those forces which are holding us back.

The Third World Today

One of the most important features of colonialism was and is to violently suppress the indigenous culture of the colonized country

and then impose its own cultural values on the colonial people. In many instances, colonialism imposed an actual ban on native cultural practices, taking away by force from the people their cultural artifacts. The loot was then transferred to the West. As a result, most of the Third World heritage is today either hidden away stored in the basement lockers of Western Museums* or insolently displayed in their glass cases as part of the evidence of the West's pride and precious possessions. AFTER EXTERMINATING MILLIONS OF PEOPLE AND THEN LOOTING THEIR BELONGINGS, THE WEST TODAY HAS THE AUDACITY TO CALL ITSELF THE PROTECTOR OF THE ARTISTIC AND CULTURAL HERITAGE OF THE WORLD.

At the same time, colonialism created and creates a native bourgeoisie by giving some of the native population Western colonial education, and by awarding them some socio-economic privileges and a share in political power. In turn, this native class, to quote Amilcar Cabral, 'assimilates the colonizer's mentality, considers itself culturally superior to its own people and ignores or looks down upon their cultural values.'†

With the coming to power of *this* native bourgeoisie, after 'independence', colonialism is only replaced by neo-colonialism; which in fact is a general phenomenon in the Third World today. One of the most important characteristics of neo-colonialism is the perpetuation of Western imperialist domination in the 'decolonized' countries through Western cultural penetration, against which the native bourgeoisie cannot and does not act as a shield. On the contrary, its own lifestyle facilitates further propagation of Western values, which openly relegate the indigenous cultural life. In effect, it virtually becomes an instrument through which Western

* A short film *You Hide Me* by Ghanaian film-maker Kwate Nee Owoo (Ifriqiyah Films, London), has thrown some light on the storage of thousands of artifacts in the basement lockers of the British Museum. In addition, there are about two million artifacts, looted mostly from the Third World, being stored in a warehouse in Shoreditch, London, and to which the public in general has no access.
† Amilcar Cabral, *Return to Source*, Modern Reader, New York/London; p. 45.

culture is projected as civilized and progressive vis-à-vis the 'primitive' and 'backward' native culture.

It is therefore no surprise that, immediately after the Second World War, Western imperialism under the leadership of its most powerful country, the US, unleashed an unprecedented cultural propaganda in the major cities of the Third World, particularly in Asia and Africa, through its control of mass media (films, TV, glossy publications, etc.). The whole purpose of this propaganda, which constantly assaulted people's senses with alien images of the values of Western life, was to inflict their minds with the illusions of a better life (in the West) and to lure them into believing that they could also possess this life, if only they would abandon their own values; thereby making them develop a sense of their own inferiority. The aim of the cultural aggression, in fact, has always been to make the dominated people totally abandon their own values and accept the projected superiority of the imperialist culture, turning them into passive objects of Western domination, since, as Amilcar Cabral has pointed out, 'with strong indigenous cultural life, foreign domination cannot be sure of its own perpetuation'.*

At a time when people were trying to recover from their colonial past and were looking forward to a new future free from foreign domination, this new onslaught from the West not only caused further loss of national cultural identity among the native bourgeoisie, who thus fell in love with 'Babylon' called AMERIKA; it also disturbed, if not shattered, the sense of direction among the urban 'intelligentsia' who could otherwise have played a positive role in the post-colonial reconstruction of the country. The native bourgeoisie who were supposed to offer a new direction, leading to a better and prosperous life which it had promised to all its people during their anti-colonial struggle, instead became an instrument of an accelerated superficial change whose main driving force has been to turn the major native cities into centres of native bourgeois life *based on vulgar imitations of the West*. It set in motion a process whose consequences can be seen today in the Third World cities. A

* Ibid.; p. 39.

skyscraper rising from/above poverty-stricken shantytowns has become a symbol of 'progress'.

One only has to cast a glance to see the absurdity of present developments in most Third World countries based on the Western prescriptions. Instead of improving the land and waterworks to produce more basic and essential food, either the land is used to produce exportable commodities or the peasants are recruited into the factories where, for example, motor cycles, blue jeans, platform shoes, etc., are assembled/manufactured mainly for the teenage kids of the affluent urban classes. Instead of improving livestock to increase milk production, Coca-Cola factories are set up everywhere. Instead of creating an incentive for the fishermen to catch more fish by providing them with better boats and equipment, the sea-shore is transformed into a holiday resort for the native, as well as international, leisure class and the inhabitants of the surrounding villages are turned into waiters, domestic servants and entertainers. Consequently some Third World cities have become exotic brothels for globe-trotters.

The basic priority, the development of an indigenous economic infrastructure serving the basic needs and interests of all the people, has been virtually ignored. Instead, the country's wealth has been appropriated by the few, through trickery, deceit and bureaucratic corruption, and spent mostly on the importation or production of Western consumer goods and sophisticated military hardware which cannot, of course, fill the hungry bellies of the masses. It simply maintains the Westernized lifestyle of small native elites and their political power.

Any human development which is based on foreign values – unless these values are absorbed through a critical process as part of the indigenous development – disturbs and suppresses the imagination and creativity of people, thereby destroying any incentive for the creation and development of new and original ideas. Instead, it perpetrates/perpetuates imitation, submission and apathy, which in fact characterizes native bourgeois life today. The native bourgeoisie thus ends up trapped in its milieu protecting its selfish interests, incapable of providing any leadership or support for the

positive and progressive forces of the people. Instead the people are fed with illusions, vulgar fantasies, religious fatalism, and populist slogans; all this leading to a life pattern which becomes insensitive to its own environment. And if all this is not enough to keep the people contented and/or silent, they are mercilessly put down by the sophisticated machinery on which the native ruling classes end up spending most of the country's wealth.

It is therefore clear that the native bourgeoisie, which virtually becomes an agent of imperialist domination, cannot and does not protect the real interests of the people. It gives almost a free hand to the multinational foreign companies which not only exploit the people indiscriminately but cause great damage to indigenous cultural life. The following example, which is typical as well as topical, illustrates how an apparently innocent commercial operation persuades people to abandon their own cultural values and take up Western ways in the hope of improving their life, whereas the actual result is a disaster, economically as well as culturally.

In most parts of the Third World, even today, breast-feeding is not only a common traditional practice, but also an important part of its socio-economic reality. And it cannot be replaced by any other method without a real change, *brought about by the conscious efforts of the people themselves*, in the economic forces, creating a socio-cultural environment in which acts like bottle-feeding, and its various implications are fully grasped by the masses. An imposition of bottle-feeding on the other hand, particularly through an aggressive cultural propaganda (euphemistically called 'commercial ads'), would in the present Third World environment naturally create dangerous health hazards and without giving much economic benefit. To say that the Western companies do not understand this simple act, would amount to calling them idiots, which they are not. They couldn't care less as long as they make money. If their actions cause malnutrition among children, poverty and starvation, and even deaths, they do not consider it their moral or human responsibility.

It is well known now how Western baby-food producers have been persuading the women in the Third World into giving up

their *traditional* breast-feeding in favour of *modern* bottle-feeding, simply to sell their products. In the hope that it would help their children grow better (as suggested by the ads), many poor women switched on to bottle-feeding, even when they did not lack their own milk. It not only deprived them of their hard-earned small income which they had to spend to buy the manufactured baby-milk, it also caused malnutrition, and a disease, unknown before, among these children. As a result, many of them died.

The debate here is not about the merits or demerits of breast-feeding or bottle-feeding. Neither is it the question of a 'failure' of women in the Third World to grasp the new reality of bottle-feeding. It would be very easy, of course, to accuse these women of a 'lack of awareness' of the problems of hygiene in bottle-feeding, but would anybody blame the mothers of the Thalidomide children for their lack of scientific knowledge?

The issue here really is the immorality of the whole money-making operations of the multinational companies in their total disregard of human life. Their aggressive commercial and cultural propaganda deceives people into believing that they can buy a better life by purchasing consumer products (which do not contribute to their welfare but only further their poverty), and undermines people's cultural values which would otherwise protect them from such vicious traps.

The paradoxical situation in which the native bourgeoisie finds itself after 'independence', must also be recognized. On the one hand, its own lifestyle betrays its acceptance of the supremacy of Western cultural values. On the other, it cannot totally ignore the national aspirations of the people and their own culture. A resurgence of interest in indigenous art and cultural activities therefore occurs. But this development, which in most cases is manipulated by the native bourgeoisie to consolidate its political power by making it part of the populist demagogy, often fails to go beyond the level of mere entertainment or a reminder of past glories.

The exuberant colourful tribal dances at Nairobi Airport, Kenya, welcoming the arrivals of international celebrities, is an interesting example of a manipulation of indigenous culture by a

native bourgeoisie *which prides itself on dressing up in European three-piece striped suits even on hot days.*

This is not to say that indigenous national art and culture should not play any role in international affairs. International diplomatic relations alone cannot provide a real dynamic for the historical development of national art and culture in the Third World. In fact, if this becomes the only basis for the preservation or continuation of indigenous art and cultural activities – as is the fact in most cases, the result is their degeneration into an exotic entertainment for those whose actual allegiance lies with foreign culture.

Although the wearing of indigenous dress does not necessarily reflect a genuine commitment to the development of national culture today, in view of the fact that indigenous dress is still an essential part of the masses in the Third World, the European dress of the native ruling classes can only project their separateness from the masses, if not an elevated status whose roots are embedded in European soil.

It is the masses who actually retain and protect the values of their own culture which, in the face of colonial domination, either remains in a state of 'hibernation' or **continues maintaining its dynamism by resisting foreign domination**. Indigenous culture in fact plays an important role in national struggle. But when the native bourgeoisie comes to power and offers foreign prescriptions for the country's post-colonial development, the dynamism of indigenous art and cultural life is either arrested or misdirected. Only the establishment of an indigenous socio-economic and political system, which genuinely serves the needs and interests of *all* the people, can enable the people to develop their own contemporary art and culture as an expression of the new dynamic of a liberated life.

Western Art v. Third World

The people's struggle to move forward in history today cannot be successful until they become, or are made, fully aware of their own role in the historical process, which requires their *full participation on every level*. This also requires their consciousness of their

particular historical position from which they want to move forward, and which must be linked to their historical past, their own cultural values and material conditions. The aim of foreign domination, on the other hand, is to take the dominated people out of their history or/and dislodge them from their particular historical position, thereby destroying their *sense of direction*. In other words, the imposition of an alien history on the people demands that they should renounce, if not denounce, their own history, their own cultural values, their right to think and determine their destiny as free people; and that they must instead accept their subservience to foreign values so that they may not be able to lift a finger against their exploiters.

The knowledge of Western art history as part of colonial education must have existed in the countries under colonialism. But the aim of its post-war accelerated propaganda as part of the overall Western cultural onslaught, which pretentiously projected Western art as a higher and universal expression of human life, was to re-establish or perpetuate its pretended supremacy in order to prevent the emergence of indigenous forces in the 'decolonized' countries. And, to a large extent, the West has been successful in re-imposing its history on Third World peoples when they were desperately looking for a new direction to move forward into the future and assert their independent existence as part of all humanity.

When young artists in Asia, Africa and the Caribbean were trying to emerge from the fog of colonialism, they found themselves in something of a dilemma. On the one hand, there was an awareness that their own traditional forms should play a fundamental role in contemporary developments, reflecting not only the spirit of the independent country but their time as well. On the other, they found themselves surrounded by Western forms which were becoming more and more intrusive in the post-independence period. And since most of them were alienated from the people and were actually aspiring to become part of the newly developing urban socio-cultural milieu in which Western values started to play a predominant role, the Western models not only offered them a more attractive alternative but also promised lucrative careers. It

is therefore no wonder that so many Third World artists should fall for Western art so easily and without understanding its historical developments.

What we see today in general is either the third-rate imitation of various Western styles (from Cubism to Pop Art), or a hotchpotch of Western techniques and native imagery; the aim being the creation of modern works of art which also *look* ethnically original. The content of these 'experiments' (which can be termed *neo-colonial* art) reflects the confusion and divided loyalties of the native bourgeoisie on which the artists are dependent for their survival, economically as well as socially. The prevalence of *neo-colonial* art today also depends on the fact that it is largely recognized and encouraged by Western Embassies' staff and Western tourists who flock to the capitals of the Third World looking for exotic entertainment and souvenirs.

There also exist considerable forces that defy the above situation, but they are not yet fully recognized. On the one hand there is a strong tendency now to renounce Western art altogether and return to what many Third World artists consider their own heritage. (It is too early to pronounce any critical judgement on the outcome of nationalist tendencies in the Third World. But, since it is part of the overall process which tends to create its own independent identity, it is an important step towards the realization of an indigenous development.) On the other, the isolation of Third World artists is a big danger; and is in fact being created by the aggressive role which Western art/propaganda plays on an international level. As such, many Third World artists have been forced to retreat behind their national frontiers. This not only deprives them of an opportunity to expand beyond their own boundaries, it also makes them look exclusively and nostalgically to their old traditions.

Other Third World artists have taken an entirely different direction, by accepting the challenge of this modern age. While conscious of their own indigenous cultural backgrounds (which they sometimes reflect in their work), they recognize the technological nature of various developments in the West. They consider it their

legitimate right to make use of contemporary knowledge in their own work (and without feeling any indebtedness to the West), just as Western artists were able to benefit, and are still benefitting, from their knowledge of Afro/Asian traditions (African Sculpture, Islamic Art, etc.). What is singular about these artists is that they are innovators. Thus they contribute to contemporary developments in their own right, by their own original ideas, concepts and synthesis/antithesis; and more importantly they offer a challenge to Western domination by defying the hegemony of art styles perpetrated and promoted internationally by the *transatlantic* gallery circuit of the Western world. But since these artists also defy the expectations of their native bourgeoisie, who would instead like them to be part of its *mediocre* and *vulgar* life, many of them are not recognized in their countries of origin or in the West, where they often end up living as self-exiled residents or 'citizens' of Western countries. (This phenomenon is not only limited to the artists of course. Many Third World scientists, engineers, doctors, architects, teachers, etc., also end up living in the West.)

Some Latin American artists are recognized for their pioneering works in the post-war development of art in the West, particularly in Kinetic Art. But since their contributions have been widely acknowledged in the West and subsequently in their own countries of origin (perhaps because of their European descent they did not find their identification with the Western mainstream, as well as their own acceptability by the West, problematic), they are outside the scope of this work.

Under consideration here are in fact the underlying causes of the general and predominant phenomenon of mediocrity in the Third World today, as well as the general non-recognition of the activities which avoid this *mediocrity* in defiance of cultural imperialism.

But before we go further, the term *mediocrity* should perhaps be clarified. We do recognize the different levels of developments in different parts of the world at a particular time in history. But it is not an issue here, because there are peoples who are not free to develop their capabilities. They are in fact deliberately deprived of

the opportunity of their historical developments, thereby condemning them to a pattern of life in which *mediocrity* takes up a *predominant* position that eliminates all the forces which would/could give the life a new dynamic for its radical change. However, the phenomenon of mediocrity is not exclusively confined to the Third World, as one might think. It is actually international, varying in form and degree in different places. In the case of the Third World, its causes are primarily external, while in the West they are internal as well. In the Third World today, mediocrity is comprised of forms created by the imposition of alien values which create stagnation in the indigenous process of development. In the West, it becomes a formalist transformation (formal innovations, frequent stylistic changes, fashion, trendiness, gimmicks, etc.), whose real content, in effect, mostly remains the same, sustaining the system that gives it driving force and which is produced by the system's capacity to dominate and exploit people nationally as well as internationally.

This brings us to the crucial question of the dominance of Western art in the world today. Is Western art really international (in its spirit and expression) or only an instrument of propaganda? Is the 'internationalism' of Western art (and culture) at this juncture in history beneficial to all mankind? If the purpose of internationalism is to bring different people nearer to each other and create a better understanding between them, why should it be monopolized by the West? Why aren't the people in/of the Third World playing any significant role in the development of so-called international art?

The question here is not really 'of the lack of thought given to the position of Third World artists in *western* discussions of art' (italics added), as Caroline Tisdall has put it (*The Guardian*, 26 April 1975), but of the exclusion of Third World people from the contemporary developments, controlled and dominated by the West. **The Third World artist is not seeking a position in Western art but his rightful place in the contemporary world which is being denied to him**. If Western art was confined to its own national boundaries or within the Western World and it made no claims at all to supremacy in the world, it would not have bothered us at all.

Since Western art is pretending to be international, spreading its vicious tentacles all over the world, it is necessary to question its real content and the motives behind its international expansion.

Now let us take the example of American Pop Art. What international significance is there in the images of Coca-Cola, Marilyn Monroe, Pin-ups, the American Flag, Hamburgers, etc.? These images are, of course, the *ethnic* images of American culture and there is no reason why they should not play a role in the development of her art. But when these very images are *universalized* through an international projection, their function changes. They are no longer the 'harmless' images of the popular culture or the innocent ambassadors of American art and culture abroad. Their international function is to propagate American consumer culture, through its glorified celebration by Pop Art, in the 'underdeveloped' world, and thus to undermine the indigenous values and their contemporary developments in the Third World.

No wonder that the *ethnic* art of modern 'icon-makers' of American 'high religion' (Pop/Consumer Culture) is considered international art and is reverently placed in the so-called historical mainstream, while the work of Mexican artist Diego Rivera, for example, is either ignored by the 'international' art pundits or relegated to 'non-history'. The only 'crime' he seems to have committed is that he defied Western cultural/art imperialism by rejecting the hegemony of art styles created in the art centres of Europe alone. Instead of merely serving the interests of Western civilization and history, he returned to his own people and committed himself to their reality. His work is a reflection of the socio-cultural, economic, and political environment in which he lived. Instead of understanding him in the context of his own historical forces, his work has been dismissed by the Western art pundits as mere propaganda.* We do not necessarily agree fully with the populist and propagandist philosophy in art, but **is Pop Art not propaganda?** If the West is only concerned with narrow boundaries of stylistic

* Herbert Read, *A Concise History of Modern Painting*, Thames & Hudson, London, Revised edition; paperback p. 8.

evolution within its own history and considers only the develop-
ments taking place within its metropolises, at the expense of other
contemporary developments, **what right has it to champion the
cause of internationalism in art and culture?**

The myth of the internationalism of Western art must now be
exploded. The fact is that there does not yet exist an art which truly
reflects international spirit of Man and Woman today. Western art
expresses the particularity of the West alone and does not reflect
upon the material condition of the world. It can therefore be said
that WESTERN ART IS NOT INTERNATIONAL; IT IS
MERELY TRANSATLANTIC ART. IT ONLY REFLECTS
THE TRANSATLANTIC CULTURE OF EUROPE AND
NORTH AMERICA. The present 'internationalism' of Western
art is no more than a function of Western politico-economic power
and the imposition of its values on other people. Therefore, in an
international context, it would be more appropriate to call it
IMPERIALIST ART.

We are not playing here with semantics. If by internationalism
is *only* meant an expression of a phenomenon taking place in more
than one country, an art movement emerging simultaneously at
more than one place across national boundaries as a reflection of
their cultural interrelationship, we would have no hesitation at all
in accepting the 'internationalism' of Western art. A style of wood-
carving is still being practised in many places across *national*
boundaries of most African countries, but would anybody call this
an international style? In the present world context, the word *inter-
national* implies *more than just a few Western countries*, unless we
accept that these few Western countries (which constitute about
25 percent of mankind) represent the whole world.

Internationalism is now an expression of a global phenomenon,
and we are sure Western artists/critics do not disagree with us here.
What they may still point out (which many often do, and not with-
out arrogance, to justify their claim of internationalism) is what
they consider a *natural* influence of Western art in the world today,
which in fact must be placed in the context of cultural imperialism.

However, even when a particular artistic development

influences or accelerates developments elsewhere, the former does not by virtue of its influence become a reflection of internationalism. African art, for example, influenced many European artists (some of them even imitated it) at the beginning of this century, giving rise to one of the most important movements in the West, Cubism. But African art did not, as Europeans would themselves say, become international art, nor did the European artists become *Africanized*.

The fact is that the Western mainstream draws material from all sources, sucking knowledge from other traditions and cultures into its own continuing development, often for *change for the sake of change*. Western 'avant-gardists' can now even appropriate the forms which were created hundreds/thousands of years ago by the peoples whom the West would call primitives (they were in fact more aware of the social function of these forms), and with the magic stick of ART HISTORY turn the 'demonism' of ancient tribes into their own 'avant-garde' art.

On the other hand, if Third World artists make use of modern methodology, creating original works that reflect their own contemporary reality, they would often be reminded of their indebtedness to the West, if not looked down upon as if they have actually stolen 'Western' property. It is not uncommon for the Third World artists who use contemporary techniques in their innovations to be seen *on the margin* or as followers of Western art. Instead of accepting them in their own right or as part of what is considered to be an international movement, they are often *Westernized* through a weird logic that can only be a reflection of imperialist mentality.

Nevertheless, the actual influence of Western art in the world today cannot be considered constructive. The nature and pace of the movement of Western art as part of Western cultural penetration in the Third World (facilitated, of course, by the native bourgeoisie) cannot offer an opportunity to the people in general to examine it critically. This is not to say that Western developments do not have positive and progressive aspects which, once analyzed and grasped, may benefit other peoples. But the aggressive propagation of Western values in the countries which are economically/

technologically underdeveloped, and particularly when as a result of this the indigenous productive forces are suppressed, it is very difficult, if not impossible, for the people to benefit positively from Western developments. It is no surprise that those countries which have understood the real motives behind Western cultural propaganda, have rightly closed their national borders to Western ideas, so they could generate their own developments without foreign interference.

The international expansion of Western art is not incidental, nor is it due to its natural attractiveness. It is in fact part of the West's missionary zeal to 'civilize' the 'primitives' of the Third World. The history of the last few centuries makes us see that behind this mask of civilizing other people, there actually exist insidious intentions whose only purpose could be, and is, to keep the Third World people as an appendage of the West, so that their physical and mental resources are used for the perpetual development of Western civilization alone, creating a vicious circle in which the West continues THINKING, CREATING and PRODUCING, while the Third World remains in a state of APATHY and its people turn into mere IMITATORS and CONSUMERS.

Of course, Western art propaganda *alone* cannot produce these results. But it functions as part of the West's economic, political and cultural operations on an international level: the aggressiveness of Western art/propaganda is actually that of the dominant system. Specifically, the function of Western art *domination* is to deny the Third World peoples of the indigenous developments of their contemporary art, and also to prevent the emergence of a unifying contemporary art movement other than in the West, in order to perpetrate/perpetuate the pretended supremacy of its own art and culture.

It is therefore no coincidence that America was suddenly awoken, after the War, to a realization that she also had her own 'geniuses'. It was a time when America, in order to establish her leadership as the most powerful of imperialist countries, launched a massive world-wide propaganda, projecting herself as the most civilized country of the world. Clinging to her cultural tentacles

were her artists, among other things, particularly *action painters* (later followed by *Pop artists*), who thus reached as far as her propaganda could penetrate. As a result, these artists in no time became internationally known, turning many of the newly emerging Third World artists into third-rate Abstract Expressionists (it was also a time when donkeys and monkeys also became 'abstract artists'). It would be an exaggeration, of course, to say that everybody turned to paint-throwing. But it certainly had an enormous impact (since it was so easy to splash the paint around) on the development of what has already been described as neo-colonial art.

The close relationship between Western concept of *international art* with international monopoly capital is obvious. As such, Western art is *mainly* developed and produced in the capitals of the most powerful of Western capitalist countries and by (white) Western artists (for they are the ones acceptable to Western art establishments), and then sold, through the *transatlantic* gallery circuit, at highly inflated prices that turn it into a precious product. Market price thus becomes signifier, content and criterion, which entitles a work of art to a place in 'history' books (propaganda books would be though a more accurate description) that are sent around the whole world for people to read about Western 'geniuses'. Once art is elevated to the position of a precious object through speculation and international publicity, it produces capital for its further propagation as a 'unique object of universal significance', and in turn this adds further to its preciousness, and so on. And since all this takes place exclusively within Western historical and cultural contexts, it enhances Western civilization and contributes to its dominating power.

The whole process of the acceptance (or rejection), evaluation, elevation, propagation and signification of art, is maintained by an economically powerful art market which operates like a stock exchange in the capitals of the Western World – capital, publicity and speculation being its basic and essential tools. It also creates a privileged class of artists who in turn serve this market and its function in the system. Having been elevated to the 'pedestal of genius', these artists not only become trapped in a privileged

socio-economic milieu believing in their 'semi-god' status and their 'superhuman' power (like Midas turning *everything* into gold – Picasso comes to mind here), but more importantly they contribute to Western cultural domination by thus becoming instruments of its international propaganda. Their 'superhuman' and international status is in fact no more than an illusion created by all that money which flows into their bank accounts and their elevations as superstars on the world stage.

The numerous and frequent claims of internationalism by the Western artists who are internationally known (the so-called radicals are not exceptions here) are as ludicrous as the very concept of an international art based exclusively on Western values and developments. The fact is that this facade of internationalism is essential for many of these artists to maintain their self-esteem, by being elevated to a position from where they can look down upon the rest of the world. Their neo-colonial mental attitude is nurtured by the politico-economic power of the imperialist West, which provides them with all the material incentives for futile and self-indulgent activities.

If we appear so condemning in our attitude towards the West, it is not because we are against Western people (they are, in fact, also the victims of the same dominant ideology) or that we are envious of their progress/affluence. Neither are we turning our backs on everything Western. But, in the present context of our relationship with the West, it is difficult for us to be more charitable towards those who are always endeavouring to accuse us of laziness, lack of imagination/incentive, and so on, thereby obscuring their own misdeeds against humanity by perpetual reiterations of their pretentious claims to all human progress and civilization through their massive international propaganda.

Those apologists of the system who cynically reproach us for not yet creating our own contemporary art with our own values (and of so-called international standard), must now get off our backs. AND STOP TELLING US WHAT WE MUST OR MUSTN'T DO, OR HOW WE SHOULD DEVELOP OUR ART. Instead they ought to examine their own roles in the process and context of cultural imperialism and get rid of their own

deliberate ignorance and patronizing attitude (is it asking too much?), so that they may also see the world in its true perspective.

It should be made clear here that by 'West' we do not mean a monolithic West – or for that matter Third World. We recognize that there are both reactionary and progressive forces on both sides of the dividing line. But although the fundamental relationship between the West and the Third World remains as that of between the dominant and the dominated respectively, **our criticism is not meant to be directed at the progressive forces in the West.**

Blacks in Britain

Imperialist domination does not end with exploitation of Third World people in their own countries. It forces ordinary workers and peasants to leave their homes and search for a livelihood in the alien environment of its socially hostile metropolises. In addition, imperialist cultural propaganda, as well as specific recruitment, effectively lure many educated and trained young men and women into believing that they can find a better and more happy life if they leave their own countries and live in the West. The actual situation in which people from 'underdeveloped' countries thus find themselves living in the advanced industrial societies of the West, does not differ much from one Western country to another. We shall, however, confine ourselves here to our own predicament *in Britain*, but we do recognize that a similar pattern of racism and exploitation exists in other Western countries employing foreign labour,* not forgetting, of course, the US and those Afro-Asian peoples who are still living under the yoke of racist colonial/imperialist rule.

Black people in Britain today cannot be treated in the same way as 25 years ago when we, after being uprooted from our native soils, were rail-roaded into menial jobs. The aspirations of the younger generation of blacks, particularly those born in Britain, are very different. We cannot, and will not, accept only shitwork. If society cannot fulfil our expectations just because it does not wish

* For the predicament of migrant workers in Europe, see *A Seventh Man* by John Berger/Jean Mohr, Penguin Books, London.

to see us rising above our present existence at the bottom of the heap, we shall continue fighting for our rights. If some black kids are in the street, and a few have become what the establishment calls 'muggers', the fault does not *totally* lie with them but with this society.

HOWEVER, TWO MILLION BLACKS AREN'T GOING BACK HOME. BRITAIN IS OUR HOME AND WE WILL NOT ACCEPT OUR SECONDARY AND INFERIOR ROLES IN THIS SOCIETY. WE SHALL CONTINUE FIGHTING FOR OUR EQUAL HUMAN STATUS. THROUGH THIS WE ARE IN FACT CONTRIBUTING TOWARDS THE DEVELOPMENT OF THIS SOCIETY INTO A BETTER ONE FOR ALL TO LIVE IN.

What must concern us is not only the blatant manifestation of racism by right-wing fascists who are now demanding our return to the countries of our origin after we have been milked for 25 years as cheap labour, but also the subtle racist attitude that prevails in every field and at every level of British life.

'. . . and I certainly wouldn't like to see a Negro minority taking over this country. A lot of nice bus conductors running the government isn't my idea of a sensible way out . . .' John Osborne's above comments (*The Observer*, 7 July 1968) on black people are, in essence, not very different from the hysterical outbursts of Enoch Powell. Besides the subtle racism and paternalism of his remarks, his contempt for working people, both black and white, is clear. The absurd notion that blacks are 'taking over this country' reflects the paranoia of his privileged lot. How could half a million 'Negroes' take over a country of about 55 million people, which is still considered to be one of the most powerful in the world? Only racists can indulge in such absurd fantasies!

That Mr Powell is a racist is not even doubted by many white people. What one can't *perhaps* do is accuse him of hypocrisy. What Powell has so far said, and we are sure he will say it again, is that he is not 'against' black people but only our *number*. He would in fact accept a small number of *us* amongst his *white society* (to do the

menial jobs). In other words, he would welcome a considerably reduced number of blacks who, because of their numerical disadvantage, would remain docile and not overstep their roles defined by *him*, and thus would find themselves unable to confront this society with its racist philosophy. But how does Powell's attitude differ from that of Osborne who doesn't appear to like black people demanding more than the crumbs offered by his society?

We have quoted John Osborne *only* because his remarks even today typify a liberal attitude, and that of the establishment, characterized by hypocrisy and paternalism. We are often told that this society is not really racist and that it does offer FREEDOM OF CHOICE, THE SAME INCENTIVES and EQUAL OPPORTUNITIES to ALL its people. NICE WORDS! BUT ARE THEY ALSO MEANT FOR US? Of course, NOT. We must stick to bus conducting and let THEM write plays or produce works of art. It is no coincidence that black people are often portrayed in the media as waiters, objects-of-fun, exotic/ethnic dancers and entertainers, muggers, smugglers, gangsters, etc., perpetuating the racist myths of *intrinsic* inferiority and criminality of black people.

We have made this country our home. We cannot be pushed around or persuaded to leave. The above attitudes can only perpetuate antagonistic black-white relations. The positive alternative to this would be to accept the legitimacy of black-white conflicts and make concerted efforts to create a process in which these conflicts are constructively resolved for the betterment of the *whole* society. This could only be achieved through openly questioning the historical background and the present roots of racism, and at the same time exposing and confronting the system's manipulation of people's fears and insecurity under capitalism.

We cannot, however, go into all the problems we face here. What we intend to show specifically is how we are prevented from participating in the cultural life of the country which we have now made our home. If our argument is confined only to black artists, whose presence in the country has been deliberately ignored, it is not because the problems facing black artists are more important

than those of black people at large. The problematic situation of black artists, in fact, reflects a social attitude which affects all of us black people. We cannot therefore separate black artists from the total context of blacks in this country. THE DOOR WHICH IS SHUT IN OUR FACE BY A WHITE LANDLADY IS ALSO THE DOOR WHICH OPENS TO THE ART ESTABLISHMENT.

Now, how does the attitude of the British art establishment towards blacks differ from the general one? This would be better understood if we recognize that the art establishment in general, and its official/public bodies in particular, act as a mechanism to regulate art and cultural activities and thereby assert control over them. Therefore, the function of the art establishment cannot be separated from the ideology of the system. In other words, if racism is part and parcel of the system, it cannot be absent from the components that regulate its art and cultural activities.

Kenneth Coutts-Smith, writing in the catalogue introduction to 'Second Commonwealth Biennial of Abstract Art', Commonwealth Institute, London, 1965, said: '. . . Some years ago commonwealth artists were arriving in London to work and establish a name, and found themselves in somewhat of a difficult position. Except in very rare instances they were receiving little or no support from the Art authorities in their home countries. At the same time the official bodies in this country, *by the very structure of their charters*, were invariably unable to do much beyond offering encouragement.' (Emphasis added).

This structure, we believe, still exists and it cannot be other than *the support structure* for the promotion and the development of art in Britain. In other words, it is the main function of the British art establishment, particularly its official bodies, to encourage, support and thus promote the art activity of its people. The question now is: whom does it actually consider *its* people? The answer to this would be, of course, the British people. But this does not answer everything, because the crucial part of the whole question is: what are the various components that make up British society? Are we black people considered part of the society or merely looked

down upon as immigrant workers? Enoch Powell provides us with the answer when he says: 'They don't belong to this society. Do they?' (ITV, 5 January 1976). We believe that the art establishment does not really disagree with Powell. This becomes evident when we look into its indifference towards black artists, denying them true recognition for their art activities in Britain for the last 20 years or so years. This was confirmed at the Third Regional MAAS Conference on Ethnic Arts, London, 19 June 1976. In answer to a complaint from a black person, one of the Arts Council's representatives, Ruth Marks, bluntly remarked that the Arts Council was a traditional British institution whose function was to support its own professional artists. The implication here is very clear. Black artists are considered neither British nor professional by the Arts Council – and that must go for the whole art establishment.

When we speak of the British art establishment, we mean the whole art establishment – art galleries, museums, art magazines and books, art schools, and what have you, official and private. But we are more concerned here with the Arts Council of Great Britain and the British Council, which are the main official bodies that support and promote art and cultural activity at home and abroad respectively. These bodies are financed by public money which must surely include the tax money from black people in British society. This means WE BLACK PEOPLE ARE ACTUALLY CONTRIBUTING TOWARDS THE COST OF RUNNING THE OFFICIAL ART BODIES AND THUS TOWARDS THE SUPPORT AND PROMOTION OF ART/CULTURE IN BRITAIN. But what do we get OURSELVES in return? NOTHING, or maybe SOME CRUMBS sometimes.

The official bodies would say that they do not discriminate on racial grounds. Of course, they don't have to hang a 'NO BLACKS PLEASE' board outside their doors. But how many black artists have ever managed to get through? If no door was ever shut on them, IT WAS ONLY BECAUSE NO DOOR WAS EVER OPENED TO THEM. The facts speak for themselves: no black artist has ever been included in any official exhibition or survey representing the various developments of visual arts in Britain

since the time we have been here, not to mention any individual show or representation abroad.

If the *absence* of black artists from *what is recognized* is any indication of the real situation in Britain, then it would either mean that there are no black artists – which would again mean that we black people are not interested in art activity – or that black artists are not good enough for any consideration by the art establishment. The truth is that the official bodies, as well as the art establishment at large, have turned a blind eye to the very presence of black artists in Britain and to their actual contributions. Furthermore, the fact that black people also need, and must have as *our right*, official support for the development of our art and cultural activities, has been *deliberately* ignored. Any suggestion here that the work of black artists might not have been, or may not be, of high standard or any significance, would be nonsensical. There is enough evidence that the work of black artists can be compared with that of their white contemporaries who are recognized both nationally and internationally, *in spite of the fact that black artists have to work under conditions (physical as well as mental) which few white artists would be able to bear for long.*

The art establishment does not have to have an open and declared policy which discriminates between white and black artists. But that does not necessarily mean that a mechanism of control, or an attitude, which denies black artists their access to the art establishment and their rightful recognition does not exist. We must not forget that the institutional structure of official bodies was considerably developed and nourished at the time when Britain had a colonial Empire. And since its old structure has not been changed to come to terms with the fact that blacks in Britain are no longer colonial subjects but British citizens, those controlling the official bodies (and the private ones as well) still act, consciously or unconsciously, with a colonial attitude towards black people.

We can understand this better when we appreciate that Britain is still an imperialist power (in a neo-colonial sense) whose values are promoted abroad as part of its international cultural propaganda. Its promotional pattern is still based on cultural purism and

exclusiveness. Its products are promoted abroad in such a way that it does not contradict the traditional British (English, to be more precise) image. The British image abroad, even today, consists of a white society in which there is a small black immigrant population 'serving its white masters'; and its creative activity must therefore be an activity which embodies white values created and defended by white artists. One only has to look into the common pattern of British art criticism which seldom fails to point out the Englishness of British art. And since Englishness is only identifiable with white people (ask Powell why!), the English chauvinistic art promotion pattern ignores the art activity of black people in the country, or it relegates it to ethnic pigeon-holes. The merits or demerits of the work of black artists do not even enter into the criterion of selection and recognition. The very mechanism of selection and recognition, based on the idea that white artists are the *only* representatives of British art, disqualifies black artists from being even considered before the merits or demerits of their work become evident. It is not surprising that a black artist who has lived in Britain for the last twenty years or so should strike a pessimistic note here: 'They can make all these noises about the multiracial society, but when it comes to the crunch they only push their own boys.'

The recent exhibition in Milan, 'Arte Inglese Oggi, 1960–76', which was supposed to represent the various developments of art in Britain during that period, is not only an example of English art chauvinism but also a deliberate misrepresentation of the actual picture, by perpetrating the lie that contemporary art in Britain is the privilege of whites only. The very title of the exhibition excludes black participation. One wonders, in this respect, if there has been a single protest from Welsh, Irish and Scottish artists who have all thus been lumped together as English, unless none of them was included in the exhibition. Or is it a part of their careerism not to question English domination?

There is no doubt that the official attitude has contributed largely to the perpetration of a white monopoly of the British art scene, and in this respect the public bodies have proved themselves incompetent in discharging their duties. They have in fact misused

all those funds which should have actually been utilized for the development and promotion of the activities of black people in this country. In view of the fact that we black people live, work and pay our taxes in Britain and thereby contribute not only towards the running of the country but also to its art and cultural institutions, WE MUST DEMAND, NOT AS CHARITY OR SPECIAL FAVOUR BUT AS OUR RIGHT AND SHARE, FULL RECOGNITION OF ALL OUR ACTIVITIES. We must have the right to be shown in all official exhibitions and galleries, without any delay and excuse. We must be paid full remuneration for our work and efforts.

The Arts Council's sponsored report 'The Arts Britain Ignores', by Naseem Khan, which has been published recently, does not present a true and full picture. It has not only *divided* black people into black and Asian groups (as if Asians are not black) but pigeon-holed their activities into various ethnic categories, thus relegating them to a subcultural level. It seems to have concluded that black artists have not yet done anything worthwhile outside the narrow boundaries of their ethnic traditions. This must be partly due to the lack of information about the activities of black artists, and/or the results of the author's own presumptions. It also appears to be an attempt now, in the face of our growing demands for equal opportunities, to pigeonhole us in such a way as to leave the white population free from the fear of black competition, particularly in the field which most white artists consider their exclusive monopoly – the British mainstream.

The issue here is not, *and should not be,* the ethnicity of black activity: one *could* also say that English art is ethnic. The question here really is why black activity is being relegated to a subcultural level. We must not accept our separate categorization, in order to receive some crumbs. WE MUST DEMAND FULL RECOGNITION OF OUR EQUAL STATUS. IT IS THE CONCEPT OF MAINSTREAM WHICH MUST BE CHANGED TO MEET THE NEW DEMANDS OF THE SOCIETY, AND NOT THE OTHER WAY ROUND, IF WE WANT TO AVOID THE PITFALL OF CULTURAL BANTUSTANS IN BRITAIN.

Towards Third World Movements

The prerequisite for the indigenous developments of contemporary art in the Third World is a *confrontation* with those forces which have, in the first place, caused its underdevelopment and are today actively obstructing its post-colonial regeneration. We cannot expect the indigenous art to flourish under the imposing shadow of an alien culture; and this shadow is not going to disappear until the tree of imperialism is uprooted from our soil. But foreign domination cannot be effectively got rid of as long as there exists a *system* in the Third World (and for that matter in the West as well) that demands its continual presence, physical as well as mental.

Although our commitments lie mainly within the domain of art, this cannot be isolated from life at large and the struggle for its constant transformation. Particularly when the present problems of our art and culture are essentially part of the predicaments of the people violently subjected to foreign domination and their struggle against it, our art activity cannot be removed from this reality.

Our art must therefore be oriented towards anti-imperialist struggle. It does not necessarily mean that art should become a mechanistic instrument of ideological and political struggle. It should be part of the historical process in its own right, making its own contributions. That is, art must *also* wage struggle against domination and reactionary forces/ideas within its own sphere, without being discarded for political activity and without being separated from it. It is not a question of *political art* but an art which embraces the radical consciousness of its time. Those political activists, or ultra-leftists, who see art only as an instrument of political reality and its propaganda and keep on reminding us about the 'uselessness' of art activity (as opposed to political activity), are only revealing their own philistinism, if not actually betraying a lack of understanding of the true function of art, as well as its limitations.

The real function of art, of course, is neither a mere expression of beauty/self, decoration or entertainment (as is commonly understood), nor political propaganda. But this does not mean that art

can be *apolitical* or *neutral*. In other words, art cannot but *reflect* an ideology, no matter how implicit it is – unless art can be emptied of all ideas and meanings, which is impossible. The so-called neutrality of art can only mask its sterility or an attitude that actually serves the interests of an ideology or a class.

Art cannot be, moreover, autonomous of culture. The myth of universal art, perpetrated by various art movements in the West in this century, must now be debunked. Behind this facade of universality lay the desire to impose Western values on rest of the world. The fact is that the conditions under which Western art has been developing and flourishing are very different from those of the Third World. The art of the society whose material foundation is laid on the exploitation of other people, cannot be at the same time an expression of exploited people. While the development of art of a dominant society derives its energies, its dynamism, from its power to expand beyond its own boundaries and impose its values on the people whom it thus dominates and exploits, the art of the dominated people cannot but reflect their own predicament – including their resistance to foreign culture.

The question of how to resist and confront domination, and the values/forms which perpetrate it, becomes central here. This would naturally require, on the one hand, a thorough and critical examination of the various aspects of Western civilization, its art and culture, and, on the other, developing our own methods and forms of art/cultural activity which not only expose the insidious aims of Western cultural penetration in the Third World but also confront it effectively.

This cannot be achieved, however, by ignoring 20th century developments (in the West) and looking exclusively to our own past traditions for the solutions to contemporary problems. Nostalgic return to our past forms would be tantamount to an avoidance of the situation, which demands action against what is dominant and what is dominating us today. We must stay in the contemporary battlefield and fight for our liberation **with all means available**, the traditional as well as the modern technological. Cultural imperialism makes use of the most sophisticated

technological means to dominate us. To confront this we would require not necessarily the same sophisticated technology but a similar *methodology* incorporating our own forms as well as of others, resulting in antitheses.

The rejection of modern knowledge, and its various forms, in favour of indigenous *traditions* is based on an ignorance or a misconception that attributes modern developments exclusively to Western history. It is important to remember that Afro-Asian peoples had actually developed considerable knowledge before it was taken over by the West at the beginning of this modern era about five/six centuries ago. Even during the colonial period when the Third World people were deliberately prevented from any *direct* participation in modern developments, they did contribute significantly to the historical process.

Modern knowledge now belongs to all humanity. But it does not mean that we, in the name of progress or modernism, must accept THE IMPOSITION OF WESTERN VALUES ON US or that we must concede to Western cultural hegemony in contemporary life. IT IS UP TO US, AND US ALONE, TO MAKE USE OF ALL AVAILABLE KNOWLEDGE IN OUR OWN CONTEMPORARY DEVELOPMENTS.

The knowledge gained from the period when our own developments were suppressed, and when the developments in the West assimilated our art and cultural traditions, could be very useful. It does not necessarily mean that we shall go through a process of learning how to paint or sculpt in Western styles, nor that our contemporary developments should be dependent on Western models. But it is important to be aware of the history of the culture which surrounds us today; and only then, by being in a position to separate its positive and negative aspects, can we accept or reject it.

Our own traditions are, indeed, our assets, and to ignore them would be tantamount to a rejection of our own history and our own identity as a people. But to go back now to our past, and paint or sculpt like our ancestors used to do, would be a backward step. Mere reminders of our past glories can disregard contemporary reality, denying us the driving force of moving forward. The

essence of the past must of course be fully grasped, by looking into how and why certain forms developed in certain periods and what were their relations with socio-economic forces. And if the traditional forms have survived as part of our present life, they must be given a new dimension to play a role in our developments today. However, this can only happen as part of an historical development of our own productive forces, giving birth to new ideas, concepts, values, forms, and symbols that reflect the new and changing reality.

What is important now is not WHAT WE WERE IN THE PAST, but WHAT WE ARE TODAY. Whether we live in our own countries of origin or in the West, neither a mechanistic revival of our traditional forms nor a trailing behind on the paths formed by the so-called historical styles of Western art can offer us a positive direction. While rejecting both these options, but still finding ourselves surrounded and dominated by the forces which either demand our return to 'ethnic' traditions or make us accept the hegemony of Western developments, WE HAVE NO CHOICE BUT TO OPPOSE THEM BOTH; AND OUT OF THIS CONFRONTATION WILL EMERGE NEW FORMS THAT TRULY REFLECT OUR PARTICULARITY IN THE WORLD TODAY.

We are no longer *national* entities, in the literal sense of the word. The problems facing us today are not necessarily of national dimensions or characteristics. They are in fact the consequences of the dominating forces *internationally* unleashed by the West. Our efforts, while containing individual/national elements, must therefore transcend both individual and national boundaries to reflect upon the international aspect of our predicaments and to come to terms with a situation that demands solidarity amongst all the peoples who are struggling against the same enemy.

The Third World must evolve its own independent identity, which cannot be, of course, homogeneous. But in its formal diversities, it must embody and express its underlying unity based on the common historical past and the present reality of 'underdevelopment', also reflecting its *unified* opposition to Western domination.

From the problematic situation of the Third World MUST EMERGE AN INTERNATIONAL MOVEMENT, WHICH IS DIFFERENT FROM AND IN OPPOSITION TO WESTERN ART. This would, of course, require the development of our own *international* platform, or communication/gallery network through which we could exchange our ideas directly without Western intermediaries/ interference, creating historic links between the peoples whose emergence can offer a new hope to all mankind.

While coming to terms with the modern technological age and our own contemporary reality, which must involve A SEARCH FOR NEW METHODS AND FORMS beyond the narrow/obsolete concept of art based on the Western tradition of purity of painting/sculpture or craftsmanship – and the content of which must be oriented towards our own cultural situation, we must avoid the pitfalls of the stylistic sectarianism which has been one of the hallmarks of the Western avant-garde.

The struggle between different styles for so-called historical primacy is one of the characteristics, if not *the* dynamic, of contemporary art in the West, perpetuating aggressive competition between individuals for recognition. No wonder that the dominant ideology lays so much emphasis on the identity of the individual through one's work; which is actually realized by turning a particular style/form into a precious pedestal on which its 'innovator', the artist, must stand, maintaining the consistent position for the identification to be established. The recognition thus achieved not only gives a tremendous boost to the artist's inflated ego – a result of alienation, it also provides one with especial material benefits and social privileges. A formal style which must be the function of content thus becomes content itself, thereby leading the artist into a formalist cocoon in which he/she is perpetually trapped, isolated from the grasp of an actual and changing reality outside.

The Western avant garde is, however, nearly reaching the end of its bourgeois cul-de-sac. On the one hand there is a wild talk about *the end of art* – as if art cannot exist or flourish outside bourgeois art history! On the other the new 'radicals', in their last and desperate attempts to keep clinging to Art History by perpetuating the

so-called evolution of historical styles, are even grabbing whatever material or forms they can get hold of from their flirtation with Marxism, class struggle, the predicament of dominated people, etc., manipulating them only to perpetrate a new formalism. The radical polemics/rhetoric of most Western artists, however, is not applicable to Third World conditions.

We ourselves do not need to look for any material outside our own existential reality, which is in fact part of our peoples' predicaments. We do not have any art-historical axe to grind. We have no art-historical pedestal to stand on and defend bourgeois values or preach sermons about beauty and aesthetics, nor shall we indulge in the futile activity of *art for art's sake*. Our history is in fact the history of the pillage and plundering by colonialism. We must grasp *this* truth and turn it into a weapon of our cultural struggle. FROM CENTURIES OF OPPRESSED EXISTENCE, FROM THE WILDERNESS OF COLONIALISM, THE THIRD WORLD MUST NOW EMERGE, LIKE A BLACK PHOENIX RISING FROM WHITE ASHES.

It does not follow from this that we must cut ourselves off from the activities of our Western contemporaries, particularly those who are also aware of their role in society and are aiming at a radical change. Since many of us live in the West, we must avoid isolation and separatism which is no recipe for the positive development of a society in which all people, irrespective of race and colour, must interrelate. But in the present situation it is very difficult. *So long as* Western people speak from their privileged positions and with their usual paternalistic attitude and arrogance, there is no possibility whatsoever for the development of a real dialogue between THEM and US.

The development of a true international platform/movement, from/to which all cultures could make their unique contributions, is not only possible but desirable in the long run. But if this is to serve the true interests of all peoples rather than become another instrument of selfish Western interests, it must be based on the clear rejection of Western art history as *the* mainstream. The subjective conditions of the affluent Western society – particularly

when these conditions have been achieved at the expense of the majority of the people in the world, cannot offer a truly international perspective.

The concept of individual geniuses as *the* creators, looking down on the rest of the people as being incapable of an art or a creative activity, is another aspect of the dominant ideology. The present relationship between an individual as a *creator* and the people as mere *consumers* must therefore be questioned. What we could instead do as art/cultural workers in the present transition, before a new society emerges in which art and culture shall be collectively developed and created, is to *initiate* activity which is then taken up *critically* by people; and the eventual development or completion of the work must depend on their actual participation/contribution.

It ought to be made clear that this work is not meant to be an objective analysis. It is *mainly* a personal statement by A THIRD WORLD MAN who, as a result of being uprooted by cultural imperialism from his Asian environment, was sucked into the Western World where he has spent a considerable part of his life in a pursuit of freedom of artistic expression in what he has now come to realize is A WHITE MAN'S WORLD. The experience of living in the West has led him to *black consciousness* and to the awareness that HIS REAL PLACE IS IN THE THIRD WORLD. This is an attempt now on his part to re-examine his relationship with the West, and redefine his artistic role in the cultural context of his people, whether they live in their own countries or in the West.

A Third World Praxis

No recipes or prescriptions are being offered here. We must not believe in ready-made solutions. Art cannot be developed by a set of rules but only through an evolving life-process that generates new ideas at every stage of its transformation. Therefore the suggestions here are not meant to be taken as canons to be followed, or guidelines for the production of art. They may in fact trap us, if followed mechanistically, into a dogmatic/formalistic situation stifling our imagination and energies.

Nevertheless, it is hoped these notes will initiate a discussion

from which may emerge a clearer picture, providing us with a starting-point in a direction towards a new dynamism which helps us liberate our energies and awaken us from our present lethargic generality. The success of this will, of course, depend on the imaginative and creative response from the Third World people, who may also be thinking in the same way but have not yet come forward or did not have an opportunity to express their ideas.

Cultural imperialism cannot be dealt with by making appeals to its liberal conscience or pretended humanity. So long as we look to others for the solutions of our own problems – and no matter how much noise we make – we will only be ignored or pushed around. We must ourselves take a concrete step. These notes are therefore being offered as A PRELUDE to A WORK whose realization and completion depends on *all of us together*, including our Western comrades.

The conceptual structure of THE PROPOSED WORK can therefore be laid down in the following order: INITIATIVE/writing of this prelude; CONTACT WITH PEOPLE through its publication; PARTICIPATION by people in the form of their critical intervention; UNIFICATION of all the material thus created by being published together as a completed work (ARTBOOK). RE-CONTACT; return of the completed work to the participants; PROPAGATION/general distribution of the work; and so on . . .

Would you therefore send your contributions, in the form of WORDS and IMAGES relating to the cultural problems of the Third World. Keeping in mind that the aim of the work is the DENUNCIATION OF AND CONFRONTATION WITH IMPERIALIST CULTURE and THE SYSTEM that perpetuates international domination. Your contributions may also include constructive criticism of the work. The visual IMAGES may be produced, for example, by collective actions (events etc.) against the cultural strongholds of the system, and by documenting them photographically. The decision how to act or what to contribute, however, entirely lies with you.

The material thus received, comprising of statements/criticism/

photographic documentation, will, it is hoped, be published (depending on the availability of publisher or money) as a completed BLACK MANIFESTO, and copies sent to the participants, who must also send their names and addresses: c/o *Black Phoenix*

(London, 1975–76)

M60 The Azad Group

Manifesto (1976)

Goruh-e Azad-e Naqqashan va Mojassameh-Sazan-e Iran, better known as the Azad (Free) Group, were an anti-commercial collective established in the mid-1970s by a group of influential Iranian artists based in Tehran. In October 1976 the Azad member Morteza Momayez (1935–2005) – regarded as the founder of modern Iranian graphic design – drafted a manifesto for the catalogue of their exhibition of political conceptual artworks, *Volume and Environment II* (*Gonj va Gostareh II*), held at Tehran's Saman Gallery.

The intention of the show was to question the direction in which modern Iranian art was heading, particularly with the emergence of a market-driven style of art, which they saw as insufficiently challenging or progressive. However, as the Azad Group sought to experiment with different mediums and concepts, they in turn were criticized for merely imitating Western artists. Azad's riposte was that the whole history of art cannot be understood without embracing the vital role of imitation, citing Picasso among others in the West, and the highly respected nineteenth-century Persian artist Kamal al-Molk, who had first introduced a European painterly sensibility to Iran.

The Azad Group's activities were brought to an abrupt end in 1979, when the Shah of Iran was overthrown by leftist and Islamic rebels and the radical Muslim cleric Ayatollah Khomeini became supreme leader of the new Islamic Republic of Iran, bringing about a cultural revolution in which Western and non-Islamic influences were banned.

* * *

They accuse us of the following:

- The works of the artists of Azad Group are an imitation of current art movements in the US and Europe.
- The artworks of Azad Group are irrelevant to our environment.
- Anyone can easily create similar artworks.

We reply:

How can an artwork be original or imitative?

Who can make such a distinction? According to what criterion and knowledge?

Can everybody claim to have the knowledge needed for making [aesthetic] judgments or is it the professional critic familiar [with the] technical aspects of contemporary art production who should do it?

The judgment of any viewer is interesting to us, for such public judgments would reveal different aspects of artworks in relation to the viewer.

Yet, all artists have been waiting for years for the illuminating words of professional critics, since all that is said in the name of criticism is not critics' words, but rather the superficial understanding of enunciators who accuse us of imitation, and their work appears substantial simply because it is published in journals . . .

If we look at much of our cultural activities, or those of other nations, from such a superficial perspective, we will come up with disastrous results:

For instance, according to such a superficial outlook, all art, from the miniatures of the past to Kamal al Molk's paintings to the work of modern artists today, are imitations of either Chinese art, the classical art of Europe, or the new art movements of the recent decades in Europe.

Or for instance, many of the American contemporary art movements are imitations of Dadaists' experiences or those of some other European artists.

Or the works of Picasso, the great artist, are imitations of African art.

Or the artworks of Modigliani or Matisse, two of the most distinguished artists of the current century, are copies of our miniatures.

As such, there remains no master at all, since one can trace in the work of any master his master, and according to such a viewpoint, the world of art is imitating itself in a chain [of imitations].

Relying on a superficial understanding, such judgments would inevitably end up in such conclusions because all sorts of 'influences' mean [nothing but] 'imitation' to the one who judges.

Imitation is an interpretation with no intellectual subtlety, and in every movement numerous imitators step forward. But history does not recall imitators who lasted long. The influenced remains at the bottom of the gutter.

We must not dismiss a new movement and ridicule its simplicity as a result of fearing the appearance of imitators. Yet being influenced is not a voluntary action that can be avoided. Those who are sensitive are influenced by their living environment, and the living environment in its turn is under the influence of communication and economic systems.

Which of us has a nonenvironmental behavior and is therefore able to condemn influence? What deceives an ignorant observer is that he chooses criteria for his empty hands, criteria that lie in the hands of others, the same way that he recognizes his worth only when it comes out of the mouth of the other.

A need has brought together the members of Azad Group despite all the differences of their artistic methods. The environmental influence has created this need in us.

The need for an intellectual play, for an investigation and for experiencing a route different from their main path, for opening a window into a different air, for smelling, tasting, digesting, and being born anew in the same main path.

The need for self-destruction to test our criteria anew.

The need for avoiding repetition.

The need for simplicity and for approaching and approximating whatever is in our lives – things we do not see in our intellectual solitude and the value of which we ignore.

The need for hailing other horizons.

M61 Kaisahan

Kaisahan Manifesto (1976)

Kaisahan (Solidarity) were an assorted group of revolutionary left-leaning Filipino artists based in Manila and led by the figurative painter Pablo Baen Santos (b. 1943). They came together in the late 1960s in opposition to the government-backed Cultural Centre of the Philippines (CCP), whose slogan was 'The true, the good and the beautiful', as part of a wider struggle against the Marcos regime and US cultural imperialism within the country. Inspired by Marxist doctrines, the group held workshops and lectures that advocated a national artistic identity based on scientific principles. Like the Artists' Front of Thailand (M57), they believed that abstract art was bourgeois; instead, art should draw its energy from the life and aspirations of the people. Paintings were bold, graphic, Socialist Realist images depicting the corruption of politicians and the plight of the workers. They took their art to the countryside and to shanty towns, staging exhibitions in places that were easily accessible to the poor.

Kaisahan's manifesto was written and circulated on 6 December 1976, at the opening of the group's first exhibition 'Truth, Relevance and Contemporary' (*Katotohanan, Kabuluhan, Kasalukuyan*) at the Ayala Museum in Makati. It argued for a national art that rejected both traditional Asian influences and the 'slavish' adoption of Western styles, and found its inspiration in the realities of contemporary Filipino society.

* * *

We, the artists of the Kaisahan, commit ourselves to the search for national identity in Philippine art. We believe that national

identity is not to be found in a nostalgic love of the past or an ideal-ized view of our tradition and history. It cannot be achieved by using the common symbols of our national experience without understanding the reality that lies within them. We recognize that national identity, if it is to be more than lip service or an excuse for personal status seeking, should be firmly based on the present social realities and on a critical assessment of our historical past so that we may trace the roots of these realities.

We shall therefore develop an art that reflects the true condi-tions in our society.

This means, first of all, that we must break away from the Western-oriented culture that tends to maintain the Filipino people's dependence on foreign goods, foreign tastes and foreign ways that are incompatible with their genuine national interests. We reject this culture insofar as it perpetuates values, habits, and attitudes that do not serve the people's welfare, but we draw from it whatever is useful to their actual needs.

We shall therefore move away from the uncritical acceptance of Western molds, from the slavish imitation of Western forms that have no connection to our national life, from the preoccupation with Western trends that do not reflect the process of our development.

We realize that our search will be meaningless if it does not become a collective experience, an experience that is understood and shared by the broadest number of people. In its beginnings, art was not the isolated act that it is now; it was as necessary, as inte-gral, a part of the people's lives as the knowledge of when to plant.

For us, therefore, the question 'for whom is art?' is a crucial and significant one. And our experiences lead us to the answer that art is for the masses. It must not exist simply for the pleasures of the few who can afford it. It must not degenerate into the pastime of a few cultists.

We are aware of the contradictions that confront us in commit-ting ourselves to this task. At present, under the conditions of our times, the audience who will view our works will mostly be the intellectuals, students, professionals and others who go to the

galleries. But we wish to gradually transform our art [into one] that has a form understandable to the masses and a content that is relevant to their life. At present, it is inevitable that our art is sometimes commercialized. But we should use this as a means and not as an end for our artistic expressions.

Our commitments to these objectives need not mean that we limit ourselves to a specific form or a specific style. We may take different roads in the forms that we evolve and use but we all converge on the same objectives. The only limitation to our experimentation, to the play of our creative impulses, is the need to effectively communicate social realities to our chosen audiences.

To be true works of imagination, our works of art should not only reflect our perception of what is, but also our insights into what is to be. We grasp the direction in which they are changing, and imagine the shape of the future.

We shall therefore develop an art that not only depicts the life of the Filipino people but also seeks to uplift their condition. We shall develop an art that enables them to see the essence, the patterns behind the scattered phenomena and experience of our times. We shall develop an art that shows the unity of their interests and thus leads them to unite.

We issue this declaration of principles, knowing that today, it is not considered fashionable for artists to be serious, to have ideas, and to commit themselves to something more than their own personal pursuit of fame.

Therefore, we do not hope to find much favor among those who use art merely to decorate their walls or to escape from the barrenness of their existence. It is our hope that our works of art should, more than anything else, endure and that the spirit of our times should live in them and reach other generations.

M62 Maria Klonaris and Katerina Thomadaki

Manifesto for a Radical Femininity for an Other Cinema (1977)

The experimental Greek artists Maria Klonaris (1950–2014) and Katerina Thomadaki (b. 1949) began making films in Paris in the mid 1970s, in order to contribute to feminist discourse surrounding the body, sexual politics and identity. They made each other the subjects of their films, which they co-signed KLONARIS/THOMADAKI, in order to question received ideas about the self. Through their *Cycle of the Umheimlich* (1977–9) they explored the female as an uncanny entity, and later, through their *Cycle of Hermaphrodites* (1982–5) and the *Angel Cycle* (1985–), were pioneers in the discourse surrounding post-gender identities.

KLONARIS/THOMADAKI's influential theory that the image affects the body and, in turn, the body affects the image, each bringing about a change in the other, has become known as *cinéma corporel* (cinema of the body). As early pioneers of 'expanded cinema' – an approach to filmmaking that rejects the traditional one-way relationship between the audience and the screen in order to push the boundaries of film – their work has incorporated projected still photography, graphics and live performance.

In October 1977 KLONARIS/THOMADAKI wrote their 'Manifesto for a Radical Femininity for an Other Cinema', and it was first published in the French journal *CinémAction* in May the following year. In it they expressed their vision of an alternative form of film, free of the cultural constraints that have been written and perpetuated by men.

* * *

'It is within the female sex that orgasm remains the most enigmatic, the most inaccessible; its ultimate essence has probably not yet been authentically located.'*

1. On a Feminine Culture: Obvious Facts

The existing culture is a male domineering culture, created by man for his own image/benefit.

Woman contributed to its creation, but mostly as a support for the male 'spirit'. In this culture, woman is near-absent. Unknown. Ignored. Mute. Imprisoned. Despised. Deformed. Enigmatic. Inaccessible.

In this culture, femininity is but a male projection.

The feminine culture remains to be created.

It is already being created by women unsubmissive to male order.

Through this culture alone, woman will be able to conquer the political territories necessary to her empowerment.

All woman's creative acts highlighting the distance between a general, standardised, male fabricated femininity and a self-revealed specific and unique female identity contribute to the creation of this culture.

'This said, I increasingly think that we should refrain from gendering cultural productions: this would be "feminine", this would be "masculine". The issue seems different to me: it is about giving women the economic and libidinal conditions which will allow them to analyse and deconstruct social oppression and sexual repression, so that every woman may express and develop her own singularities and her own differences, as they have been produced by the risks and necessities of nature, family or society.'†

A feminine culture can only be rupture from dominant culture.

* Jacques Lacan, 'L'angoisse', quoted by Irène Diamantis in 'Recherches sur la féminité', *Ornicar? Analytica*, vol. 5 (1977).

† Julia Kristeva, 'Unes femmes', conversation with Eliane Boucquey in *Les Cahiers de GRIF*, vol. 7, no. 1 (June 1975).

Can only be the negation of dominant language.

Can only reject the processes of dominant art.

Can only let arise all that is oppressed by social order: body, desire, sexuality, unconscious, singularities.

Can only let the rebellion of the repressed fracture the norms of expression.

2. *Vision of a Radical Femininity*

A radical femininity can only break, shatter, crush, tear apart all that weighs on her and restrains her.

Can only invent and explode.

Ripping her inventions from the depths of her own guts. Giving birth to her own identity.

A radical femininity can only be a harmony between so called feminine and masculine traits.

A symbiosis of 'female' and 'male' energies.

Can only be an equilibrium between the physical sex and the mental, subjective sex.

Can only bring together contradictory and/yet complementary pulsions.

A radical femininity can only be a whole – neither fragment nor lack nor deficiency.

A yoghini manifesting a serpentine energy out of her vulva.

3. *Passion for a Radical Creation: This Other Cinema*

Unsubmissiveness. Independence. Rupture. Autonomy.

To tear apart the economic dependence of the cinema of huge crowds, huge budgets, huge means, huge consumption, huge dependency.

To tear apart the illustrative images, hostages of the social tales merchandised by the capitalist film industry.

To shatter the academicism of the gaze maintained by the industry of images.

To shatter the prefabricated notions of 'real', 'natural', 'normal', 'objective', 'comprehensible' – alibis of a society which can only produce neuroses propagated by mass media.

To shatter the partition of specialisations.

To shatter hierarchies and roles.

To shatter the mirror of the fabricated woman, the passive actress, the one who obeys, the one who accepts being manipulated, the one who mediates for a stranger's orgasm.

To shatter glasses and mirrors.

I emerge.

A radical femininity can only blossom within a radical creation.

I construct my own images.

I invent my own vision, neither 'natural' nor 'normal' nor 'objective', but real as it surges from desire, and comprehensible if one forgets whatever institutions have taught us to understand.

I free my own introspection.

I expose my roots and my sufferings: childhood, desire, revolt, repression, torture, old age, death.

I expose my archetypal and social colours: red, black, white, pink, gold, silver.

I stage my own mental structures, my geometries.

My body image imprints the film.

I open myself to you by my sentient and sensitive body. My body of woman-subject.

I offer you the rituals of my identity.

A haemorrhage of identity not mediated by anyone else, but fully asserted by myself in front of you.

I look at you.

I question you.

I give birth to an OTHER cinema.

M63 Valerie Jaudon and Joyce Kozloff

Art Hysterical Notions of Progress and Culture (1978)

The artists Valerie Jaudon (b. 1945) and Joyce Kozloff (b. 1942) were founding members of the feminist Pattern and Decoration movement that emerged in the US in the late 1970s. Many of the artists involved with the group had been abstract painters who had grown frustrated by the limitations of minimalism and conceptualism. They wanted to explore all aspects of abstraction, and that included those elements considered trivial by most contemporary artists and critics in the West: repetition, beauty, disjunction, symmetry, sensuality and complexity. The group took issue with the idea that pattern and decoration were 'low' status artistically and often categorized as 'craft', arguing that in many parts of the non-Western world, pattern and decoration had long been regarded as the highest forms of visual expression.

In support of these ideas, Jaudon and Kozloff published their manifesto at the beginning of 1978 in the journal *Heresies: A Feminist Publication on Art and Politics*, arguing that the entire language of art needed to be rewritten. Through a devastating accumulation of quotations from critics and historians, the duo exposed the latent prejudices that underpinned artistic received opinion – that the 'high' arts of painting and sculpture were necessarily Western, male, and morally and intellectually 'superior', whereas the 'low' decorative arts were perceived as African or 'Oriental', female and 'decadent'. The same number of *Heresies* also featured Melissa Meyer and Miriam Schapiro's manifesto, 'Waste Not Want Not: An Inquiry into What Women Saved and Assembled – Femmage'

(M64), which raised similar questions about the role of women in the decorative arts.

* * *

As feminists and artists exploring the decorative in our own paintings, we were curious about the pejorative use of the word 'decorative' in the contemporary art world. In rereading the basic texts of Modern Art, we came to realize that the prejudice against the decorative has a long history and is based on hierarchies: fine art above decorative art, Western art above non-Western art, men's art above women's art. By focusing on these hierarchies we discovered a disturbing belief system based on the moral superiority of the art of Western civilization.

We decided to write a piece about how *language* has been used to communicate this moral superiority. Certain words have been handed down unexamined from one generation to the next. We needed to take these words away from the art context to examine and decode them. They have colored our own history, our art training. We have had to rethink the underlying assumptions of our education.

Within the discipline of art history, the following words are continuously used to characterize what has been called 'high art': man, mankind, the individual man, individuality, humans, humanity, the human figure, humanism, civilization, culture, the Greeks, the Romans, the English, Christianity, spirituality, transcendence, religion, nature, true form, science, logic, purity, evolution, revolution, progress, truth, freedom, creativity, action, war, virility, violence, brutality, dynamism, power and greatness.

In the same texts other words are used repeatedly in connection with so-called 'low art': Africans, Orientals, Persians, Slovaks, peasants, the lower classes, women, children, savages, pagans, sensuality, pleasure, decadence, chaos, anarchy, impotence, exotica, eroticism, artifice, tattoos, cosmetics, ornament, decoration, carpets, weaving, patterns, domesticity, wallpaper, fabrics and furniture.

All of these words appear in the quotations found throughout this piece. The quotations are from the writings and statements of

artists, art critics and art historians. We do not pretend to neutrality and do not supply the historical context for the quotations. These can be found in the existing histories of Modern Art. Our analysis is based on a personal, contemporary perspective.

War and Virility

Manifestoes of Modern Art often exhort artists to make violent, brutal work, and it is no accident that men such as Hirsch, Rivera, and Picasso like to think of their art as a metaphorical weapon. One of the longstanding targets of this weapon has been the decorative. The scorn for decoration epitomizes the machismo expressed by Le Corbusier, Gabo/Pevsner and Marinetti/Sant'Elia. Their belligerence may take the form of an appeal to the machine aesthetic: the machine is idolized as a tool and symbol of progress, and technological progress is equated with reductivist, streamlined art. The instinct to purify exalts an order which is never described and condemns a chaos which is never explained.

Joseph Hirsch, from 'Common Cause,' O. W. Larkin, 1949:
'The great artist has wielded his art as a magnificent weapon truly mightier than the sword . . .'

Diego Rivera, 'The Revolutionary Spirit in Modern Art,' 1932:
'I want to use my art as a weapon.'

Pablo Picasso, 'Statement about the Artist as a Political Being,' 1945:
'No, painting is not done to decorate apartments. It is an instrument of war for attack and defense against the enemy.'

Le Corbusier, 'Guiding Principles of Town Planning,' 1925:
'Decorative art is dead . . . An immense, devastating brutal evolution has burned the bridges that link us with the past.'

Naum Gabo and Antoine Pevsner, 'Basic Principles of Constructivism,' 1920:
'We reject the decorative line. We demand of every line in the work of art that it shall serve solely to define the inner directions of force in the body to be portrayed.'

Filippo Tommaso Marinetti and Antonio Sant'Elia, 'Futurist Architecture,' 1914:
'The decorative must be abolished! . . . Let us throw away monuments, sidewalks, arcades, steps; let us sink squares into the ground, raise the level of the city.'

El Lissitsky, 'Ideological superstructure,' 1929:
'Destruction of the traditional . . . War has been declared on the aesthetic of chaos. An order that has entered fully into consciousness is called for.'

'Manifesto of the Futurist Painters,' 1910:
'The dead shall be buried in the earth's deepest bowels! The threshold of the future will be free of mummies! Make room for youth, for violence, for daring!'

Purity

In the polemics of Modern Art, 'purity' represents the highest good. The more the elements of the work of art are pared down, reduced, the more visible the 'purity.' Here Greenberg equates reductivism with rationality and function. But it is never explained why or for whom art has to be functional, nor why reductivism is rational. Among artists as diverse as Sullivan, Ozenfant and de Kooning, we found the sexual metaphor of 'stripping down' art and architecture to make them 'nude' or 'pure.' The assumption is that the artist is male, and the work of art (object) female.

Clement Greenberg, 'Detached Observations,' 1976:
'The ultimate use of art is construed as being to provide the experience of aesthetic value, therefore art is to be stripped down towards this end. Hence, modernist "functionalism," "essentialism" it could be called, the urge to "purify" the medium, any medium. "Purity" being construed as the most efficacious, efficient, economical employment of the medium for purposes of aesthetic value.'

Louis Sullivan, 'Ornament in Architecture,' 1892:
'. . . it would be greatly for our aesthetic good, if we should refrain from the use of ornament for a period of years, in order that our thought might concentrate acutely upon the production of buildings well formed and comely in the nude.'

Amédée Ozenfant, *Foundations of Modern Art*, 1931:
'Decoration can be revolting, but a naked body moves us by the harmony of its form.'

Willem de Kooning, 'What Abstract Art Means to Me,' 1951:
'One of the most striking aspects of abstract art's appearance is her nakedness, an art stripped bare.'

Purity in Art as a Holy Cause

Purity can also be sanctified as an aesthetic principle. Modern artists and their espousers sometimes sound like the new crusaders, declaring eternal or religious values. A favorite theme is that of cleansing art. The ecclesiastical metaphor of transcendence through purification (baptism) is used to uphold the 'Greek' tradition (as in the van de Velde quotation) or the 'Christian' tradition (as in the Loos quotation). Cleansing and purification are sometimes paired with an exalted view of the artist as a god, as in Apollinaire's desire to 'deify personality.'

Henry van de Velde, 'Programme,' 1903:
'As soon as the work of cleansing and sweeping out has been finished, as soon as the true form of things comes to light again, then

strive with all the patience, all the spirit and the logic of the Greeks for the perfection of this form.'

Adolf Loos, 'Ornament and Crime,' 1908:
'We have outgrown ornament; we have fought our way through to freedom from ornament. See, the time is nigh, fulfilment awaits us. Soon the streets of the city will glisten like white walls, like Zion, the holy city, the capital of heaven. Then fulfilment will be come.'

Guillaume Apollinaire, *The Cubist Painters*, 1913:
'To insist on purity is to baptize instinct, to humanize art, and to deify personality.'

The Superiority of Western Art

Throughout the literature of Western art there are racist assumptions that devalue the arts of other cultures. The ancient Greeks are upheld as the model, an Aryan ideal of order. Art in the Greco-Roman tradition is believed to represent superior values. Malraux uses the word 'barbarian' and Fry the word 'savages' to describe art and artists outside our tradition. The non-Western ideals of pleasure, meditation and loss of self are clearly not understood by the exponents of ego assertion, transcendence and dynamism.

David Hume, 'Of National Characters' (on Africans), 1748:
'There scarcely ever was a civilized nation of that complexion nor even any individual, eminent either in action or speculation. No ingenious manufactures amongst them, no arts, no sciences.'

Roger Fry, 'The Art of the Bushmen,' 1910:
'. . . it is to be noted that all the peoples whose drawing shows this peculiar power of visualization (sensual not conceptual) belong to what we call the lowest of savages, they are certainly the least civilizable, and the South African Bushmen are regarded by other native races in much the same way that we look upon negroes.'

André Malraux, *The Voices of Silence*, 1953:
'Now a barbarian art can keep alive only in the environment of the barbarism it expresses . . .'
'. . . the Byzantine style, as the West saw it, was not the expression of a supreme value but merely a form of decoration.'

Roger Fry, 'The Munich Exhibition of Mohammedan Art,' 1910:
'It cannot be denied that in course of time it [Islamic art] pandered to the besetting sin of the oriental craftsman, his intolerable patience and thoughtless industry.'

Gustave von Grunebaum, *Medieval Islam*, 1945:
'Islam can hardly be called creative in the sense that the Greeks were creative in the fifth and fourth centuries B.C. or the Western world since the Renaissance, but its flavor is unmistakable . . .'

Sir Richard Westmacott, Professor of Sculpture, Royal Academy (quoted in *Rediscoveries in Art: Some Aspects of Taste, Fashion and Collecting in England and France*, Francis Haskell, 1976):
'. . . I think it impossible that any artist can look at the Nineveh marbles as works for study, for such they certainly are not: they are works of prescriptive art, like works of Egyptian art. No man would ever think of studying Egyptian art.'

Adolf Loos, 'Ornament and Crime,' 1908:
'No ornament can any longer be made today by anyone who lives on our cultural level.'
'It is different with the individuals and peoples who have not yet reached this level.'
'I can tolerate the ornaments of the Kaffir, the Persian, the Slovak peasant woman, my shoemaker's ornaments, for they all have no other way of attaining the high points of their existence. We have art, which has taken the place of ornament. After the toils and troubles of the day we go to Beethoven or to Tristan.'

Fear of Racial Contamination, Impotence and Decadence

Racism is the other side of the coin of Exotica. Often underlying a fascination with the Orient, Indians, Africans and primitives is an urgent unspoken fear of infiltration, decadence and domination by the 'mongrels' gathering impatiently at the gates of civilization. Ornamental objects from other cultures which appeared in Europe in the nineteenth century were clearly superior to Western machine-made products. How could the West maintain its notion of racial supremacy in the face of these objects? Loos's answer: by declaring that ornament itself was savage. Artists and aesthetes who would succumb to decorative impulses were considered impotent and/or decadent.

Adolf Loos, 'Ornament and Crime,' 1908:
'I have made the following discovery and I pass it on to the world: *The evolution of culture is synonymous with the removal of ornament from utilitarian objects.* I believed that with this discovery I was bringing joy to the world: it has not thanked me. People were sad and hung their heads. What depressed them was the realization that they could produce no new ornaments. Are we alone, the people of the nineteenth century, supposed to be unable to do what any Negro, all the races and periods before us have been able to do? What mankind created without ornament in earlier millennia was thrown away without a thought and abandoned to destruction. We possess no joiner's benches from the Carolingian era, but every trifle that displays the least ornament has been collected and cleaned and palatial buildings have been erected to house it. Then people walked sadly about between the glass cases and felt ashamed of their impotence.'

Amédée Ozenfant, *Foundations of Modern Art*, 1931:
'Let us beware lest the earnest effort of younger peoples relegates us to the necropolis of the effete nations, as mighty Rome did to the dilettantes of the Greek decadence, or the Gauls to worn-out Rome.'
'Given many lions and few fleas, the lions are in no danger; but when the fleas multiply, how pitiful is the lions' lot!'

Albert Gleizes and Jean Metzinger, *Cubism*, 1912:
'As all preoccupation in art arises from the material employed, we ought to regard the decorative preoccupation, if we find it in a painter, as an anachronistic artifice, useful only to conceal impotence.'

Maurice Barrès (on the Italian pre-Renaissance painters), 1897 (quoted in André Malraux, *The Voices of Silence*):
'And I can also see why aesthetes, enamored of the archaic, who have deliberately emasculated their virile emotions in quest of a more fragile grace, relish the poverty and pettiness of these minor artists.'

Racism and Sexism

Racist and sexist attitudes characterize the same mentality. They sometimes appear in the same passage and are unconsciously paired, as when Read equates tattoos and cosmetics. The tattoo refers to strange, threatening customs of far-off places and mysterious people. Cosmetics, a form of self-ornamentation, is equated with self-objectification and inferiority (Schapiro). Racism and sexism ward off the potential power and vitality of the 'other.' Whereas nudity earlier alluded to woman as the object of male desire, here Malevich associates the nude female with savagery.

Herbert Read, *Art and Industry*, 1953:
'All ornament should be treated as suspect. I feel that a really civilized person would as soon tattoo his body as cover the form of a good work of art with meaningless ornament. Legitimate ornament I conceive as something like mascara and lipstick – something applied with discretion to make more precise the outlines of an already existing beauty.'

Adolf Loos, 'Ornament and Crime,' 1908:
'The child is amoral. To our eyes, the Papuan is too. The Papuan kills his enemies and eats them. He is not a criminal. But when

modern man kills someone and eats him he is either a criminal or a degenerate. The Papuan tattoos his skin, his boat, his paddles, in short everything he can lay hands on. He is not a criminal. The modern man who tattoos himself is either a criminal or a degenerate. There are prisons in which eighty percent of the inmates show tattoos. The tattooed who are not in prison are latent criminals or degenerate aristocrats. If someone who is tattooed dies at liberty, it means he has died a few years before committing a murder.'

Meyer Schapiro, 'The Social Bases of Art,' 1936:
'A woman of this class [upper] is essentially an artist, like the painters whom she might patronize. Her daily life is filled with aesthetic choices; she buys clothes, ornaments, furniture, house decorations: she is constantly re-arranging herself as an aesthetic object.'

Kasimir Malevich, 'Suprematist manifesto Unovis,' 1924:
'. . . we don't want to be like those Negroes upon whom English culture bestowed the umbrella and top hat, and we don't want our wives to run around naked like savages in the garb of Venus!'

Iwan Bloch, *The Sexual Life of Our Time*, 1908:
'. . . [woman] possesses a greater interest in her immediate environment, in the finished product, in the decorative, the individual, and the concrete: man, on the other hand, exhibits a preference for the more remote, for that which is in process of construction or growth, for the useful, the general, and the abstract.'

Leo Tolstoy, 'What is Art?' 1898:
'Real art, like the wife of an affectionate husband, needs no ornaments. But counterfeit art, like a prostitute, must always be decked out.'

Hierarchy of High-Low Art

Since the art experts consider the 'high arts' of Western men superior to all other forms of art, those arts done by non-Western people,

low-class people and women are categorized as 'minor arts,' 'primitive arts,' 'low arts,' etc. A newer more subtle way for artists to elevate themselves to an elite position is to identify their work with 'pure science,' 'pure mathematics,' linguistics and philosophy. The myth that high art is for a select few perpetuates the hierarchy in the arts, and among people as well.

Clement Greenberg, 'Avant-Garde and Kitsch,' 1939:
'It will be objected that such art for the masses as folk art was developed under rudimentary conditions of production – and that a good deal of folk art is on a high level. Yes, it is – but folk art is not Athene, and it's Athene whom we want: formal culture with its infinity of aspects, its luxuriance, its large comprehension.'

H. W. Janson, *History of Art*, 1962:
'. . . for the applied arts are more deeply enmeshed in our everyday lives and thus cater to a far wider public than do painting and sculpture, their purpose, as the name suggests, is to beautify the useful, an important and honourable one, no doubt, but of a lesser order than art pure and simple.'

Amédée Ozenfant, *Foundations of Modern Art*, 1931:
'If we go on allowing the minor arts to think themselves the equal of Great Art, we shall soon be hail fellow to all sorts of domestic furniture. Each to his place! The decorators to the big shops, the artists on the next floor up, several floors up, as high as possible, on the pinnacles, higher even. For the time being, however, they sometimes do meet on the landings, the decorators having mounted at their heels, and numerous artists having come down on their hunkers.'

Le Corbusier (Charles-Édouard Jeanneret) and Amédée Ozenfant, 'On Cubism,' 1918 (quoted in Ozenfant, *Foundations of Modern Art*):
'There is a hierarchy in the arts: decorative art at the bottom, and the human form at the top.'
'Because we are men.'

André Malraux, *The Voices of Silence*, 1953:
'The design of the carpet is wholly abstract; not so its color. Perhaps we shall soon discover that the sole reason why we call this art "decorative" is that for us it has no history, no hierarchy, no meaning. Color reproduction may well lead us to review our ideas on this subject and rescue the masterwork from the North African bazaar as Negro sculpture has been rescued from the curio-shop; in other words, liberate Islam from the odium of "backwardness" and assign its due place (a minor one, not because the carpet never portrays Man, but because it does not *express* him) to this last manifestation of the undying East.'

Barnett Newman, 'The Ideographic Picture,' 1947 (on the Kwakiutl artist):
'The abstract shape he used, his entire plastic language, was directed by a ritualistic will towards metaphysical understanding. The everyday realities he left to the toymakers; the pleasant play of nonobjective pattern to the women basket weavers.'

Ursula Meyer, *Conceptual Art*, 1972:
'In the same sense that science is for scientists and philosophy is for philosophers, art is for artists.'

Joseph Kosuth, 'Introductory Note by the American Editor,' 1970:
'In a sense, then, art has become as "serious as science or philosophy" which doesn't have audiences either.'

That Old Chestnut, 'Humanism'

Humanism was once a radical doctrine opposing the authority of the church, but in our secular society it has come to defend the traditional idea of 'mankind' and status quo attitudes. The 'human values' such authorities demand of art depend on the use of particular subject matter or particular ideas of 'human' expression. Without humanist content, ornament, pattern and ritual or decorative elaborations of production are condemned as inhuman, alien

and empty. 'The limits of the decorative,' says Malraux, 'can be precisely defined only in an age of humanistic art.' We could rather say that the generalities of 'humanist' sentiment characterize only a small part of world art, most of which is non-Western and decorative. But why should anyone prefer the false divisions of these writers, based on ethnic stereotypes, to a historical awareness of the interdependence of all 'human' cultures?

Camille Mauclair, 'La Réforme de l'art décoratif en France' (on the Impressionists), 1896:
'Decorative art has as its aesthetic and for its effect not to make one think of man, but of an order of things arranged by him: it is a descriptive and deforming art, a grouping of spectacles the essence of which is to be seen.'

Rudolf Arnheim, *Art and Visual Perception*, 1954:
'Paintings or sculpture are self-contained statements about the nature of human existence in all its essential aspects. An ornament presented as a work of art becomes a fool's paradise, in which tragedy and discord are ignored and an easy peace reigns.'

Hilton Kramer, 'The Splendors and Chill of Islamic Art,' 1975:
'. . . for those of us who seek in art something besides a bath of pleasurable sensation, so much of what it [the Metropolitan Museum's Islamic wing] houses is, frankly so alien to the expectations of Western sensibility.'
'Perhaps with the passage of time, Islamic art will come to look less alien to us than it does today. I frankly doubt it – there are too many fundamental differences of spirit to be overcome.'
'. . . there is small place indeed given to what looms so large in the Western imagination: the individualization of experience.'

Sir Thomas Arnold, *Painting in Islam*, 1928:
'. . . the painter was apparently willing to spend hours of work upon the delicate veining of the leaves of a tree . . . but it does not seem to have occurred to him to devote the same pains and effort

on the countenances of his human figures . . . he appears to have been satisfied with the beautiful decorative effect he achieved.'

André Malraux, *The Voices of Silence*, 1953:
'The limits of the decorative can be precisely defined only in an age of humanistic art.'
'It was the individualization of destiny, this involuntary or unwitting imprint of his private drama on every man's face, that prevented Western art from becoming like Byzantine mosaics always transcendent, or like Buddhist sculpture obsessed with unity.'
'How could an Egyptian, an Assyrian or a Buddhist have shown his god nailed to a cross, without ruining his style?'

Decoration and Domesticity

The antithesis of the violence and destruction idolized by Modern Art is the visual enhancement of the domestic environment. (If humanism is equated with dynamism, the decorative is seen to be synonymous with the static.) One method 'modernism' has used to discredit its opponents has been to associate their work with carpets and wallpaper. Lacking engagement with 'human form' or the 'real world,' the work of art must be stigmatized as decorative (Sedlmayr and Barnes/de Mazia). So decorative art is a code term signifying failed humanism. Artists such as Gleizes and Kandinsky, anxious to escape the tag of the decorative, connect their work to older, humanist aspirations.

Aldous Huxley on Pollock's *Cathedral*, 1947:
'It seems like a panel for a wallpaper which is repeated indefinitely around the wall.'

Wyndham Lewis, 'Picasso' (on *Minotauromachy*), 1940:
'. . . this confused, feeble, profusely decorated, romantic carpet.'

The *Times* of London critic on Whistler, 1878:
'. . . that these pictures only come one step nearer [to fine art] than a delicately tinted wallpaper.'

Hans Sedlmayr, *Art in Crisis: The Lost Center*, 1948:
'With Matisse, the human form was to have no more significance than a pattern on a wallpaper . . .'

Dr. Albert C. Barnes and Violette de Mazia, *The Art of Cézanne*, 1939:
'Pattern, in Cézanne an instrument strictly subordinated to the expression of values inherent in the real world, becomes in cubism the entire aesthetic content, and this degradation of form leaves cubistic painting with no claim to any status higher than decoration.'

Albert Gleizes, 'Opinion' (on Cubism), 1913:
'There is a certain imitative coefficient by which we may verify the legitimacy of our discoveries, avoid reducing the picture merely to the ornamental value of an arabesque or an Oriental carpet, and obtain an infinite variety which would otherwise be impossible.'

Wassily Kandinsky, *Über das Geistige in der Kunst*, 1912:
'If we begin at once to break the bonds that bind us to nature and to devote ourselves purely to combinations of pure color and independent form, we shall produce works which are mere geometric decoration, resembling something like a necktie or a carpet.'

Autocracy

Certain modern artists express the desire for unlimited personal power. The aesthetics of 'modernism' – its egomania, violence, purity-fixation and denial of all other routes to the truth – is highly authoritarian. The reductivist ideology suggests an inevitable, evolutionary survival of the (aesthetic) fittest. Reinhardt declares throughout his writings that all the world's art must culminate in his 'pure' paintings. Ozenfant equates purism with a 'superstate.'

Mendelsohn believes the advocates of the new art have a 'right to exercise control.'

Ad Reinhardt, 'There is Just One Painting,' 1966:
'There is just one art history, one art evolution, one art progress. There is just one aesthetics, just one art idea, one art meaning, just one principle, one force. There is just one truth in art, one form, one change, one secrecy.'

Amédée Ozenfant, *Foundations of Modern Art*, 1931:
'Purism is not an aesthetic, but a sort of super-aesthetic in the same way that the League of Nations is a superstate.'

Erich Mendelsohn, 'The Problem of a New Architecture,' 1919:
'The simultaneous process of revolutionary political decisions and radical changes in human relationships in economy and science and religion and art give belief in the new form, an *a priori* right to exercise control, and provide a justifiable basis for a rebirth amidst the misery produced by world-historical disaster.'

Adolf Hitler, speech inaugurating the 'Great Exhibition of German Art,' 1937:
'I have come to the final inalterable decision to clean house, just as I have done in the domain of political confusion . . .'
'National-Socialist Germany, however, wants again a "German Art," and this art shall and will be of eternal value, as are all truly creative values of a people . . .'

Frank Lloyd Wright, 'Work Song,' 1896:
I'LL THINK
AS I'LL ACT
AS I AM!
NO DEED IN FASHION FOR SHAM
NOR FOR FAME E'ER MAN MADE
SHEATH THE NAKED WHITE BLADE
MY ACT AS BECOMETH A MAN

MY ACT
ACTS THAT BECOMETH THE MAN'

*

We started by examining a specific attitude – the prejudice against the decorative in art – and found ourselves in a labyrinth of myth and mystification. By taking these quotes out of context we are not trying to hold these artists and writers up to ridicule. However, to continue reading them in an unquestioning spirit perpetuates their biases. The language of their statements is often dated – indeed, some of them are over a century old – but the sentiments they express still guide contemporary theory in art.

Modernism, the theory of Modern Art, claimed to break with Renaissance humanism. Yet both doctrines glorify the individual genius as the bearer of creativity. It seems worth noting that such heroic genius has always appeared in the form of a white Western male. We, as artists, cannot solve these problems, but by speaking plainly we hope to reveal the inconsistencies in assumptions that too often have been accepted as 'truth.'

M64 Melissa Meyer and Miriam Schapiro

Waste Not Want Not: An Inquiry into What Women Saved and Assembled – Femmage (1978)

The American artists Melissa Meyer (b. 1946) and Miriam Schapiro (1923–2015) wrote their 'Femmage' manifesto to rectify an artistic injustice. Hundreds of years before modernist artists adopted collage as a radical, avant-garde practice for creating art, women had been practising similar techniques. Yet why were their highly skilled appliqué, patchwork and découpage commonly dismissed as 'low' art and the collages of artists such as Picasso and Braque admired as 'high' art? Instead, argued Meyer and Schapiro, all instances of female creativity that employed 'traditional women's techniques to achieve their art' should be recognized as belonging to a new art form, with a new name: 'femmage'.

By establishing a new theoretical framework for appraising traditional women's work – there were fourteen criteria for determining whether something was an example of femmage – Meyer and Schapiro's manifesto represented a vigorous challenge to the conventional belief that female artistry was associated with domesticity and hobbyists, and therefore fit neither for the gallery nor as a worthwhile subject for artistic debate. It was published at the beginning of 1978 in the journal *Heresies: A Feminist Publication on Art and Politics*, in an issue devoted to traditional arts. The same number also featured Valerie Jaudon and Joyce Kozloff's manifesto, 'Art Hysterical Notions of Progress and Culture' (M63), which

raised similar questions about the role of women in the decorative arts.

<div align="center">★ ★ ★</div>

Virginia Woolf talks about the loose, drifting material of life, describing how she would like to see it sorted and coalesced into a mold transparent enough to reflect the light of our life and yet aloof as a work of art.* She makes us think of the paper lace, quills and beads, scraps of cloth, photographs, birthday cards, valentines and clippings, all of which inspired the visual imaginations of the women we write about.

In the eighteenth century, a nun in a German convent cuts delicate lace from thin parchment and pastes it around minutely detailed paintings of saints. Performing an act of devotion in the service of her God, she makes what later, in the secular world, are called the first valentines.

An Iroquois woman in 1775 sews five elliptical quillwork designs at the base of a black buckskin bag, quillwork borders at the top and additional moosehair embroidery at the bottom and sides.

Hannah Stockton, a New Jersey woman, in 1830 dips into her scrap bag in the tradition of waste not want not and finds just the right pieces with which to appliqué her quilt.

In the 1860s, Lady Filmer photographs the Prince of Wales and his shooting party. Later she cuts up these photos and creates a composition of them in her album, producing the first photocollage.†

Rita Reynolds, resident of Southend, England, keeps a scrapbook during World War II. In it she glues birthday cards, valentines and clippings from her local newspaper which record the progress of the war. As the world situation worsens, the scrapbook reflects its gravity.

* Virginia Woolf, *Self Explorations, Diarists in England and America*, Exhibition catalog (New York: 42nd St. Public Library, May 2–September 15, 1977) (excerpted from 'A Writer's Diary').

† *Women of Photography, An Historical Survey*, Catalog (San Francisco: San Francisco Museum of Art, April 18–June 15, 1975).

Collage: a word invented in the twentieth century to describe an activity with an ancient history. Here are some associated definitions:

Collage: pictures assembled from assorted materials.

Collage: a French word after the verb *coller* which means pasting, sticking or gluing, as in application of wallpaper.

Assemblage: a collection of things, often combined in the round.

Assemblage: a specific technical procedure and form used in the literary and musical, as well as the plastic arts, but also a complex of attitudes and ideas ... collage and related modes of construction manifest a predisposition that is characteristically modern.*

Découpage: (literally, cutting) a mode of decorating painted furniture with cutouts of flowers, fruit, etc. Also, the art of decorating surfaces with applied paper cutouts.

Photomontage: the method of making a composite picture by bringing photographs together in a single composition and arranging them, often by superimposing one part on another, so that they form a blended whole.

Femmage: a word invented by us to include all of the above activities as they were practiced by women using traditional women's techniques to achieve their art – sewing, piecing, hooking, cutting, appliquéing, cooking and the like – activities also engaged in by men but assigned in history to women.

Published information about the origins of collage is misleading. Picasso and Braque are credited with inventing it. Many artists made collage before they did, Picasso's father for one and Sonia Delaunay for another. When art historians mandate these beginnings at 1912, they exclude artists not in the mainstream. Art

* William C. Seitz, *The Art of Assemblage* (New York: Museum of Modern Art, 1961), p. 10.

historians do not pay attention to the discoveries of non-Western artists, women artists or anonymous folk artists. All of these people make up the group we call *others*. It is exasperating to realize that the rigidities of modern critical language and thought prevent a direct response to the eloquence of art when it is made by *others*.

Our information on women artist-makers of the past was inspired by the definitive texts on collage written by critics and art historians Herta Wescher, William Seitz, Harriet Janis and Rudi Blesh. We did not find our material in the main body of their works but rather in their introductions and in their notes in the back of their books, indicating they were unable to relax their modernist theories enough to appreciate the diversity, beauty and significance of the original makers of collage. Many of these ancestors were women who were ignored by the politics of art.

Janis and Blesh put it succinctly: 'Collage was once only the simple pleasant fold art or pastime of cutting and pasting bits of paper into pictures or ornamental designs. It was no concern of serious artists . . . Its origins began so many centuries ago . . . It is only with this century and the advent of modern art that this quondam delight of schoolgirl and housewife came to the attention of serious artists grappling with revolutionary ideas . . .'* It is in fact the 'schoolgirl' and 'housewife' we must look at more carefully to understand the aesthetics of our ancestors and their processes.

William Seitz includes this information in his work on assemblage: 'Valentines, postcards, and folk art of various kinds incorporating pasted elements as well as pictures and objects made of butterfly wings, feathers, shells, etc. were common much earlier. Indeed various stamped letters, passports and official documents can be looked at as a form of unintentional collage.'†

Now that we women are beginning to document our culture, redressing our trivialization and adding our information to the recorded male facts and insights, it is necessary to point out the

* Harriet Janis and Rudi Blesh, *Collage Personalities Concepts Techniques* (Philadelphia/New York/London: Chilton Book Co., 1969), p. 3.
† Seitz, p. 150, note 5.

extraordinary works of art by women which despite their beauty are seen as leftovers of history. Aesthetic and technical contributions have simply been overlooked. Here, for example, we are concerned with the authenticity and energy in needlework.

When it becomes possible to appreciate a sewn object like a quilt (even though it was created for utilitarian purposes) because it employs thirty stitches to the inch, and uses color which by all standards is rich and evocative, contains silhouetted forms which are skillfully drawn and connects perfectly measured geometrical units of fabric, then it will be clear that woman's art invites a methodology of its own.

Women have always collected things and saved and recycled them because leftovers yielded nourishment in new forms. The decorative functional objects women made often spoke in a secret language, bore a covert imagery. When we read these images in needlework, in paintings, in quilts, rugs and scrapbooks, we sometimes find a cry for help, sometimes an allusion to a secret political alignment, sometimes a moving symbol about the relationships between men and women. We base our interpretations of the layered meanings in these works on what we know of our own lives – a sort of archeological reconstruction and deciphering. We ask ourselves, have we ever used a secret language in our works? Patricia Mainardi, in her essay, says: 'Women not only made beautiful and functional objects but expressed their own conviction on a wide variety of subjects in a language for the most part comprehensible only to other women . . . There was more than one man of Tory persuasion who slept unknowingly under his wife's 'Whig Rose Quilt' . . . women named quilts for their political belief . . . at a time when they were not allowed to vote.*

Collected, saved and combined materials represented for such women acts of pride, desperation and necessity. Spiritual survival depended on the harboring of memories. Each cherished scrap of percale, muslin or chintz, each bead, each letter, each photograph,

* Patricia Mainardi, 'Quilts: The Great American Art,' *Feminist Art Journal*, Winter 1973, p. 19.

was a reminder of its place in a woman's life, similar to an entry in a journal or a diary. Cynthia Ozick says, '. . . a diary is a shoring-up of the ephemeral, evidence that the writer [we substitute artist-maker] takes up real space in the world.'*

Women's culture is the framework for femmage, and makes it possible for us to understand 'combining' as the simultaneous reading of moosehair and beads, cut paper and paint or open-work and stitches. Our female culture also makes it possible to see these traditional aesthetic elements for what they are – the natural materials needed for spiritual, and often physical, survival.

In the past an important characteristic of femmage was that women worked for an audience of intimates. A woman artist-maker always had the assurance that her work was destined to be appreciated and admired. She worked for her relatives and friends and unless she exhibited in church bazaars and county fairs, her viewers were almost always people she knew. In their book, Joel and Kate Kopp tell about Mrs. Eleanor Blackstone of Lacon, Illinois, who in the years between 1880 and 1890 hooked six large rugs, all recording events in the history of her family. These rugs show her six children, their pastimes and their pets including actual strands of the children's hair worked into the individual portraits.†

We feel that several criteria determine whether a work can be called femmage. Not all of them appear in a single object. However, the presence of at least half of them should allow the work to be appreciated as *femmage*.

1. *It is a work by a woman.* 2. *The activities of saving and collecting are important ingredients.* 3. *Scraps are essential to the process and are recycled in the work.* 4. *The theme has a woman-life context.* 5. *The work has elements of covert imagery.* 6. *The theme of the work addresses itself to an audience of intimates.* 7. *It celebrates a private or public event.* 8. *A diarist's point of view is reflected in the work.* 9. *There is drawing and/or*

* Cynthia Ozick, '*The Loose Drifting Material of Life*,' New York *Times* Book Review, Oct. 2, 1977, p. 41.

† Joel and Kate Kopp, *American Hooked and Sewn Rugs, Folk Art Underfoot* (New York: E. P. Dutton, 1975), p. 72.

handwriting sewn in the work. **10.** *It contains silhouetted images which are fixed on other material.* **11.** *Recognizable images appear in narrative sequence.* **12.** *Abstract forms create a pattern.* **13.** *The work contains photographs or other printed matter.* **14.** *The work has a functional as well as an aesthetic life.*

These criteria are based on visual observation of many works made by women in the past. We have already said that this art has been excluded from mainstream, but why is that so? What is mainstream? How may such an omission be corrected?

The works themselves were without status because the artists who made them were considered inferior by the historians who wrote about art and culture. Since the works were intimate and had no data or criticism attached to them and were often anonymous, how could these writers identify them as valid, mainstream history?

Mainstream is the codification of ideas for the illumination of history and the teaching of the young. What a shame that the young remain ignorant of the vitality of women's art. Yet the culture of women will remain unrecognized until women themselves regard their own past with fresh insight. To correct this situation, must we try to insert women's traditional art into mainstream? How will the authorities be convinced that what they consider low art is worth representing in history? The answer does not lie in mainstream at all, but in sharing women's information with women.

Toward this end we have evaluated a selection of women's art and looked for similar elements which appeared most frequently. As we recorded them, we discovered with pleasure that they presented a form in many guises – a form we call femmage.

M65 Grupo Antillano

Manifesto (1978)

Grupo Antillano (the Antilles Group) were a black-consciousness art collective founded by the sculptor and printmaker Rafael Queneditt Morales (1942–2016) in Havana, Cuba, in 1978. They were a loose gathering of like-minded intellectuals, artists, writers and musicians who wanted both to establish a national Cuban identity that embraced its African heritage and also to express their solidarity with other Caribbean artists (hence the group's name). Unlike the earlier Afrocubanismo movement of the 1930s, in which black street culture in Cuba was hijacked by middle-class whites, most members of Grupo Antillano were Afro-Cubans who saw themselves as part of a wider conversation about art, race and colonialism, picking up the thread of Caribbean cultural resistance from 'Légitime Défense' (M4) and the Négritude movement (M7). Some of the group's artists had attended FESTAC 77, the Second World Black and African Festival of Arts held in Nigeria in 1977, which promoted the concepts of Pan-Africanism (M39) and fraternity between African nations and across the African diaspora. The works created by the group's members possessed no single distinct, defining style. Instead, they displayed a wide variety of African aesthetic influences, from folk art to religious symbolism, and were characterized by a strong underlying desire to represent the whole of Antillean culture, not just its Hispanic heritage.

Grupo Antillano's manifesto is believed to have been presented as a poster at their exhibition at the International Gallery of Art, Havana, in September 1978. In acknowledging the group's debt to the Afrocubanismo revolution, the manifesto singles out two of the earlier movement's most prominent proponents, the poet Nicolás

Guillén and composer Amadeo Roldán. Grupo Antillano held their final exhibition in 1983, after which they faded into obscurity, predominantly due to a lack of critical recognition.

* * *

Art and literature are the most refined and profound representations of the social condition and development of people.

Through such manifestations cultural groups project their personality fully and reaffirm their nationality. Imperialism understands this phenomenon, which accounts for its incessant efforts to culturally penetrate other peoples, with the ultimate goal of depersonalization and denationalization.

The Cuban people could not escape this ideological struggle. Thus in the 1930s, parallel with the Revolution then in gestation, a cultural movement emerged with genuinely Cuban roots which began to discover and develop our personality and to reaffirm our nationality and its underlying rationale.

Once again in our history the empire tried to take over our revolution, halting, rolling back, and attempting to chip away at the process. Imperialism understands the strength and power of the spirit, and spiritual phenomena could not escape these material and socioeconomic efforts by the forces of imperialism. A process of cultural penetration that deformed and misdirected the movement began, not coincidentally, with the halting steps toward revolution.

Such penetration never achieved its goal. Forces which were indomitable, because they were the legitimate representation of the people, engaged in a great ideological battle. This was the case, among others, of Nicolás Guillén.

Consciously or unconsciously, this movement resolved all the anxieties over the underlying rationale of the ethnic origins of the Cuban people, 'our definitive profile.' 'We are Latin-Africans,' said

our commander in chief, thus profoundly defining the roots of our world and the only possible path for the development of our national personality and consciousness. In music this came to be called Afro-Cuban, and upon reflection we can synthetize it more simply by calling it Cuban. Being Cuban is the result of our Latin-African origins.

In the 1940s three painters, independently and without yet knowing one another began to move along the path marked by Guillén and Roldán, among others, and today defined by our maximum leader. Their struggle was not easy. They were opposed by social, racial and other prejudices which could not adjust to the truth and fullness of our mixed blood, despite the strength and quality of their work.

Today, with the definitive triumph of our revolution, and the social-ist character that gives it definition and orientation, the repressed creative forces of our people have been liberated. In the past expression was limited by the cultural repression of the times. Today, in contrast, we see a growing number of Cuban painters and sculptors who are motivated simply by their profound condition as Cubans and an awareness of their ethnic origins who consciously or uncon-sciously are taking the only path possible toward a common identity. When this movement began they were separated by distance, often did not know one another personally, or know one another's work.

This is not the creation of a group that holds forth a new ideal to struggle toward. It is, rather, the reformation of a group of artists who for years have been travelling along this path – some for 35 years, others for 15. Now we have identified ourselves and are connected by the common incentive to analyze together the path that up to now we have travelled separately, which we know to be the only way capable of providing a common rationale which con-nects us to our origins and whose full development will lead us to our encounter with a new, young, and strong culture which we can only describe as Cuban.

The Antilles are our common real environment, and we aspire to greater communication with our sibling peoples of the Antillean world. We are not interested in other worlds whose understanding cannot have spiritual depth. This does not mean that we reject them, but we need to base ourselves in our own language and strengthen ourselves conceptually and with sensitivity on what for us is most immediately ours – the Antilles.

Unfortunately in this regrouping not everyone finds their values in line with these principles. This is not our fault. We have invited them to analyze and come together while developing full awareness of our path. They are fulfilling their desire for isolation. By saying this we do not criticize them. We simply want to declare publicly that we have not ignored anyone and that this is not a group organized around personal interests. The whole group is united around the ideals expressed here and must collaborate in seeking our artistic path. If we have left out any comrade it is because we do not know him personally, and we would appreciate being so informed.

Although we do not avoid aesthetics, our objective is not simply aesthetic. On the contrary, we struggle toward our objective as a statement of our personality, but the basis of our path is, in sum, what is Cuban.

Havana, 26 of July 1978
Manuel Couceiro, Painter; Ángel Laborde, Painter-ceramist; Leonel Morales, Painter; Arnaldo Larrinaga, Painter; Rogelio Rodríguez Cobas, Sculptor; Rafael Queneditt Morales, Sculptor-engraver; Ramón Haiti, Sculptor-painter

M66 The Crystalist Group

The Crystalist Manifesto (1978)

After Sudan formally gained its independence on 1 January 1956, there was a desire in the country to forge a new national cultural identity in an attempt to reconcile old ethnic divisions. Sudanese artists like the influential Ibrahim El-Salahi, caught between the heritage of the predominantly rural population and their own modernist aspirations, embraced their paradoxical situation by pioneering a style of painting that incorporated Western abstraction, traditional African motifs and, like other pioneering artists in the Islamic world, Arabic calligraphy (see M52). Although they were never a formal group, these artists became known as the Khartoum School (*Madrasat al-Khartoum*); and because they occupied prominent teaching roles in the Sudanese capital's college of fine arts, they were able to promulgate their aesthetic and position themselves as the country's art establishment, inspiring later artists such as the members of the School of the One (M86).

In the early 1970s Kamala Ibrahim Ishaq (b. 1939), who had been associated with the Khartoum School, founded the Crystalist Group (*Al-Kristali*) along with two of her students, Muhammad Hamid Shaddad and Nayla El Tayib, in order to challenge this male-dominated artistic status quo. Ishaq's paintings explored the role of women in Sudan, and focused on traditional ceremonies and rituals, such as the *zar*, in which women are possessed by spirits. The Crystalist Group coupled such themes with an interest in European mysticism – in particular William Blake – in order to promote a philosophy that was existential in nature. The cosmos, they believed, was like a crystal cube: translucent, interconnected and constantly changing according to the viewer's perspective.

The group's manifesto ('Al-Bayan al-Kristali') was written in Arabic by Shaddad at some point in 1978, when extracts were reproduced in the Sudanese newspaper *Al Ayyam* (*The Day*). It was published in its entirety for the first time in the catalogue of the exhibition *Tradition and Contempora(neity)*, part of the Third Cultural Festival at the Friendship Hall, Khartoum, in 1981.

* * *

1. The Crystalists testify with their kind minds that the Cosmos is a project of a transparent crystal with no veils but an eternal depth. The truth is that the Crystalists' perception of time and space differs from that of others.

2. The Crystalists' goal is to bring to life the language of the crystal and transform (your) language into a transparent one, to the extent that no word can veil another – no selectivity in the language. That is, people's utterance of one transparent word would be their utterance of the whole language. The whole language will extend to become one transparent letter that utterance of one letter would not block other letters. In that respect, language becomes one transparent tune that does not block other tunes. Otherwise, people should remain silent, which is in itself a crystal – that is, silence is a crystal.

3. We live a new life which necessitates a new language and a new poetry. A new life means that we have acquired new contents, which requires new forms and framing which are capable of expressing these modern contents. That is, we do not cling to the old forms because we do not like rhyming verses and old metric poetry.

4. The Crystalists testify that there is no empirical (practical/experimental) knowledge. Everything that has been said about empirical knowledge is a myth. The human mind has not evolved, and will not make any progress, because of experimentation or practice. The essence of Crystalist thought is that the ability to know is also knowledge. The ability to know is older than experimental knowledge. The truth is that the mind is more intelligent, more holistic and complete than

experience/practice. We (the Crystalists) have been asked about the place of this non-empirical knowledge in the mind. We have settled this debate by saying that what is originally in the mind is pleasure and not knowledge.

5. Yes, pleasure is intrinsic to knowledge. Our observations in life are but observations in pleasure. We should know that the dividing line between knowledge (science) and pleasure falls into absurd mirrors of water and light. The Cosmos is small and large, realised and non-realised, and what separates the two a dialectic of absurd mirrors composed of light and water. The world around us is calculated against a permanent one which is the light speed. Yet we focus our vision on the idea of the inverse of the light speed, so we can arrive at the edge and frontiers of the absurd mirrors.

6. We, the Crystalists, do not trust the law of evolution. The dinosaur has evolved into extinction. Vanished and extinct! You, men! you carry two breasts on your chests which are remnants of the woman in you which is extinct. You know, the breast has a function and there is no organ in the human body without a function to perform, now or in the past. Were you also breast feeding? What was your name?

7. We prefer vision (revelation) to skill and craftsmanship, and we oppose the trend which calls for skill and craftsmanship as a measure of a good work.

I conclude my statement without asking you to commit yourself to anything.

M67 Mangelos

manifesto of manifesto (1978)

'Mangelos' was the pseudonym of the historian, critic and concep-
tual artist Dimitrije Bašičević (1921–87), who had been a member of
the Croatian anti-art group Gorgona (M20) in the 1960s and
the international movement New Tendencies (*Nove Tendencije*).
Inspired by Concrete poetry and Dadaism, he embraced a nihilist
philosophy rooted in absurdity, alienation and irony which
reflected the paradoxes of life in Eastern Europe during the Cold
War. He referred to his output as 'no-art' because it occupied the
space between image and text where thought and concepts occur,
often taking the form of handmade books of images and chimerical
observations, which he called 'no-stories'. To mark the transition
from historian to artist, he changed his name to Mangelos, after a
village near to the town where he had been born.

Between 1959 and his death in 1987, Mangelos was a prolific
writer of manifestos, which he saw as expressing his quest for art-
istic and intellectual freedom. They were chalked on blackboards,
scribbled in small notebooks and painted on wooden panels. To
coincide with his exhibition, *Manifesti*, at the Tošo Dabac Atelier in
Zagreb in 1978, Mangelos collected his manifestos in a book titled
manifesto of manifesto, which included the following text, reflecting
on his earlier efforts, and declaring that the rapid advance of tech-
nology had made art redundant.

* * *

dear friends
dear fiends
this is not a manifest claim that the experiments

carried out over the years were entirely successful
(because they were not)
but that another route has been discovered
instead of following the line of meaning
the thinking process proceeds
along the line of function
corresponding to other processes of life.
this is the framework for my manifestos.
the world is not only changing
it has changed.
we are in the second century
of the second civilization. the machine one.
the social use of the machine
has put an end to the civilization of manual work
and to all the social phenomena
rooted in manual work.
by changing the character of work
the world changes its way of thinking.
the revolution of thinking has the character
of a long-term evolution.
in the course of this process
the previous artistic or naïve thought
has integrated itself into the process of application
with another one based on
the principles of mechanical work.
civilization is practically evolving
into a cultural organization of the interplanetary kind
with uniform mechanical production.
and consequently
with uniform types of social superstructure.
based on the principle of social functionality.
instead of emotionally structured unities
a type of social unit is formed
which thinks functionally.

M68 Huang Rui

Preface to the First Stars Art Exhibition (1979)

The Stars Group (*Xingxing*) were a provocative art collective that emerged in China in 1977, during a brief period of political liberalization following the end of the Cultural Revolution and the death of Mao Zedong. Many of the artists associated with the group were self-taught – an arts education being relatively difficult to obtain during the later years of Mao's rule – and were actively hostile to Maoist ideology. They took their inspiration from Käthe Kollwitz, who had sought to depict the harsh lives of working-class women in Germany at the turn of the century. They embraced their outsider status, and argued that for art to have any significance it must be actively involved in society.

To this end, the Stars Group staged an unofficial exhibition in September 1979 on the street outside the National Art Museum of China in Beijing. Their manifesto, written by the artist Huang Rui (b. 1952), was printed on posters announcing the exhibition. Two days after the opening, a hundred police seized the artworks, which ranged from ink-brush and oil paintings to minimalist sculptures. The Stars responded on National Day (1 October), which marked the thirtieth anniversary of the People's Republic of China, by holding a public demonstration and issuing a statement attacking the malicious motives of the police. Unexpectedly, they were given permission to restage the exhibition, which was attended by thousands of people.

However, this unprecedented period of artistic freedom was short-lived. The government of the new premier, Deng Xiaoping,

proceeded to ban all further unofficial group activities and organizations in China. The Stars' founding members Ma Desheng (b. 1952) and Wang Keping (b. 1949) moved to France, where they became signatories of the Chinese United Overseas Artists' manifesto (M80), while Qu Leilei (b. 1951) moved to the UK. Huang Rui himself spent a decade in Japan – where he also became involved with the Chinese United Overseas Artists – before returning home to China.

* * *

We, twenty-three art explorers, place some fruits of our labor here.

The world leaves unlimited possibilities for explorers.

We have used our own eyes to know the world, and our own brushes and awls to participate in it. Our paintings contain all sorts of expressions, and these expressions speak to our own individual ideals.

The years come at us; there are no mysterious indications guiding our action. This is precisely the challenge that life has raised to us. We cannot remove the element of temporality; the shadow of the past and the glow of the future are folded together, forming the various living conditions of today. Resolving to live on and remembering each lesson learned: this is our responsibility.

We love the ground beneath our feet. The land has nurtured us, we have no words to express our passion for the land. Seizing this moment of the thirtieth anniversary of the nation's founding, we give our harvest back to the land, and to the people. This brings us closer. We are full of confidence.

M69 Andrzej Partum

Animal Manifesto (1980)

The Polish conceptual artist and cultural provocateur Andrzej Partum (1938–2002) was fascinated by the limitations of language and in particular the limitations that exist under totalitarianism. Working in the fields of Concrete poetry, performance art and conceptualism, he founded the deliberately bureaucratic sounding Biuro Poezji (Bureau of Poetry) in Warsaw in 1971. Here, together with other avant-garde artists and poets – such as Zbigniew Warpechowski, and his wife, the important feminist artist Ewa Partum – he illicitly published and distributed manifestos and poetry in a variety of languages, in which he would often play with grammar and style and subvert poetic conventions. An artist with an anarchic sensibility, he believed wholeheartedly in the spirit of opposition and rebellion, lampooning the absurdities of the communist regime. He was also less than enamoured with the Polish avant-garde that centred around Gallery Foksal, which he thought humourless and slow to embrace new ways of working.

In 1980 Partum composed the 'Animal Manifesto' ('Manifest Zwierzęcy'), in which he mocked the arguments that rational thought makes humans superior to animals, and that progress can be determined only by the technology humans create. Printed on the poster for the 18th International Meeting of Artists, Scientists and Art Theorists (*Międzynarodowe Spotkania Artystów, Naukowców i Teoretyków Sztuki*), held in the Polish seaside village of Osieki in August 1980, the manifesto employs a variety of grammatical peculiarities that are characteristic of Partum's work.

* * *

the universe is only partially nature – where it exists without nature it contains concealed sense (movement opposing the human mind) which need not be guessed by humans.

evolution in nature is not progress, it is only a change directed to annihilation of its own matter – most likely beaming out into space.

progress – can only be applied to the development of human technology which, as pseudonature, can destroy or improve it, and without influencing the cosmos, will stay passive before the universe.

the emotional development of man is determined by technology. the screening of thoughts and emotions in total technology inside intimate creation becomes impossible – facing the monopoly of power, preset directives. anonymous technology kills creative subjectivity as it directs the hegemony of control. technological upsurge is always dogmatic. a man lost in the development of technology is worth less than an object produced by new technology. the benefits of production become more important than progress itself and the skill of the maker of products. on the one hand, progress grew out of darkness, coldness, and misery, as well as out of competition; on the other hand, the technocrats drove themselves crazy – because by means of progress they found themselves hampered by mediaeval laws. they sterilize one another in the hierarchy of power with an uncountable quantity of secrets – sacrifices in the name of progress, while the poor and the unskilled perish under the technocrats' express satisfaction.

obedience in science is the aim of superstition.

if the universe in its being possesses conscious movement (?) then its matter is totally animal.

every animal is essence as ideal as you are.

the division of animals into species is artificial, necessary as a pretext for making deals (?) resulting for the animals only in demagogy – that we know something about them – building super – slaughterhouses for them in consumer societies.

the unraveling of nature's mysteries is as great a nonsense as comprehending it.

your cachexy is the trump card of progress.

evolution is too slow: facing unrepeated, brief life – in order to catch the 'truth of course' consequently, the mind finds itself (always) in the condition of unenlightenment – the aim of the movement of the universe.

consciousness is found only in the feeling of death.

I exist only by recognizing each movement from outside to inside and vice versa across the frontier: contingency creates the postulate for the existence of thought. thus the view that man uses his thought better than the animals – based on the same evolutionary abyss as the animals, which do not need to be human, because man is becoming more and more like them.

in the new fourth dimensional universal geometry, the curved light beam confirms the action of a dilating universe: that the condition of matter at rest does not exist, though the thickness of galaxies is roughly the same explains why man can in the utopia of his own thinking correspond only to an animal with a tremendous thickness of bacteria – as theoretically astronomic black holes from which new galaxies blast out in order to come out from the unlimited boundaries of gravity emerged the chaos of evolution – back to the repeated fossils of ancestors and there to arise in the ideal view.

I derive happiness for you because you do not know me yet.

A. PARTUM

M70 Reality and Utterance

On Founding 'Reality and Utterance' (1980)

Reality and Utterance (*Hyeonsil gwa Bareon*) were a dissident collective of artists and theorists who were active in defining a new modern art in South Korea at a time of serious political instability which followed the assassination of President Park Chung-hee. Founded in 1979, during the struggle for democracy, the group were part of a grass-roots cultural movement later called *minjung misul* (people's art). Reality and Utterance believed in using art to express political messages, hence the word 'utterance'. They were anti-colonial, pro-democracy and keen to promote a collective, nationalist art that was rooted in the social conditions of everyday life, which gave them the word 'reality'. Through silkscreens, photography, paintings, posters and banners focusing on themes such as urban development and the Korean War, they challenged the dominance of *tansaekhwa* – the Korean school of monochrome abstract painting which, they argued, was merely a weak imitation of Western abstraction.

Reality and Utterance published their manifesto on the opening page of the catalogue that accompanied their first exhibition, which was held in Seoul in October 1980 at the Munyejinhungwon Art Gallery. The show was closed in a matter of hours due to complaints from an abstract painter exhibiting in the same gallery. Despite this inauspicious beginning, the group went on to hold further exhibitions throughout the 1980s and become a forceful voice in modern Korean art whose influence can still be felt today: the

leading cultural critic and curator Sung Wan-kyung (b. 1944), for example, is one of the group's former members.

* * *

We harbor great discontent and doubt about all kinds of today's established artistic forms and also continue to wander in the midst of our own contradictions. This self-awareness about reality urges us to return to primal and essential questions, such as what meanings art truly carries, what artists' responsibilities are, and how we should fulfil them. It also presses us to reaffirm our desire to seek new directions.

In hindsight, established art, whether it is conservative and traditional or avant-garde and experimental, either flatters the philistine tastes of the leisure class or insists on highbrow conceptual plays by closing the space of art to the outside; the result is art that alienates and quarantines the true reality of selves and neighbors, leading even to its own inability to discover the inner truths of isolated individuals. Furthermore, the so-called art scene has been confounded by power struggles and interests that are far from artistic principles and diligence. And by participating in such partisan conflicts knowingly and unknowingly, many in this art world have debased themselves and contributed to polluting the general artistic landscape, including art education. Most of us ourselves have believed that the best attitude is for each of us to agonize in solitude. Even in our encounters with colleagues, we have been unable to escape our own biases and habits, and by doing so, we wonder if we have given up on possibilities for shared resolution of problems and advancement.

It is the first intention of our gathering that we reflect seriously on all of this. Furthermore, it will be our soaring goal to restore the true and active functions of art and to promote collaborative work and theorization in order to form an original and solid artistic ideology.

As a group we pledge our conviction that to attain this goal, we will play a creative role in the development of art for a new time by

bringing together all those who share our resolve, including artists and critics, exchanging frank conversations amongst ourselves, deepening our consciousness, and shaping a sense of alliance.

We believe, therefore, that our group's thesis, 'Reality and Utterance,' contains in it the following questions with regard to the direction we must seek from now on:

1. What is reality? For artists, does reality end with internal coherence within art, or does it expand to the urgency of recharging outside of art? –
 and from these questions to the question of re-examining the meaning of reality as well as the encounter between reality and the artist's awareness.

2. How do we view and feel reality? –
 deepening of the angle of reality consciousness and of critical consciousness; hopes for relationships among observations of reality rooted in the self, the reality of neighbors, historical reality, and spatial reality, for the restoration of alienated human beings, and for a positive reality of the future.

3. What does utterance mean? How is utterance accomplished? Who can utter, and toward what is the utterance directed? For whom and by whom is the utterance done? What is the relationship between the subjects and the recipients of the utterance?

4. What should the methods of utterance be? How, where, and under the expectation of what kind of efficiency should it be done? –
 the creativity of the methods of utterance; critical overcoming of the established methods of expression and reception; and appropriateness and mutual operation between reality and utterance.

From the premise that these questions must be ceaselessly pursued within the thesis of 'Reality and Utterance,' our group believes that while enriching substance through expanded conversations,

our individual creativities, through continued practice and theory, will converge to develop into the formation of a shared principle.

We seek to form a group with members who wholeheartedly agree with this goal.

Founding Members of the Group 'Reality and Utterance'

M71 Habib Tengour

Maghrebian Surrealism (1981)

In 1981 the Algerian Surrealist poet Habib Tengour (b. 1947) wrote the manifesto of 'Maghrebian Surrealism', in French, in which he posited that Surrealism originated, not in early twentieth-century France, but from the much older Islamic tradition of Sufism, which had long been practised in Arab North Africa (the Maghreb). Here, in this mystical form of Islam, he thought, could be found the Surrealist precepts of 'mad love', 'subversion' and 'revolt', and 'pure psychic automatism'. Sufism has inspired many Islamic artists, including those of the One Dimension Group (M52) and the School of the One (M86).

Tengour is an ethnologist as well as a poet, and much of his work also explores Algerian identity and exile (particularly his own during the civil war) through the country's music, stories and collective memories. Exile is also a form of Surrealism – a disconnection from home arising from a state of 'confiscated identity'.

The manifesto ends with a list of potential Maghrebian Surrealists, which includes himself in exile, the poets Mouloud Feraoun, Kateb Yacine, Maroin Dib and Mohammed Khaïr-Eddine, and culminates with the celebrated painter Baya Mahieddine, whose work André Breton famously misinterpreted as 'Surrealist' due to its bold colouring and the dreamlike quality of its imagery. In fact, Mahieddine never subscribed to this Western interpretation of her art, which she explained was rooted in her childhood and her home.

Tangour's manifesto of 'Maghrebian Surrealism' was first published in issue number 17 of the French cultural magazine *Peuples méditerranéens (Mediterranean People)* in October–December 1981.

* * *

During these past twenty years, some Maghrebians in exile have made an act of Relative Surrealism. They could hardly do otherwise: the family was an absence they mourned in front of a postal window, homeland a confiscated identity, and religion an I.O.U.

It is, after all, in Maghrebian Sufism that surrealist subversion asserts itself: pure psychic automatism, mad love, revolt, unanticipated encounters, etc. Always there is a spark of un-conscious Sufism in those Maghrebian writers who are not simply sharp operators – reread Kateb or Khaïr-Eddine.

Feraoun is surrealist in Si Mohand
Kateb is surrealist in tradition
Dib is surrealist in the *derive*
Senac is surrealist in the street
Khaïr-Eddine is surrealist in ethylic delirium
I am surrealist when I am not there
Baya is not surrealist, despite Breton's sympathy.

M72 Eddie Chambers

Black Artists for Uhuru (1982)

In 1980 an association of young black artists came together for an exhibition to be held at Wolverhampton Art Gallery in 1981. All of the exhibitors – Keith Piper, Eddie Chambers, Dominic Dawes, Ian Palmer and Andrew Hazel – were children of Caribbean descent who had been raised in the industrial landscape of the West Midlands. As were two other artists who joined later: Claudette Johnson and Donald Rodney while Marlene Smith, who was from Manchester, was studying at Wolverhampton Polytechnic. Their first exhibition in June 1981 was called *Black Art an' Done*, and questioned what black art was and what it could be, while also confronting endemic racism in British society.

Inspired by the wider Black Arts Movement that grew out of the Black Power movement in the United States (see M46), the group spent the next four years exhibiting under the title 'The Pan-Afrikan Connection', highlighting the difficulties black artists faced in being taken seriously by the global art world and actively seeking to exhibit in galleries which were normally the preserve of white artists. They exhibited in a wide range of media and were not tied to one aesthetic, although all the art confronted trauma with powerful vitality. They held conferences, most notably the First National Black Art Convention in Wolverhampton in October 1982, where they discussed the 'form, function and future' of black art. Guest speakers included the prominent black activist artist Rasheed Araeen (M59); the conference was also attended by members of the Black Audio Film Collective (M74) and the artist Sonia Boyce.

The association eventually became known as the Blk Art Group. One of the founding artists, Eddie Chambers (b. 1960)

published the manifesto 'Black Artists for Uhuru' in the fifth issue of *Moz-Art: The Arts Magazine of the West Midlands* (March–July 1982). Published the year after race riots in London, Birmingham, Leeds and Liverpool had shocked the UK, its revolutionary rhetoric appeals for a socially and politically engaged black art (*uhuru* means 'sounds of freedom' in Swahili). The manifesto concludes with a quotation from the prominent African-American activist Ron Karenga's essay 'Black Cultural Nationalism' (1968).

* * *

Some of them, of course, are being heard and felt: in particular I salute Rastafarian orientated/influenced work which has helped to create within some of us a new vision of self. However, even Rastafarian art cannot completely avoid the risk of becoming stagnant and predictable; but the vast majority of our artists, where are they? Well I'm afraid that they are primarily where our tormentors (including the ruling classes and the so-called 'liberals') would have them to be: in their studios. Furthermore, they are doing what our oppressors can only regard as 'safe', producing lame ineffective work.

I don't make this accusation lightly, but most of us (especially those outside art schools) are made to feel that our activities are positive, enhancing race relations and educating the ignorant as to the form and functioning of our Afro-Caribbean culture. We're too busy being 'ethnic' and 'cultural' (cultural in the historic sense of the word) to realise that we are near enough completely politically ineffective.

At this particular period of time in the history of Black people in Britain, I find it necessary to make this appeal to the Black artists and art students of our communities here in the West Midlands. Though white artists/art students reading this article would do well to note, and strive to emulate our vocal, resolute, and articulate producers of 'political' art.

This appeal stems from my concern for the wellbeing of the better people of our race who constantly find themselves drawn towards positions of both attack and defence where the battle is hottest: on the streets of our communities.

It seems that most of our artists and their student counterparts

desire no great role in the contemporary struggles of Black people: choosing rather to concern themselves with the vogues of art for art's sake and with subjects which, at the very most, are secondary to the quest for liberation, in fact, our struggle for survival as Black people.

I myself shun the word 'ethnic' though I have no doubt that its users are mostly well intentioned. I choose rather to call our art what it should and must be: BLACK ART!

As for most of us in art schools, one would not for a minute consider us to be members of a race who have been systematically enslaved in the most brutal forms of slavery ever, if not merely for the colour of our skins. By this I mean the work we produce gives no indication of our experiences, past or present.

The Black art student, by the very colour of his/her skin, should find him/herself drawn towards the nerve points of social and political tension and unrest choosing to respond in this situation by producing work which voices their dissatisfaction with the offending bodies or people, offenders who may at one point in time or another include the police, the state, the educational system, the church, and so on. This work, in its clear, resolute, and eloquent terms cannot fail in the strength of its impact.

Black art students! You have a growing obligation to acknowledge our race and the fundamental elements which characterise our existence in and through your work.

Black art, at the very least, should indicate and/or document change. It should seek to effect such change by aiming to help create an alternative set of values necessary for better living, stronger communities, contemporary cultural identity, and so on, otherwise it fails miserably to be art befitting the black community. Black art, like everything else in the Black community, must respond positively to the reality of revolution: revolution seen in earnest on our streets last summer.

A Black American writer has written 'let our art remind us of our distaste for the enemy, our love for each other and our commitment to the revolutionary struggle . . .' So let it be.

EDDIE CHAMBERS

M73 Colectivo de Acciones de Arte

A Declaration by the CADA (1982)

The Colectivo de Acciones de Arte (Collective for Art Actions), or CADA, was founded in Chile in the late 1970s by the visual artists Lotty Rosenfeld (b. 1943) and Juan Castillo (b. 1952), the poet Raúl Zurita (b. 1950), the novelist Diamela Eltit (b. 1944) and the sociologist Fernando Balcells (b. 1950) with the aim of interrogating the relationship between art and politics under the brutal realities of General Augusto Pinochet's dictatorship. Some of the members had previously been involved in the communist group Brigada Ramona Parra, creating agit-prop murals during elections. CADA's art took the form of public art actions and everyday happenings, using the Chilean capital Santiago as the foundation on which their interventions were performed.

In August 1982 they published their manifesto, 'Una ponencia del CADA' ('A Declaration by the CADA'), in the journal *Ruptura: Documento de arte*, which discusses how widespread social resistance to Pinochet's regime could be achieved through cultural interventions, referring to the French left-wing philosopher Maurice Merleau-Ponty and his writings on art, politics and perception. Their ideas were perhaps most clearly illustrated in their final work, the direct action *No +* (*No más*, or *No More*) (1983–4). The group clandestinely covered the walls of Santiago with the sign 'No +', tacitly inviting the public to voice their protests by completing the phrase: 'No + Murders', 'No + Torture', 'No + Guns', and so on. The work's impact made '*No más*' a potent anti-Pinochet slogan which continued to be used until the collapse of the dictator's regime in 1990.

*　*　*

To reaffirm dialectically the concept of creativity in a context such as ours demands not only calling into question the language of certain practices and their particular means of signposting, but also unavoidably leads to an adjustment of the strategy that emerges when the very concept of specificity in reference to artistic products is challenged.

Historically marginalized from international art movements and their financial and distribution networks, any form of expression born in these regions, even if it refers to the same international terminology and takes shelter under the same ideas of art defined by the international hubs of culture, raises questions about its own nature, about its methods and about its objectives. The answers to these questions go beyond the field of semiological axiomatics, raising instead the issue of its overall relationship to the struggles and the developments in our socialized reality.

On the other hand, the scarcity of what might properly be labelled 'Latin American art', which could allow for a comparison, based on its very own parameters of value, of the diverse phenomena and epiphenomena that have emerged in this context, raises the old questions about usefulness and meaning – although not in an academic sense, but escaping the realm of theory to a place where debating art becomes a matter of life and death. (Some radical responses show that the statement above is far from merely rhetorical.)

And it is this very concept of art that is in doubt when discussing some of the practices carried out in our setting. That which, in developed capitalist countries, allows us to distinguish between activities such as politics, science, art or religion, and thus to define specific objectives, individual strategies, degrees of development for each, is exactly what is called into question in these other realities (born of dependency, imperialism, authoritarian regimes) through the simple fact of confronting any specificity with our situation's overall perspective.

However, our marginality in relation to 'international art', or rather, our marginality with regards to the history of a so-called international art, is not in itself a well-established reality; it does

not constitute an immutable landscape. On the contrary, to work in that marginal space implies a degree of belonging that is not necessarily fixed and that, instead, establishes itself as a field of battle, as an arena of confrontation in which the concepts of art and life complement and tear each other apart.

To work at the margins of an internationally established art movement means, first and foremost, to doubt the qualifying terms. Duchamp's premise that art is everything the artist labels as such is not immediately applicable to those whose work defines the terms of their survival (and we mean survival in its most concrete sense) and the fate of their surroundings. That is how, for instance, artistic practices that were fashionable a decade ago, including body art, landscape art or performance art, and which signified international art opening its eyes to new forms of life, are immediate realities in our own landscapes, pre-dating their labelling as art, precisely because of the degree of daily familiarity with these living forms: hungry bodies, vast infertile plains, fallow fields. To operate in this reality, in whatever area we may formally develop this work, implies working with change, with the transformation of the form. It implies, to summarize it in two words, revolutionary practices.

Because they are beyond any mannerisms, the achievements of art in the great international centres – the signifying of the body as medium, of landscape as text – are for us familiar facts, although such familiarity is the result of other types of deprivation. It is not the typical terms of the development of art that define the scene, but rather the contact with the precarious and painful, as well as with the barrenness of concrete lives. There is, then, little that we can learn from artists who define their work as temporal, or as landscape art – hardly anything beyond our own difference, which inevitably leads us not only to shift the limits of our reality, but also to criticize or revise from a global perspective what the avant-garde signifies.

Therein lies the criticism both of art's self-referential nature and of the specificity of its practice, over which we favour its connectedness in the development of any *mise-en-scène* that we establish. It

is not about launching new products into the international art market – now, from South America – but about establishing a practice that operates within the parameters of our own history. In that sense, any work structured around the random and the indeterminate reveals itself today as a practice that subverts established models and images, in other words, a subversion of life.

And it is in the concrete terms of the developments, the alternatives and the progress of our own history that art – defined in its South American context – acquires its particular dimension. There, inevitably, whatever we do will refer to its own self-impugnation, denying its artistic nature to become instead a political act and referring the political act to its existence as art; and its originator operates as both a summation and sublimation, the black and white of collective circuits. The artistic creator is both scenery and scene; the hunger to reproduce reality is identical to the hunger for food, or at least they share the same nature. The creator's body is, in the final instance, a black hole in which all the misgivings about meaning converge and where theory and practice become synonymous. It is that bipolarity of creation and creator that precedes the formalization of artistic currents. Urgency adds commitment to every fact, every step, and makes them committed to the total course of action, and therefore inescapably confronts them with backdrops of sociability. It is this sociability – not the artist – that defines the degree to which it must cope with reality.

Similarly, the expectation, whether catastrophic or hopeful, of a change in the totality of social relations, mirrors its own material base, and becomes a characteristic trait of the way in which our history operates. Constantly subjected to the comings and goings of history (from right-wing dictatorships to socialist experiences), that expectation reinforces the historical nature underpinning creative practices; the stage is not only the present, but also a certain dimension of the future, that manifests itself both in faith (in the Christian sense of the word) and in political positions – a permanently denied, altered, remade future, whose effects are visible in the challenging of the past (in socialist agendas) and the quest for traces of that past in models of the future (typical of authoritarian

governments); in any case it affirms an understanding torn from the present. It is precisely the bringing back to the present of future possibilities that defines the most consequential artistic practices. Therein lies the model of action. That model is action art.

Politics and art share a degree of interchangeability that, if assumed under the idealist notion of a 'work of art', redraws the framework within which the artistic act is committed. Political action necessarily presupposes a project, an image of the future whose realization depends on the efficacy of current operations taking into account future coordinates. Merleau-Ponty's idea – a mistaken revolutionary is more dangerous than a bourgeois – is true insofar as it refers to the definition of public debate, its internal cleavages and the risks of action. The work of art, on the other hand, has always operated with reference to the past. Its efficacy and its value are a function of its ability to recreate the illusion of eternity, of immutability in the face of time, acquiring its greatest value at the moment when it is able to expel from itself all traces of contingency, that is, when it belongs in a Museum. The work is most valued, then, when it takes on the aura of being unreachable by human means. Modern reproduction techniques, from lithograph to videos, depend in turn on the value of the established work of art, preserving continuity inasmuch as those institutionalized works act as guarantors of the new works for those who wish to produce goods that will not depreciate. From this stems the model of artistic action. Its practice implies an image and a perspective of the future and therefore a link to history; therein lies its political character. Its break with frivolous art models is the product of the here and now and is subject to action.

That expectation of change and its role in the field of creative activity which, in the final instance, differentiates what we make here from any trends in contemporary art. The body as a medium for art (body art) is not the same as the body as a vehicle for change, as a real revolutionary agent. Nor is the landscape as a medium for art (as it was on canvas) the same as the landscape as evidence of fallowness. It is this latter condition that condemns the colonized nature so often reflected by the chronology of art in South America.

Not that it 'copies' what happens in the main centres of art, but whatever the centres have designated as art is consumed here as an experience, and therefore whatever is produced is seen as a political act. The act of copying is a form of confrontation with experience, and not only with the original works. That is what distinguishes the dissociation between artistic production and the collectivity; its schizophrenia comes from a double mismatch: we paint (we make art) one-dimensionally, as if faced with consummated facts, and in turn those facts deny the evidence of their pictorial transfer. Thus, South American art does not intervene in the image of the world, *it has not invented perspective*, because it is a point of view that reality does not reflect back to it. Instead it is reality itself: the sum total of production that reinvents perspective in art.

It is that settling down amid the multi-dimensionality of the whole of socialized reality that synthetically defines the most conscious Latin American creative practices. Its artistic value is not given by its efficacy in rescuing the immutable ideological conditions that are evidence of a concrete social situation, but in the measure of its ability to go deeper into the symbolic conditions with which the dominant system hides the intentions of its action.

That is where the creative practices, in this case the practice of art, emerge. To operate in the totality of socialized reality is to operate at the production base of that reality and in the specific conditions of its transformation, that is, in the present arrangement of its future. To understand from that vantage point the work of art and to state its efficacy with regards to the construction of a distinct order is to understand fully the only sense in which it is possible to refer to art as a specific practice and assumes its own significance: the work of building its emotions.

To signify emotion, that is the crucial agenda with which artistic action can justify (or not) creative practices in our environment. Emotion establishes the first level of contact with a seemingly inscrutable reality. It constitutes the prehistory of the action and in that sense is the matrix in which the practice will develop. The work with emotion thus becomes, in practice, an operation that aims to capture content. Its value underscores any writing and

informs the signifier of any representation. Therein lies the artistic action's enormous power of transgression in the field of experimentation. Therein, also, lies the extreme and radical character with which many artists and cultural operators have taken on their artistic practice. To establish oneself in that field of significance by referring it to a model of the present as the finality of action, while undermining the Manichean notion of art as an alternative to life, is to subvert frivolous artistic practices and transform them, instead, into militancy.

To work on building emotions, with the aim of creating the tangible marks of a new emotiveness, implies creating a new programme that allows for a plurality of meanings in the creative action as it expands the image of reality. In that programme, the artistic action, faced with its own emerging condition, traces the mental topology that will allow it to access, in the here and now, the necessary conditions for change. In other words, this means operating with real-life conditions, putting them in tension with their history, that is, with the inevitability of its destiny.

In that way the art action and the political act can be distinguished more by a consequence of their fields of impact than by any dualistic or distinct nature. To extract from immediacy an image of the future, and thus create some form of emotionality, is what defines the sphere of artistic action *today*. To establish a strategy for practice in relation to a theory of the future, that is political action. Nevertheless this distinction is also rhetorical. This can be seen more clearly if we observe that some efforts by the Latin American vanguard in the field of artistic action have already proven that both collective objectives (a classless society) and a militancy towards those objectives can be understood as art.

And it is these efforts, then, that we can properly refer to as 'The Art of History', not because they have historical events as their theme (as in Picasso's *Guernica*, or Muralismo), but *because they make historical development, with the dialectic process of its contradictions and synthesis, the object and the product of art*. That is the key issue, and it is there that the CADA has defined itself as a revolutionary force. It may not be easy to understand this, even more so

when its concrete nature unveils the contradictions of those who, wanting to reformulate creative space, have been absolutely incapable of even calling into question the art gallery – as demonstrated not long ago by a 'critique' that, in the face of prevailing gallery practices, did not hesitate to confront the CADA with anything less than . . . permanent revolution.

So nominating artistic actions as 'The Art of History' is something that must be learned in all its consequences; its success or failure is not separate from the success or failure of the perspectives of total alteration of the environment nor, in the final instance, the creation of a classless society. The work *completes* the history, and that brings any action into the here and now where that work is at stake. The most immediate precedent for this is the Brigada Ramona Parra. The obliteration of those murals was already contained in the moment of their creation. The times Chile has lived through since then are now part of that unfinished work.

On drawing to a close, we pay homage to them.

CADA
May 1982

M74 John Akomfrah

Black Independent Film-Making: A Statement by the Black Audio Film Collective (1983)

In 1983 a manifesto by the Black Audio Film Collective (BAFC) appeared in the summer issue 3–4 of the political art journal *Artrage: Inter-Cultural Arts Magazine*. Written by John Akomfrah (b. 1957), it explores the question of what 'black independent film-making' is, and should be, in the broader context of a cinema that is predominantly white and Western.

BAFC had been founded the year before by seven art and sociology undergraduates at Portsmouth Polytechnic – Akomfrah, Lina Gopaul, Reece Auguiste, Avril Johnson, Trevor Mathison, Edward George and Claire Joseph (later joined by David Lawson) – who were dedicated to creating complex film narratives that chronicled and questioned life in multicultural Britain. Their first collective work was a tape/slide performance with Akomfrah, George and Mathison reciting extracts from the long prose poem *Notebook of a Return to The Native Land* (*Cahier d'un retour au pays natal*, 1939) by Aimé Césaire, one of the founders of Négritude (M7). Emerging after fierce race riots had erupted in London, Birmingham, Leeds and Liverpool in 1981, they sought to reflect a black experience in Thatcherite Britain and question the way the media represented black British people – not just in the mainstream media, but also in academic discourse and in the creative arts.

BAFC's radical approach to filmmaking – together with a firm theoretical basis informed by the work of the cultural theorist Stuart Hall and artistic influences ranging from Négritude to the

theory of 'third cinema' – resulted in films that broke most cinematic conventions. They challenged racism, stereotyping and social injustice, not with angry social realism, but through a series of visually evocative films that meditated on themes of memory, migration, globalization, loss and displacement. Perhaps most characteristic of the group's films is *Handsworth Songs* (1986), which was directed by Akomfrah and won the British Film Institute's John Grierson Award for Best Documentary in 1987. Its collage of music, reportage, first-hand testimony and archival footage creates an elegiac depiction of the experiences of people caught up in the violent civil disturbances that broke out in Handsworth, Birmingham and beyond, in 1985.

Although the group disbanded in 1998, the fundamental ideas that underpin their manifesto, particularly those to do with the relationships between memory and archives, presence and absence, continue to inform the work of the individual members.

* * *

The area of black independent film-making will soon see the growth of a number of workshops established with the specific aim of catering for black film needs. We will also see a growth in the number of films made by members of these workshops. As in any other field of cultural activity and practice such a development calls for collective debate and discussion. Some of the important issues to be raised will be around the relationship between the workshop organisers and participants in the course. The others should obviously be about the nature and structure of the courses themselves.

Prior to this debate, however, is the task of accounting for the specificity of black independent film-making. What, after all, does 'black independent film-making' mean when present film culture is a largely white affair? And does this posture of independence presuppose a radical difference of film orientation? If this is the case how does one work within this difference?

The Black Audio Film Collective has chosen to take up these issues in a very particular way and this is around the question of the 'figuration of ethnicity' in cinema. Our point of entry is around

the issue of black representation. The Collective was launched with three principal aims. Firstly, to attempt to look critically at how racist ideas and images of black people are structured and presented as self-evident truths in cinema. What we are interested in here is how these 'self-evident truths' become the conventional pattern through which the black presence in cinema is secured.

Secondly, to develop a 'forum' for disseminating available film techniques within the independent tradition and to assess their pertinence for black cinema. In this respect our interests did not only lie in devising how best to make 'political' films, but also in taking the politics of representation seriously. Such a strategy could take up a number of issues which include emphasising both the form and the content of films, using recent theoretical insights in the practice of film-making.

Thirdly, the strategy was to encourage means of extending the boundaries of black film culture. This would mean attempting to de-mystify in our film practice the process of film production; it would also involve collapsing the distinction between 'audience' and 'producer'. In this ethereal world film-maker equals active agent and audience usually equals passive consumers of a predetermined product. We have decided to reject such a view in our practice.

Underlying these aims are a number of assumptions about what we consider the present priorities of independent film-making should be. These assumptions are based on our recognition of certain significant achievements in the analysis of race and the media. It is now widely accepted that the media play a crucial role in the production and reproduction of 'common-sense assumptions' and we know that race and racist ideologies figure prominently in these assumptions. The point now is to realise the implications of these insights in creating a genuinely collective black film culture.

Such a programme is also connected with our awareness of the need to go beyond certain present assumptions about the task of black film-making. We recognise that the history of blacks in films reads as a legacy of stereotypes and we take the view that such stereotypes, both in mainstream and independent cinema, should

be critically evaluated. This can be connected to a number of things that we want to do. We not only want to examine how black culture is mis-represented in film, but also how its apparent transparency is given a 'realism' in film. It is an attempt to isolate and render intelligible the images and statements which converge to represent black culture in cinema. The search is not for '*the* authentic image' but for an understanding of the diverse codes and strategies of representation.

It could be argued that all this is stale water under a decaying bridge and that we know all this stuff already and that black film-makers already accept their responsibility and are aware of these problems. There is a lot of truth in this. Others may say that as long as we are making films and gaining exposure of our work we are keeping black film culture alive.

To place our discussion in a relevant and meaningful context the Black Audio/Film Collective in conjunction with Four Corners cinema will be organising a number of screenings to run with the Colin Roach photography exhibition at Camerawork Gallery.

The series of films and discussion will run under the title of *Cinema and Black Representation* and will deal specifically with the complexity of black portrayal in films. The main aim here is to see how film can contain 'information' on race, nationality and 'ethnicity' with (Presence) or without (Absence) black people in films. With this in mind we hope to cover a number of films and themes ranging from prison movies like *Scum* to Hollywood social criticism films like *Imitation of Life*. What we will be attempting will not be to push all the films into one category of racist films but rather attempting to examine what specific responses these films make to the question of race and ethnicity.

In the end we realise that questions of black representation are not simply those of film criticism but inevitably of film-making. These issues need to be taken up on both fronts. With this in mind we are also making preparations with the GLC Ethnic Minorities' Committee to organise a number of courses on some of the themes outlined in this article. Neither the dates for the screenings nor

film courses have been finalised – both will be advertised when they are.

I am indebted to *'The Core'* – Eddie George, Lina Gopaul, Claire Joseph, Trevor Mathison – for discussion which led to this transcription.

M75 Women Artists of Pakistan

Women Artists of Pakistan Manifesto (1983)

Early in 1983 Pakistan was shocked by the brutal manner in which the authorities repressed a small demonstration protesting against the introduction of a law that would, in the eyes of the courts, give women's legal evidence half the value of men's testimony. The incident focused attention in the country on the appalling treatment of women and minorities, which had been steadily deteriorating since General Muhammad Zia-ul-Haq's *coup d'état* in 1977. It also provoked a group of fifteen women artists in Lahore into privately meeting in Model Town at the home of the artist Salima Hashmi and writing a manifesto decrying the oppression they endured. Composed while the country's showcase National Exhibition was being staged at the Alhamra Art Centre, this remonstration was the first time that women artists had overtly identified their work with the political struggle for female emancipation, employing it to criticize the government's policies and subvert traditional attitudes.

Due to the political circumstances of the time, the manifesto was never made public. But as one of the signatories, the artist and academic Salima Hashmi (b. 1942), has stated, simply the act of putting their names to the paper empowered the women to become more outspoken in their art against misogyny.

* * *

We, the women artists of Pakistan,
 having noted with concern the decline in the status and conditions of life in Pakistani women; and having noted the adverse

356

effects of the anti-reason, anti-arts environment on the quality of life in our homeland; and having noted the significant contribution the pioneering women artists have made to the cause of arts and art education in Pakistan; and believing as we do in the basic rights of all men, women and children to a life free from want and enriched by the joys of fruitful labour and cultural self-realisation; and our commitment, as practitioners and teachers of the arts, to the noblest ideals of a free, rational and civilised existence:

affirm the following principles to guide us in our struggle for the cultural development of our people to serve as the manifesto of the women artists of Pakistan.

1. We acknowledge the outstanding contribution made by women artists to the conservation and promotion of the artistic genius of our people and their role in pioneering art education in the country; we salute them for this and for their determination to spread out at all levels of education and to all strata of society.
2. We unreservedly support the Pakistani women's struggle for equality of rights, status, and dignity with menfolk.
3. We call upon women engaged in any creative field in Pakistan to stand together for the cause of women's emancipation not only from all constraints, perpetrated in the name of law and morality, but also from all forms of prejudice, superstition and cant.
4. We recognise, respect and uphold the right of every woman artist to her own faith, her individual approach to content, form, medium, method, technique and style in the realisation of her artistic ideals. And we denounce any attempt, overt or covert, to suppress, inhibit, control or regiment her artistic functioning, or to interfere otherwise with her basic right to freedom of expression.
5. We vigorously condemn the attitude which minimises woman's constructive role in society, and attempts to restrict her active and rightful participation in society.
6. We condemn the attitude which distorts the original and age-old role of woman as the giver and sustainer of life, love and affection and vulgarises it into an image of obscenity.

7. We call upon all women artists to take their place in the vanguard of the Pakistani women's struggle to retain their pristine image and their rightful place in society.

So that we may replace in the lives of our people despair with hope, brutality with compassion, darkness with light, and anarchy with culture, and leave the world a happier, more beautiful and more peaceful a place than we found it.

Signed by 15 Women Artists of Lahore – 1983
Rabia Zuberi, Abbasi Abidi, Mamoona Bashir, Salima Hashmi, Lala Rukh, Talat Ahmad, Zubeda Javed, Sheherezade Alam, Jalees Nagi, Birjees Iqbal, Riffat Alvi, Meher Afroz, Nahid, Qudsia Nisar, Veeda Ahmed

M76 Bedri Baykam

The San Francisco Manifesto (1984)

The young Turkish Neo-Expressionist painter Bedri Baykam (b. 1957) wrote 'The San Francisco Manifesto' in June 1984 out of frustration at the absence of works by non-Western artists in the museums and galleries of the United States. A well-respected artist in Turkey, with a number of critically regarded exhibitions, Baykam had moved to the US in the early 1980s in the hope of gaining better recognition outside his homeland. His manifesto, written in English, was distributed outside the San Francisco Museum of Modern Art (SFMMA) at the opening of an exhibition of Figurative Expressionist paintings titled *The Human Condition*. All of the artists in the show were from Europe and the United States, leading Baykam to ask if the story of Figurative Expressionism would go down in the history books as a purely Western phenomenon. The manifesto recounts his efforts to challenge the prevailing orthodoxy of museum culture and argues that an insidious institutional racism conspired to obstruct all non-Western artists.

In 2015 Baykam was elected president of the International Association of Art (IAA), an organization supporting and promoting artists from all over the world and forging links between nations and cultures through art.

* * *

ONE QUESTION HAS TO BE ANSWERED:
IS THE WESTERN WORLD ONCE AGAIN IN THE
PROCESS OF BUILDING MODERN ART HISTORY AS
SOLELY THE HISTORY OF OCCIDENTAL ARTISTS?

We are not going to change the way things have been for 100 years, but we should be able to think about the issue without being afraid.

In spring 1983, the assistant curator of the SFMMA informed me of a coming new expressionist show and advised me to write to the museum so that I could be considered to be part of it.

I wrote a letter and all I got back was a reply from the assistant curator telling me the director was too busy to see me, and my work. Being one of the leading artists of my country who has had a lot of international exposure, and the fact that in March 1983 I had had a 100 piece showing of my figurative expressionist work in a major museum in Istanbul, had rather led me to believe that the SFMMA would at least be interested in 'looking' at my pieces.

The first question is simple: Would the museum have had this attitude toward leading French, or German or Dutch artists?

I do not claim that I had to be part of this show . . . Maybe, I do not deserve it. But this refusal to listen, to see (which is not even a rejection), along with some similar incidents I have seen in the American art scene, makes me also ask the following questions:

1 – How many third world artists are represented in this show?
2 – Is the western world trying through its curators and critics to make out that modern art history is exclusively the history of occidental artists?
3 – Is the same script played in regards to new expressionism?

These points raise some disturbing questions regarding the credibility of Western art politics.

I WISH THAT A SHOW ENTITLED 'THE HUMAN CONDITION' ALSO REFERRED TO SOME OTHER BILLIONS OF HUMANS, INSTEAD OF TURNING INTO A SHOW THAT COULD HAVE BEEN CALLED, 'THE HUMAN CONDITION IN ZURICH AND CHICAGO, ETC.'

The issue goes way beyond my career concerns. Are we preparing shows and symposiums to determine a truthful approach to

art, or is all of this a game played so that the western establishment can surely and peacefully perpetuate its cultural domination. I wish that a show entitled 'The Human Condition' also referred to some other billions of humans, instead of turning into a show that could have been called 'The human condition in Zurich and Chicago'. What happened between SFMMA and me deserves apologies. Not from me. But from another curator. From another museum. From another country. From another group of countries for so long under heard, underestimated, neglected. Such prejudices have their economic reasons of course. But it takes art to bind nations and to jump over them.

What happened to myself in a way made me skeptical of all the Modern Art History I have learned. Here today you will be talking in reference to the past decades, mentioning Pollock, de Kooning, and Bacon. Maybe there also was Mohammed, or Roberto De La Pampas, and maybe the respected Turkish painter Abidin Dino, now living unknown in Paris, deserved as much credit as those other names. How come you want to quickly define new expressionism as only an American or European movement? Is it that you want to make sure that we are going to present new expressionism as a purely western phenomenon in the future reference books that our descendants will read?

To dismiss these issues is to take a step back into an easy and familiar resolution and to avoid confronting this major problem.

If you had never thought about it, now you did. The integrity of western art in the eyes of the rest of the world is at stake, the choice is yours. I could have gone inside the symposium and raised my own voice, but I would be easily vulnerable to accusations. I prefer leaving you with the issue. I will be available for comments between 12 and 2 pm in front of the museum. At 12 o'clock sharp, I want to believe that one American among 1000 will dare to raise his voice on behalf of this issue. In case the panelists or participants decide to invite me, I am ready to go in and to discuss this subject. Another world needs to be heard.

M77 Vladan Radovanović

The Vocovisual (1984)

The Serbian artist and composer Vladan Radovanović (b. 1932) is a
pioneer of early electronic music, sound art and Concrete poetry.
Like many of the avant-garde who emerged in Yugoslavia in the
1950s and early 1960s, including the artists of Exat 51 (M14), Gorgona
(M20) and the OHO group (M32), he created works that defied the
state-enforced cultural orthodoxy of Socialist Realism by drawing
on influences that derived from earlier modern art movements
such as Dada. As a brief member of the Belgrade group Mediala, he
had promoted happenings and gestural actions, but in the late 1950s
he turned his attention to an entirely new artistic genre.

Radovanović's most distinctive work consists of interdisciplin-
ary compositions that blend sounds, words and the human body
in three-dimensional space in order to transcend the traditional
boundaries between art disciplines and directly engage with every-
day society. These he called the 'vokovizuel', a concept later explored
by the Canadian theorist Marshall McLuhan in his 1967 book Verbi-
Voco-Visual Explorations. Restlessly inventive, Radovanović devised
minimalist chorales, experimented with tape music and in 1976
devised Yugoslavia's first computer composition, Kompjutorija
(Computoria).

In Belgrade in July 1984, Radovanović published a slim pamphlet
entitled Vokovizuel to accompany an exhibition of the same name.
Its text (reproduced in its entirety below) explained the theoretical
underpinnings of what he believed was a unique artistic synthesis
of sound, form and meaning.

* * *

The interpretation of the vocovisual as an artistic genre, and my special VV poetics (or Sema Synthesis), have been determined through my work since 1954 and theoretically since the 1960s.

The vocovisual is a common term for the entire tendency from Simmias to date that despite its literary origin is neither poetry nor any other single medium genre. Today this can be seen as an independent art genre. It is an interdisciplinary, multimedia art that involves not only the visual and phonetic but also the tactile, kinetic and so forth. Despite being a multimedia discipline, it is different from mixed media, multimedia and intermedia in its designative meaning. By the same token the visual in the vocovisual may be distinguished from that in the plastic arts, as the phonic is different from that in music. The vocovisual is characterized by signs of a conventional and allusive type (including verbal and iconic signs), but not by those of a self-acting type. As in all arts, the basic type of meaning is designative, but in the vocovisual, artistic impact comes through an encounter of formal and designative meaning. The vocovisual is in continual semantic and syntactic interaction between artistic and extra-artistic realms. The designative quality expresses itself through the thematic. The theme can be anything (metaphysical, scientific, social, political, literary), but there must be a theme.

My own special poetics are just a part of the vocovisual and a synthesis, in a way, of features of 'figured verse', the symbolic letter, and those of the more recent poetics (concrete, visual, sound, kinetic, and spatial), but should not be identified with any tendentious poetics.

M78 Laboratoire AGIT'art

Memory of the Future? (1984)

The radical art collective known as Laboratoire AGIT'art was founded in Dakar, Senegal, in 1974 by the artists Issa Samb (1944–2017), Ass M'Bengue (b. 1959) and El Hadji Sy (b. 1954), the filmmaker Djibril Diop Mambéty (1945–98) and the playwright Youssoufa Dione in order to highlight the contradictions of the Négritude philosophy (see M7) prevailing over the country's vibrant cultural policies.

Although the most popular forms of Senegalese artistic expression had traditionally been music, dance and performance, when the country's first president, Léopold Sédar Senghor (one of the founders of Négritude), came to power in 1960, he had established an École de Dakar – loosely based on the École de Paris – to spearhead the development of an African style in painting, sculpture and the decorative arts. By the 1970s, however, the younger generation of cultural provocateurs who called themselves Laboratoire AGIT'art decided, in the spirit of Pan-Africanism (M39), to rebel against the constraints of this cultural status quo – which they believed to be too Western – and to attempt to restore Senegalese art to its rightful owners: the people. They staged street performances and experimental situations, constructed installations and paintings, and managed workshops that were politically and communally focused, in order to challenge Senghor's state-run arts programme.

In 1981, the less culturally enlightened President Abdou Diouf came to power in Senegal, and set about reversing Senghor's arts policies, reducing spending and shutting down cultural centres. AGIT'art's activities were regarded with increasing suspicion by the authorities, and in 1983 the group were evicted from the squatted

Village des Arts, in Dakar. A year later, in September 1984, the group wrote a manifesto (in French) commemorating the event.

Laboratoire AGIT'art continue to operate today under the leadership of Issa Samb. At the time of writing the group were once again facing eviction from their premises, this time at the hands of property developers.

* * *

Dakar, an interesting African metropolis? Without a doubt! Brain and practically the lung of Senegal? Definitely!

But a filthy city! And pretty disorderly in many ways. Still, an angel passes by whispering to whomever will listen:

'And the crisis? And . . .'

To the unobservant witness, the streets of the capital offer a spectacle at once nonchalant, extravagant and even suspiciously insouciant. He may become jaded from seemingly jumbled reality seen through a slightly deforming prism.

In this regard, it is not really about denouncing as there are situations when not doing so can even be appropriate. Just as not choosing constitutes in many ways a kind of choice. And it should be made clear, first and foremost, that the vehemence of the lines to follow is hardly polemical. Better yet, it is about an invitation to reflect. And again in a cool way!

To say that times have changed today is to put it mildly (our tongue having tripped over the word 'truism'). The difficulty lies rather in the articulation of discourse, in its order. And this is no easy feat if the order of discourse is literally disorderly. From this perspective, methodological caution requires adequately taking into account the dialectical relationship between order and disorder and properly grasping the subtle nuances that exist between order and disorder and the disorder of order.

By the way, it was a year ago to this day that the forces of order invaded the Village des Arts to evict the artists.

Today we can say, 'That was only yesterday, of course!' and add, 'No comment!' What is crucial here is to remember what happened especially given the importance that memory holds for us.

Furthermore, we have chosen to not allow some important cultural incidents to slumber in the past, that is to say, in the present. History – and this is neither our fault nor anybody else's perhaps – is increasingly written in the present.

For the record, let us remind those who may not recall that the Village des Arts was located at 126 Avenue A. Peytavin, facing the Atlantic Ocean.

This may make you dream! Or else, to put it more eloquently, be cause for reverie!

But beware! Let's not mix things up.

It's tempting and at the same time it might not work. One main point: the Village was above all a framework that provided the conditions for creation to take shape, not a structure that intervened or was orchestrated.

Its existence was, at the very least, an achievement. And fortunately, the artists didn't die. Creatively suffered from its closure but didn't vanish.

DAKAR bears witness.

If one must speak again of Senegal, it would be to acknowledge that appearing and being make strange bedfellows there. Don't expect an angel to whisper anything about bazin cloth, embroidery or double Tabaski.

We remain convinced that in the end we know little of Being: we must above all listen to it.

Because listening to it is a measure of communicability and therefore an invitation to levelheadedness.

The need for such a precondition is clear if we envision DAKAR/1984 to be replete with myriad and versatile signs and reference points beckoning.

Indeed, besides the filth, DAKAR is also a city of madness and mendicancy. An ideal witness, the blind deaf-mute knows what he's talking about when questioned on the issue.

All of this means that the parameters of the crisis must be slightly modified somehow in order to identify and define some new phenomena relating to our global society.

In short, better analysis is needed to distinguish between that which is destabilised from the outside and that which is destabilised from within.

Even if it is true that nothing great is ever done without passion, we remain 'calm' enough not to conflate out remarks with the visceral scream of an impassioned partisan of accelerated history: 'In this country, who doesn't get the hell out?' We'd rather rephrase the question in other terms by asking ourselves: 'What is lasting in all this?' Isn't our situation complex because it's so cultural?

This reminds us of another interlocutor, deaf-mute but not blind. With a gesture which needn't be described here, he let us know how he had the impression that Senegal was undergoing 'cultural depreciation' after more than two decades of real artistic expression.

And our witness added roughly this: 'The question may be to ask ourselves when the milk will turn sour . . .' Nonetheless, one must

recognise that the survival of the country is in part a question related to the cultural factor (but for how much longer?).

Serious problems of ambivalence, here and elsewhere! To go as far as to call for the transformation of values is a mere step that we'll happily take. Out of necessity and urgently! And also in vehement opposition to the status quo.

If only because present history has the unfortunate habit of happening in the present. And that Machiavellianism goes hand in hand with a lack of confidence, in both good times and bad!

Once again not long ago, we warned that the troops' assault on artistic creation would have serious consequences. That could entail cutting back on culture. We should therefore consider the relevance of a culture held hostage.

And without passion in order not to so swiftly lump together imagination and carceral environment.

Silence, we're shooting! The name of the film: 'Wake-up Call'. But wait! Did we do a run-through? A ... Never mind! (It doesn't matter.)

Cut!

In the play 'Has the Milk Gone Sour?' the acting perspective shifted, both implicitly and explicitly. Hence the new connections between orality and mime, on the one hand; between the order of acting and theatrical discourse, on the other.

On the contrary, we don't underestimate the influence of Eugen Fink's book 'Acting as Representation of the World'. He shows us how acting is an object worthy of philosophical enquiry as is the case for most of the humanities. In fact, acting actually has mythical origins. And this remained to be seen.

This leads us, more or less, to the subject of the effectiveness of artistic training. Borrowing from J.R. (not the one from Dallas), we agree that artistic education is an ideal means of developing intuition, invention and creation.

It must focus on the creative process rather than the faithfulness of the copy. And again to paraphrase Joël de Rosnay, varied and modern forms of expression exist in this regard to promote a rebalancing of man. They can effectively contribute to his recentring and reunification.

Let us mention in passing that the President of the Republic is extremely concerned about national culture.

The cultural development plan is in preparation. A naysayer would call it stagnating. No problem!

We say that it will come in time. In this regard, we remind you that a sculpture was recently the subject of debate. That isn't bad in and of itself since the daily 'SOLEIL' picked up on it.

The sculpture was damaged following some incidents. Because Islam 'would prohibit representation'. Iconoclasm, you know?!!

However, the future plan makes this a motive for arrest. What is a socialised cultural object? How much importance will be given to the live model in the plan? Won't it envision installing any monumental sculptures in the Cité?

So many questions to be discussed. Taking care to reflect before speaking: at the very least!

We are wondering nonetheless why the Galerie Nationale, located on Avenue Albert Sarraut, remains closed after an investment of a hundred million and following the one and only exhibition on the occasion of its inauguration by the President of the Republic.

Senegal is certainly a land of coincidences and a country of para-
doxes. Concomitant to this current discourse, which is far from a
discourse in the order of discourse, a 'spiral theatre' experiment is
taking place in the actual country.

In the latest news, a performance in Grand-Yoff was interrupted by
children throwing rocks. The reason: the adults took all the good
seats in the free theatre instead of letting their offspring sit in front
while they sat behind.

The moral: it will hurt somewhere!

Last but not least, the almost certain appointment of 'administra-
tors' and not 'cultural figures' to high-level positions in the arts
clearly appears to indicate a will to establish the all-out administra-
tion of the cultural sector. We hope we're wrong. And it's good that
we continue to have hope and confidence in a country that has
hardly any left.

To the spoilsports, and what's more, the sworn enemies of preju-
dice who would riposte that there are the risks of becoming totali-
tarian, we reply a bit disillusioned ¿Quién sabe?

At any rate, something is amiss in this 'SUNUGAL'.

Something is also emerging.

Wishing to arrive at this bitter assessment we have missed the
opportunity to speak of theatre. But anyway, theatre is created. It is
said and not said. Besides, what can we do? That's the question!

And then, 'Quiet, we're sinking'!!!

Dakar, 26 September, 1984
Issa Samb, Ass M'Bengue, El Hadji Sy

M79 Dumb Type

Flyer for Plan for Sleep #1 (1984)

Dumb Type are a visionary multimedia performance collective founded by students from Kyoto City University of the Arts in Japan in 1984 and still active today. The English name 'Dumb Type' was chosen partly because the group were anti conventional theatre, choosing not to use scripts or scenarios in their work, but also to articulate their belief that there is an overabundance of redundant information in modern society. Their original aim was to create an alternative art that was inclusive and immersive, had no fixed aesthetic, and cut across genres, and so their early performances pioneered a new, interdisciplinary approach to art-making that combined performance, computer graphics, lighting and music.

Much of Dumb Type's work has examined the effects of consumption, globalization and technology on contemporary Japanese society, in particular the 'lost decade' of economic and social stagnation caused by the financial crash of 1991. In 1995 the group's most prominent member, Furuhashi Teiji (1960–95), died from complications relating to AIDS. In the preceding years, the group had staged a number of performances that confronted HIV and the discrimination experienced by members of the LGBT community in Japan.

Dumb Type's manifesto appeared in the flyer for their inaugural work, *Plan for Sleep #1 (Suimin no keikaku #1)*, which was performed at Kyoto City University of the Arts in November 1984.

∗ ∗ ∗

'I' connotes every self and every other person and, simultaneously, the whole of time and every instant. It is 'he' and at the same time 'we'.

– Sleep. An eternally unchanging group behaviour. An accumulation of the loneliness of 'I'. The work of shedding signs. An agreement between the shadow of the sun and a blueprint.

– The accumulation of trajectories that are left in our wake on a very sunny day continue to move in parallel, turning into inorganic matter.

Compared to theatre in the past, Dumb Type is a group that advocates a freer relationship between the audience and the stage. And based on the premise that a reaffirmation of the existing theatre space should not serve as our sole objective, we have begun our activities with a core group of members from the Karma theatre company, which served as a prototype for Dumb Type. Over the past year, these activities have comprised a series of works: *1m² Dining Table* [*1m² shokutaku*], *An Admirable Health Method* [*Shōsansubeki kenkōhō*], and *An Asteroid Addition* [*Hitode no tashizan*]. Hereafter, under the new name of Dumb Type, considering the potential of artistic and theatrical acts as live productions that violate the concept of performance and utilizing all types of elements that can be subjected to analysis, including vision, the body, the voice, sound, and objects, we will create 'theatre', which might be seen as creatively regressive, through experimental activities and the experience of real feelings.

– This plan for sleep is one part of the new Dumb Type's first project.

Members

Furuhashi Teiji, Koyamada Tōru, Andō Yuriko, Hozumi Yukihiro, Yasuda Masako, Hagi Yurie, Tomari Hiromasa, Ikubo Mari, Yabuuchi Masako, Jindō Tomoko, Fukuhara Masami, Miyamoto Sakiko, Okamoto Kōji, Takatani Shirō, Hanaishi Masato, Harada Naoki, Ōuchi Seiko, Kitamura Misaka, Matsui Yōko

M80 Chinese United Overseas Artists

Manifesto Chinese United Overseas Artists (1985)

In December 1985 a group of dissident Chinese artists in exile sought to articulate their condition and envision a new Chinese art by writing the 'Manifesto Chinese United·Overseas Artists'. Many of them had been active members of the first wave of avant-garde artist groups that had emerged in China in 1977 after the end of the Cultural Revolution and death of Mao Zedong – most notably the Stars Group (M68). But their promotion of free artistic expression was regarded as an unacceptable challenge to the communist regime, which retaliated with outspoken criticism, oppressive censorship and relentless persecution, driving them out of the country in the early 1980s.

One of these artists was Ai Wei-wei (b. 1957), who took refuge in New York, where he became involved with a circle of exiled Chinese artists, composers and filmmakers. Another was the radical and outspoken artist and poet Ma Desheng (b. 1952), who had addressed the crowds at the open-air Stars exhibition in Beijing in 1979; he moved to Switzerland, and then settled in Paris, where he was joined by fellow Stars artists Wang Zhiping (b. 1947) and Wang Keping (b. 1949). And the author of the Stars' manifesto, Huang Rui (b. 1952), moved to Japan, where he lived for over a decade before returning to China.

The Chinese United Overseas Artists' manifesto was written during a brief but vibrant period of artistic activity in China known as the '85 Art Movement (M84), which had been inspired by the influx of Western culture and liberal ideas that accompanied the

foreign trade and investment encouraged by the Open Door policy. It sought to establish their position as China's 'official' avant-garde in exile, observing their homeland's rapid modernization, and calling on those intellectuals and artists still in China to seize this opportunity to agitate for freedom of expression.

* * *

- We are artists from China. We have seen the profound influence of classical Chinese art on the world. We have also seen the rapid development of modern Western art in the last century. What concerns us is the current state and future of Chinese art.
- We are happy to see the changes in China in recent years. But looking back, we must conclude that Chinese art has just experienced its darkest century in history.
- In the face of the realities of Chinese culture as a whole, the greatest responsibility of China's intellectuals and artists is to exert every effort at any cost to help the people of China to shed the past and transform into a society of free and creative spirits. This will be the true measure of China's 'modernization.'
- We look at the concept of modern art and study its trends in our search for a new beginning for Chinese art.
- Freedom is the condition for creativity; only through creativity can we truly experience freedom. The creative spirit honors tradition by breaking with tradition. Only by continuously moving away from tradition can we cultivate tradition.
- Opposites complement each other. We respect differences and uphold pluralism. These are our beliefs.
- The world is watching closely the future of Chinese art!

New York, December 1985

For more information, contact: Ai Wei-wei
185 East Third Street
Apartment 3c
New York, New York 10009
Telephone: (212) 614-0476

Chinese United Overseas Artists

Directors:	Yuan Yun-sheng and Wang Ke-ping
America:	Executive Committee Members:
	Yuan Yun-sheng, Zhang Hong-tu, Ai Wei-wei,
	Ding Shao-guang, and Wu Hong
	General Secretary: Bai Jing-zhou
	Liaison Officers: Yan Li, Jiang Tie-feng,
	Ji Cheng, Qin Yuan-yue, Zhang Hong-nien, Yuan Zuo,
	and Zeng Xiao-Jun
Europe:	Committee Members and Officers: Wang Zhi-ping,
	Ma De-sheng, and Wang Ke-ping
Asia:	Committee Members and Officers: Huang Rui and
	Zhong A-cheng

M81 NSK

Internal Book of Laws (1985)

NSK – short for *Neue Slowenische Kunst*, or New Slovenian Art – were a provocative collective founded in Ljubljana in Yugoslavia in the early 1980s. Including (among others) the industrial pop band Laibach, the painting collective IRWIN (M90), the graphic design team New Collectivism (*Novi Kolektivizem*) and the underground theatre troupe Scipion Nasice Sisters Theatre (*Gledališče sester Scipion Nasice*), NSK were established to explore the relationship between art and totalitarianism. In 1992, in the aftermath of Slovenian independence from Yugoslavia, NSK disbanded and reformed as the NSK State, a hypothetical utopian territory through which they continue to critique the nature of society, government and the nation.

Several theorists have addressed the group's work, in particular the Slovenian philosopher Slavoj Žižek, who argues that to be properly subversive in a late capitalist society one needs to take the systems that govern more seriously than those systems take themselves. This is a good description of NSK, whose strategy has been to make explicit the hidden transgressions of contemporary society. In recent years their activities have included setting up imaginary embassies as the site for conceptual art experiments, establishing corporations with no apparent purpose, appropriating fascist symbols in their art and using totalitarian rhetoric.

The individual groups that make up NSK have issued many manifestos over the course of their lifetime. This 'Book of Laws' ('Interne Knjige Zakonov') was originally written in 1985 for the entire membership of NSK and mimics the language of Soviet art workers' manifestos of the 1930s.

* * *

Constitution of Membership and Basic Duties of NSK Members

I.

A member of NSK should be hard-working; he should respect the concepts of NSK and its history, be compliant and co-operative in carrying out joint decisions, and irreproachable in administering the general and secret statutory and moral norms of NSK.

2.

A member of NSK is particularly obliged to act in accordance with the moral, political, aesthetic and ethical norms stipulated by the NSK Internal Book of Laws (IBL).

3.

A member of NSK adapts creatively to his environment and is wise in following and complying with the rules set by the authorities regardless of his place of residence or work. He should never, without reason or permission and power vested in him by the Council of the Organization (NSK Council), get involved in any secret political meetings or various plots that could directly jeopardize the existence and sovereignty of the Organization.

4.

In carrying out the exacting tasks, in view of accomplishing the objectives required to attain common goals, the members make use of every means permitted or required by the 'Law of Action', should the situation so require (see IBL).

5.

To cherish mutual respect, friendly and brotherly love, assistance and devotion, is a law obligatory for ALL members of the Organization. The entire association should function according to the principles of equality and harmony of internal distinctions.

6.

No personal animosity, no settling of personal conflicts or disputes may enter the Organization. The same holds true, yet even to a larger extent, of arguments related to religion, nationality or political system, which never have and never shall serve the purpose of the Organization.

7.

Once a member is inducted, the association denies each member his own freedom of choice regarding his religious persuasion, and political and aesthetic affiliation.

8.

Each membership candidate must believe in the hierarchical principle and existence of the supreme substance (ICS – the immanent, consistent spirit), occupying the uppermost position in the hierarchy of NSK.

9.

Each candidate must be aware of the past, be active in the present and susceptible to the future. He should be conscious of the tradition of the fundament, should have a feel for innovating experiments and a talent for combining the two.

10.

A member-to-be should be of sound character, emotionally balanced and of sound mental health. He should be capable, with all sincerity and conscience, of answering the following questions

1. Do you present yourself before this Organization, with truth and honesty, free of any prejudice that would interfere with your personal dispositions, as a free person and of your own free will, without being forced or subjected to inappropriate pressure, and present yourself as a candidate for membership in this Organization?
2. Do you maturely and responsibly claim the status of member in this Organization and its pertaining privileges, having taken a clear stand on the world and its history?
3. Do you truly and responsibly pledge to perform your duties for the Organization loyally, respectfully, and in the spirit of its laws and practices?

11.

Once a novice is given his pledge of allegiance, he is required to adopt the principle of conscious renunciation regarding his personal tastes, judgement, and beliefs (. . .); he is required to renounce his personal practices of the past and devote himself to work in the body whose integral element he has become by joining the Organization.

12.

Novices must respect elder members and the 'Triple Principle', which is the supreme designer of the Law of the Organization.

13.

During the first year of their novitiate, the novices belong to the so-called team reservoir and have the status of a student-apprentice.

They first learn the law of cause and effect, which applies to the art of genuine domination and genuine subordination.

14.

When praising tradition, history and the supreme principle of NSK, each member must obey the following law of the IBL: a member should never speak of the Organization and its inner principles of action without due respect.

15.

When honouring and exposing himself through self praise, etc., a member should avoid any exaggeration and inconsistencies so as to preserve his individual and collective pride.

16.

Concerning one's love for one's neighbour (one's friends, family, wife and neighbourhood), IBL exceptionally permits members of NSK to practise Christian relations, if these comply with the social system and its system of values, yet advises them to exercise caution in their good deeds.

17.

In his role of a social and civil being, a member should be cooperative and benevolent should the circumstances so require, to the extent that such behaviour and generosity do not harm himself, his family, and his friends in particular.

18.

As a community member and a citizen, a member of the Organization should abide by the laws designed to protect him. He should avoid any punishment and interdiction: in critical

circumstances, he should not allow any prejudice, originating from what he does, to instigate a feeling of self-guilt.

19.

When a person expresses the wish to become a member of the Organization, his wish should be given careful consideration and a recommendation submitted only if and when he is found to comply with the principles of the Organization and to contribute positively, in terms of personality and activity, to the strength and promotion of its common interests.

20.

Members are recommended to devote their spare time associating with those who co-operate with the Organization.

THE FIVE BASIC PRINCIPLES OF FRIENDSHIP:

1. I shall lavish brotherly respect on you if I know you are worthy of it.
2. I shall risk danger and hardships to help you in your time of need, providing this does not harm me nor the Organization.
3. In my daily activities and when taking on special duties, I shall first mention your name and then mine.
4. I shall support you in your work and self-denial, and shall help you reach these goals as if I were in your place.
5. I shall never do unto you what I do not want you to do unto me, unless there is a common reason for that.

21.

If a member knows his place in his home group and in a wider body to which he belongs, and has particularly excelled in his work, he shall be presented with a reward according to his rank and stipulations of the IBL. Should he neglect his work, he shall be excommunicated or punished.

M82 Vohou-Vohou

The Vohou Revolution (1985)

Vohou-Vohou was a movement formed in the 1970s in Côte d'Ivoire (Ivory Coast) by artists at the École des Beaux-Arts in Abidjan who sought to address the country's social and cultural problems. It coincided with a culturally fertile period in Côte d'Ivoire, when artists, theatre companies, poets and musicians were desirous of finding an authentic Ivorian voice. The history of the group is rooted in the story of colonialism in West Africa and in the influence of their teachers from the French-governed Caribbean island of Martinique who drew their attention to the anti-colonial art movements of Légitime Défense (M4) and Négritude (M7).

One of the founder members, Kra Nguessan (b. 1954), described Vohou-Vohou as a spirit, partly because it grew out of the desire for a home-grown Ivorian culture, but also because of the group's distinctive aesthetic. The name 'Vohou-Vohou', meaning 'junk' or 'trash', came about because the students chose to use local materials – such as tapa (cloth made from beaten tree bark), rattan, soil and clay – rather than traditional Western materials, like oil paint and canvas. Their works were non-figurative, emerging – the Vohou-Vohou artist Théodore Koudougnon (b. 1951) said – from their guts, the shapes and colours decided by the materials they used. The name was originally intended as an insult; but, much as the Négritude Surrealists recast the term *'nègre'* as possessing positive connotations, the Vohou-Vohou artists took ownership of it and embraced their outsider status.

Many of the Vohou-Vohou artists went to study in France in the early 1980s, and so their first exhibition, *Les Peintres Vohou-Vohou*, at the Centre Culturel Français (CCF) in Abidjan, was not held until

1985. 'La Révolution Vohou' was written around this time and articulates the rebellious energy and humour of the group. It is published here together with statements from some of the Vohou members.

<p style="text-align:center">* * *</p>

If there is an emergency today, it is good to take a Vohou cure. If, saturated with the fare of 'Dynasty' or 'Rambo,' you feel your soul has become 'polluted' take a Vohou cure. If you find that the camembert you ate has a bad flavour, or that it gives you indigestion: Vohou is the SALVATION, the road to follow.

Vohou is a cultural rebellion (Youssouf Bath, Vohou painter). It consists of pragmatic Ivorian painters who . . . have pinpointed the disturbing effect of colonialism in their creation and suggest a therapy born from the encounter between traditional African society and the modern world. Indeed, if political independence has unshackled the chains of colonisation, the spiritual essence that flows from the Black-African aesthetics, they claim, is the only remedy open to unshackle the invisible chains, after-effects of this colonisation. Applying contemporary methods to the deep sources of tradition is not a negation of the latter, but rather a means for a person fragmented by the obligation to live within several cultures to regain the integrity of his being and to find the authentic areas within himself.

Vohou is not a school, it is a SPIRIT. It is not opposition (Kra Nguessan, Vohou painter), it is POSITION . . . It is the third road between that tradition and that of the modern world. IT IS VOHOU. It is not suicide, it is REBIRTH. IT IS VOHOU. It is not stagnation, it is the path to the summit of EVOLUTION. IT IS VOHOU. It is not visible, it is INTANGIBLE. IT IS VOHOU. It is PRIMITIVE, it is MODERN. IT IS VOHOU. It is PAST, it is PRESENT, it is FUTURE. IT IS VOHOU. It is not FRENZY, it is AWARENESS, it is THINKING. IT IS VOHOU. It is without a Mao collar, it is IDENTITY, it is LIBERTY. IT IS VOHOU. It is NATIONAL, it is INTERNATIONAL. It is BLACK-AFRICAN, it is WORLDWIDE. IT IS VOHOU. It is ACTION, it

is DECOCTION. IT IS VOHOU. It is AFFIRMATIVE, it is NOMINATIVE. IT IS VOHOU. IT IS POSITIVE.

The capacity of Vohou is so huge that it can hold Japanese, Aborigine, Chinese, American, Papuan, obviously provided that they are in the possession of the Vohou spirit (Auguste Mimi Errol, art critic).

Convinced that the problem of cultural identity is a debate that will dominate the world of ideas in the coming years . . . Vohou artists have set themselves the goal of rehabilitating African art by creating canvases in which the spectator can receive the shock of the material and the colour directly, although these nevertheless are wedded to signs and references within the spirit of the people. Technically, they are not concerned with the representation of the third dimension the Italian Renaissance established. They mean to be original and free in the choice of their materials (Théodore Koudougnon, Vohou painter).

M83 The Pond Association

Declaration of the Pond Association (1986)

The Pond Association (*Chi she*) were a short-lived Hangzhou-based avant-garde group founded by recent graduates of the Zhejiang Academy of Fine Arts in 1986, during the dynamic era of artistic activity in China known as the '85 Art Movement (M84). Zhang Peili (b. 1957), Geng Jianyi (b. 1962), Song Ling (b. 1961), Wang Qiang (b. 1963) and Bao Jianfei (b. 1962) originally got together with the self-taught artist Cao Xuelei (b. 1962) to stage an exhibition of their art called *'85 New Space (85 Xin kongjian)* in December 1985. Keen to explore new ideas in art, they were committed to experimentation and the collective creation of installations, collages and performances.

On 1 June 1986 the Pond Association issued a bulletin, which was accompanied by a 'Declaration' and distributed privately across China. The following day they staged an event, in which twelve two-dimensional paper figures were collaged from newspaper and then displayed on a wall near the Zhejiang Academy. Further collective interactions in public spaces followed over the course of that year, which had a decisive influence on the evolution of performance and actions in Chinese art in the next decade.

The Pond Association's gnomic manifesto expresses their central ideas: that enlightenment comes through a shared aesthetic experience, and that experimentation and the action of making are more important than the final outcome. In many respects, their ethos had affinities with Chan Buddhism – particularly their belief that art should be a response to internal needs rather than to social or political circumstances, and also their determination to dissolve

the boundaries between media in order that the artists could become fully immersed in the process of creation.

* * *

Art is a 'pond', we rely on carbohydrates to live.

It's not because we want to be like this. It's just that we rely on carbohydrates . . .

We are eager to purify our minds. Our thoughts are flowing and vague.

Have you ever experienced a rational impulse? The moment of immersion is intoxicating. The moment of resurfacing is a kind of 'enlightenment'.

The result is not so important; However, the seeds are sprouting.

M84 Wang Guangyi

We – Participants of the "85 Art Movement' (1986)

In 1978 the Chinese premier Deng Xiaoping initiated the Open Door policy in order to open up China to foreign trade and investment. As Western culture and liberal ideas became more widely known in the country, through magazines and exhibitions, they inspired an unprecedented outpouring of nonconformity and radical activism, particularly among the student population, which agitated for a more open society.

Since the establishment of communist rule some thirty years earlier, many art schools had closed and the visual arts had been constrained into the service of the state as a vast propaganda machine. Now, art schools were opening up again, and many young art graduates were inspired by the idea of creating China's very own brand of modern art. Between 1984 and 1986 some eighty-five artist groups emerged across the country, forming an energetic, nationwide, avant-garde movement. To express their idealistic vision and radical intent, they issued manifestos and artistic statements, staged conferences and held unofficial exhibitions – giving rise to the catch-all term referring to this short-lived period of buoyant artistic creativity: the "85 Art Movement' (also sometimes referred to as the "85 Art New Wave').

This optimistic era in China came to an abrupt end in 1989 with the brutal suppression of the country's growing democracy movement following the killing of hundreds of students who were peacefully demonstrating in Beijing's Tiananmen Square. Although most of the groups of the '85 Art Movement swiftly disbanded – such as

Xiamen Dada, the Northern Art Group, the Pond Association (M83) and the Red Brigade (M87) – many of their members went on to become internationally recognized, most notably the painter and installation artist Wang Guangyi (b. 1957) and the sculptor Huang Yong Ping (b. 1954).

Wang Guangyi was a member of the Northern Art Group (*Beifang yishu qunti*), which sought, through Kant's and Hegel's philosophies of romanticism, to establish a Northern aesthetic rooted in the sublime. He published the manifesto 'We – Participants of the '"85 Art Movement"' ('Women – "85 Meishu yundong" de can-yuzhe') in the radical new journal *Fine Arts in China* (*Zhongguo meishu bao*) on 8 September 1986. In it he articulated the need for a strong, healthy civilization, espousing humanist beliefs, which would give birth to a new and exciting visual culture: a modern Chinese Renaissance.

* * *

Life's inner drive – the underlying power of culture today has arrived at its supreme moment! We thirst for and 'happily embrace all forms of life' by giving rise to a new, more humanistic spiritual model, to bring order to the evolutionary process of life. To this end, we only oppose those morbid, rococo styles of art as well as all things unhealthy and detrimental to the evolution of life. Since these arts abet man's weaknesses, they cause people to be far from health and far from life. As we see it today, the ideas of art have already exceeded its [traditional] conceptual definitions. Although Conceptual art is regarded as art's alienation from itself, before a new culture of art arrives, we can only accept this kind of aliena-tion. In this way, we can use the alienation of art to express the concept of anti-alienation.

It is exactly in this sense that the participants of the '85 Art Movement are not engaged in creating art for art's sake, but rather in advancing a process of articulation and behavior that is not merely the philosophy of a philosophical concept. This is similar to the peculiar qualities of uncertainty found in art at the beginning of the European Renaissance. The reason that Renaissance art has

historical value is not because it perfected artistic models, but rather because it conveyed the revelatory expression of non-philosophical philosophy and gave rise to humanist thought. This, in turn, prompted Europe to depart from the difficult conditions of the Middle Ages, to discover humanity and the value of human nature.

It is precisely this significance that the '85 Art Movement shares with the earlier Renaissance. However, the difference is that the importance of Renaissance art lies in its discovery and awakening of human nature, while the '85 Art Movement is grounded in the context of modern civilization and is intent on elevating humankind's sublimity and health.

We oppose speculation over so-called pure artistic forms because excessive discussion of these kinds of questions will lead to the unchecked spread of a morbid state of formalism. This will then cause humanity to forget its own difficult conditions. Therefore, we once again propose the ancient proposition, 'content determines form'. What our images articulate is not art! They prophesy a new culture, the Culture of the North. The reason that we choose painting as the medium for transmitting our predictions is because the act of painting itself possesses an unknowability in its deeply layered semantics that approaches the ultimate essence of existence.

M85 Chila Kumari Burman

There Have Always Been Great Blackwomen Artists (1986)

Chila Kumari Burman (b. 1957) is a British multimedia artist of Punjabi descent who features her dual ethnicity in her art in order to explore ideas relating to post-colonialism and multicultural identity. Together with the artists Lubaina Himid and Claudette Johnson, she has been an influential figure in the promotion of British black female art.

'There Have Always Been Great Blackwomen Artists' is Burman's own synopsis of a talk she gave in October 1986 at the Institute of Contemporary Arts (ICA) in London, during the Black Visual Artists Forum, which discussed race representation (it was published in February the following year in the *Women Artists Slide Library Journal*). The text was intended as a riposte to, and an elaboration on, the question raised by the American art historian Linda Nochlin in her feminist essay 'Why Have There Been No Great Female Artists?' (1971). Nochlin's thesis was that women artists in history had not received the plaudits given to their male counterparts because of a lack of social and educational opportunities. Not only that, but white Western males controlled the history books, thereby determining the accepted viewpoint.

Burman's manifesto, written fifteen years later, takes this argument and applies it to black women artists in order to highlight the fact that Nochlin's essay concerns only white, Western female artists – something that is indicative of the feminist art movement as a whole. Black women artists are *still* struggling for visibility, and Burman offers plenty of empirical evidence to support this.

The last section of the manifesto draws on the black feminist writers Barbara Smith and Alice Walker to discuss the development of a black female consciousness. The joining of 'black' and 'women' into a single word by Burman is intentional, as a way of endowing disenfranchised and misrepresented black female artists with a strong collective identity.

* * *

We face many problems when trying to establish the very existence of Blackwomen's art, and a strong social and political base from which to develop our study of it. Firstly, we have to struggle to establish our existence, let alone our credibility as autonomous beings, in the art world. Secondly, we can only retain that credibility and survive as artists if we become fully conscious of ourselves, lest we are demoralised or weakened by the social, economic and political constraints which the white-male art establishment imposes and will continue to impose on us.

This paper, then, is saying Blackwomen artists are here, we exist and we exist positively, despite the racial, sexual and class oppressions which we suffer, but first, however, we must point out the way in which these oppressions have operated in a wider context – not just in the art world, but also in the struggles for black and female liberation.

It is true to say that although Blackwomen have been the staunchest allies of black men and white women in the struggle against the oppression we all face at the hands of the capitalist and patriarchal system, we have hardly ever received either the support we need or recognition of our pivotal role in this struggle. Blackwomen now realise that because of the specific ways in which we are oppressed by white-male dominated society, we must present a new challenge to imperialism, racism and sexism from inside and outside the established black liberation movement and at a critical distance to the white-dominated feminist movement. It is this realisation which has a lot to do with many second generation British Blackwomen reclaiming art, firstly as a legitimate area of activity for Blackwomen as a distinct group of people, secondly as

a way of developing awareness (denied us by this racist, sexist, class society) of ourselves as complete human beings, and thirdly as a contribution to the black struggle in general.

Having said this, Blackwomen's ability to do any or all of these three things is restricted by the same pressures of racism, sexism and class exclusivity which we experience in society in general. The bourgeois art establishment only acknowledges white men as truly creative and innovative artists, whilst recognising art by white women only as a homogenous expression of femininity and art by black people (or, more accurately, within the terms of reference used, black men) as a static expression of the ritual experience of the daily lives of their communities, be they in the Third World or the imperialist hinterland. In this system of knowledge, Blackwomen artists, quite simply, do not exist.

Nevertheless, if we look at the way in which these assumptions have been challenged to date, particularly by white women, we can still see nothing that acknowledges that Blackwomen exist. Art history is an academic subject, studied in patriarchal art institutions, and white middle-class women have used their advantageous class position to gain access to these institutions by applying pressure to them in a way which actually furthers the exclusion of black artists in general. White women's failure to inform themselves of the obstacles faced by black artists and in particular Blackwomen artists has led to the production of an extremely Eurocentric theory and practice of 'women's art'. It seems that white feminists, as much as white women in general, either do not attempt or find it difficult to conceive of Blackwomen's experience. Some of those who do not attempt to may claim that they cannot speak for Blackwomen, but this is merely a convenient way of sidestepping their own racism. The fact remains that in a patriarchal and sexist society, all black people suffer from racism, and it is quite possible for white women to turn racism, which stems from patriarchy, to their advantage. Black men are unable to do this and, theoretically, are unable to turn sexism to their advantage, although they can do this for short-term gains which in the long term will never benefit black people as a whole. This has happened to a certain extent in

the art world, where black men have failed to recognise Blackwomen artists or have put pressure on us to produce certain kinds of work linked to a male-dominated notion of struggle. However, because of their race and class position, black men have been unable to use the resources of information in art institutions in the same way that white middle-class women have.

The Struggles of Blackwomen Artists

The first stage of most Blackwomen artists' encounter with the art establishment is their entry into art college. There are hardly any Blackwomen attending art college in Britain, and those who do, according to a survey of Blackwomen artists I carried out, seem to have experienced a mixture of hostility and indifference from their college. Because their white tutors work within an imperialist art tradition, using the aesthetic conventions of the dominant ideology, they are unwilling to come to terms with Blackwomen students and their work. This resistance manifests itself in many ways – some Blackwomen art students have found themselves asking why they as individuals found it easy to get into art college, only to realise that they are there purely as tokens, and in general it appears that Blackwomen's very presence in white-male art institutions is frequently called into question. Apart from denying us the support and encouragement that white art students receive, art colleges make us feel as though we don't belong inside their walls by the way in which our work is looked at. Those of us who have done more overtly political work have made white tutors very uncomfortable and, as a result, hostile, whilst students who have done less obviously challenging work have been questioned for not producing the kind of work which tutors expect black people to produce. Class differences amongst Blackwomen are significant here, for working-class Blackwomen have generally been quicker to reject the ideology of the art establishment and have therefore found it difficult to accept any kind of token status or to produce work of a more acceptable nature. Those who have not taken such an oppositional stance have still suffered from having their work

analysed within a very narrow framework because their tutors have expected them to produce 'ethnic' work which reflects their 'cultural origin' using, for example, 'bright carnival colours', and white tutors and students alike have expressed confusion when such work has not been forthcoming. Another tendency of white tutors, irrespective of the work they are presented with, is to discuss art from the Third World with Blackwomen in a patronising and racist manner.

Of course, the assumption that Blackwomen will produce work with 'ethnic' or 'primitive' associations is one that white tutors make about black men as well, but it is important to point out that male *and* female white tutors are more inclined to see black men as having a more prominent role in this misconceived tradition. One Blackwoman student at Bradford art college commented:

'Funny how they always refer to you as some sort of bridge or crossing point between two things. Black meets woman. That's handy. As if you don't have an experience which is your own, but borrow from the brothers and sisters in struggle'.

It seems, then, that when art colleges and universities give places to Blackwomen, which in itself is a rare event, all the forces of the dominant aesthetic ideology are brought to bear on us. Blackwomen artists are ignored, isolated, described as 'difficult', slotted into this or that stereotype and generally discouraged in every conceivable way from expressing ourselves in the way that we want to. This system of oppression and exclusion extends well beyond our time as art students. There are no full-time lecturing posts at art colleges and universities filled by Blackwomen in the entire country – instead we are offered 'freelance' work as visiting lecturers, which will never be enough to initiate a critique of contemporary art practice which is so desperately needed in every single art department in the country.

In addition, Blackwomen artists are denied the opportunity to develop their work as individuals in the same way that white artists can through grants from sources such as the Arts Council, the Greater London Council, regional arts associations and the Calouste Gulbenkian Foundation. Even though some of these

sources such as the GLC and the Greater London Arts Association have recently begun to realise how much they have neglected Black visual arts, on the only occasion that a Blackwoman has received funding from the GLC as an individual, this has still been on unsatisfactory terms which differ significantly from the terms on which the only black man in this position has been funded. The man in question has been funded without any preconditions except that he produces a certain amount of work, whilst the woman was funded by the Arts and Recreation Department of the GLC for a year on the condition that she was attached to a community arts centre as a 'community artist', and the stipulation was made that the work she produced should not reflect her desires as an individual, but 'the interests of the black community'. The GLC had ignored the importance to the black community of the experience of individual Blackwomen and had funded her on the basis of an ahistorical notion of 'community' or 'ethnic minority' arts, but when it came to applying to the Arts Council, it appeared that the role she had been pushed into was not individual enough. The rejection of her application to this body read:

'We do not think that your proposed project fits the terms of reference for this training scheme which is specifically aimed at developing the individual's skills, and is not to assist with research projects'.

If even the GLC funded a Blackwoman artist only as a 'community artist', this illustrates our position in a kind of funding no-woman's-land, because the Arts Council, racist and sexist as it is already, will continue to see our work as unfundable research projects and, as was the case with the application mentioned, refer us to bodies such as the Association of Commonwealth Universities, further relegating us to the marginality of the 'ghetto artist', completely outside the mainstream British art world.

Blackwomen Artists Fight Back

The resilience of Blackwomen in the face of oppression has manifested itself in the art world through our ability to produce and

exhibit work despite all the social, economic and political constraints described above. The first all-Blackwomen's show at the Africa Centre in 1983 was not just a beginning; Blackwomen artists have been actively involved in exhibitions with white artists and Black men artists for several years, but this all-Blackwomen's show and the ones that have taken place since then – Blackwoman Time Now, 1985 International Women's Day Show, Mirror Reflecting Darkly, etc. – represent a significant new direction which is as much to do with the development of what Barbara Smith describes as 'our own intellectual traditions'.

It is obvious that the majority of Black artists see their work in opposition to the establishment view of art as something that is 'above' politics, and Blackwomen artists see their work as integral to the struggles of Blackwomen and black people in general, but although Blackwomen's own culture plays a large part in determining the culture and form of our work, we often concentrate on different issues to black men, who, as one Blackwoman artist points out, often believe that 'artists who are making through their works a collective, aggressive challenge to cultural domination are "real" black artists and making Black Art. But some male artists fail to understand or comprehend the struggles women artists go through to assert their identity and survive'.

Alice Walker illustrates the difference between these two ideas of Black Art in 'In Search of Our Mother's Gardens' and goes on to put forward an alternative way for the black artist to operate:

'I am impressed by people who claim they can see every thing and event in strict terms of black and white but their work is not, in my long contemplated and earnestly considered opinion, either black or white, but a dull, uniform gray. It is boring because it is easy and requires only that the reader be a lazy reader and a prejudiced one. Each story or poem has a formula, usually two-thirds "hate whitey's guts" and one-third "I am black, beautiful and almost always right". Art is not flattery, and the work of every artist must be more difficult than that.

'My major advice to young black artists would be that they shut themselves up somewhere away from all the debates about who

they are and what colour they are and just turn out paintings and poems and stories and novels. Of course the kind of artist we are required to be cannot do this (our people are waiting)'.

Alice Walker's advice is important here, for she is not suggesting that we cut ourselves off from the outside world, because we cannot forget the mark our oppressions as black women have made on us, or the fact that 'our people are waiting'. The point is that what we need as artists is the opportunity to create the situation she describes so that we are allowed to develop an understanding of ourselves and of the struggle we have to wage within British society for recognition and respect. If we are able to do this by having adequate resources put at our disposal, we hope to share our experiences with, awaken the consciousness of and impart our strength to the whole society.

M86 The School of the One

Founding Manifesto (1986)

Sudan is a country in which nearly every African ethnic and linguistic group exists. In the immediate aftermath of independence in January 1956, there was consequently an urgent desire to establish a Sudanese national culture that could unite this multifarious society. Just as in Nigeria (M18) and Senegal (M78), artists, writers and theoreticians took up the challenge to create a collective identity. In Sudan these efforts centred round the teaching of the college of fine arts in the capital city. What emerged was the visually rich aesthetic referred to as the Khartoum School (*Madrasat al-Khartoum*): a style of abstract painting that combined Arabic calligraphic motifs with a subdued palate inspired by the earthy tones of the Sudanese landscape.

As early as the 1970s, younger artists sought to challenge the Khartoum School's pre-eminence, including the Crystalist Group (M66) and left-wing artists who believed the style perpetuated an exotic image of Sudan. However, other artists continued to explore its creative possibilities. One such was the painter Ahmed Abdel Aal (b. 1946), who founded the School of the One (*Madrasat al-Wahid*) in 1986 in conjunction with other artists who had been taught by Ibrahim El-Salahi, one of the leading exponents of the Khartoum School. Emerging at a time of increasing Islamic fundamentalism in Sudan, the School of the One sought to enrich the Khartoum School's aesthetic with a new-found religious dimension, believing that a spiritual form of art could express profound universal truths.

To mark the School of the One's formation, the group's five members issued the following declaration of their artistic credo.

* * *

The Sudanese visual artists, the undersigned of this manifesto, are of the opinion that contemporary artistic creation has no value without a civilised foundation. That is why they are connecting to the Arabic Islamic heritage, the heritage of the last human civilisation founded on a universal divine revelation. They are drawing on their heritage, not as a depository of past achievements, but as a dynamic living entity similar to other living things in weaknesses and strength. They are embracing its unlimited potential, and viewing it with gratitude, appreciation, scrutiny and an eye for its benefits.

> 'Verily this your order is one order,
> and I am your Lord, so fear Me'
> Quranic verse (The Believers: 23:52)

The undersigned artists believe that any claim to internationalism in the arts must be founded on an awareness of the particular personal heritage of the creator.

The artists of the School of the One do not advocate the emulation of past creations. Instead, they make an effort to grasp their significance, and to develop their potential for constant growth and evolution.

For over half a century, the contemporary Sudanese visual art movement has reflected the above assertions, albeit with differences in levels of clarity and depth of individual contributions. It is in this context that the Khartoum School came into being as a civilised and historic project – a project which has been realised through the works of many Sudanese artists, yet without a clear theoretical vision.

The Sudanese artists, the undersigned of this manifesto, appreciate and take into consideration the contribution of the Khartoum School. The proposed project of the School of the One embodies all aspects of life in Sudan – religious, cultural, social, economic and political – and considers these aspects as branches and streams that

nurture Sudanese contemporary plastic art works. Hence it is a project which is based on a holistic and civilised vision.

We, the undersigned, have agreed to call this project 'The School of the One' and define it as follows:

The School of the One is a Sudanese visual art school with Islamic, Arabic and African identity. It stands on the foundation of the civilised heritage of the people of the Sudan, in which Arabic and Islamic culture has ingeniously mixed with local African culture.

The School of the One draws its inspiration and goals from the meaning of monotheism in Islam, the last of the divine revelations. The values of monotheism in Islam which have entered the life of the Sudanese people through Sufi Islam will remain the tie that binds the finest of their mannerisms to their arts and their literary traditions.

The School of the One upholds the principle of unity in diversity. Its motto in this matter is: 'Allah – The One and Only, The Almighty and Most Revered, The Healer, The Initiator, The Repeater, The Creator (painter), The Creative, and The Creator of All Things, The Whole – *is* a Whole Who is manifested in a rhythm of multiplicity and diversity.'

We therefore regard nature with reverence as it is a divine creation. There is no separation between this new vision and the appearance of nature and its essence. Due to their place in the ladder of creation, human beings are entrusted with nature. In pursuing their aesthetic endeavours, human beings shall pay attention to the wisdom of the abundant beauty surrounding them.

We insist on revelation/inspiration as a creative necessity, which makes the art work a reminder of the need for a constant, vigilant consciousness. This means the need for a wise and more practical consciousness, which shall free human beings from the confines of inattention to the wisdom of the beauty of existence. Our relationship to the nature with which we have been endowed is one of inspiration and intimacy, and not a relationship of emulation, conflict or distortion.

The School of the One believes that the two pillars of creative

experience are vision and skill. The revelation of the great vision requires a refined skill. This is why we are interested in improving skills and vocations as a means for civilised development. The artists of this school regard them as an entrance to charity and good deeds, and 'Allah requires charity on everything' (Hadith, or Prophetic Tradition).

The School of the One regards visual art as a system of thought and a way of thinking, even though it is channelled or expressed through colour, stone and other raw materials. Therefore it advocates the need for dialogue between creative individuals of all orientations. Creativity is the total sum and ultimate goal around which creative beings should gather, without any conflict.

In examining the reality of Sudan's cultural and religious diversity, the School of the One is guided by the principle of unity and diversity which has been essential to Islamic art throughout its different ages. It is the same principle which has been upheld throughout the vast land of Islamic civilisation, and has consequently led to the awakening of local national genius among the people of the nation of Islam. It embodies one aesthetic consciousness, with diverse traditional and conventional origins.

Throughout its ages, the Islamic civilisation has never destroyed any local heritages. Instead, guided by the principle of unification, it has tended to assimilate them. Sudan, with its fertile land for creative dialogue, has been an arena of cross-fertilisation and mixing, not of hegemony or conflict.

To implement the above goals, it is important to emphasise the need for aesthetic education throughout the different levels of the educational system in Sudan. We stress the importance of aesthetic and artistic research in institutions of higher education, especially the Khartoum College of Fine and Applied Art which must be enabled to fulfil its role in cultural, social and economic arenas. This can be achieved through a well-grounded curriculum and modernisation of its teaching tools.

The School of the One appreciates that 'nation' (homeland) is not a romantic expression, but an indisputable entity rooted in time and space. Its substance is the heritage of its people and their

land, their present and future predicaments, their pain and triumph, and their aspiration to fulfil their ideal values within secure and happy lives.

In the end, artists of the School of the One find comfort in their belief in the unity of human existence. It is this conviction which makes their distinct creativity a long-awaited contribution to human heritage, a contribution in harmony with the uninterrupted prophetic orientation of the Islamic civilisation.

The artist who believes in the unity of God (i.e. in monotheism) is a struggling cultural entity. Therefore members of the School of the One believe that freedom is the essence of religious and moral responsibility. Freedom is a basic demand of all artists, as it is a demand of all people. Freedom is a means of revival and nation-building. At the same time, it is the only means of victory in the struggle against weakness, dogmatism, fear and poverty.

Artists of the School of the One believe that there is an urgent need for developing civilised unifying concepts, for the purpose of recreating a healthy Sudanese people who are able and productive in their lives. They consider this founding manifesto and, if Allah wills, their future works to be a necessary contribution towards these noble goals.

And Allah be behind our intention.

Signed: Ahmed Abdel Aal, Ibrahim Al-Awam,
Muhammad Hussayn Al-Fakki, Ahmed Abdallah Utaibi,
Ahmed Hamid Al-Arabi

M87 Ding Fang

Red Brigade Precept (1987)

The Red Brigade (*Hongse lu*) were a Surrealist painting group founded by the artist Ding Fang (b. 1956) in 1986 in the Chinese city of Nanjing after the Jiangsu Youth Art Week's *Modern Art Exhibition*. They formed part of the '85 Art Movement (M84) – the nationwide wave of artistic activity that swept China in the mid-1980s in the wake of Deng Xiaoping's Open Door policy.

Ding wrote the group's manifesto to coincide with their first exhibition, *Vanguard (Xinfeng)*, in 1987. The 'Red Brigade Precept' is strong stuff, in which Ding argues that the ordinary artist must find inspiration in the act of creation, rather than in grand schemes and ideologies which have done nothing to aid humanity's progress. Using the Greek myth of Sisyphus pushing his boulder up a hill as an analogy, Ding writes of the artist's search for the sublime, and the spiritual consolation that can be found in simple creativity. As a result of these ideas, many of the paintings associated with the Red Brigade focus on mystical or religious themes.

The 'Red Brigade Precept' ('Hongse lu zhenyan') was originally published in the bi-monthly magazine *The Trend of Art Thought (Meishu sichao)* in January–February 1987. This journal was devoted to articles on Western and Chinese art, with a particular emphasis on artists of the '85 Art Movement.

<p style="text-align:center">* * *</p>

Red Brigade Precept*

- In the solemnity of self-sacrifice, we find common points of support.
- We thirst to re-create life in the depths of our hearts.
- In the course of our journey to the other shore, we reach the sublime.
- When we collide with eternity, we sense the call to mystery.

On that mountaintop, while the flame propelled us to continue on the path toward rebirth, it also never ceased in diverting our steel hammer to the rocks.

One can conceive of how wise and intelligent the Earth is within the Universe; but at the same time, one can also imagine its loneliness. For humans, this loneliness is innate, for, in the end, there is nothing that can engage with it in a 'final' dialogue.

Everyone on Earth is shrouded in loneliness. Because of this lack of a 'possibility for a final dialogue,' history can only become a 'process.' In the eternity of space and time, they [these processes of history] 'accumulate' and 'regenerate,' without beginning and without end.

When we pursue the sublime, we feel the aforementioned 'accumulation.' This not only indicates to us the paths of human creativity that have already been laid out in this infinite time and space, but also makes clear our mission in this eternal existence.

The various things described above accumulate in the deepest reaches of our spirit and cohere in a tragic consciousness. This consciousness not only encompasses the specific temporal and cultural orbits in which we find ourselves, but also embraces those feelings of difference between cultures, times and places that are necessarily produced when we encounter another great cultural formation.

* 'Red Brigade' – the journey of life, that is, our appreciation of the course of history, culture, and life.

Consequently, long before performing an action, we realize, *a priori*, the 'meaninglessness' of that 'action' within history itself.

This sense of tragedy is also manifested as a 'tragic consciousness in painting.' It involves not only our concern for the fate of common 'people,' but also a profound concern for their orbiting, without beginning or end, as destined through this eternal existence. It makes visible this kind of fate. Even 'life,' which [seems] so permanent, is also a mere 'process,' for it eternally lacks a 'goal.' Its course merely involves a certain 'superposition' over the 'tracks of past courses'; thus, any of its essential meaning that [might seem to constitute an] 'advance forward' is in actuality a 'superposition' of the 'common,' 'great dreams' [shared across] 'dissimilar' space-times.

Our 'astonishing imagination' today is also a flame that recalls 'the originary flame.' This is a soul that roams forever in nighttime musings. It is like an intense wind that blows across the lowlands, chasing a brilliance that can never be attained. In spite of this, our innate will still chooses to 'push rocks up the mountain.'* Such an action originates in this kind of hope – in the hope that one gazes up to from the abysses of despair.

The essence of this 'act of climbing the mountain' could be described as 'using art forms to rebuild a vital creation.' Because of the light that it gives off when it is being composed, it also becomes a new 'religion.' At the same time, this great 'vital creation' is necessarily structured from every angle. It is not that one's 'choice can be

* The story of Sisyphus's pushing the rock up the mountain is found in 'The Myth of Sisyphus' (Albert Camus): 'Sisyphus met with the punishment of heaven: the gods ordered him to push a boulder up a mountain day and night. When he reached the mountain peak, because of the boulder's own weight, it would roll down again. He would again summon all his body's strength to roll the boulder, and his face pressed against it, he would begin again to push. At the end of that long travail, he would reach his goal. However, Sisyphus would then again look on helplessly as the boulder rolled back down the mountain with the quickness of lightning; he would again have to start from the bottom and push upwards, striving toward the peak. He repeatedly returned to the limitless countryside at the mountain's bottom. Whenever he left the mountaintop and walked alone toward the residence of the gods, he transcended his fate. This constituted the lucidity in his torture, yet it also gave his crown of victory.'

free' but that it 'must be free.' Because the fate of 'people's creative behavior' is a refusal of the will of 'existing gods,' when 'he' is reborn like a phoenix from the ashes of history, a 'new god' is also born following him; and he says: 'You must raise up the "newly born" will of the "newly born" man.'

We tread along our journey, and in the darkness we thirst for the brilliance of fire. When it burns brightest, we unexpectedly discover that this flame is actually ourselves. That color like blood is smeared on the emergent will in the fire of the self.*

* After Jiangsu Youth Art Week's *Modern Art Exhibition* (*Daxing xiandai yishuzhan*), the primary participants founded a 'Surrealist Group' based on their painting style and called it the 'Red Brigade.' Now there are seven members [sic]: Ding Fang (Nanjing Arts Institute), Yang Zhilin (Nanjing Normal University), Shen Qin (Chinese Painting Institute of Jiangsu), Cao Xiaodong (Changzhou), Chai Xiaogang (Lianyungang City), Xu Lei (Chinese Painting Institute of Jiangsu), Xu Yihui (Nanjing Arts Institute), Guan Ce (Nanjing) and Yang Yingsheng (studying abroad in England).

M88 Anita Dube

Questions and Dialogue (1987)

The Radical Painters and Sculptors Association – otherwise known as the Kerala Radicals – were a short-lived but influential art group founded in Baroda (modern Vadodara), in the Indian state of Gujarat, in 1987. However, their beginnings can be traced back a few years earlier, to the south-western state of Kerala. This small coastal state is a left-leaning, highly educated part of the country, and it was here, in the atmosphere of revolutionary Marxist ideology that surrounded the Trivandrum College of Art, that a group of young artists led by the charismatic K. P. Krishnakumar (1958–89) got together to discuss the problematic relationship between art and politics.

The students' key concern was how to challenge through their art the marginalization and oppression of the people. They looked to German Expressionism, which had reflected the life of the poor and the dispossessed in the early twentieth century; they used cheap and easy-to-obtain materials, like cloth, plaster and enamel; and they sought to situate their art in the context of post-colonial discourse, rejecting revivalism (as promoted by many earlier Indian artistic groups) of any kind. When the students dispersed to further their studies elsewhere in India, many going to the Maharaja Sayajirao University of Baroda's Faculty of Fine Arts, Krishnakumar proposed they become a formal group.

The Kerala Radicals held their first exhibition in March 1987 at the gallery inside the Faculty of Fine Arts in Baroda. The show was accompanied by a manifesto, titled 'Questions and Dialogue', written in English by the only non-Keralan member of the group, Anita Dube (b. 1958). It called for a more socially conscious form of art making and the rejection of art as a commodity.

The Radicals' militant ideas, however, were not popular in Baroda, and they soon moved their activities back to Kerala, pursuing their Marxist agenda through community workshops and discussions groups that raised questions about the relationship between art and modernity. Gradually Krishnakumar's passionate idealism began to cause problems. After a disastrous series of meetings at the end of 1989, the group voted to cease activities for twelve months. Krishnakumar was devastated, and took his own life on 26 December.

* * *

A dialectical situation arises in the cultural arena. A group of artists consciously reject the practices of the 'mainstream' and mobilize into a radical new-left collective to search for a pedagogy of art; an alternative 'philosophy of praxis'. This critical act turns the compound questioning eye on everything, seizes the present moment, stands crude, naked and knife-sharp, and will not allow anyone to pass.

Antonio Gramsci in his 'Prison Notebooks' lucidly states our position – 'Creating a new culture does not only mean one's own individual "original" discoveries. It also, and most particularly, means the diffusion, in a critical form, of truths already discovered, their "socialization" as it were, and even making them the basis of vital action, an element of coordination and intellectual and moral order. For a mass of people to be led to think coherently, and in the same coherent fashion about the real present world, is a "philosophical" event far more important and "original" than the discovery by some philosophical "genius" of a truth which remains the property of small groups of intellectuals.'

The philosophical question haunting history and the consciousness of artists, more acutely in modern times with the global expansion of capitalism, is, what is man? and, what can man become? In as much as man does not exist alone but consciously and intellectually interacts with other men, the natural world and the world of things to transform them, he is a political 'species being' who creates history. History is therefore this process of

becoming or humanization of man. In the swamp of class-society, the swamp-filled darkness of repression, all 'human substance' is petrified. Yet through the swamp voices have risen; vital potential voices of 'man'. In radical art, in radical thoughts, in radical philosophies, radical literature, radical scientific achievements, revolutionary struggles: pushing against the wall. A politics of resistance and discovery, a continuous human search for truth and knowledge to enlarge the world and its meaning, struggling for a classless freedom for every man – as a necessity, and the ultimate freedom from that for a realization of true humanism.

In art, taken as aesthetic strategy and intellectual and philosophical struggle (located absolutely in the material and philosophical conditions of the present, carrying a national and global consciousness of today, to change this), the search for a persona and voice and a search for an authentic history are interlinked. They demand an uncompromising consciousness of 'nationhood' through which an artist can speak to his people and at the same time stand in the world arena shoulder to shoulder with the community of universal human and artistic truths. The criteria and meaning of 'nationhood' has become significant under the pressures of Imperialism and Social-fascism, especially if we see this not in a causal relation to history or as a populist slogan, but as closely connected to the idea of the freedom of 'man' which can only be realized within the concept of a nation.

Indian Nationalism, for all its passion and sincerity has been unable to develop this philosophical and revolutionary potentiality contained within the idea of nationhood. It has remained fatally attached to the limited perspective of gaining independence and preserving it. The Congress leadership, submissive to what George Steiner calls 'the imagined garden of liberal culture' originating in 19th century England, has failed to fully undertake the process of decolonization and radical independent modernization. In the tacit conviviality of private enterprise, government, national leadership, bureaucracy, educational institutions, cultural platforms, in the attitude of the bourgeoisie, the educated petty bourgeoisie and the intelligentsia, there emerges under the veneer of liberalism,

secularism, nationalism, quasi-socialism and scholarly practice, the philosophy of the dominant majority, the Hindu philosophy, which has turned the state, its supporters and its slogans into fascist ones.

Today, Indian society is a complex class and caste society, hooked onto the diabolic mechanism of world capitalism since the early 19th century, susceptible to its dominant logic in the political, economic and cultural arenas. It is therefore, I believe, a gross mistake and a view from across the line, to overlook this fact in any dialogue on Indian history, culture and art.

In the forty years of Independence, our Art reflects these very problems. Out of a colonized consciousness of fear, arises a concurrence of the bourgeois and petty bourgeois classes (from which the artists are drawn) with democracy and its myth of progress and freedom, in which the role of an artist is marginalized and tolerated in the same fashion as the 'opposition', as a sulking pet dog. The artist learns to 'perform' as a juggler or a cynic the 'labour of Sisyphus'.* He struggles defensively without fully comprehending the forces he is struggling against and therefore what he is struggling for. The questions that arise are therefore formal or pseudo questions, far away from the real issues.

During the National Movement, an authoritative nostalgia was widely generated in the arts, for the lost coherence of a centre that held, over and above the objectivities of historical fact and processes. Notwithstanding the perspicacious and sensitive scholarship of Indologists like E. B. Havell and Ananda Coomaraswamy and artists like Abanindranath Tagore, they created an overpowering mythical vision of Indian cultural history and art traditions from a feudal bourgeois point of view. In the process they rejected the most advanced humanistic thoughts of the time arising out of the philosophy of dialectical materialism, but turned instead to

* This phrase is used by Rosa Luxemburg to describe the trade union struggle which she considers a defensive struggle in which the proletariat seeks to achieve the best conditions possible but within the Capitalist System. The labour movement and parliamentary reform movements she feels occupy themselves only with one side, i.e. the formal site of democracy, without questioning its 'real' content.

idealist organic streams of thought which were incapable of understanding the world under capitalism as a totality. The artists associated with such scholarship, in the Bengal revivalist movement, dispersed strategically to all the prominent art schools in India, at Santiniketan, Lucknow, Delhi, Lahore and Madras, to entrench this parochial vision on a national scale.

The after life of the same vision continues today in the philosophy of the 'Living tradition', which seems to be a fetishistic form of the earlier Nationalism. It contains an inability to live in one's own time, and is also a strategy to survive in it. K. G. Subramanyan, searching for a 'total' holistic vision of art as against the 'fragmented' sensibility of the modern,* locates his philosophy on the idea of an 'electric plurality' within the traditional hierarchic interpenetration of the 'little' and the 'larger' manifestations in art and culture. In an essay, 'Do we need an Art Movement', he writes – 'If one walks through the state of Orissa, for instance, village to town, you can see a whole spectrum of these simple wall decorations of untrained tribal housewives, the work of the village potter, metal worker, muralist with greater skill inputs, the works of various skilled craftsmen like the silversmith, whose filigree work is no less refined than a "Lippold" and weavers whose geometricism and colour sense will do credit to any modern artist or designer, then the well known temples with their astounding sculpture. You can see this in many parts of India. The ordered circuits of their activity as against the adventurous and self defeating cross-circuiting of the modern scene I have described should certainly make us think and recall Coomaraswamy's statement that while artists can be special kinds of men all men can be special kinds of artists (without each

* This is an unnecessary polarization since the modern with all its fragmentation is constantly preoccupied with the utopia of 'total' man. The fragmentation Subramanyan refers to is probably a symptom of the post-modern and its waning of values. But Subramanyan's own works, his murals, his terracottas and his glass paintings, for all their wit and clever references to the 'little' tradition, paradoxically do not escape many aesthetic features of the post-modern, namely flatness, impenetrable surfaces, a turning to the past as a search for historicism etc. – which I will discuss a little later.

being a Michelangelo or a Cézanne). In fact some of the specialities of certain levels of these activities come from their simplicity or unambitiousness, even unconcern about being art'.

Today, in our situation, it is difficult to accept Subramanyan's great nostalgia for the collective practices of proto-capitalist, moribund village and town economies. What is his idea of historical process? When he speaks of the potter, the weaver, the tribal woman, as fixed in history, with no right to a choice of expression, all in the name of an 'electric plurality', a grand hierarchic design which should not be disturbed, he speaks with a paternal false-humanism of a feudal bourgeois. Obviously for him state capitalism and class society are eternal unchanging institutions.* Yet capitalism, having destroyed at the root a collective way of life, has destroyed the raison-d'être of folk art. Therefore to speak of a living tradition in art and culture, outside the perspective of socialism, is to parody, or make a pastiche, of the same. This is increasingly evident in the cultural policies of today where folk art and culture are being preserved and marketed as precisely a parody, to satisfy the increasing historical appetite of the bourgeoisie.

Folk art can no longer economically sustain, in any honourable fashion, the craftsmen involved in it. What then is the reason for its survival if not as a political act of resistance against the phenomena of forgetting that capitalism entails. Organic historic memory is a preserve of these pockets of culture, one which cannot be seen formally or appropriated or sold in a sophisticated urban context outside the organized vulgarization of history which has become a symptom of our times.

The other mainstream modern Indian Art carries an ambivalent relationship, one of admiration and rejection, to the whole revolutionary drama of 'Modernism' played out in Europe between the

* According to Rosa Luxemburg – 'The necessity of determining the final goal of socialism provides the teleology by which it becomes possible to understand the present as a process of becoming. Without this teleology bourgeois society would have to be accepted as essentially eternal, and social analysis would be reduced to empirical inductive methods which are incapable of dealing with capitalism as a totality'.

mid 19th to the mid 20th century. Fundamentally the resistance is located against the radical-intellectual strains within modernism, especially its apotheosis of science, its contemporaneity, its knowledge of the world made available through research in anthropology and sociology. Its objective materialist engagement with reality, history, truth, utopia, its close connection to philosophy, literature and the other arts, its resistance to the freezing of the 'human substance' under capitalism, expressed in psychopathological escape, moral protest to attempts at objectively and scientifically interpreting reality as a totality, in its multifaceted dimensions, both individual and typical. Art under modernism became a measure of humanistic concern in the blood-stream of an artist engendering a clash with the old syntax of visual language, its untenable philosophic content, in the changing times.

The Indian artists, influenced by the sensibility of the older Victorian and post-Victorian bourgeoisie could not fully penetrate this materialist humanist tradition. For them its forms and ethos were 'variously ugly, dissonant, obscure, scandalous, immoral, subversive and generally anti-social'*. And yet this same has perversely fascinated them. By appropriating modernism's attractive features as a 'style' and a method of avant-garde art practice, its original spirit was in fact 'vulgarized'. Ironically they have usurped the anarchic classless freedom of the modern artist not as a struggle, but simply as a corollary to their profession. This conveniently places them outside the problems of 'real' history, outside questions in class terms, somewhere between the workings of subjective consciousness and phenomenology. From such a position the imaginary, personal and historic events and characters are put in inverted commas as part of their commodification which can serve the artist as 'referents' to make all kinds of critical gestures, even gestures of anarchy and protest.

This is related in fact to the canonization or institutionalization of 'modernism', its reduction to a set of dead classics in Europe around the '50s when the Indian artists contacted it. The waning of

* Frederic Jameson, The Cultural logic of Capital, N.L.R. [New Left Review] 146.

its effect was giving rise to a whole new phenomena of post-modernism. This philosophy was the cultural logic of multi-national capitalism, in which a new populist rhetoric was slowly taking over the older modernist, metaphysical concerns with truth and utopia. Ideologically it was celebrating a commodification of culture and demonstrating that the omnipresence of the class struggle which had haunted modernism was now in retreat.

When we examine broadly the features of the post-modern (after Frederic Jameson's brilliant analysis of it in an essay, 'The cultural logic of capital'), we find that with the exception of a few artists like Amrita Sher Gil & Binode Bihari Mukherjee, the majority of our artists have submitted in a lesser or greater degree to the over-powering logic of the same. What is this philosophy, then, which is freezing the blood of artists all over the world. Frederic Jameson writes '. . . aesthetic production today has become integrated into commodity production generally: the frantic economic urgency of producing fresh waves of ever more novel seeming goods (from clothing to air planes), at even greater rates of turn-over, assigns an increasingly STRUCTURAL function and position to aesthetic innovation and experimentation. Such economic necessities then find recognition in the institutional support of all kinds available for the newer art, from foundations and grants to museums and other forms of patronage'. Post-modernism is therefore a triumph of capitalist aesthetics, one from which Indian artists without knowing it have been unable to escape.

In a literal sense post-modernism brings with it an obvious superficiality. It focuses on surface and features of the surface, smoothness, or textures and marks and multiple surfaces which stubbornly resist an opening up into depth, even in a literal sense. Everything is as if held on the surface – a flatness prevails, which is reminiscent of mechanical reproductions. Colour and principles of construction are apotheosized and the art product begins to resemble a commodity in the market with a new anti-human autonomy over 'man'. All search for 'real' history is replaced by a pseudo historical depth. In the absence of the old artist's monadic ego, which compelled him to struggle for a distinctive subject and a style as

unique as his own physiognomy, 'the producers of culture have nowhere to turn to but the past'.* There emerges a 'random cannibalization of all the styles of the past, the play at random stylistic allusion'.† Here the past or history becomes a mere referent, concerned with 'textuality' and the 'glossy qualities of the image'. All this is prompted by a growing 'consumers' appetite for a world transformed into sheer images of itself and for pseudo events and "spectacles"'.‡ In post-modernism then, parody and pastiche, kitsch and 'camp' tastes rule. In the assembly line, in the marketing copy, in the museums and galleries, all art, all philosophies, are made to look alike, to compete. Glamour irons out all radical differences. In the myth of individual freedom, individual choice reigns supreme and opportunities appear endless.

The Narrative movement, in India, in recent years, taking character from the British example and continuing a tradition of colonial patronage and approval, is the Indian version of an archaeology of historicism emerging from the post-modern. Through the history of art, Narration has been a special method which places the 'individual' in the 'historical' axis, i.e. it dialectically confronts the 'inside' 'outside' perception of reality of the artist through his protagonists, to face the special temper of his times. However, within the narrative mode also lies the danger of dramatic incidental storytelling, of creation of arbitrary situations and facts which deny the political and intend to surpass history. I believe the great Narrative tradition whether Indian; from the Ajanta murals, to the sculptures at Sanchi, Ellora and Mahabalipuram or European; from Piero della Francesca to Michelangelo's 'Last Judgement', to Bruegel to Courbet right up to Beckmann and Léger, does not fall into a populist rhetoric by compromising individuals and events and history of their times. The narrative paintings of today do not seem to escape from this very populist rhetoric, which I have mentioned earlier is post-modernism's triumphant 'historicism', which

* Frederic Jameson, The Cultural logic of Capital, N.L.R. 146.
† Frederic Jameson, The Cultural logic of Capital, N.L.R. 146.
‡ Frederic Jameson, The Cultural logic of Capital, N.L.R. 146.

can consume and in the process devalue almost anything, even the past.

The paintings of this 'Narrative' movement appear to stand in a critics' court to argue their social and political consciousness, their scholarship and painterly virtuosity. The events and characters portrayed are subordinated to principles of structuring and surface design, and carry a causal relation to historical processes. With the use of multiple references, what we have called 'textuality', with the use of pseudo historical content, with the use of narration, with the use of a rhetorical tone, a myth is created which says that, that which is being portrayed is reality and the 'historical'. I fail to see how, without seriously examining the politics of visual language and subjects (i.e. their particular existence under bourgeois aesthetics), how it works, for whom and from whom, to attempt the 'historical' is to 'vulgarize' the same. Further, to pledge a preoccupation with the human figure and to be unable to draw and paint it freely and imaginatively, with a depth of observation and knowledge, certainly speaks for the shrinking sincerity and ability of artists, one that can never be justified with any theoretical argument.

Any art tradition, Indian or Western, offers a philosophy of understanding 'man' in his surroundings. Within each exists a definite method of observation, of study, of gathering knowledge, a developed linguistic system by which this can be expressed. In any case, whatever his or her choice, an artist's skills must be sharp enough, his means viable enough, to penetrate the world around him in its material and philosophic truth.

Related to this whole new phenomena of art practice is a growing cultural leadership that has acquired a determinist role in the arts. Pure intellectualism indulges in polemical complexities and exercises in thought in a rarefied atmosphere. As professionals and specialists they articulate their thoughts outside class-terms. Antonio Gramsci discussing the role of such scholars writes, 'The Pure intellectuals as elaborators of the most developed ruling-class ideology were forced to take over at least some marxist elements to revitalize their own ideas and to check the tendency towards excessive speculative philosophising with the historical realism of the

new theory in order to provide new weapons for the social group to which they were allied'.*

We do not want to see the relationship between intellectuals (artists as special kinds of intellectuals) and the masses in mechanistic terms. In a theoretical leadership of intellectuals of the faceless masses (outside any real contact) we see distinct fascist tendencies. The only alternative to these existing modes of art practice appears to us in a collective organization of artists to recover lost pedagogic-didactic values of art. By organizing radical activities outside the dominant cultural itinerary we believe we may stand somewhere between mass consciousness and the pure intellectuals, directing in the process both towards a more meaningful and truthful engagement with reality.

In this brief critique of the post-modern and apotheosis of the spirit of high modernism, I do not in any way suggest a step backwards. In fact features of the post-modern are definite cultural symptoms of our times, on which we stand. Yet we cannot deny within it a loss of values. Ideologically the formation of our group is related to all these issues I have argued above.

Our group takes character on the decision of its members, not on anything else. In the crisis of our times, we believe that a philosophy of praxis other than one of an isolated artistic search is demanded of artists to avoid the inevitable petrification of life and art under capitalist competition and the exercise of individual ambitions. Our commitment, towards a political pedagogy in art, places a heavy responsibility on us. It is no easy decision. Only via a politicization of consciousness and a reaffirmation of true nationalism, perhaps, we can return to our real past, understand history outside the will of the dominators with the knowledge of the most advanced global philosophies and science. As artists our real battle lies in our work against all forms of kitsch: national kitsch, international kitsch, political kitsch, social kitsch, social-fascist kitsch, feminist kitsch. The jargon of generalizations is overwhelming. Sameness,

* Antonio Gramsci, Marxism and Modern Culture: quoted in Marxism and Art, ed. Maynard Solomon, Harvester Press.

mundanity, banality make us nauseous. The battle, as much as it is outside, is within us.

In such a large group of artists sharing a particular history, sensibility and vision, it is quite remarkable that there emerge distinct directions of individual enquiry. The old monadic ego is not dead. The search, and resistance of my friends, visible in their Art, will clarify I believe, what I have written.

A sleepless wind is raising a sleepless song in sleepless heads in sleepless nights.

ANITA DUBE
Baroda, 1987

M89 The Eye Society

The Eye Manifesto (1989)

In 1989 five artists in the Nigerian city of Zaria formed the Eye Society in response to what they saw as a serious threat to the creative integrity of the country's visual arts. All of the artists had studied at the Ahmadu Belo University in Zaria. At the time, Nigeria was suffering from a long-running economic crisis caused by the collapse of oil prices after a 'golden decade' of prosperity in the 1970s. This severe downturn in Nigeria's fortunes in the 1980s coincided with a desire among wealthy Western collectors for traditional African art. Cynical dealers actively discouraged innovation by African artists, arguing that any artwork of a conceptual or experimental nature would be dismissed as inferior by the international art market. Instead, Nigerian artists were encouraged to turn out old-fashioned, stereotypically 'African' paintings of stilt dancers and 'exotic' Fulani maidens, and they struggled to find an audience for anything more sophisticated. Concerned by such constraints on their creativity, the Eye Society took direct action, publishing a journal called *The Eye*, which promoted contemporary Nigerian artists, and undertaking to establish an arts programme in order to educate the general public about contemporary art.

'The Eye Manifesto' was written by the Eye Society members and published in *The Eye Monograph* in 1989. In it the group advocated the right of artists not to have their work prescribed by tradition or prevailing expectations, but instead be free to engage unreservedly with the dynamic, international nature of the modern world.

* * *

The Society believes in the freedom of the artist to use his varying experiences for the benefit of mankind. Such experiences embrace the whole of human imagination – deriving, for example, from such phenomena as nature, tradition, science and technology.

While it acknowledges the presence of tradition in all societies it is aware, however, that every society is affected by cultural changes. These changes may be brought about or are influenced by the culture of others. It is insincere, therefore, for an artist to pretend not to notice these changes and to insist on portraying his society as if it were static. The Eye believes that the visual arts provide the forum whereby the dynamism of culture can be appreciated. Thus the Society does not expect artists to be tied down to mere local expectations to the detriment of other dynamic cultural developments of mankind through art. It identifies the seeming absence of progress in most developing nations as a resultant effect of such self-limiting methods that usually are propagated by those who often wish that artists chart a direction purportedly national in appearance but essentially parochial. In the present African and Nigerian circumstance, the Society believes that the artist should not be seen to propagate artistic narrow-mindedness.

Objectives

The projection of the visual arts as an instrument of development of the society.

The documentation and analysis of developments and history in the visual arts.

The promotion of community projects in the area of environmental aesthetics, arts and crafts through workshops and other activities involving members and selected communities from time to time.

The organisation and promotion of exhibitions, workshops and symposia.

M90 Eda Čufer and IRWIN

The Ear behind the Painting (1990)

The visual art group IRWIN emerged in Yugoslavia in 1983, following the end of Marshal Josip Tito's dictatorship. Part of the Slovenian artist collective NSK (M81), IRWIN use art to interrogate and critique the institutional structures around us and to raise questions about the history of twentieth-century art. Early projects, like *Was ist Kunst?* (*What is Art?*, 1985), featured small framed paintings which layered and repeated religious symbols and images from Slovenian history, confusing their meaning in the process. Later, they combined totalitarian emblems and slogans with modern art styles and quotations by European modernists, subverting the firmly held belief that these were polar opposites. Having witnessed the strange dichotomy of Western artists ideologically drawn to Marxism, while Eastern European avant-gardists' desire for freedom of expression drew them towards liberal democracy, IRWIN suggest that critical and affirmative positions in art are more complex than traditionally assumed.

In 1990, as the communist regimes were collapsing across Eastern Europe, IRWIN and the curator Eda Čufer (b. 1961) – co-founder of the NSK underground theatre troupe Scipion Nasice Sisters Theatre (*Gledališče sester Scipion Nasice*) – wrote the manifesto 'The Ear behind the Painting' in the Slovenian city of Ljubljana. (It was subsequently published for the first time, in English, in the catalogue for their exhibition *Kapital* at the PS1 Contemporary Art Center in New York in 1991.) It stated their intention not to allow their distinctive perspective, as Eastern European artists who had lived through a failed utopian concept, to be neutralized by the West. They called their art 'Eastern

modernism' and defined its method, which would draw on the history of Eastern European art, as 'retrogardism'.

* * *

The approach of the 21st century raises the question of whether the period we will have entered in ten years time will be the same for all of us.

At the beginning of this century, the utopian triad – A NEW TIME, A NEW MAN, A NEW WORLD – set the pace for the genesis of a process nowadays claimed by two different men and worlds under the common name of MODERN ART.

The fundamental linguistic structure of MODERN ART, i.e., MODERNISM, was generated in the period of various avant-garde movements. Having descended into the realm of the non-aesthetic, these avant-garde movements expanded into the sphere which was originally penetrated by a MEDIATOR – INTERPRETER – MEDIUM – IDEOLOGIST. The rise and fall of these avant-garde movements make up the starting and terminating points of the first, i.e., the UTOPIAN stage of MODERN ART.

The REALIST UTOPIA, confined to the period between the two wars, climaxed when the tectonic forces of the collective conscious-ness were shattered by the proletarian revolution in Russia and by the outburst of Fascist and Nazi doctrines.

In this period, MODERN ART caught a quick glimpse of how its concept could make the world change in fire, smoke and blood.

Both doctrines, FASCISM-NAZISM and COMMUNISM, regarded MODERN ART as an inspiring method for the violent aesthetici-zation and idealization of their worlds. The problem of these two formally identical worlds reflected the schism: LEFT vs. RIGHT, GOOD vs. EVIL.

The third, POST-UTOPIAN stage, started with the capitulation of EVIL, not with the capitulation of the DIFFERENCE, which was, in addition to COMMUNISM, denoted by FASCISM and NAZISM.

The LEFT and the RIGHT worlds, Eastern Europe with the Soviet Union and Western Europe with the United States of America, set out to experiment with the two different worlds and times, which, due to fundamental differences in their starting points, fatally transformed the then still uniform linguistic nucleus of MODERN ART.

The arguments underlying the conviction that EASTERN MODERNISM was caught in the ice of Siberia should be sought in the methodology of the COMMUNIST EXPERIMENT. The latter arose in 1917 from the belief that the victory of the proletarian revolution established conditions in which a conflict-free society could develop. Once this belief was formally legalized, art was deprived of its creative force and confined to the role of the interpreter of society and the idealized concept associated with it. Thus society, the monumental edifice of an Eastern state, turned out to be the sole theme to be treated in MODERN ART of the EAST.

EASTERN MODERNISM and the WESTERN STATE speak the same language – a language rooted in the language of the avant-garde movements and their idealist concepts of society functioning as a work of art as a whole. The act of EASTERN MODERNISM interpreting a state as free from conflict and the act of a conflict-free state interpreting Eastern modernism became meaningless. Art was captured in the image of the state and was forced to wither away with it.

The COMMUNIST EXPERIMENT cleared the space and stopped time, capturing it in the static and everlasting experience of revolutionary triumph at the moment when the present day triad – SCIENCE, IDEOLOGY and ART – united in the belief

that it went beyond the horizon and occupied the vacant throne of God.

The principles of interaction require that another question be asked: to what extremes has the CAPITALIST WEST developed in the COMMUNIST EAST?

With regard to the common starting points of MODERN ART, the circumstances in which WESTERN MODERNISM developed were controversial in many ways. However, WESTERN MODERNISM also retained the linguistic code which was established during the utopian stage. Unlike the COMMUNIST system, the CAPITALIST regards this code as strange, hostile and aimed at the subversion of the system's very foundation.

Confronted with this antagonism, CAPITALISM takes advantage of the hyperfunctionality of the interpreters-mediums, who daily translate into the linguistic categories of capitalism, converting its subversive essence into market values. Consequently, the activities performed by these media are reflected in the inflationary acceleration of WESTERN TIME and in the imperialist charge of the WESTERN SPACE. The disintegrative intervention of time-inflation into the structure of WESTERN MODERNISM is most evident in the inflation of -isms, in the production of PREFIXES for the same SUFFIX.

The demonic power of a signifiant in the West has expanded in the East as well. During the Cold War, numerous artists emigrated to the West, and the false conviction that MODERN ART, no matter whether coming from the East or from the West, is so universal as to be classified under a common name: the current -ISM appeared to be very common. The evidence that this conviction only reflects the imperialist charge of the West may be well observed in the fact that, after 1925, the act of application of the signifiant was developed and monitored in five Western states at the most.

We may conclude the study of the POST-UTOPIAN stage in MODERN ART with the statement that the two different contexts in which the WESTERN and EASTERN experiments were carried out deprived MODERN ART of its international character, each in its own domain ALIENATING it from religiously-UTOPIAN function. With EASTERN time preserved in the PAST and Western time stopped in the PRESENT, MODERN ART lost its driving element – the FUTURE. A general interpretation of the current breakdown of the Eastern regimes hides the mutually held illusion that the world will uniformly evolve towards a WESTERN type of government.

As artists from the EAST, we claim that it is impossible to annul several decades of experience of the EAST and to neutralize its vital potential.

The development of EASTERN MODERNISM from the past into the present will run through the FUTURE. The FUTURE is the time interval denoting the difference.

Being aware that the history of art is not a history of different forms of appearance, but a history of signifiants, we demand this DIFFERENCE be given a name.

THE NAME OF EASTERN ART IS EASTERN MODERNISM.

THE NAME OF ITS METHOD IS RETROGARDISM.

Ljubljana, 1990

M91 VNS Matrix

Cyberfeminist Manifesto for the 21st Century (1991)

In 1991 the Australian art collective VNS Matrix wrote the joyfully ironic 'Cyberfeminist Manifesto for the 21st Century'. 'VNS' is a 'fauxcronym' conceived in the style of a corporate acronym, which the group say they designed to 'insert slimy playful koans into the matrix' for people to interpret in their own way. The text was hacked into websites, broadcast on the radio, printed as a poster, mailed and emailed, as well as posted and reposted online.

The group, whose members are Virginia Barratt (b. 1959), Josephine Starrs (b. 1955), Francesca da Rimini (b. 1956) and Julianne Pierce (b. 1963), had emerged out of the country's pioneering new-media art movement, during a period when the World Wide Web was beginning to move into the mainstream. Their interest in the digital world coincided with the rise of cultural theorists writing about the impact of cybertechnology on society, such as the influential philosopher Sadie Plant; and they were partly inspired by Donna Haraway's feminist 'Cyborg Manifesto' (1984), which urged the re-examination of gender, politics and identity through technology.

In reaction to the lack of female characters or storylines in the burgeoning computer games industry, and the prevalence of male-oriented pornography in the digital sphere, VNS Matrix sought to radicalize the landscape of computer technology by using guerrilla tactics: hacking games, designing posters, producing advertisements on websites and creating their own games and pornography 'by women for women'. They described themselves as 'the virus of

the new world disorder', infecting the cyberswamp of early web technology with their subversive, funny feminist messages. Although the group disbanded in 1997, they reformed briefly in 2016 to write and perform a major new work, *A Tender Hex for the Anthropocene*.

* * *

We are the modern cunt
positive anti reason
unbounded unleashed unforgiving
we see art with our cunt we make art with our cunt
we believe in jouissance madness holiness and poetry
we are the virus of the new world disorder
rupturing the symbolic from within
saboteurs of big daddy mainframe
the clitoris is a direct line to the matrix
VNS MATRIX
terminators of the moral code
mercenaries of slime
go down on the altar of abjection
probing the visceral temple we speak in tongues
infiltrating disrupting disseminating
corrupting the discourse
we are the future cunt

M92 Marko Peljhan

Projekt Atol Manifesto: In Search for a New Condition (1993)

In 1992 the Slovenian conceptual and new-media artist Marko Peljhan (b. 1969) founded *Projekt Atol* (Project Atoll), an artistic platform through which to consider the role of art after the collapse of the communist regimes of Eastern Europe and the subsequent eruption of civil war caused by the break-up of Yugoslavia. In this unpredictable new world, Peljhan wrote a manifesto that reflected on the utopian spirit of early avant-garde art movements and applied their expansive vision to the future of art, with a particular emphasis on the role of communications technologies. It was first presented as part of a performance at the Diskurs Festival in Giessen, Germany, in October 1993, and subsequently published in the American journal *Theatre Topics* in September 1996.

Peljhan has described *Projekt Atol* as 'an organism' that is 'a perfect example of stealth and dynamics with all the limitations and strengths of such a system'. Through it he has set up a series of research-based initiatives that combine performance, visual art, science, engineering and information technology. Perhaps the best-known of these is Makrolab, a mobile arts and technology hub designed to navigate the unknown territories of the post-modern world by mapping such phenomena as telecommunications, climate change and the migration of flora, fauna, people, ideas and capital. The organization also runs a technology arm called PACT (Projekt Atol Communication Technologies) Systems, a flight and space programme and also the Arctic Perspective Initiative, an environmental research base working

in collaboration with indigenous inhabitants of the Northern hemisphere.

* * *

The 'end' of this century is the era of the erosion of utopias, constituted in its beginning. The revolutionary strategies have failed, new social organisms, orders, have not been successfully implemented or developed. Physical imperial powers have transformed themselves into intangible, invisible forces that control and dominate the social, spiritual and economic fields. The FRAGMENTATION of large dimensions is still going on. We, Europe, the World, are living the dawn of utopia which has been substituted with the experience of the white noise of communication. The insight into future is lost in the channels of the eternal present.

The decision to use art in the present state is not an efficient solution to the problem described above. Every human being as individual has less and less possibilities to become a 'creator' or somebody who has influence on a 'new social organism.' EGORHYTHMS I, II, III, IV, the one that will follow, and the rhythmical-scenic structure ATOL are an 'evolutionary ec(g)o-system,' a small scale closed environment which presupposes that in spite of the politically forced unimportance of the individual in the present social system (be it democratic or totalitarian), the only force that can overcome the present is the wisdom which is withdrawn in SILENCE. The thoughts, images and emotions of which we think are useless for the world as it is, because there is no one who could listen, think of them or watch them.

These glimpses of oppressed wisdom, whether they belong to a well-situated individual in the West or to a physically endangered individual on the battlefields and concentration camps of the East, are the real power to produce NEW EVOLUTIONARY STRATEGIES. The ongoing political, social, economic and spiritual division that is spreading throughout Europe and farther is going to result in the complete isolation of the constituent parts of

the planetary macro-systems. The closed environments will have to develop new strategies of survival in order to re-establish the lost and disappearing channels of communication. Only freed and creative individuals can produce new objective conditions for a small leap into the future of human relationships. The shaping of history has yet to be defined by a NEW HUMAN BEING capable of walking on the edge of globally controlled communication, without losing its integrity, that is: the possibility of BECOMING, not just BEING.

M93 The Institute of People-Oriented Culture 'Taring Padi'

Manifesto (1998)

The Indonesian cultural activists Taring Padi (Teeth of the Rice Plant) formed their collective in the city of Yogyakarta, on Java, on 21 December 1998. Earlier that year, President Suharto's stridently anti-communist government had collapsed, and during the political and financial upheavals that followed, groups like Taring Padi emerged that had an anti-capitalist, anti-imperialist agenda.

Taring Padi, who are still active today, are strongly opposed to the concept of 'art for art's sake', and seek to promote a people's culture through artistic modes of production like printmaking which cannot be ascribed to one individual creator. Much of their art takes the form of black-and-white illustrations (in prints, on banners and on posters) agitating against government policies, as well as street theatre, lecture series and publications created collectively under the group's name. For Taring Padi, art is a powerful tool for social justice, and they continue to agitate for a spirited cultural democracy.

Coinciding with their foundation, Taring Padi proclaimed their vigorous manifesto for artistic freedom, in which they identified five threats to contemporary Indonesian art. These included the way the country's art institutions, driven by profit, promoted an exoticized form of art for the Western market, and failed to support grassroots innovation and experimentation.

<p style="text-align:center">* * *</p>

Five Evils of Culture

1 Institutes of art and culture that emphasize art for art's sake, individualist and opportunist groups that socialize misguided doctrines with the goal of preserving the status quo and for the sake of estranging the people from the development of art, and that divide the people into groups for economic/material purposes (upper/lower/middle classes).

2 Governments/leaders, via departments that manage art and culture, that support the status quo and seek to shape Indonesian culture only to be sold for its exoticness in the interest of economy and power.

3 Institutes of culture that enable institutions as legitimators of artists and artwork, and determine the direction of development in art.

4 A system that destroys art workers' morality through working only for individual interests without thought of community interests, even exploiting the suffering of the people for the sake of individual profit.

5 Lack of understanding about the function of art in society resulting from New Order politics that emphasize 'Economics in Command,' along with the tactics of Collusion, Corruption and Nepotism.

Mission

Taring Padi Cultural Institute seeks to foster art and culture by channeling the people's desires and needs and prioritizing openness, social prosperity, the sovereignty of the people, justice between generations, democracy, the appreciation of human rights without dismissing responsibilities, gender perspectives, the reformation of global relations and the preservation of a good environment.

Vision

The people's cultural institute Taring Padi seeks to play the following roles:

First, as a forum for artists supporting all parties in the cultivation of local art and culture with a populist orientation, emerging from the needs of the people and the private, social, and democratic development of the people.

Second, as a forum for artists to play an optimal role in supporting change as well as (among others):

Developing the transformative potential of art by providing solutions to the problems, needs, and desires of the people with the artwork that is created.

Deconstructing hegemonic national symbols that weaken the abilities of the people and control policies for the development of art and culture.

Prompting changes in the understanding of art, in order to address the desires, needs, and aspirations of the people in all things.

Third, as an art workers' forum for communication, exchange of experience and information as well as a place for strengthening cooperative ties in accordance with the vision, mission, and institutional goals of the people's cultural institute of Taring Padi.

M94 Frente 3 de Fevereiro

Manifesto of Frente 3 de Fevereiro (2004)

Frente 3 de Fevereiro (Third of February Front) are a Brazilian direct-action art collective founded by artists, cultural practitioners and academics angered by the longstanding problems of police violence and racism in their country. Their name is significant, as it marks the date of the mistaken killing in 2004 of a black student dentist called Flávio Ferreira Sant'Ana by the São Paulo police. Their first public intervention was to place a plaque on the spot where Sant'Ana had been shot, inscribed: 'Who polices the police? Police racism'. At the same time they issued the following manifesto, which proclaimed their horror at the killing and their determination to raise awareness of racial injustice.

The group use art as a political tool, taking their cue from performances and happenings from the 1960s and 70s – such as the radical interventions of Artur Barrio (M43), who sought to evade censorship by the Brazilian authorities through spontaneous street actions – and they present new forms of protest through artistic research projects, public interventions, the mass media and experimental community projects. They gained international recognition in 2007 with their video artwork *Zumbi Somos Nós (We Are Zumbi)* which depicted the lives of Afro-Brazilians (Zumbi was the leader of a large settlement of escaped African slaves in late seventeenth-century Brazil, and is a national hero among modern Afro-Brazilians).

* * *

Through this manifesto, we of Frente 3 de Fevereiro wish to declare the grave risk facing society as a whole. On 3 February, Flávio

Ferreira Sant'Ana was brutally murdered by the São Paulo State police. This heinous crime not only highlights police violence, but also indicates the dangerous relationship between police stop and search and the racial bias underlying the definition of who is or is not a suspect. These events also show the lack of control that civil society has over those that should be keepers of the peace.

So-called 'racially motivated stop and search' is no more than a euphemism for police racism (91% of young black men from São Paulo State have been stopped by the police – *Datafolha*, 2004), as their actual, day-to-day conduct is based on black members of the public being the preferred suspect for any criminal activity. That conduct arises from a mindset instilled early on in Brazilian socio-cultural education, which covers topics ranging from the etymological root of the word 'negro' and its negative connotations (someone of the negro race, black, dirty, grimy, very sad, grim, evil, slave – from the *Dicionário Aurélio*) to the discriminatory effects that this mindset has on the daily lives of our society.

Flávio's death shows the deep schism between individual rights (enshrined in the Constitution of 1988) and day-to-day reality. This case clearly reveals the true conditions in which we live. In fact, the so-called 'multiracial democracy' does not exist. Racial discrimination is just camouflaged. In turn, society gives the discriminatory role to a 'third party', creating the illusion that the Brazilian population is exempt from racist behaviour. This 'third party' is institutionally embedded in the police, which ironically has a considerable number of black policemen in its ranks. This points to the urgent need to change the social parameters in place, where the young black male is 'confined' (almost completely) either to the role of enforcer (policeman) or offender (crook), with no other accepted social role that falls outside these two parameters.

Thus Brazil has created one of the cruellest and most efficient racial discrimination mechanisms, as the system excludes any possibility of questioning the existence of racism in Brazilian society.

For these reasons, we of Frente 3 de Fevereiro want to break this veiled silence, asking society to stand up for this urgent situation, and condemn the blind eye that the justice system, the state and the media would have us turn to the issue of racism confronting the public.

From the fundamental principles [of the Brazilian constitution]

Article 3:

IV – promoting the well-being of all, without preconceptions of origin, race, sex, colour, age and any other form of discrimination.

Article 5:

XLII – acts of racism constitute a crime, subject to a custodial sentence by law, without bail or suspension.

M95 Pélagie Gbaguidi

Manifesto Against The 'Black Code' edict of Louis XIV, 1685 (2008)

In 1685 King Louis XIV of France issued an edict formalizing the legal framework that underpinned the system of slavery in the French colonies of the Caribbean and the Gulf of Mexico. Known as *The Black Code (Le Code noir)*, it regulated how black slaves should be treated, from insisting on their baptism as Catholics to specifying that fugitives should be branded with a fleur-de-lis and have their ears cut off. *The Black Code* went on to serve as a blueprint for slave laws in the former French colonies in the United States and governed the lives of millions of African Americans until slavery was abolished.

In 2004, while on a residency in France, the Beninese artist Pélagie Gbaguidi (b. 1965) encountered a copy of the code at a book fair in Nantes. Embarking on a series of drawings and paintings entitled *Le Code noir*, Gbaguidi sought to make sense of the violence represented by the text through distorted, screaming faces and withered bodies. She later extended the theme to address the state violence of Nazism when she realized that the first chapter of *The Black Code* also concerned the treatment of the Jewish people.

Gbaguidi's impassioned response to *The Black Code* culminated in the embroidered 'Manifeste Contre du "Code Noir" de Louis XIV, 1685', which she presented at the Dakar Biennale in Senegal in May–June 2008. The work challenges readers to acknowledge the brutal stain of African slavery on history and 'accept the notion of collective trauma'.

* * *

Manifesto
Against
The 'Black Code' edict of Louis XIV, 1685

Memory is a birthright

We are each free to honour the death of our forebears, male and female

The sites of our Memories are undeniable

Beware a return to domestication as the number of dogs only increases

For 400 years displaced men and women dreamed of freedom. Thus the Legislator spread the infectious spores of racism

Racism is a virus transmitted from one man to another – it did not spring from Mars

Ask yourself what became of the descendants of those severed ears and noses and of those who committed those acts?

Does the memory of the slaves hover, an errant remembrance without a tomb?

Ask yourself what were THEIR legacies or whether THEIR words have gone unheeded?

We each carry with us part of the collective trauma

Trauma is a sorrow that never disappears

Memory is a spirit everlasting

We can only envisage war through the victories, the medals, and the reparations

We must devote ourselves to understanding the Testimonies, the psychological and spiritual repercussions wreaked on humanity

Are we capable and finally ready

To accept the notion of collective trauma?

Is the monster yet living?

M96 Adam Pendleton

Black Dada (2008)

The American artist Adam Pendleton (b. 1984) wrote the 'Black Dada' manifesto while en route to Italy, where he performed it at *Manifesta 7* (the European Biennial of Contemporary Art) in the autumn of 2008. The manifesto takes its framework from two notorious political artworks: 'The Dada Manifesto' spoken by the German poet Hugo Ball in Zurich in 1916, which arguably initiated the art movement of Dadaism; and the poem 'Black Dada Nihilismus' (1964) by LeRoi Jones (later known as Amiri Baraka), which became one of the defining statements of the Black Arts Movement founded by Jones in the 1960s.

For Pendleton, the term 'Black Dada' is a way of questioning where the African-American aesthetic fits into the history of avant-garde art while not forgetting its own cultural and civil struggles. Importantly it articulates the social theorist Paul Gilroy's influential concept of the 'Black Atlantic', which argues that black consciousness had a central role in the development of modernism as a result of black artists' engagement with white culture rather than their rejection of it. Pendleton has also made a series of black paintings called *Black Dada*, which refract minimalism through a similar prism. The manifesto, in a way, is like a minimalist sculpture in that it conforms to a strict mathematically defined structure, beginning with one line and then doubling the length of each section it until it reaches 128 lines.

<p style="text-align:center">★ ★ ★</p>

1.

it's a matter of fact

2.

it's a matter of fact

a full moon hanging in a low sky irradiates the day with a milky glow

4.

it's a matter of fact

going in a taxi from the train station

a full moon hanging in a low sky irradiates the day with a milky glow

i was with nielsen living and painting in a north beach flat

8.

it's a matter of fact

a full moon hanging in a low sky irradiates the day with a milky glow

i was with nielsen living and painting in a north beach flat

going in a taxi from the train station

and then somebody kicks off the lid

sigh and then breathe

these buildings don't uncover a single truth, so which truth do you want to tell?

the grant is 800 euros

16.

it's a matter of fact

a full moon hanging in a low sky irradiates the day with a milky glow

the grant is 800 euros

it's theological; it's a revelation

going in a taxi from the train station

and then somebody kicks off the lid

need i cite charles van doren

Why Are We 'Artists'?

on a stool in a greasy spoon

human beings were born to live in a relationship of interdependence with nature

the performance must be done on location

regular communication by email with a commitment to responding within a reasonable time frame

the performer must not be credited

a revolving door

she was a unit in a bum space; she was a damaged child

so did i love

architecture is bound to situation

32.

it's a matter of fact

a full moon hanging in a low sky irradiates the day with a milky glow

now i am older and wiser

going in a taxi from the train station

she was a unit in a bum space; she was a damaged child

so did i love

regular communication by email with a commitment to responding within a reasonable time frame

sigh and then breathe

the performer must not be credited

and then somebody kicks off the lid

it's theological; it's a revelation

steel bell drops

the grant is 800 euros

on a stool in a greasy spoon

need i cite charles van doren

i want the grey-blue grain of western summer

i want the cardboard box of wool sweaters on top of the bookcase to indicate home

i want a very beautiful woman

a common doubt expressed about the "practice-based" researcher is whether they are equipped for "competent reading"

the performance must be done on location

these buildings don't uncover a single truth, so which truth do you want to tell?

the desire for coffee

the formal beauty of a back porch

remember the wedding?

dada is our intensity

i want a very beautiful man

when a work of architecture successfully fuses a building and situation, a third condition emerges

i think what black arts did was inspire a whole lot of black people to write

monuments are embarrassing to dutch culture

revolving door

song of the garbage collectors beneath the bedroom window

seeds of the fig

64.

it's a matter of fact

a full moon hanging in a low sky irradiates the day with a milky glow

going in a taxi from the train station

now i am older and wiser

she was a unit in a bum space; she was a damaged child

the formal beauty of a back porch

and then somebody kicks off the lid

i need the grey-blue grain of western summer

i need the cardboard box of wool sweaters on top of the bookcase to indicate home

i need a very beautiful woman

steel bell drops

when a work of architecture successfully fuses a building and situation, a third condition emerges

what black arts did was inspire a whole lot of black people to write

Why Are We 'Artists'?

Black Dada, black dada

this is dada's balcony, i assure you

from there you can hear all the military marches, and come down cleaving the air like a seraph landing in a public bath(s) to piss and understand the parable

i had a nice dick, average length and all

i wanted ron to look at it, want it

dada is our intensity; it erects inconsequential bayonets and the sumatral head of german babies

i need a very beautiful man

it's theological; it's a revelation

the grant is 800 euros

need i cite charles van doren on a stool in a greasy spoon

how are we to define this poem?

what makes you think that's what this is for?

what do you want for christmas?

does it mean that if the universe is infinite, then in some other world a man sits in a kitchen, possibly in a farmhouse, the sky lightening, and nobody else up and about as he writes down these words?

i want the perfume back in the bottle

i need a prick in my mouth

i need an explanation

what did you think when they converted the funeral home into a savings and loan?

revolving door

dry blood

song of the garbage collectors beneath the bedroom window

seeds of the fig

white dada remains within the framework of european weakness

the essence of architecture is an organic link between concept and form

pieces cannot be subtracted or added without upsetting fundamental properties

we want coherence

she was a unit in a bum space; she was a damaged child, sitting in her rocker by the window

i want western movies

i need monday morning, a prick in my mouth and coffee

a cigarette and coffee for two

primal soup

pineapple slices

Black Dada is a way to talk about the future while talking about the past; it is our present moment

a common doubt expressed about the "practice-based" researcher is whether they are equipped for "competent reading"

yellowing gauze curtains

remember the wedding?

the raised highway through the flood plain

regular communication by email with a commitment to responding within a reasonable time frame

so did i love this

the performer must not be credited

the performance must be done on location

feet, do your stuff

sigh and then breathe

i want a young man with long eyelashes

white wings of a magpie

red shingle roof

i'm unable to find the right straw hat

how will i know when i make a mistake?

presentness

soap

we ate them

128.

it's a matter of fact

she was a unit in a bum space; she was a damaged child

a full moon hanging in a low sky irradiating the day with a milky glow

the formal beauty of a back porch

Why Are We 'Artists'?

but now i am older and wiser

Black Dada

The Black Dada must . . .

The Black Dada must use irrational language.

The Black Dada must exploit the logic of identity.

The Black Dada's manifesto is both form and life.

can you feel it?

does it hurt?

is this too soft?

do you like it?

do you like this?

is this how you like it?

is it alright?

is he here?

is he breathing?

is it him?

is it hard?

is it cold?

does it weigh much?

is it heavy?

do you have to carry it far?

what about dinner?

The Black Dada is neither madness, nor wisdom, nor irony.

song of the garbage collectors beneath the bedroom window

look at me, dear bourgeois

dada is a new tendency in art

art used to be a game of nuts in may, children would go gathering words that had a final ring, then they would exude, shout out the verse, and dress it up in dolls' bootees . . .

one can tell this from the fact that until now nobody knew anything about it, and tomorrow everyone in zurich will be talking about it

Black Dada: we are not naive

Black Dada: we are successive

Black Dada: we are not exclusive

Black Dada: we abhor simpletons and are perfectly capable of an intelligent discussion!

DA DA DA DA DA DA DA TK TK TK TK

thus saith the lord

i need ron to look at it, want it

i need a beautiful woman

i need the cardboard box of wool sweaters on top of the bookcase to indicate home

i need western movies

i need the grey-blue grain of western summer

Sol LeWitt exhibited his Variations of Incomplete Open Cubes in the early 1970s.

Which is to say LeWitt's Paragraphs on Conceptual Art (1967) and Sentences on Conceptual Art (1969) had already been written.

In 1969 a young June Jordan dedicated her poem "Who Look at Me" to her son Christopher:

We come from otherwhere

In part we grew by looking back at you

BLACK DADA.

Malcolm X arrived in Harlem in the early 1950s.

In 1952 John Cage composed his famous silent work 4' 33".

At the Meredith March in June 1966, a year before LeWitt wrote Paragraphs on Conceptual Art, Stokely Carmichael arguably laid the foundation for the Black Power movement.

In a talk given at the University of Massachusetts, Amherst on the 6th of November 2006, Kathleen Cleaver asked:

The 1960s, is that something that still makes you stand up and notice? Do you still notice the 1960s?

Hugo Ball read his Dada Manifesto at the first public Dada soirée in Zurich's Waag Hall on July 14th, 1916:

Dada psychology, dada Germany cum indigestion . . . dada literature, dada bourgeoisie, and yourselves, honored poets, who are always writing with words but never writing the word itself, who are always writing about the actual point. Dada world war without end, dada revolution without beginning, dada your friends and also-poets . . .

Dadaism in the wake of the First World War.

Public gatherings.

Demonstrations.

Why Are We 'Artists'?

Art of protest.

BLACK DADA.

Did our conceptual artists join hands with our freedom fighters?

Did they demonstrate in Birmingham?

Did they cover their faces when the hoses were turned on them?

History is in fact an incomplete cube shirking linearity.

BLA K DA . B DA . BLACK D D .

a common doubt expressed about the 'practice-based' researcher is whether they are
equipped for 'competent reading'

feet, do your stuff

sigh and then breathe

i want the perfume back in the bottle

i want a prick in my mouth

i want a young man with long eyelashes

regular communication by email with a commitment to responding within a reasonable
time frame

so did i love (this)

the performer must not be credited

the performance must be done on location

props and sets must not be brought in

the sound must never be produced apart from the images or vice versa

any cameras for documentation must be handheld

special lighting is not acceptable

optical tricks and "effects" are forbidden

the performance must not contain superficial action, declarations or jokes

temporal and geographical alienation are forbidden

genre performances are not acceptable

the format must be set: 30 minutes, 20 minutes, 1 hour

white wings of a magpie

red shingle roof

steel bell drops

wave glory

soap

presentness

human beings were born to live in a relationship of interdependence with nature

the desire for coffee

how will i know when i make a mistake?

the grant is 800 euros

does it mean that if the universe is infinite, then in some other world a man sits in a kitchen, possibly in a farmhouse, the sky lightening, and nobody else up as he sits and writes down these words?

if the function of writing is to express the world

i need an explanation

i'm unable to find the right straw hat

Black Dada is a way to talk about the future while talking about the past

History is an endless variation, a machine upon which we can project ourselves and our ideas

that is to say it is our present moment

The history of conceptual art as (is) an intimately constructed narrative deserving of an aggressive deconstructive interpretation.

An iconic structure that embraces linearly passive readings of its ideological principals and the moment of its "coming into being."

the raised highway through the flood plain

pineapple slices

we want coherence

we want a revolving door

song of the garbage collectors beneath the bedroom window

seeds of the fig

white dada remains within the framework of european weakness

i need monday morning and a prick in my mouth

a cigarette and coffee for two

what does it cost?

do you speak english?

do you hear a ringing sound?

are you high yet?

Why Are We 'Artists'?

is he the father?

are you a student at the radio school?

what is it that attracts you to bisexual women?

do you know which insect you most resemble?

did you know i have a nice dick, average length?

did you know his cum is the eighth color of the rainbow?

do you know what it tastes like?

but now, look at me, we don't agree with them, for art isn't serious, i assure you, and if we reveal the crime so as to show that we are learned denunciators, it's to please you, dear audience, i assure you, and i adore

but now i was older and wiser

black dada your history of art

we ate them

M97 Allyson Mitchell

Deep Lez (2009)

'Deep Lez' is a concept devised by the Canadian artist Allyson Mitchell (b. 1967) that uses the history of radical lesbian feminism to address the state of contemporary culture. It has been described by the academic Elizabeth Freeman in her book *Time Binds: Queer Temporalities, Queer Histories* (2010) as 'a catchphrase *cum* artistic vision *cum* political movement', and certainly the philosophy of Deep Lez has informed Mitchell's art, which has included a giant crocheted vagina installation, and primeval she-beasts fabricated from fur and yarn using traditional craft techniques like appliqué.

The 'Deep Lez' manifesto was originally constructed out of yarn and plastic in 2003, before being photographed and distributed as a poster in 2004. This version, which expands on that first draft, was written in 2009 and published in *GLQ: A Journal of Lesbian and Gay Studies* in 2011. In it Mitchell uses Deep Lez as a way of critiquing 'third-wave' feminism (which is chiefly defined by the inclusion of queer and non-white women, whose particular agendas had hitherto been ignored) and ensuring that radical lesbian and bi voices of the past are not lost in the current 'muddied-up' discourse but can still contribute to the formulation of future feminist strategy. To this end, in 2010 Mitchell set up the Feminist Art Gallery (FAG) in Toronto, in conjunction with the artist Deirdre Logue, as a platform for feminist and queer thinking.

* * *

Deep Lez is an experiment, a process, an aesthetic and a blend of theory and practice. Deep Lez is right this minute and it is rooted in herstories and theories that came before. It takes the most

relevant and capable ideas and uses them as tools to create new ways of thinking, while simultaneously clinging to more radical politics that have already happened but definitely aren't over yet. Part of the deep of Deep Lez is about commitment, staying power, and significance. Part of the deep of Deep Lez is about philosophies and theories, as in, 'Wow man, that's deep.'

Deep Lez uses cafeteria-style mixings of craft, context, food, direct action and human connections to maintain radical dyke politics and resistant strategies. Part quilting bee, part public relations campaign, and part collective self-care, Deep Lez seeks to map out the connections between the second position feminisms that have sustained radical lesbian politics and the other feminist/queer, anti-racist, critical disability and trans politics that look to unpack many of the concepts upon which those radical politics have been developed. These political positions have set forth a host of important critiques about radical lesbianisms as they have historically unfolded, and look to provide correctives in this regard. Unfortunately, this is often accomplished through the wholesale dismissal of a radical lesbian practice and identification. Deep Lez was coined to acknowledge the urgent need to develop inclusive liberatory feminisms while examining the strategic benefits of maintaining some components of a radical lesbian theory and practice in dreaming big queer worlds. This project is carefully situated not to hold on to history, but rather to examine how we might cull what is useful from lesbian herstories to redefine contemporary urban lesbian/queer/trans existence. In so doing, 'lesbian' is resurrected as a potential site of radical identification, rather than one of depoliticized apathy or erasure.

Deep Lez originally began as a cultural project of mine, largely informing my art practice. I make lesbian feminist monsters using abandoned domestic handicraft. This has meant the creation of giant 3D sasquatch ladies, room-size vagina dentatas, a FAG feminist art gallery and a lesbian feminist hell house. The objects and environments that I create are about articulating some of the ideas

and imaginings from second-wave feminisms that were so foundational to me, while still remaining committed to an inclusive queer theory and practice that continue to keep me alive.

In a short time, this idea grew beyond my own practice, and took hold among a variety of local and international communities. For example, the language of Deep Lez was adopted by some folks at the Michigan Womyn's Music Festival who lobbied for trans inclusion and supported Camp Trans. Here, Deep Lez is mobilized to move radical lesbianism and identification with, or allegiance to, trans communities out of the realm of either/or and into the space of and/both – as encouraged by bell hooks.

A Deep Lez art exhibition was mounted in San Francisco, in which lesbian identification was explored as a relevant and strategic site of young queer urban politics. Given the growth of this idea, I write and expand on the ideas of Deep Lez with this statement.

Deep Lez is meant to be a point of departure for me to start thinking about my politics and what is important to me and my communities. Deep Lez is meant to be a macraméed conceptual tangle for people to work through how they integrate art into their politics and how they live their lives, and continue to get fired up about ideas. Deep Lez can offer alternative ways of imagining the world and who we are. It is meant to be passed hand-to-hand from crafter to filmmaker to academic to students to teachers to leaders and back again. My wish is that it permeates and also loosens things up.

Deep Lez is not meant to become its own dogma but to encourage thinking about new/old feminist and dyke strategic positions. Every Deep Lez text, installation, manifesto and potluck offering is different because it is contingent on the contributions and participations of many, and also because it is accumulating and discarding as it goes. We can band together through Deep Lez to imagine and realize our way out of this dysfunctional habitat to create ecologies, policies, and styles without war, poverty, violence and waste.

Deep Lez is the volunteer, the workshop coordinator, the curator, the consumer, the first initiated and the instigator – anyone who gets intrigued by this bell-bottomed fat-assed catch all: whether they are dykes or not, they are still Deep Lez.

Signed in solidarity for a new kind of sisterhood that isn't based on gender and privilege and a new kind of brotherhood that isn't based on rape and pillage.

M98 Abounaddara

What is to be done? (2011)

In 2011 a Syrian art collective calling itself Abounaddara (meaning 'man with glasses') began posting weekly short films online, no easy task during a revolution. Using a *cinéma-vérité* style of film-making, first pioneered by the Soviet documentary director Dziga Vertov, of whom 'man with glasses' refers to, the group revealed what life was like for thousands of ordinary Syrian citizens as the populist uprising of the Arab Spring descended into a murderous civil war. Many of the films are poetic meditations on everyday life: a shopkeeper joking with his customers, or an underground school for beauticians. Others evoke the realities of civil war with horrific candour – child refugees talking about heads and hands being cut off – while never explicitly showing them.

Abounaddara describe their output as 'emergency cinema': they use an expedient, pared-down aesthetic to convey their messages and counter the information being reported through the international media to the outside world. The group's manifesto, 'What is to be done?' ('Ma al-Amal?'), which was posted online on 15 April 2011, argues for the way that society can be brought together through shared artistic values and cultural pride. Recalling the Syrian Civil War of 1860, the manifesto discusses how Syrian craftsmen and the Syrian nationalist writer Butrus al-Bustani once energized a battle-worn and beleaguered people. The mention of 'Adonis' in the first paragraph refers to the pen-name of the influential modernist Syrian poet Ali Ahmad Said Esber. In October 2014, Abounaddara won the Vera List Center Prize for Art and Politics.

* * *

What is to be done?

They shout 'One, one, one / The Syrian people are one!' and then they fall one after another. Still, here we are, behind the walls of our screens. We rant, we foam at the mouth, we weep from power-lessness, hoping that the monster won't single us out, the way they were singled out. They are our brothers and sisters, actually. And we support them, naturally. But we keep quiet or cover our backs or slip out of view or wait and see what will happen on Friday. For the wise man never confronts, or so the wise man Adonis advises us.

So what is to be done?

That was the very question being asked on days like these in 1860 when our country also faced civil strife. It was besieged by the sultan's janissaries and his thugs, when the answer came from the hand of a carpenter, who invented an original art form. This art form embodied the desire of Syrians to live a shared life within the frame of a nation they had crafted themselves. The name of this carpenter from Damascus is barely remembered, despite his over-flowing artistic talent. But he was at work while the great Butrus al-Bustani called for something new, something called 'the nation' that included all people regardless of their religion ('religion is for God, the nation is for all'). Everybody remembers, however, the mosaic art that our carpenter invented through his synthesis of wood, mother of pearl and bone, inlaid within a single frame, bringing together the traditions of Byzantine mosaics and Arab-Islamic abstraction. This mosaic art became a national symbol that Syria's people took pride in, especially when their president stood in front of foreign delegates.

Today we are faced with a monster that threatens to break this frame over our heads. But this monster is our monster, and we can only call for him to return to his humanity, and then to the ranks of the Syrian people. This is precisely what our brothers and sisters are doing when they respond to bullets with roses and songs. And

this is what we must also do. Produce dignified images and music which reflect the shared humanity of the Syrian people, and shun mainstream media outlets, whether partisan to the regime or the opposition, and their sordid ploys.

M99 Tania Bruguera and Immigrant Movement International

Migrant Manifesto (2011)

The work of the Cuban artist and activist Tania Bruguera (b. 1968) is rooted in performance and in her belief that artists should be active and engaged citizens who create art that is useful to society. In this respect she has been inspired by the Argentinian artist Eduardo Costa and his concept of 'Arte Útil' ('Useful Art': see M36). Bruguera's socially engaged practice navigates the space between art, cultural criticism and socio-political activism, taking utopian art ideas and attempting to translate them into real-world activity.

The idea for Immigrant Movement International was first sparked in 2005, when Bruguera became concerned at the way immigrants were being misrepresented in the media during a wave of riots that swept across France. The unrest occurred after two youths died after trying to escape police harassment in the Clichy-sous-Bois commune of Paris, and quickly spread to the suburbs of other major cities. Many of the rioters were thought to be from poor migrant families, and this resulted in tighter restrictions on immigration being imposed in the riots' aftermath.

In response Bruguera initiated a long-term art project intended to give greater visibility to the plight of immigrants and provide them with better access to political power. The result was Immigrant Movement International, which launched in Queens, New York, in 2010 with support from the Queens Museum of Art and the public-art organization Creative Time. It is now an international association with affiliations in many countries, where it operates as a grass-roots community action group, running

periodic events and providing (among other things) free legal advice.

The 'Migrant Manifesto' was composed 'in collaboration with immigration academics, activists, politicians, and community members' during a convention hosted by Immigrant Movement International in Queens in November 2011. It was read in public for the first time by Tania Bruguera during the United Nations Student Conference on Human Rights, held in New York on 2 December.

* * *

We have been called many names. Illegals. Aliens. Guest Workers. Border crossers. Undesirables. Exiles. Criminals. Non-citizens. Terrorists. Thieves. Foreigners. Invaders. Undocumented.

Our voices converge on these principles:

1. We know that international connectivity is the reality that migrants have helped create, it is the place where we all reside. We understand that the quality of life of a person in a country is contingent on migrants' work. We identify as part of the engine of change.

2. We are all tied to more than one country. The multilaterally shaped phenomenon of migration cannot be solved unilaterally, or else it generates a vulnerable reality for migrants. Implementing universal rights is essential. The right to be included belongs to everyone.

3. We have the right to move and the right to not be forced to move. We demand the same privileges as corporations and the international elite, as they have the freedom to travel and to establish themselves wherever they choose. We are all worthy of opportunity and the chance to progress. We all have the right to a better life.

4. We believe that the only law deserving of our respect is an unprejudiced law, one that protects everyone, everywhere. No

exclusions. No exceptions. We condemn the criminalization of migrant lives.

5. We affirm that being a migrant does not mean belonging to a specific social class nor carrying a particular legal status. To be a migrant means to be an explorer; it means movement, this is our shared condition. Solidarity is our wealth.

6. We acknowledge that individual people with inalienable rights are the true barometer of civilization. We identify with the victories of the abolition of slavery, the civil rights movement, the advancement of women's rights, and the rising achievements of the LGBTQ community. It is our urgent responsibility and our historical duty to make the rights of migrants the next triumph in the quest for human dignity. It is inevitable that the poor treatment of migrants today will be our dishonor tomorrow.

7. We assert the value of the human experience and the intellectual capacity that migrants bring with them as greatly as any labor they provide. We call for the respect of the cultural, social, technical, and political knowledge that migrants command.

8. We are convinced that the functionality of international borders should be re-imagined in the service of humanity.

9. We understand the need to revive the concept of the commons, of the earth as a space that everyone has the right to access and enjoy.

10. We witness how fear creates boundaries, how boundaries create hate and how hate only serves the oppressors. We understand that migrants and non-migrants are interconnected. When the rights of migrants are denied the rights of citizens are at risk.

Dignity has no nationality.

Immigrant Movement International
November 2011

M100 Tania Bruguera

Manifesto on Artists' Rights (2012)

Over the years, the Cuban performance artist and activist Tania Bruguera (b. 1968) has experienced many forms of censorship in order to curtail her artistic activities. Most notably, in December 2014, she was arrested, interrogated and had her passport confiscated for six months by the Cuban authorities when she attempted to stage the work *Yo También Exijo* (*I Also Demand*). Following the announcement a few days earlier of the restoration of diplomatic relations between Cuba and the US, Bruguera intended to place a microphone and podium in Havana's Plaza de la Revolución, and invite ordinary Cubans to express their views on any subject for one minute, without interruption or restriction. On the morning of the event, Bruguera was detained by the police for attempting to disturb the public order, and participants were arrested on the plaza itself. A few months later she was held again after trying to stage a reading of Hannah Arendt's book *The Origins of Totalitarianism* (*Elemente und Ursprünge totaler Herrschaft*, 1951).

In December 2012 Bruguera was invited to Switzerland to attend a meeting of experts on the subject of artistic freedom and cultural rights held by the Office of the United Nations High Commissioner for Human Rights at the Palais des Nations in Geneva. As her address to the gathering, she read out in English a 'Manifesto on Artists' Rights', which argues forcefully for the vital importance of freedom of artistic expression and that it is the duty of governments to safeguard it.

<p style="text-align:center">* * *</p>

Art is not a luxury. Art is a basic social need to which everyone has a right.

Art is a way of building thought, of being aware of oneself and of the others at the same time. It is a methodology in constant transformation for the search of a here and now.

Art is an invitation to questioning; it is the social place of doubt, of wanting to understand and wanting to change reality.

Art is not only a statement of the present, it is also a call for a different future, a better one. Therefore, it is a right not only to enjoy art, but to be able to create it.

Art is a common good that does not have to be entirely understood in the moment one finds it.

Art is a space of vulnerability from which what is social is deconstructed to construct what is human.

Artists not only have the right to dissent, but the duty to do so.

Artists have the right to dissent not only from affective, moral, philosophical, or cultural aspects, but also from economic and political ones.

Artists have the right to disagree with power, with the status quo.

Artists have the right to be respected and protected when they dissent.

The governments of nations where artists work have the duty to protect their right to dissent because that is their social function: to question and address what is difficult to confront.

Without the possibility to dissent, an artist becomes an administrator of technical goods, behaves like a consumption manufacturer and transforms into a jester. It is a sad society where this is all social awareness creates.

Artists also have the right to be understood in the complexity of their dissent. An artist should not be judged first and discussed later. Artists should not be sent to jail because of proposing a 'different' reality, for sharing their ideas, for wanting to strike up a conversation on the way the present unfolds. If the artist's proposal is not understood, it should be discussed by all, not censored by a few.

If one publicly expresses and evinces ideas in a different way from that of those in power, governments, corporations and religious institutions too easily declare that one is irresponsible, wanting to use guilt and incite the masses to violent reactions as their best defense strategy, instead of processing criticism and calling for public debate. Nothing justifies the use of violence against an idea or the person suggesting it.

Governments have the duty to provide a space for self-criticism in which they are accountable for their actions, a space where the people can question them. No government is infallible; no human being – even if elected – has the right to talk for all the citizens. No social solution is permanent and it is the artists who have the opportunity and the duty to suggest the imagery of other social alternatives, of using their communication tools from a space of sensitive responsibility.

Artists suggest a meta-reality, a potential future to be experienced in the present. They suggest experimenting a moment which has not yet arrived, a situation of 'what if that were this way.' Therefore, they cannot be judged from spaces in the past, from laws trying to preserve what is already established.

Governments must stop fearing ideas.

Governments, corporations (today they are like alternative governments), and religious institutions are not the only ones with a right to build a future; this is the right of citizens, and artists are active

citizens. That is why artists have the right and the responsibility not only to think up a different and better world, but to try to build it.

Artists have the right to be artivists (part artists/part activists), because they are an active part of civil society, because art is a safe space from which people can debate, interpret, build, and educate. This space must be defended because it benefits us all: art is a social tool.

Governments should not control art and artists. They should protect them.

Artists have the right not to be censored when gestating their work or during the research process of conceiving it. Artists have the right to create the work they want to create, with no limits; they have the duty to be responsible without self-censorship.

Society has the right to have its public spaces as spaces for creativity and artistic expression, since they also are collective spaces for knowledge and debate. Public space belongs to civic society, not to governments, corporations, or religious institutions.

Freedom of artistic expression does not emerge spontaneously. It is something one learns to reach leaving behind pressure, emotional blackmail, censorship, and self-censorship. This is a difficult process that should be respected and appreciated.

Artistic censorship not only affects artists but the community as well, because it creates an atmosphere of fear and self-censorship paralyzing the possibility of exercising critical thinking.

To think differently from those in power does not make you irresponsible.

In moments of high sensitivity (wars, legislative changes, political transitions), it is the duty of the government to protect and

guarantee dissident, questioning voices, because these are moments in which one cannot do away with rationality and critical thought and it is sometimes only through art that many emerging ideas can make a public appearance. Without dissent there is no chance of progress.

Socially committed artists talk about difficult moments, deal with sensitive topics, but, unlike journalists, they have no legal protection when doing their work. Unlike corporations, they have no significant economic backing. Unlike governments, they have no political power. Art is a social work based on a practice that makes artists vulnerable and, as is the case with journalists, corporations, and governmental or religious institutions, they have the right to be protected because they are doing a public service.

The right to decide the value of an artistic statement is not a right of those in power. It is not the right of governments, of corporations, of religious institutions to define what art is. It is the right of artists to define what art is for them.

Art is a complex product without a single and final interpretation. Artists have the right of not having their oeuvre reduced or simplified as a schematic interpretation which may be manipulated by those in power to provoke and, consequently, result in public offenses directed to the artists, so as to invalidate their proposals.

To create a space for dialogue and not for violence against works of art questioning established ideas and realities, governments should provide educational platforms from which artistic practice may be better understood.

We must be cautious about the increasing criminalization of socially committed artistic creation under the rationale of national security and the need to control information because of political reasons with the purpose of censoring artists.

There are many types of strategies for political censorship. Political censorship is not only exercised through direct political pressure, but censoring the access to economic support, creating a bureaucratic censorship postponing production processes, marginalizing the visibility of a project by drawing artists away from legitimization, and distribution circuits; controlling the right to travel, deciding who has the right to talk on what subjects; and, at times, even using 'popular sensitivity' as censorship. All these are decisions taken and conducted from political power so as not to be challenged.

On the other hand, there are artists who are internationally acknowledged and admired because of being artivists in their countries of origin and who, at a given time, for one reason or another, migrate and establish themselves temporarily in other countries where they find a new type of censorship, a censorship that relegates, pigeonholes, and sets them inside a limited mental geography where they are only allowed to talk critically of the country they come from and not the country to which they have arrived. This is a situation of censorship in which artists are relegated to being uni-dimensionally political: a used political object.

The process of discovering a different society, the inner negotiation required to understand the place of arrival and the place one has left, is inherent to the contemporary condition, which is, increasingly, a migrant condition. This is a condition that artists embody and on which they have the right to express. After all, a national culture is the hybridization of the image those who do not live in the country have of it and all present day by day build, wherever they have originally come from.

We cannot ask artists, whose work is to question society, to keep silent and resort to self-censorship once they cross a territorial border.

Artists have the right not to be fragmented as human beings or as social beings.

Artistic expression is a space to challenge meanings, to defy what is imaginable. This is what, as times goes by, is recognized as culture.

A society with freedom of artistic expression is a healthier society. It is a society where citizens allow themselves to dream of a better world where they have a place. It is a society that expresses itself better, because it expresses itself in its entire complexity.

There is no other type of practice in the public sphere providing the qualities of the space created by art. That is why this space must be protected.

Governments have the duty to protect all their citizens, including those who may be considered uncomfortable because they question government or what is socially established.

Critical thinking is a civic right which becomes evident in artistic practices. That is why, when threatened, we should not talk of censorship, but of the violation of artists' rights.

List of Artist Groups

The following list of artists, art critics, writers, poets, philosophers, sociologists, playwrights, musicians and activists associated with each artist group represented by a manifesto in this book is not exhaustive. In most cases, we have just listed the founding or most prominent members, particularly in cases where the group contains more than fifteen individuals. Some of those listed here have since left their respective groups, but it is hoped that the list will nevertheless help readers create a general picture of the nature of the protagonists associated with each manifesto. Wherever possible, life dates have been given for each member. Where we have been unable to track these dates down, or living artists have chosen not to have their birth date included, we have written 'n.d.' for 'no date'.

Members of the Artists' Front of Thailand (M57), Taring Padi (M93), Frente 3 de Fevereiro (M94) and Abounaddara (M98) have not been listed here because these groups work under their collective name only. For the polymorphous giant Slovenian cooperative NSK (M81) – which comprises the industrial pop band Laibach, the painting collective IRWIN, the graphic design team New Collectivism, the underground theatre group Scipion Nasice Sisters Theatre, as well as various departments of philosophy, film and architecture – only the members of IRWIN are listed here, in relation to their own manifesto, 'The Ear behind the Painting' (M90).

M2. Zenitizma

Dragan Aleksić (1901–58)
Ivan Goll (1891–1950)
Jo Klek (1904–87)
Ljubomir Micić (1895–1971)
Mihailo S. Petrov (1902–83)
Branko Ve Poljanski (1898–1940)
Boško Tokin (1894–1953)

M3. The Art Movement Society

Li Puyuan (1901–56)
Lin Fengmian (1900–91)
Lin Wenzheng (1903–89)

M4. Légitime Défense

Étienne Léro (1910–39)
Thélus Léro (1909–96)
René Ménil (1907–2004)
Jules-Marcel Monnerot (1908–95)
Michel Pilotin (1906–72)
Maurice-Sabas Quitman (n.d.)
Auguste Thésée (n.d.)
Pierre Yoyotte (1900–40)
Simone Yoyotte (1910–33)

M5. The Storm Society

Chang Yu (1901–66)
Chen Zhengbo (1895–1947)
Ni Yide (1901–70)
Pang Xunqin (1906–85)
Qiu Ti (1906–58)
Wang Daoyuan (n.d.)
Wang Jiyuan (1895–1974)
Yang Taiyang (1909–2009)
Zhou Bichu (1903–95)
Zhou Duo (1905–89)

M6. D Group

Nurullah Berk (1906–82)
Abidin Dino (1913–93)
Zeki Faik İzer (1905–88)
Zühtü Müridoğlu (1906–92)
Elif Naci (1898–1987)
Cemal Tollu (1899–1968)

M7. Négritude

First Wave

Aimé Césaire (1913–2008)
Léon Damas (1912–78)
Wifredo Lam (1902–82)
Ronald Moody (1900–84)
Léopold Sédar Senghor (1906–2001)

Second Wave

Frank Bowling (b. 1936)
Uzo Egonu (1931–96)
Ben Enwonwu (1917–94)
Donald Locke (1930–2010)
Aubrey Williams (1926–90)

M8. The European School

Margit Anna (1913–91)
Endre Bálint (1914–86)
Béla Bán (1909–72)
Jenő Barcsay (1900–88)
Lajos Barta (1899–1986)
István Beöthy (1897–1961)
Dezső Bokros Birman (1889–1965)
Miklós Borsos (1906–90)
Béla Czóbel (1883–1976)
József Egry (1883–1951)
Erzsébet Forgács Hann (1897–1954)
Jenő Gadányi (1896–1960)
Tihamér Gyamathy (1915–2005)

Pál Gegesi Kiss (1900–93)
Tihamér Gyarmathy (1915–2005)
Étienne Hajdú (1907–96)
József Jakovits (1909–94)
Lajos Kassák (1887–1967)
Dezső Korniss (1908–84)
Tamás Lossonczy (1904–2009)
Ödön Márffy (1878–1959)
Árpád Mezei (1902–98)
Imre Pán (1904–72)
Bertalan Pór (1880–1964)
Endre Rozsda (1913–99)
Ernő Schubert (1903–60)
Piroska Szántó (1913–98)

M9. The Surrealist Group of Cairo
Ikbal El Alailly (?–1984)
Adel Amiu (n.d.)
Georges Henein (1914–73)
Fouad Kamel (1919–73)
Hassan el Telmisany (1923–87)
Ramses Younane (1913–66)
Kamel Zehery (n.d.)

M10. Arte Madí
Carmelo Arden Quin (1913–2010)
Martín Blaszko (1920–2011)
Estéban Eitler (1913–60)
Gyula Košice (1924–2016)
Diyi Laañ (b. 1927)
Rhod Rothfuss (1920–69)

M12. The Baghdad Modern Art Group
Qahtan Abdallah (n.d.)
Mohammad al-Husni (n.d.)

Jabra Ibrahim Jabra (1919–94)
Mahmoud Sabri (1927–2012)
Shakir Hassan al-Said (1925–2004)
Jewad Selim (1919–61)
Lorna Selim (b. 1928)

M13. The Fighting Cock Art Group
Gholam Hossein Gharib (1922–2005)
Hooshang Irani (1925–73)
Hassan Shirvani (n.d.)
Manuchehr Sheybani (1924–91)
Jalil Ziapoor (1920–99)

M14. Exat 51 Group
Bernardo Bernardi (1921–85)
Zdravko Bregovac (1924–98)
Vlado Kristl (1923–2004)
Ivan Picelj (1924–2011)
Zvonimir Radić (1921–83)
Božidar Rašica (1912–92)
Vjenceslav Richter (1917–2002)
Aleksandar Srnec (1924–2010)
Vladimir Zarahović (n.d.)

M15. Grupo ruptura
Geraldo de Barros (1923–98)
Lothar Charoux (1912–87)
Waldemar Cordeiro (1925–73)
Kazmer Féjer (1923–89)
Leopold Haar (1910–54)
Luiz Sacilotto (1924–2003)
Anatol Władysław (1913–2004)

M16. The Calcutta Group
Gobardhan Ash (1907–96)

Sheila Auden (1913–2002)
Ramkinkar Baij (1906–80)
Kamal Dasgupta (1912–74)
Prodosh Dasgupta (1912–91)
Makhan Dutta Gupta (n.d.)
Gopal Ghose (1913–80)
Rathin Maitra (1913–97)
Nirode Mazumdar (1916–82)
Hemanta Misra (1917–2009)
Pran Krishna Pal (1915–88)
Abani Sen (1905–72)
Paritosh Sen (1918–2008)
Sunil Madhav Sen (1910–79)
Subho Tagore (1912–85)

M17. Interplanetary Art
Giuseppe Alfano (n.d.)
Giovanni Anceschi (b. 1939)
Enrico Baj (1924–2003)
Luca Bajini (n.d.)
Nanni Balestrini (b. 1935)
Guido Biasi (b. 1933)
Lucio Del Pezzo (b. 1933)
Bruno Di Bello (b. 1938)
Farfa (1876–1964)
Sergio Fergola (b. 1936)
Donato Grieco (n.d.)
Mario Persico (b. 1930)
Antonio Porta (1935–89)
Antonio Recalcati (b. 1938)
Paolo Redaelli (n.d.)
Ettore Sordini (1934–2012)
Angelo Verga (b. 1933)

M18. The Zaria Art Society
Jimoh Akolo (b. 1934)

Felix Nwoko Ekeada (b. 1934)
Yusuf Grillo (b. 1934)
Ogbonnaya Nwagbara (1934–85)
Demas Nwoko (b. 1935)
Emmanuel Okechukwu Odita
 (b. 1936)
Simon Obiekezie Okeke
 (1937–1969)
Uche Okeke (1933–2016)
William Olaosebikan (n.d.)
Bruce Onobrakpeya (b. 1932)
Oseloka Osadebe (b. 1935)

M19. El Techo de la Ballena
Edmundo Aray (b. 1936)
Juan Calzadilla (b. 1931)
Carlos Contramaestre (1933–1996)
Mary Ferrero (?–2003)
Daniel González (b. 1934)
Adriano González León
 (1931–2008)
Fernando Irazábal (b. 1936)
Rodolfo Izaguirre (b. 1931)
Gabriel Morera (b. 1933)
Dámaso Ogaz (1926–2001)
Caupolicán Ovalles (1936–2001)
Francisco Pérez Perdomo (1930–2013)

M20. Gorgona
Dimitrije Bašičević (1921–87)
Miljenko Horvat (1935–2012)
Marijan Jevšovar (1922–98)
Julije Knifer (1924–2004)
Ivan Kožarić (b. 1921)
Matko Meštrović (b. 1933)
Radoslav Putar (1921–94)

Đuro Seder (b. 1927)
Josip Vaništa (b. 1924)

M22. Jikan-Ha
Doi Junen (n.d.)
Nagano Shōzo (1928–2007)
Nakazawa Ushio (1932–2015)
Tanaka Fuji (b. 1929)

M23. Group 1890
Jyoti Bhatt (b. 1934)
Eric Bowen (1929–2002)
Raghav Kaneria (b. 1939)
Ambadas Khobragade (1922–2012)
Rajesh Mehra (b. 1932)
M. Reddeppa Naidu (1932–99)
S. G. Nikam (b. 1931)
Balkrishna Patel (b. 1927)
Jeram Patel (1930–2016)
Himmat Shah (b. 1933)
Gulam Mohammed Sheikh
 (b. 1937)
Jagdish Swaminathan (1928–94)

M26. Aktual Art
Milan Knížák (b. 1940)
Jan Mach (b. 1943)
Vit Mach (b. 1945)
Soňa Švecová (b. 1946)
Jan Trtílek (b. 1938)

M27. Viennese Actionism
Günter Brus (b. 1938)
Otto Mühl (1925–2013)
Hermann Nitsch (b. 1938)
Rudolf Schwarzkogler (1940–69)

M28. HAPPSOC
Stano Filko (1937–2015)
Zita Kostrová (n.d.)
Alex Mlynárčik (b. 1934)

M31. Arte de los Medios de
Comunicación Masivos
Eduardo Costa (b. 1940)
Raúl Escari (b. 1944)
Roberto Jacoby (b. 1944)

M32. OHO
Milenko Matanović (b. 1947)
David Nez (b. 1949)
I. G. Plamen (b. 1945)
Marko Pogačnik (b. 1944)
Andraž Šalamun (b. 1947)
Tomaž Šalamun (1941–2014)

M33. The Kineticist Group
Galina Bitt (b. 1946)
Pawel Burdukow (b. 1950)
Viktor Buturlin (b. 1946)
Tatiana Bystrowa-Grigorjewa
 (b. 1944)
Vladimir Galkin (b. 1946)
Mikhail Dorokov (b. 1942)
Galina Golowejka (b. 1955)
Alexander Grigoriev (b. 1949)
Francisco Infante-Arana (b. 1943)
Sergei Itzko (b. 1949)
Viacheslav Koleichuk (b. 1944)
Claudia Nedelko (b. 1950)
Lev Nussberg (b. 1937)
Ludmilla Orlowa (b. 1942)
Natalia Prokuratova (b. 1948)

Wjatscheslaw Schtscherbakow
(b. 1941)
Viktor Stepanov (b. 1943)
Rimma Zanevskaya (b. 1930)

M34. The Aouchem Group
Hamid Abdoun (b. 1929)
Mustapha Adane (b. 1933)
Mohamed Ben Baghdad (b. 1941)
Mustapha Dahmani (b. 1942)
Baya Mahiedine (b. 1931)
Denis Martinez (b. 1941)
Choukri Mesli (b. 1931)
Said Saidani (b. 1944)
Rezki Zerarti (b. 1938)

M35. The Vanguard Artists' Group
Maria Elvira de Arechavala (n.d)
Beatriz Balbé (n.d)
Graciela Borthwick (b. 1941)
Aldo Bortolotti (1930–2017)
Graciela Carnevale (b. 1942)
Jorge Cohen (1941–93)
Rodolfo Elizalde (1932–2015)
Noemí Escandell (b. 1942)
Eduardo Favario (1939–75)
León Ferrari (1920–2013)
Emilio Ghilioni (b. 1935)
Edmundo Giura (n.d)
María Teresa Gramuglio (b. 1939)
Martha Greiner (b. 1940)
Roberto Jacoby (b. 1944)
José Maria Lavarello (n.d)
Sara López Dupuy (n.d)
Rubén Naranjo (1929–2005)

David de Nully Braun (n.d)
Raúl Perez Cantón (n.d)
Oscar Pidustwa (n.d)
Estella Pomerantz (b. 1947)
Norberto Púzzolo (b. 1948)
Juan Pablo Renzi (1940–92)
Jaime Rippa (b. 1929)
Nicolás Rosa (1938–2006)
Domingo J. A. Sapia (n.d)
Carlos Schork (n.d)
Nora de Schork (n.d)
Roberto Zara (n.d)

M37. The Casablanca School
Mohamed Ataallah (1939–2014)
Farid Belkahia (1934–2014)
Mohamed Chebaa (1935–2013)
Mustapha Hafid (b. 1942)
Mohamed Hamidi (b. 1941)
Mohamed Melehi (b. 1936)

M38. Bikyōtō
Hikosaka Naoyoshi (b. 1946)
Hori Kōsai (b. 1947)
Ishiuchi Miyako (b. 1947)
Miyamoto Ryūji (b. 1947)
Tone Yasunao (b. 1935)

M41. The New Vision Group
Dia al-Azzawi (b. 1939)
Muhammad Mahr al-Din
(b. 1938)
Ismail Fattah (1934–2004)
Saleh al-Jumaie (b. 1939)
Rafa al-Nasiri (1940–2013)
Hashem Samarji (b. 1937)

M42. Grupo Vértebra
Roberto Cabrera (1939–2014)
Marco Augusto Quiroa (1937–2004)
Elmar René Rojas (b. 1942)

M45. Rivolta Femminile
Carla Accardi (1924–2014)
Elvira Banotti (1933–2014)
Carla Lonzi (1931–82)

M50. Sots-Art
Vitaly Komar (b. 1943)
Aleksandr Melamid (b. 1945)

M51. The Fight Censorship Group
Judith Bernstein (b. 1942)
Louise Bourgeois (1911–2010)
Martha Edelheit (b. 1931)
Joan Glueckman (1940–78)
Eunice Golden (b. 1927)
Juanita McNeely (b. 1936)
Barbara Nessim (b. 1939)
Anne Sharp (b. 1943)
Joan Semmel (b. 1932)
Anita Steckel (1930–2012)
Hannah Wilke (1940–1993)

M52. The One Dimension Group
Jamil Hamoudi (1924–2003)
Madiha Omar (1908–2005)
Shakir Hassan al-Said (1925–2004)

M53. AFRI-COBRA
Sherman Beck (b. 1942)
Jeff Donaldson (1932–2004)
Napoleon Henderson (b. 1943)

Jae Jarrell (b. 1935)
Wadsworth Jarrell (b. 1929)
Barbara Jones-Hogu (b. 1938)
Omar Lamar (n.d.)
Carolyn Lawrence (b. 1940)
Nelson Stevens (b. 1938)
Gerald Williams (b. 1941)

M54. Generation Anak Alam
Maryam Abdullah (n.d.)
Usman Awang (1929–2001)
Zulkifli Dahlan (b. 1952)
Abdul Ghafar Ibrahim (b. 1943)
Mustapha Ibrahim (b. 1946)
Siti Zainon Ismail (b. 1949)
Tajuddin Ismail (b. 1949)
Latiff Mohidin (b. 1938)
Yussoff Osman (b. 1950)
Ali Mabuha Rahamad (b. 1952)
Sharifah Fatimah Zubir (b. 1948)

M58. The Indonesian New Arts Movement
Siti Adiyati (n.d.)
Bonyong Munni Ardhi (b. 1946)
Anyool Soebroto (n.d.)
Hardi (b. 1951)
F. X. Harsono (b. 1949)
Muryoto Hartoyo (b. 1942)
Nanik Mirna (b. 1951)
Bonyong Muniardi (b. 1946)
David Albert Peransi (1939–93)
Ris Purwono (n.d.)
Pandu Sudewo (n.d.)
Jim Supangkat (b. 1948)
Bachtiar Zainoel (n.d.)

M60. The Azad Group
Massoud Arabshahi (b. 1935)
Abdorreza Daryabeygi (b. 1924)
Hossein Kazemi (1924–96)
Sirak Melkonian (b. 1931)
Morteza Momayez (1935–2005)
Gholam Hossein Nami (b. 1936)
Faramarz Pilaram (1937–82)
Parviz Tanavoli (b. 1937)

M61. Kaisahan
Papo de Asis (b. 1949)
Pablo Baen Santos (b. 1943)
Antipas Delotavo (b. 1954)
Renato Habulan (b. 1953)
Albert Jimenez (n.d.)
Edgar Talusan Fernandez (b. 1955)

M65. Grupo Antillano
Esteban Guillermo Ayala Ferrer
 (1929–95)
Osvaldo Castilla Romero (b. 1942)
Manuel Couceiro Prado (1923–81)
Herminio Escalona González
 (b. 1944)
Ever Fonseca Cerviño (b. 1938)
Ramón Haiti Eduardo (1932–2013)
Ángel Laborde Wilson (b. 1942)
Manuel Mendive Hoyo (b. 1944)
Leonel Morales Pérez (b. 1940)
Claudina Clara Morera Cabrera
 (b. 1944)
Miguel de Jesús Ocejo López
 (b. 1940)
Rafael Queneditt Morales
 (1942–2016)

Marcos Rogelio Rodríguez Cobas
 (1925–2014)
Arnaldo Tomás Rodríguez
 Larrinaga (b. 1948)
Oscar Rodríguez Lasseria (b. 1950)
Pablo Daniel Toscano Mora
 (1940–2003)

M66. The Crystalist Group
Kamala Ibrahim Ishaq (b. 1939)
Muhammad Hamid Shaddad (n.d.)
Nayla El Tayib (n.d.)

M68. The Stars Group
Ai Weiwei (b. 1957)
Bo Yun (b. 1948)
Huang Rui (b. 1952)
Li Shuang (b. 1957)
Ma Desheng (b. 1952)
Mao Lizi (b. 1950)
Qu Leilei (b. 1951)
Shao Fei (b. 1954)
Wang Keping (b. 1949)
Wang Zhiping (b. 1947)
Yan Li (b. 1954)
Zhong Acheng (b. 1949)

M70. Reality and Utterance
Ahn Chang-hong (b. 1953)
Joo Jae-hwan (b. 1941)
Kim Jeong-heon (n.d.)
Min Jeong-gi (b. 1949)
Noh Won-hee (b. 1948)
Shin Kyeong-ho (n.d.)
Son Jang-seob (b. 1941)
Sung Wan-kyung (b. 1944)

M72. Blk Art Group
Eddie Chambers (b. 1960)
Dominic Dawes (n.d.)
Andrew Hazel (n.d.)
Claudette Johnson (b. 1959)
Wenda Leslie (n.d.)
Ian Palmer (n.d.)
Keith Piper (1960)
Donald Rodney (1961–98)
Marlene Smith (b. 1964)

M73. Colectivo de Acciones de Arte
Fernando Balcells (b. 1950)
Juan Castillo (b. 1952)
Diamela Eltit (b. 1947)
Lotty Rosenfeld (b. 1943)
Raúl Zurita (b. 1950)

M74. The Black Audio Film Collective
John Akomfrah (b. 1957)
Reece Auguiste (n.d.)
Edward George (n.d.)
Lina Gopaul (n.d.)
Avril Johnson (n.d.)
Claire Joseph (n.d.)
David Lawson (n.d.)
Trevor Mathison (n.d.)

M75. Women Artists of Pakistan
Abbasi Abidi (n.d.)
Meher Afroz (b. 1948)
Talat Ahmad (n.d.)
Veeda Ahmed (n.d.)

Sheherezade Alam (b. 1948)
Riffat Alvi (b. 1945)
Mamoona Bashir (n.d.)
Salima Hashmi (b. 1942)
Birjees Iqbal (n.d.)
Zubeda Javed (1937–2015)
Jalees Nagi (b. 1938)
Nahid (n.d.)
Qudsia Nisar (b. 1948)
Lala Rukh (b. 1948)
Rabia Zuberi (b. 1940)

M78. Laboratoire AGIT'art
Youssoufa Dione (n.d.)
Djibril Diop Mambéty (1945–98)
Ass M'Bengue (b. 1959)
Issa Samb (1944–2017)
El Hadji Sy (b. 1954)

M79. Dumb Type
Andō Yuriko (n.d.)
Hagi Yurie (n.d.)
Hanaishi Masato (n.d.)
Harada Naoki (n.d.)
Hozumi Yukihiro (n.d.)
Fukuhara Masami (n.d.)
Furuhashi Teiji (1960–95)
Ikubo Mari (n.d.)
Jindō Tomoko (n.d.)
Kitamura Misaka (n.d.)
Koyamada Tōru (b. 1961)
Matsui Yōko (n.d.)
Miyamoto Sakiko (n.d.)
Okamoto Kōji (n.d.)
Ōuchi Seiko (n.d.)
Takatani Shirō (b. 1963)

Tomari Hiromasa (b. 1960)
Yabuuchi Masako (n.d.)
Yasuda Masako (n.d.)

M80. Chinese United Overseas Artists

Ai Weiwei (b. 1957)
Bai Jingzhou (1946–2011)
Ding Shaoguang (b. 1939)
Huang Rui (b. 1952)
Ji Cheng (b. 1956)
Jiang Tiefeng (b. 1938)
Ma Desheng (b. 1952)
Qin Yuanyue (b. 1940)
Wang Keping (b. 1949)
Wang Zhiping (b. 1947)
Wu Hong (b. 1945)
Yan Li (b. 1954)
Yuan Yunsheng (b. 1937)
Yuan Zuo (b. 1957)
Zeng Xiaojun (b. 1954)
Zhang Hongnien (b. 1947)
Zhang Hongtu (b. 1943)

M82. Vohou-Vohou

Youssouf Bath (b. 1949)
Tiébéna Dagnogo (b. 1963)
Barhima Keita Ibak (b. 1955)
Théodore Koudougnon (b. 1951)
Essoh Marcel N'Guessan (b. 1959)
Kra Nguessan (b. 1954)
Mathilde Moro (b. 1958)
Yacouba Touré (b. 1955)

M83. The Pond Association

Bao Jianfei (b. 1962)

Cao Xuelei (b. 1962)
Geng Jianyi (b. 1962)
Song Ling (b. 1961)
Wang Qiang (b. 1957)
Zhang Peili (b. 1957)

M86. The School of the One

Ahmed Abdel Aal (b. 1946)
Ahmed Hamid Al-Arabi (n.d.)
Ibrahim Al-Awam (n.d.)
Muhammad Hussayn Al-Fakki (n.d.)
Ahmed Abdallah Utaibi (n.d.)

M87. The Red Brigade

Cao Xiaodong (b. 1961)
Chai Xiaogang (b. 1962)
Ding Fang (b. 1956)
Guan Ce (b. 1957)
Shen Qin (b. 1958)
Xu Lei (b. 1963)
Xu Yihui (b. 1964)
Yang Yisheng (n.d.)
Yang Zhilin (b. 1956)

M88. The Kerala Radicals

Jyothi Basu (b. 1960)
Anita Dube (b. 1958)
K. R. Karunakaran (n.d.)
K. P. Krishnakumar (1958–89)
K. M. Madhusudhanan (b. 1956)
Alex Mathew (b. 1957)
K. Raghunathan (b. 1958)

M89. The Eye Society

Jerry Buhari (b. 1959)
Matt Ehizele (b. 1958)

Jacob Jari (b. 1960)
Gani Odutokun (1946–95)
Tonie Okpe (b. 1961)

M90. IRWIN
Dušan Mandič (b. 1954)
Miran Mohar (b. 1958)
Andrej Savski (b. 1961)

Roman Uranjek (b. 1961)
Borut Vogelnik (b. 1959)

M91. VNS Matrix
Virginia Barratt (b. 1959)
Julianne Pierce (b. 1963)
Francesca da Rimini (b. 1956)
Josephine Starrs (b. 1955)

Sources and Further Reading

In most instances, the sources from which these manifestos have been reproduced are the first port of call for readers wishing to find out more. On those occasions where that is not the case, then alternative suggestions for further reading have been specified where they exist.

For permission to use the manifestos collected here, we are most grateful to the following:

M1. 'Art and Swadeshi' (1909), by Ananda K. Coomaraswamy. First published in the *Central Hindu College Magazine*, vol. 9 (1909). Text taken from Ananda K. Coomaraswamy, *Art and Swadeshi* (Madras: Ganesh & Co., 1912).

M2. 'Manifest Zenitizma' (1921), by Ljubomir Micić. First published in *Zenit* (*Zenith*), no. 1 (February 1921). English text taken from *Impossible Histories: Historical Avant-Gardes, Neo-Avant-Gardes, and Post-Avant-Gardes in Yugoslavia, 1918–1991*, ed. Dubravka Djurić and Miško Šuvaković (Cambridge, MA: MIT Press, 2003). Translation by Branka Nikolić Arrivé. Reprinted here by kind permission of the National Museum in Belgrade.

M3. Manifesto of the Art Movement Society (1929), by Lin Fengmian. First published in *Yapole* (*Apollo*), no. 8 (1929). English text taken from *Shanghai Modern, 1919–1945*, ed. Jo-Anne Birnie Danzker, Ken Lum, Zheng Shengtian (Ostfildern: Hatje Cantz, 2004). Translation by Michael Fei.

M4. Légitime Défense Manifesto (1932). First published in *Légitime défense* (*Legitimate Defence*), no. 1 (June 1932). English

text taken from *Black, Brown and Beige: Surrealist Writings from Africa and the Diaspora*, ed. Franklin Rosemont and Robin D. G. Kelley (Austin, TX: University of Texas Press, 2009). Translation by Alex Wilder. Reprinted here by kind permission of Robin D. G. Kelley and Surrealist Editions, Chicago.

M5. Manifesto of the Storm Society (1932). First published in *Yishu xunkan (Art Journal)*, vol. 1, no. 5 (October 1932). English text taken from *Shanghai Modern, 1919–1945*, ed. Jo-Anne Birnie Danzker, Ken Lum, Zheng Shengtian (Ostfildern: Hatje Cantz, 2004). Translation by Michael Fei. Copyright © The Storm Society, 1932.

M6. 'D Group Manifesto' (1933), by Peyami Safa. First published in the exhibition catalogue *d Grubunu Takdim (Introducing the d Group)* (Istanbul, 1933). English text taken from *d Grubu = d Group, 1933–1951*, ed. Nihal Elvan (Istanbul: Yapı Kredi Yayınları, 2004). Translation by Mary Işin. Copyright © Peyami Safa, 1933.

M7. 'Nègreries: Black Youth and Assimilation' (1935), by Aimé Césaire. First published in *L'Étudiant noir (The Black Student)*, no. 1 (March 1935). English text taken from *Black, Brown and Beige: Surrealist Writings from Africa and the Diaspora*, ed. Franklin Rosemont and Robin D. G. Kelley (Austin, TX: University of Texas Press, 2009). Translation by Dale Tomich. Reprinted here by kind permission of Robin D. G. Kelley and Surrealist Editions, Chicago. Copyright © Aimé Césaire Estate, 1935.

M8. Manifesto of the European School (1945). First published in *Az Európai Iskola füzetei (Brochures of the European School)* (Budapest: Misztótfalusi, Budapest, 1946). English text taken from Éva Forgács, *Hungarian Art: Confrontation and Revival in the Modern Movement* (Los Angeles: DoppelHouse Press, 2016). Translation © Éva Forgács, 2016.

M9. 'Manifesto' (1945), by Georges Henein. First published in the pamphlet *L'Enfance de la chose (The Childhood of the Thing)* (Cairo, 1945). English text taken from *Black, Brown and Beige:*

Surrealist Writings from Africa and the Diaspora, ed. Franklin Rosemont and Robin D. G. Kelley (Austin, TX: University of Texas Press. 2009). Translation by P. Wood. Reprinted here by kind permission of Robin D. G. Kelley and Surrealist Editions, Chicago. Copyright © Georges Henein, 1945.

M10. 'Madí Manifesto' (1947), by Gyula Košice. First published in Arte Madí's journal in 1947. English text taken from Dawn Ades, *Art in Latin America: The Modern Era, 1820–1980* (New Haven, CT: Yale University Press, 1989). Copyright © Gyula Košice, 1947.

M11. 'Explosionalism Manifesto No. 2' (1949), by Vladimír Boudník. First published in *Tvář (Face)*, no. 9 (March 1949). Text taken from M. Nešlehová et al., *Český informel: Průkopníci abstrakce z let 1957–1964 (Czech Informel: Pioneers of Abstraction, 1957–1964)* (Prague: Galerie hlavního města Prahy, 1991). New translation by Dan and Pavlína Morgan. Copyright © Vladimír Boudník, 1949.

M12. 'Manifesto of the Baghdad Modern Art Group' (1951), by Shakir Hassan al-Said. First published in *Al-Adib*, vol. 10, no. 7 (July 1951). English text taken from *Modern Art in the Arab World: Primary Documents*, ed. Anneka Lenssen, Sarah A. Rogers and Nada Shabout (New York: Museum of Modern Art, forthcoming). Translation by Dina El Husseiny. Translation copyright © MoMA, 2017/18. See further, *Al-Bayanat al-Fanniyya fi al-Iraq (Art Manifestos in Iraq)*, ed. Shakir Hassan al-Said (Baghdad: Wizarat al-Ilam, Mudiriyyat al-Thaqafa al-Amma, 1973).

M13. 'The Nightingale's Butcher Manifesto' (1951), by the Fighting Cock Art Group. First published in *Khorous-e jangi (Fighting Cock)* (June 1951). English text taken from *ARTMargins*, vol. 3, no. 2 (June 2014). Translation by Bavand Behpoor. Courtesy of Bavand Behpoor and the Library, Museum and Document Centre of the Parliament of Iran. Translation copyright © *ARTMargins* and the Massachusetts Institute of Technology, 2014.

M14. Manifesto of Exat 51 Group. First self-published by Exat 51 in December 1951. English text taken from *Impossible Histories:*

Historical Avant-Gardes, Neo-Avant-Gardes, and Post-Avant-Gardes in Yugoslavia, 1918–1991, ed. Dubravka Djurić and Miško Šuvaković (Cambridge, MA: MIT Press, 2003). Translation by Branka Nikolić Arrivé. Translation copyright © MIT Press, 2003. Reprinted by kind permission of the Institute for the Research of the Avant-Garde, the Marinko Sudac Collection.

M15. 'ruptura Manifesto' (1952), by Waldemar Cordeiro. First published in the newspaper *Correio Paulistano,* 11 January 1953. English text taken from Mari Carmen Ramírez and Héctor Olea, *Inverted Utopias: Avant-Garde Art in Latin America* (New Haven, CT: Yale University Press in association with the Museum of Fine Arts, Houston, 2004). Translation by Laura Pérez. Reprinted here by kind permission of Waldemar Cordeiro Estate, and Luis Sacilotto Estate, with thanks to Analivia Cordeiro and Valter Sacilotto. Copyright © Grupo ruptura, 1952.

M16. 'Manifesto of the Calcutta Group' (1953) (extract). First self-published in a Calcutta Group handbook in 1953. Text taken from Sanjoy Malik, 'The Calcutta Group (1943–1953)', in *Art & Deal,* vol. 3, no. 2 (October–December 2004). Copy of the text kindly provided by Asia Art Archive. See further, Pran Nath Mago, *Contemporary Art in India: A Perspective* (New Delhi: National Book Trust, India, 2001).

M17. 'Interplanetary Art' (1959), by Enrico Baj. First published in *Il gesto (The Gesture),* no. 4 (September 1959). English text taken from *The Catalogue Raisonné for Baj's Complete Works,* ed. Enrico Crispolti, Roberta Cerini Baj, Henry Martin, Herbert Lust (Turin: Giulio Bolaffi, 1973). Translation by Henry Martin. Reprinted here by kind permission of Roberta Cerini Baj. Copyright © Estate of Enrico Baj, 1959.

M18. 'Natural Synthesis' (1960), by Uche Okeke. First published in *Art Society, Zaria* (October, 1960). Text taken from *Seven Stories about Modern Art in Africa,* ed. Clémentine Deliss and Jane Havell (London: Whitechapel Art Gallery, 1995). Reprinted here by kind permission of Ijoema Okeke. Copyright © Uche Okeke, 1960.

M19. 'For the Restitution of Magma' (1961), by El Techo de la Ballena. First published in *Rayado sobre el Techo de la Ballena* (*Stripes on the Roof of the Whale*), no. 1 (March 1961). English text taken from *Alfredo Boulton and His Contemporaries: Critical Dialogues in Venezuelan Art, 1912–1974*, ed. Ariel Jiménez (New York: Museum of Modern Art, 2008). Translation by Laura Pérez. Translation copyright © MoMA, 2008.

M20. 'Untitled (Gorgona Manifesto)' (1961), by Josip Vaništa. First published in *Gorgona*, no. 1 (Easter 1961). English text taken from *Impossible Histories: Historical Avant-Gardes, Neo-Avant-Gardes, and Post-Avant-Gardes in Yugoslavia, 1918–1991*, ed. Dubravka Djurić and Miško Šuvaković (Cambridge, MA: MIT Press, 2003). Translation copyright © MIT Press, 2003. Translation by Branka Nikolić Arrivé. Reprinted here by kind permission of the Institute for the Research of the Avant-Garde, the Marinko Sudac Collection. Copyright © Josip Vaništa, 1961.

M21. 'A Statement of Principles' (1961), by Maya Deren. First published in *Film Culture*, nos. 22–3 (Summer 1961). Text taken from *Film as Film: Formal Experiment in Film, 1910–1975* (London: Arts Council of Great Britain, 1979). With thanks to Anthology Film Archives. See further, VèVè A. Clark, Millicent Hodson and Catrina Neiman, *The Legend of Maya Deren: A Documentary Biography and Collected Works*, 2 vols (New York: Anthology Film Archives/Film Culture, 1984–8). Copyright © Maya Deren, 1961.

M22. 'Manifesto of the Jikan-Ha Group' (1962), by Nakazawa Ushio. First self-published by Jikan-Ha as a flyer in 1962. English text taken from *From Postwar to Postmodern: Art in Japan 1945–1989. Primary Documents*, ed. Doryun Chong, Michio Hayashi, Kenji Kajiya and Fumihiko Sumitomo (New York: Museum of Modern Art, 2012). Translation by Christopher Stephens. Reprinted here by kind permission of Nakazawa Hideko. Copyright © Nakazawa Ushio, 1962.

M23. 'Group 1890 Manifesto' (1963), by Jagdish Swaminathan. First published in the exhibition catalogue *Group 1890* (New

Delhi, 1963). Copy of the text kindly provided by Asia Art Archive. Copyright © Jagdish Swaminathan, 1963. See further, Pran Nath Mago, *Contemporary Art in India: A Perspective* (New Delhi: National Book Trust, India, 2001).

M24. 'Manifesto Vivo-Dito' (1963), by Alberto Greco. Original unpublished manuscript can be seen on the website Documents of 20th-Century Latin American and Latino Art (International Center for the Arts of the Americas at the Museum of Fine Arts, Houston) at www.icaadocs.mfah.org. English text taken from *Listen Here Now! Argentine Art of the 1960s: Writings of the Avant-Garde*, ed. Inés Katzenstein (New York: Museum of Modern Art, 2004). Translation by Marguerite Feitlowitz. Copyright © Alberto Greco, 1963.

M25. 'The Emballage Manifesto' (1964), by Tadeusz Kantor. First published in *Opus*, no. 6 (September 1968). English text taken from Tadeusz Kantor, *A Journey through Other Spaces: Essays and Manifestos, 1944–1990*, ed. and trans. by Michal Kobialka (Berkeley, CA: University of California Press, 1993). Reprinted here by kind permission of Maria Kantor and Dorota Krakowska. Copyright © Maria Kantor, Dorota Krakowska, 1993.

M26. 'Manifesto of Aktual Art' (1964), by Milan Knížák, Jan Mach, Vit Mach, Soňa Švecová and Jan Trtílek. First published in *Aktualní umění (Contemporary Art)*, no. 1 (October 1964). English translation of the text kindly provided by Milan Knížák. Reprinted here by kind permission of the artists. Copyright © Milan Knížák, Jan Mach, Vit Mach, Soňa Švecová, Jan Trtílek, 1963–5. See further, Marian Mazzone, 'Drawing Conceptual Lessons from 1968', *Third Text: Critical Perspective on Contemporary Art and Culture*, vol. 23, no. 1 (January 2009).

M27. 'Material Action Manifesto' (1965), by Otto Mühl. First published in *Le Marais* (July 1965). English text taken from *Brus, Muehl, Nitsch, Schwarzkogler: Writings of the Vienna Actionists*, ed. and trans. Malcolm Green (London: Atlas Press, 1999). Translation © Malcolm Green, 1999. Copyright © Otto Mühl Archive, 1965.

M28. 'HAPPSOC Manifesto' (1965), by Stano Filko, Alex Mlynárčik and Zita Kostrová. First published in *Stano Filko – 1965/69* (Bratislava: A-Press 1970). English text taken from *Primary Documents: A Sourcebook for Eastern and Central European Art since the 1950s*, ed. Laura Hoptman and Tomáš Pospiszyl (New York: Museum of Modern Art, 2002). Translation by Eric Dluhosch. Reprinted here by kind permission of the Institute for the Research of the Avant-Garde, the Marinko Sudac Collection. Copyright © HAPPSOC, 1965.

M29. 'MMMMMMM . . . Manifesto (a fragment)' (1965), by David Medalla. First published in *Signals Newsbulletin*, no. 8 (June 1965). Copy of the text kindly provided by David Medalla. Reprinted here by kind permission of David Medalla. Copyright © David Medalla, 1965. See further, Guy Brett, *Exploding Galaxies: The Art of David Medalla* (London: Kala, 1995).

M30. 'Anti-Happening (Subjective Objectivity System)' (1965), by Július Koller. Translation courtesy of the Július Koller Society. Reprinted here by kind permission of the Institute for the Research of the Avant-Garde, the Marinko Sudac Collection. Copyright © Július Koller, 1965. See further, http://www.tate.org.uk/art/artists/julius-koller-10345.

M31. 'A Mass-Mediatic Art' (1966), by Eduardo Costa, Raúl Escari and Roberto Jacoby. First published in *Happenings*, ed. Oscar Masotta (Buenos Aires: Editorial Jorge Álvarez, 1967). English text taken from Mari Carmen Ramírez and Héctor Olea, *Inverted Utopias: Avant-Garde Art in Latin America* (New Haven, CT: Yale University Press in association with the Museum of Fine Arts, Houston, 2004). Translation by Héctor Olea. Reprinted here by kind permission of the artists. Copyright © Eduardo Costa, Raúl Escari, Roberto Jacoby, 1966.

M32. 'OHO' (1966), by I. G. Plamen and Marko Pogačnik. First published in *Tribuna*, no. 6 (November 1966). English text taken from *Impossible Histories: Historical Avant-Gardes,*

Neo-Avant-Gardes, and Post-Avant-Gardes in Yugoslavia, 1918–1991, ed. Dubravka Djurić and Miško Šuvaković (Cambridge, MA: MIT Press, 2003). Translation by Branka Nikolić Arrivé. Reprinted here by kind permission of the artists. Copyright © I. G. Plamen and Marko Pogačnik, 1966.

M33. 'A Kinetic Manifesto' (1966), by Lev Nussberg. Originally distributed privately in manuscript in 1966. English text taken from Igor Golomshtok and Alexander Glezer, *Unofficial Art from the Soviet Union*, ed. Michael Scammell (London: Secker & Warburg, 1977). Reprinted here by kind permission of Index on Censorship. Copyright © Lev Nussberg, 1966.

M34. 'The Aouchem Manifesto' (1967), by the Aouchem Group. First self-published by the Aouchem Group in 1967. English text taken from *Critical Interventions: Journal of African Art History and Visual Culture*, vol. 3, no. 1 (2009). Translation by Susan Greenspan and Cynthia Becker. Reprinted here by kind permission of Denis Martinez. Copyright © Aouchem Group, 1967.

M35. 'Tucumán Arde Manifesto' (1968), by the Vanguard Artists' Group. First self-published by the Vanguard Artists' Group in 1968. English text taken from Mari Carmen Ramírez and Héctor Olea, *Inverted Utopias: Avant-Garde Art in Latin America* (New Haven, CT: Yale University Press in association with the Museum of Fine Arts, Houston, 2004). Translation by Julieta Fombona. Copyright © Vanguard Artists' Group, 1968.

M36. 'Useful Art Manifesto' (1969), by Eduardo Costa. First published as part the *Street Works* event (New York, 1969). Reprinted here by kind permission of Eduardo Costa. Copyright © Eduardo Costa, 1969. See further, *Listen, Here, Now! Argentine Art of the 1960s: Writings of the Avant-Garde*, ed. Inés Katzenstein (New York: Museum of Modern Art, 2004).

M37. Manifesto of the Casablanca School (1969). First published in *Lamalif*, no. 30 (May–June 1969). Copy of the text kindly provided by Katarzyna Pieprzak. New translation by Hervé

Sanchez. Copyright © Casablanca School, 1969. See further, Katarzyna Pieprzak, 'Moroccan Art Museums and Memories of Modernity', in *A Companion to Modern African Art*, ed. Gitti Salami and Monica Blackmun Visonà (Malden, MA: Wiley-Blackwell, 2013).

M38. 'Why Are We "Artists"?' (1969), by Hori Kōsai. First published in Hikosaka Naoyoshi, *Hanpuku: Shinkō geijutsu no isō (Recurrence: Phases of New Art)* (Shoten: Tokyo, 1974). English text taken from *From Postwar to Postmodern: Art in Japan 1945–1989. Primary Documents*, ed. Doryun Chong, Michio Hayashi, Kenji Kajiya and Fumihiko Sumitomo (New York: Museum of Modern Art, 2012). Translation by Ken Yoshida. Reprinted here by kind permission of Hori Kōsai. Copyright © Hori Kōsai, 1969.

M39. 'Pan-African Cultural Manifesto' (1969), by the Organization of African Unity (extract). First published in *Présence Africaine*, no. 71 (1969). English text taken from *Africa Today*, vol. 17, no. 1 (January–February 1970). *Africa Today* © 1970 Indiana University Press.

M40. 'A Manifesto' (1969), by Agnes Denes. Text taken from *Feminist Art Manifestos: An Anthology*, ed. Katy Deepwell (London: KT Press, 2014). Copyright © Agnes Denes, 1969. See further, *Agnes Denes: Work, 1969–2013*, ed. Florence Derieux (Milan: Mousse Publishing, 2016).

M41. 'Towards a New Vision' (1969), by Dia al-Azzawi, Rafa al-Nasiri, Muhammad Mahr al-Din, Ismail Fattah, Hashem Samarji and Saleh al-Jumaie. First published in *Al-Bayanat al-Fanniyya fi al-Iraq (Art Manifestos in Iraq)*, ed. Shakir Hassan al-Said (Baghdad: Wizarat al-Ilam, Mudiriyyat al-Thaqafa al-Amma, 1973). English text taken from *Modern Art in the Arab World: Primary Documents*, ed. Anneka Lenssen, Sarah A. Rogers and Nada Shabout (New York: Museum of Modern Art, forthcoming). Translation by the editors. Translation copyright © MoMA, 2017/18. See further, the Modern Art Iraq Archive website at https://artiraq.org/maia/.

M42. 'The Vértebra Manifesto' (1970), by Grupo Vértebra. First published in *Alero* (March 1970). Copy kindly provided by Rodrigo Fernández. New translation by Ángel Gurría-Quintana. Reprinted here by kind permission of Rodrigo Fernández. Copyright © Grupo Vértebra, 1970.

M43. 'MUD/MEAT SEWER' (1970), by Artur Barrio. First published in *Artur Barrio: Barrio-Beuys* (Ghent: Stedelijk Museum voor Actuele Kunst, 2005). With thanks to Jeffry Dean Archer at the University of Chicago Library. Reprinted here by kind permission of Artur Barrio. Copyright © Artur Barrio, 1970.

M44. 'The First Pseudo Manifesto' (1970), by Gyula Pauer. First self-published by Gyula Pauer as a flyer in 1970. English text taken from *Subversive Practices: Art under Conditions of Political Repression, 60s–80s South America and Europe*, ed. Hans D. Christ and Iris Dressler (Ostfildern: Hatje Cantz, 2010). Reprinted here by kind permission of Gellért Pauer and Emánuel Pauer. Copyright © Estate of Gyula Pauer, 1970. Translation © Hatje Cantz.

M45. 'On Woman's Absence from Celebratory Manifestations of Male Creativity' (1971), by Rivolta Femminile. First published in Carla Lonzi, *Sputiamo su Hegel: La donna clitoridea e la donna vaginale e altri scritti* (*Let's Spit on Hegel: The Clitoral Woman and the Vaginal Woman, and Other Writings*) (Milan: Scritti di Rivolta Femminile, 1974). New translation by Carla Zipoli. Published courtesy of Battista Lena. Copyright © Carla Lonzi Estate, 1974.

M46. 'Proposition for a Black Power Manifesto' (1971), by Ted Joans. First published in *Arsenal: Surrealist Subversion, No. 2* (1973). Text taken from *Black, Brown and Beige: Surrealist Writings from Africa and the Diaspora*, ed. Franklin Rosemont and Robin D. G. Kelley (Austin, TX: University of Texas Press, 2009). Reprinted here by kind permission of Laura Corsiglia. Copyright © Ted Joans Estate, 1971.

M47. 'NET Manifesto' (1972), by Jarosław Kozłowski and Andrzej Kostołowski. First published in *Mail Art: Osteuropa im*

Internationalen Netzwerk (*Eastern European Mail Art: International Network*), (Schwerin: Staatliches Museum, Schwerin, 1996). Text taken from 'NET, Jarosław Kozłowski in Conversation with Klara Kemp-Welch', in *ARTMargins*, vol. 1, no. 2–3 (June–October 2012). Reprinted here by kind permission of the artists. Copyright © Jarosław Kozłowski and Andrzej Kostołowski, 1972.

M48. 'Women's Art: A Manifesto' (1972), by VALIE EXPORT. First published in *Neues Forum*, no. 228 (January 1973). English text taken from *Feminist Art Manifestos: An Anthology*, ed. Katy Deepwell (London: KT Press, 2014). Translation by Regina Haslinger. Reprinted here by kind permission of the artist. Copyright © VALIE EXPORT, 1972. See further, Sabeth Buchmann et al., *VALIE EXPORT: Zeit und Gegenzeit / Time and Countertime* (Cologne: Walther Konig, 2010).

M49. 'I don't know what to think about anything (It don't matter, nohow)' (1972), by Mike Brown. First self-published by Mike Brown in 1972. Copy of the text kindly provided by Art Gallery NSW Research Library. Reprinted here by kind permission of Zen Lucas. Copyright © Estate of Mike Brown, 1972. See further, Richard Haese, *Permanent Revolution: Mike Brown and the Australian Avant-Garde, 1953–1997* (Melbourne: Miegunyah Press, 2011).

M50. 'Sots-Art Manifesto' (1972–3), by Vitaly Komar and Aleksandr Melamid. Originally distributed privately in manuscript in 1972–3. Copy of the English text translated and provided by Vitaly Komar. Copyright © Vitaly Komar and Aleksandr Melamid, 1972–3. See further, *Komar/Melamid: Two Soviet Dissident Artists*, ed. Melvyn B. Nathanson (Carbondale, IL: Southern Illinois University Press, 1979).

M51. 'Statement on Censorship' (1973), by Anita Steckel. First published in the *Village Voice* weekly newspaper, 29 March 1973. Text taken from the copy in the Anita Steckel archives at the National Museum of Women in the Arts, Washington, DC. Reprinted here by kind permission of Rachel Middleman on behalf of the Estate of Anita Steckel, with thanks to the

Betty Boyd Dettre Library and Research Center. Copyright © Anita Steckel, 1973. See further, Rachel Middleman, 'Anita Steckel's Feminist Montage: Merging Politics, Art, and Life', *Woman's Art Journal*, vol. 34, no. 1 (Spring–Summer, 2013).

M52. 'One Dimension' (1973), by Shakir Hassan al-Said. First published in the One Dimension Group's exhibition catalogue, 1973. New translation by Sue Copeland. See further, Nada M. Shabout, *Modern Arab Art: Formation of Arab Aesthetics* (Gainesville, FL: University Press of Florida, 2007).

M53. 'The History, Philosophy and Aesthetics of AFRI-COBRA' (1973), by Barbara Jones-Hogu. First published in the exhibition catalogue *AFRI-COBRA III* (University of Massachusetts at Amherst, 1973). Text from a copy provided by the Brooklyn Museum Archives. Reprinted here by kind permission of the artist. Copyright © Barbara Jones-Hogu, 1973. See further, Rebecca Zorach, ' "Dig the Diversity in Unity": AfriCOBRA's Black Family', in *Afterall*, no. 28 (Autumn–Winter 2101).

M54. 'Manifesto Generation Anak Alam' (1974), by Generation Anak Alam. First published in *Dewan Sastra (Arts Council)* (June 1974). Copy of the text kindly provided by Ali Rahamad. Translation by Wong Hoy Cheong. Reprinted here by kind permission of Ali Rahamad. Copyright © Anak Alam, 1974. See further, *Narratives in Malaysian Art*, Volume 2: *Reactions – New Critical Strategies*, ed. Nur Hanim Khairuddin and Beverly Yong (Kuala Lumpur: RogueArt, 2013).

M55. 'Towards a Mystical Reality' (1974), by Sulaiman Esa and Redza Piyadasa. First published in the exhibition catalogue *Towards a Mystical Reality* (Kuala Lumpur, 1974). Copy of the text kindly provided by the Australian National University Library and Sulaiman Esa. Reprinted here by kind permission of Sulaiman Esa. Copyright © Redza Piyadasa and Suleiman Esa, 1974. See further, Patrick D. Flores, 'First Person Plural: Manifestos of the 1970s in Southeast Asia', in *Global Studies: Mapping Contemporary Art and Culture*, ed.

Hans Belting, Jacob Birken, Andrea Buddensieg and Peter Weibel (Ostfildern: Hatje Cantz, 2011).

M56. 'Metaphysical Synthetism Manifesto: Programme of the St Petersburg Group' (1974), by Mikhail Chemiakin and Vladimir Ivanov (extract). Originally distributed privately in manuscript in 1974. English text taken from Igor Golomshtok and Alexander Glezer, *Unofficial Art from the Soviet Union*, ed. Michael Scammell (London: Secker & Warburg, 1977). Reprinted here by kind permission of Index on Censorship. Copyright © Mikhail Chemiakin and Vladimir Ivanov, 1974.

M57. 'Manifesto of the Artists' Front of Thailand' (1975). Originally distributed privately in manuscript in 1975. New translation by Dr Kritsana Canilao, 2011. Reprinted here by kind permission of the artists. Copyright © Artists' Front of Thailand, 1975. See further, Patrick D. Flores, 'First Person Plural: Manifestos of the 1970s in Southeast Asia', in *Global Studies: Mapping Contemporary Art and Culture*, ed. Hans Belting, Jacob Birken, Andrea Buddensieg and Peter Weibel (Ostfildern: Hatje Cantz, 2011).

M58. 'Manifesto of the Indonesian New Arts Movement' (1975). First published in *Gerakan Seni Rupa Baru* (*New Arts Movement*), ed. Jim Supangkat (Jakarta: Gramedia, 1979). Copy of the text kindly provided by F. X. Harsono. Reprinted here by kind permission of F. X. Harsono. Copyright © Indonesian New Art Movement, 1975. See further, Patrick D. Flores, 'First Person Plural: Manifestos of the 1970s in Southeast Asia', in *Global Studies: Mapping Contemporary Art and Culture*, ed. Hans Belting, Jacob Birken, Andrea Buddensieg and Peter Weibel (Ostfildern: Hatje Cantz, 2011).

M59. 'Preliminary Notes for a BLACK MANIFESTO' (1975–6), by Rasheed Araeen. First published in *Black Phoenix*, no. 1 (January 1978). Reprinted here by kind permission of the artist. Copyright © Rasheed Araeen, 1975–6. See further, Rasheed Araeen, *Making Myself Visible* (London: Kala Press, 1984).

M60. Manifesto of the Azad Group (1976). First published in the exhibition catalogue *Gonj va Gostareh II* (*Volume and Environment II*) (1976). English text taken from *ARTMargins*, vol. 3, no. 2 (June 2014). Translation by Bavand Behpoor. Translation copyright © *ARTMargins* and the Massachusetts Institute of Technology, 2014.

M61. 'Kaisahan Manifesto' (1976). Originally distributed privately in manuscript in 1976. English text taken from Alice Guillermo, *Protest/Revolutionary Art in the Philippines, 1970–1990* (Quezon City: University of the Philippines Press, 2001). Copy of the text kindly provided by the artists. Copyright © Kaisahan, 1976. See further, Patrick D. Flores, 'First Person Plural: Manifestos of the 1970s in Southeast Asia', in *Global Studies: Mapping Contemporary Art and Culture*, ed. Hans Belting, Jacob Birken, Andrea Buddensieg and Peter Weibel (Ostfildern: Hatje Cantz, 2011).

M62. 'Manifesto for a Radical Femininity for an Other Cinema' (1977), by Maria Klonaris and Katerina Thomadaki. First published in *CinémAction*, no. 1 (May 1978). English text taken from *Feminist Art Manifestos: An Anthology*, ed. Katy Deepwell (London: KT Press, 2014). Translation by Cécile Chich and Katerina Thomadaki. Reprinted here by kind permission of Katerina Thomadaki. Copyright © KLONARIS/THOMADAKI, 1977. All rights reserved. See further, Maria Klonaris and Katerina Thomadaki, *KLONARIS/THOMADAKI: Manifestes, 1976–2002* (Paris: Éditions Paris Expérimental, 2003).

M63. 'Art Hysterical Notions of Progress and Culture' (1978), by Valerie Jaudon and Joyce Kozloff. First published in *Heresies: A Feminist Publication on Art and Politics*, vol. 1, no. 4 (Winter 1978). Reprinted here by kind permission of the artists. Copyright © Valerie Jaudon and Joyce Kozloff, 1978.

M64. 'Waste Not Want Not: An Inquiry into What Women Saved and Assembled – Femmage' (1978), by Melissa Meyer and Miriam Schapiro. First published in *Heresies: A Feminist Publication on Art and Politics*, vol. 1, no. 4 (Winter 1978).

Reprinted here by kind permission of Melissa Meyer. Copyright © Melissa Meyer and Miriam Schapiro, 1978.

M65. Manifesto of Grupo Antillano (1978). Originally presented by Grupo Antillano as an exhibition poster in 1978. English text taken from *Grupo Antillano: The Art of Afro-Cuba / El arte de Afro-Cuba*, ed. Alejandro de la Fuente (Santiago de Cuba: Fundación Caguayo, 2013). Translation by Tom Holloway. Reprinted here by kind permission of Alejandro de la Fuente. Copyright © Grupo Antillano, 1978.

M66. 'The Crystalist Manifesto' (1978), by the Crystalist Group. First published in the exhibition catalogue *Tradition and Contempora(neity)* (1978). English text taken from *Seven Stories about Modern Art in Africa*, ed. Clémentine Deliss and Jane Havell (London: Whitechapel Art Gallery, 1995). Translation by Salah M. Hassan. Reprinted here by kind permission of Salah M. Hassan. Copyright © Kamala Ibrahim Ishaq, Muhammad Hamid Shaddad and Nayla El Tayib, 1978.

M67. 'manifesto of manifesto' (1978), by Mangelos. First published in Mangelos, *manifesto of manifesto* (Zagreb: Tošo Dabac Atelier, 1978). Text taken from *Impossible Histories: Historical Avant-Gardes, Neo-Avant-Gardes, and Post-Avant-Gardes in Yugoslavia, 1918–1991*, ed. Dubravka Djurić and Miško Šuvaković (Cambridge, MA: MIT Press, 2003). Copyright © Mangelos, 1978.

M68. 'Preface to the First Stars Art Exhibition' (1979), by Huang Rui. Originally presented by the Stars Group as an exhibition poster in 1979. English text taken from *Contemporary Chinese Art: Primary Documents*, ed. Wu Hung (New York: Museum of Modern Art, 2010). Translation by Philip Tinari. Copyright © Stars Group, 1979. See further, *Huang Rui: The Stars' Times, 1977–1984*, ed. Huang Rui (Beijing: Thinking Hands and Guanyi Contemporary Art Archive, 2007).

M69. 'Animal Manifesto' (1980), by Andrzej Partum. Originally presented by Andrzej Partum as a poster for the 18th International Meeting of Artists, Scientists and Art Theorists

(*Międzynarodowe Spotkania Artystów, Naukowców i Teoretyków Sztuki*) in 1980. Courtesy Wanda Lacrampe. Copyright © Andrzej Partum, 1980. See further, *Art Always Has Its Consequences* (Zagreb: WHW, 2010).

M70. 'On Founding "Reality and Utterance"' (1980), by Reality and Utterance. First published in Reality and Utterance's exhibition catalogue in 1980. English text taken from Haegue Yang, *Condensation* (Seoul: Arts Council Korea, 2009). Translation by Doryun Chong, with thanks to Asia Art Archive. Copyright © Reality and Utterance, 1980. See further, Sohl Lee, 'Images of Reality / Ideals of Democracy: Contemporary Korean Art, 1980s–2000s' (PhD thesis: University of Rochester, New York, 2014).

M71. 'Maghrebian Surrealism' (1981), by Habib Tengour. First published in *Peuples méditerranéens* (*Mediterranean People*), no. 17 (October–December 1981). English text taken from *Black, Brown and Beige: Surrealist Writings from Africa and the Diaspora*, ed. Franklin Rosemont and Robin D. G. Kelley (Austin, TX: University of Texas Press, 2009). Translation by Myrna Bell Rochester. Reprinted here by kind permission of Robin D. G. Kelley and Surrealist Editions, Chicago. Copyright © Habib Tengour, 1981.

M72. 'Black Artists for Uhuru' (1982), by Eddie Chambers. First published in *Moz-Art: The Arts Magazine of the West Midlands*, no. 5 (March–July 1982). Copy of the text kindly provided by the Blk Arts Archive. Copyright © Eddie Chambers, 1982. See further, *Shades of Black: Assembling Black Arts in 1980s Britain*, ed. David A. Bailey, Ian Baucom and Sonia Boyce (Durham, NC: Duke University Press, 2005).

M73. 'A Declaration by the CADA' (1982), by Colectivo de Acciones de Arte. First published in *Ruptura: Documento de arte* (August 1982). Copy of the text kindly provided by Lotty Rosenfeld. New translation by Ángel Gurría-Quintana. Copyright © CADA, 1982.

M74. 'Black Independent Film-Making: A Statement by the Black Audio Film Collective' (1983), by John Akomfrah. First

published in *Artrage: Inter-Cultural Arts Magazine*, no. 3–4 (Summer 1983). Copyright © John Akomfrah, 1983. See further, *The Ghosts of Songs: The Film Art of the Black Audio Film Collective, 1982–1998*, ed. Kodwo Eshun and Anjalika Sagar (Liverpool: Liverpool University Press, 2007).

M75. 'Women Artists of Pakistan Manifesto' (1983). First published in Salima Hashmi, *Unveiling the Visible: Lives and Works of Women Artists of Pakistan* (Lahore: Sang-e-Meel Publications, 2002). Text taken from *Feminist Art Manifestos: An Anthology*, ed. Katy Deepwell (London: KT Press, 2014).

M76. 'The San Francisco Manifesto' (1984), by Bedri Baykam. First self-published by Bedri Baykam as a flyer in 1984. Copy of the text kindly provided by Bedri Baykam. Copyright © Bedri Baykam, 1984. See further, Bedri Baykam, *Monkeys' Right to Paint and the Post-Duchamp Crisis: The Fight of a Cultural Guerilla for the Rights of Non-Western Artists and the Empty World of the Neo-Ready-Mades* (Istanbul: Literatür, 1994).

M77. 'The Vocovisual' (1984), by Vladan Radovanović. First published in Vladan Radovanović, *Vokovizuel* (Belgrade: Galerija Doma Omladine, 1984). English text taken from *Impossible Histories: Historical Avant-Gardes, Neo-Avant-Gardes, and Post-Avant-Gardes in Yugoslavia, 1918–1991*, ed. Dubravka Djurić and Miško Šuvaković (Cambridge, MA: MIT Press, 2003). Translation by Branka Nikolić Arrivé. Copyright © Vladan Radovanović, 1984.

M78. 'Memory of the Future?' (1984), by Laboratoire AGIT'art. Originally distributed privately in manuscript in 1984. English text taken from *Contemporary Art of Africa*, ed. André Magnin and Jacques Soulillou (London: Thames & Hudson, 1996). Reprinted here by kind permission of the artists. Copyright © Laboratoire AGIT'art, 1984. See further, Clémentine Deliss, 'Brothers in Arms: Laboratoire AGIT'art and Tenq in Dakar in the 1990s', in *Afterall*, no. 36 (Summer 2014).

M79. 'Flyer for Plan for Sleep #1' (1984), by Dumb Type. First self-published as a flyer by Dumb Type in 1984. Text taken from *From Postwar to Postmodern: Art in Japan 1945–1989. Primary*

Documents, ed. Doryun Chong, Michio Hayashi, Kenji Kajiya and Fumihiko Sumitomo (New York: Museum of Modern Art, 2012). Reprinted here by kind permission of the artists. Copyright © Dumb Type, 1984.

M80. 'Manifesto Chinese United Overseas Artists' (1985), by Chinese United Overseas Artists. Originally distributed privately in manuscript in 1985. Copy of the original manuscript can be seen on the Iconophilia website at www.iconophilia.net/ai-weiweis-1985-manifesto/. Reprinted here by kind permission of the artists. Copyright © Chinese United Overseas Artists, 1985.

M81. 'Internal Book of Laws' (1985), by NSK. Originally distributed privately in manuscript in 1985. Copy of the text kindly provided by NSK (*Neue Slowenische Kunst*). With thanks to Michele Drascek. Reprinted here by kind permission of the artists. Copyright © NSK, 1985. See further, *NSK: From Kapital to Capital*, ed. Zdenka Badovinac, Eda Čufer and Anthony Gardner (Cambridge, MA: MIT Press, 2015).

M82. 'The Vohou-Vohou Revolution' (1985), by Vohou-Vohou. Originally distributed privately in manuscript in 1985. English text taken from *Contemporary Art of Africa*, ed. André Magnin and Jacques Soulillou (London: Thames & Hudson, 1996). Reprinted here by kind permission of the artists. Copyright © Vohou-Vohou, 1985.

M83. 'Declaration of the Pond Association' (1986). Originally distributed privately in manuscript in 1986. English text taken from Paul Gladston, *Deconstructing Contemporary Chinese Art: Selected Critical Writings and Conversations, 2007–2014* (Heidelberg: Springer, 2015). Reprinted here by kind permission of the artists. Copyright © The Pond Association, 1986.

M84. 'We – Participants of the "'85 Art Movement"' (1986), by Wang Guangyi. First published in *Zhongguo meishu bao* (*Fine Arts in China*), no. 36 (September 1986). English text taken from *Contemporary Chinese Art: Primary Documents*, ed. Wu Hung (New York: Museum of Modern Art, 2010). Translation by Kristen Loring. Copyright © Wang Guangyi, 1986.

M85. 'There Have Always Been Great Blackwomen Artists' (1986), by Chila Kumari Burman. First published in *Women Artists Slide Library Journal*, no. 15 (February 1987). Reprinted here by kind permission of the artist. Copyright © Chila Burman, 1986. See further, *Visibly Female: Feminism and Art – An Anthology*, ed. Hilary Robinson (London: Camden Press, 1987).

M86. 'Founding Manifesto' (1986), by the School of the One. Originally distributed privately in manuscript in 1986. English text taken from *Seven Stories about Modern Art in Africa*, ed. Clémentine Deliss and Jane Havell (London: Whitechapel Art Gallery, 1995). Translation by Salah M. Hassan. Reprinted here by kind permission of Salah M. Hassan. Copyright © School of the One, 1986.

M87. 'Red Brigade Precept' (1987), by Ding Fang. First published in *Meishu sichao* (*The Trend of Art Thought*), no. 1 (January–February 1987). English text taken from *Contemporary Chinese Art: Primary Documents*, ed. Wu Hung (New York: Museum of Modern Art, 2010). Translation by Phillip Bloom. Copyright © Ding Fang, 1987.

M88. 'Questions and Dialogue' (1987), by Anita Dube. First published in the Kerala Radicals' exhibition catalogue (Faculty of Fine Arts, Baroda, 1987). Copy of the text kindly provided by Asia Art Archive. Reprinted here by kind permission of Anita Dube. Copyright © Anita Dube, 1987. See further, Anita Dube, 'Midnight Dreams: The Tragedy of a Lone Revolutionary', and Shanay Jhaveri, 'Mutable Bodies: K. P. Krishnakumar and the Radical Association', both in *Afterall*, no. 36 (Summer 2014).

M89. 'The Eye Manifesto' (1989), by the Eye Society. First published in *The Eye Monograph* (1989). Text taken from *Seven Stories about Modern Art in Africa*, ed. Clémentine Deliss and Jane Havell (London: Whitechapel Art Gallery, 1995). Reprinted here by kind permission of Jacob Jari. Copyright © The Eye Society, 1989.

M90. 'The Ear behind the Painting' (1990), by Eda Čufer and IRWIN. First published in the exhibition catalogue *Kapital* (New York: PS1 Contemporary Art Center, 1991). Copy of the text kindly provided by the artists. With thanks to Michele Drascek. Reprinted here by kind permission of the artists. Copyright © Eda Čufer and IRWIN, 1990. See further, *NSK: From Kapital to Capital*, ed. Zdenka Badovinac, Eda Čufer and Anthony Gardner (Cambridge, MA: MIT Press, 2015).

M91. 'Cyberfeminist Manifesto for the 21st Century' (1991), by VNS Matrix. First distributed online in 1991. Copy of the text kindly provided by the artists. Reprinted here by kind permission of the artists. Copyright © VNS Matrix, 1991. See further, the group's website, VNS Matrix: Merchants of Slime, at vnsmatrix.net.

M92. 'Projekt Atol Manifesto: In Search for a New Condition' (1993), by Marko Peljhan. First published in *Theatre Topics*, vol. 6, no. 2 (September 1996). Text taken from Johannes H. Birringer, *Performance on the Edge: Transformations of Culture* (London: The Athlone Press, 2000). Reprinted here by kind permission of the artist. Copyright © Marko Peljhan, 1993.

M93. Manifesto of the Institute of People-Oriented Culture 'Taring Padi' (1998). Originally distributed privately in manuscript in 1998. Copy of the text kindly provided by the artists. Reprinted here by kind permission of the artists. Copyright © Taring Padi, 1998. See further, the group's website at https://www.taringpadi.com/?lang=en.

M94. 'Manifesto of Frente 3 de Fevereiro' (2004). Originally distributed privately in manuscript in 2004. Text taken from the group's website at www.frente3defevereiro.com.br. New translation by Rory Campbell. Copyright © Frente 3 de Fevereiro, 2004. See further, *Living as Form: Socially Engaged Art from 1991–2011*, ed. Nato Thompson (New York: Creative Time Books, 2012).

M95. 'Against The "Black Code" edict of Louis XIV, 1685' (2008), by Pélagie Gbaguidi. First published in *Slavery in Art and Literature: Approaches to Trauma, Memory and Visuality*, ed. Birgit Haehnel and Melanie Ulz (Berlin: Frank & Timme, 2010). Translation by Zoe Whitley. Copy of the text kindly provided by the artist. Copyright © Pélagie Gbaguidi, 2008.

M96. 'Black Dada' (2008), by Adam Pendleton. First performed at *Manifesta 7* in Italy in 2008. Copy of the text kindly provided by the artist. Copyright © Adam Pendleton, 2008. See further, *Adam Pendleton: I'll Be Your*, ed. Suzanne Perling Hudson (London: Pace Gallery, 2012).

M97. 'Deep Lez' (2009), by Allyson Mitchell. First published in *GLQ: A Journal of Lesbian and Gay Studies*, vol. 17, no. 4 (2011). Copy of the text kindly provided by the artist. Copyright © Allyson Mitchell, 2009. See further, Kaitlin Noss, 'Queering Utopia: Deep Lez and the Future of Hope', *Women's Studies Quarterly*, vol. 40, no. 3–4 (October 2012).

M98. 'What is to be done?' (2011), by Abounaddara. First distributed online in 2011 at https://www.facebook.com/notes/abounaddara-films/العمل-ما-/888403867886988. New translation by Stefan Tarnowski. Published here by kind permission of the artists. Copyright © Abounaddara, 2011.

M99. 'Migrant Manifesto' (2011), by Tania Bruguera and Immigrant Movement International. First presented by Tania Bruguera at the United Nations Student Conference on Human Rights in New York in 2011. Text taken from Tania Bruguera's website at www.taniabruguera.com/cms/682-0-International+Migrant+Manifesto.htm. Reprinted here by kind permission of the artist. Copyright © Tania Bruguera, 2011. See further, Claire Bishop, *Artificial Hells: Participatory Art and the Politics of Spectatorship* (London: Verso, 2012).

M100. 'Manifesto on Artists' Rights' (2012), by Tania Bruguera. First presented by Tania Bruguera at the Office of the United Nations High Commissioner for Human Rights at the Palais des Nations in Geneva in 2012. Text taken from Tania

Bruguera's website at http://www.taniabruguera.com/cms/680-0-ExpertMeetingonArtisticFreedomand+Cultural Rights.htm. Reprinted here by kind permission of the artist. Copyright © Tania Bruguera, 2012. See further, Claire Bishop, *Artificial Hells: Participatory Art and the Politics of Spectatorship* (London: Verso, 2012).

Every effort has been made to contact copyright holders. The authors and publisher would be glad to amend in future editions any errors or omissions brought to their attention.

Acknowledgements

Thanks to: Marcus Freeman, Hannah Lack, Cecilia Stein, Kit Shepherd, Maria Bedford, Rory Campbell, Hervé Sanchez, Ángel Gurría-Quintana, Carla Zipoli, Sue Copeland, Stefan Tarnowski, Bavand Behpoor, Laura Corsiglia, Robin D. G. Kelley, Battista Lena, Angelica Lena, Oyku Eras, Da-eun Lee Stark, John Stark, Salima Hashmi, Ijeoma Uche-Okeke, Giovanna Zapperi, Rodrigo Fernández, Paul Gladston, Patrick D. Flores, Richard Freeman, Malcolm Green, Michael Scammell, Richard Haese, Zen Lucas, Gellért Pauer, Emánuel Pauer, Klara Kemp-Welch, Len Breen, Kritsana Canilao, Hideko Nakazawa, Éva Forgács, Dale Tomich, Lotty Rosenfeld, Ken Yoshida, Marguerite Feitlowitz, Dubravka Djurić, Joan Semmel, Rachel Middleman, Doryun Chong, Kem Schultz, Nora Heymann, Analivia Cordeiro, Valter Sacilotto, Antoni Burzyński, Stephanie Adamowicz, Roberta Cerini Baj, Michael Fei, Alastair Brotchie, Pauline Freeman, Zak Freeman, Alexis Freeman, Nick Lack, Nora Lack, Benedict Lack, Maria Kantor, Dorota Krakowska, Bartłomiej Marianowski, Katy Deepwell, Rebecca Zorach, Kuumba Hogu, Akiko Sato, Peggy Gough, Mustafa Shah, Johni Wong, Julia Rajkovic-Kamara, Clémentine Deliss, Janet Stanley, Julia Whitney, Max Gadney, Salah M. Hassan, Ossian Ward, Kathy Noble, Justin Jesty, Yoko Takatani, Christopher Stephens, Nada Shabout, Anneka Lenssen, Cynthia Becker, Peter Nagy, Emily Pethick, Victoria Lupton, Panada Lerthattasin, Wanda Lacrampe, Makiko Mikawa, Annamaria Szőke, Mine Haydaroglu, Kadir Yilmaz, Mary Işin, Morag Barnes, Karin Eklund, Chloe Beresford-Jones, Karine Chiron, Chloe Kinsman, Heather Jenks at the Australian National

Acknowledgements

University library, Jeffry Dean Archer at the Joseph Regenstein Library, Gabrielle Chan at Asia Art Archive, Lydia Hejka and Jennifer Page at the National Museum of Women in the Arts, Vivian Huang at Art Gallery NSW Research Library, Jessica Palinski at the Brooklyn Museum, Catherine Belloy at the Marian Goodman Gallery, the Juan Muñoz Foundation, Stephen Matthew Williams at Indiana University Press, Wysing Arts Centre and all the artists who kindly gave permission to publish their manifestos in this collection.

Finally, the book's origins grew out of a writer's residency at Jerwood Visual Arts in 2012, during the exhibition *Now I Gotta Reason*, curated by Marcus Coates and Grizedale Arts. To that end, I would like to thank Sarah Williams, Shonagh Manson and Oliver Fuke at Jerwood Visual Arts and Adam Sutherland at Grizedale Arts.

THE HEARING TRUMPET

Leonora Carrington

The Hearing Trumpet is the story of 92-year-old Marian Leatherby, who is given the gift of a hearing trumpet only to discover that what her family is saying is that she is to be committed to an institution. But this is an institution where the buildings are shaped like birthday cakes and igloos, where the Winking Abbess and the Queen Bee reign, and where the gateway to the underworld is open. It is also the scene of a mysterious murder. Occult twin to *Alice in Wonderland*, *The Hearing Trumpet* is a classic of fantastic literature that has been translated and celebrated throughout the world.

'Reading *The Hearing Trumpet* liberates us from the miserable reality of our days' Luis Buñuel

THE FEMININE MYSTIQUE

Betty Friedan

When Betty Friedan produced *The Feminine Mystique* in 1963, she could not have realized how the discovery and debate of her contemporaries' general malaise would shake up society. Victims of a false belief system, these women were following strict social convention by loyally conforming to the pretty image of the magazines, and found themselves forced to seek meaning in their lives only through a family and a home. Friedan's controversial book about these women – and every woman – would ultimately set Second Wave feminism in motion and begin the battle for equality.

This groundbreaking and life-changing work remains just as powerful, important and true as it was forty-five years ago, and is essential reading both as a historical document and as a study of women living in a man's world.

'One of the most influential nonfiction books of the twentieth century' *The New York Times*

LITTLE BIRDS

Anaïs Nin

Delta of Venus and *Little Birds*, Anaïs Nin's bestselling volumes of erotica, contain striking revelations of a woman's sexuality and inner life. In *Little Birds*, each of the thirteen short stories captures a moment of sexual awakening, recognition or fulfilment, and reveals the subtle or explicit means by which men and women are aroused. Lust, obsession, fantasy and desire emerge as part of the human condition, as pure or as complex as any other of its aspects.

'One of the most extraordinary and unconventional writers of this century' *The New York Times Book Review*